CLASSICAL PRESENCES

General Editors

LORNA HARDWICK JAMES I. PORTER

CLASSICAL PRESENCES

Attempts to receive the texts, images, and material culture of ancient Greece and Rome inevitably run the risk of appropriating the past in order to authenticate the present. Exploring the ways in which the classical past has been mapped over the centuries allows us to trace the avowal and disavowal of values and identities, old and new. Classical Presences brings the latest scholarship to bear on the contexts, theory, and practice of such use, and abuse, of the classical past.

Fragmentary Modernism

The Classical Fragment in Literary and Visual Cultures, c.1896–c.1936

NORA GOLDSCHMIDT

OXFORD
UNIVERSITY PRESS

Great Clarendon Street, Oxford, OX2 6DP,
United Kingdom

Oxford University Press is a department of the University of Oxford.
It furthers the University's objective of excellence in research, scholarship,
and education by publishing worldwide. Oxford is a registered trade mark of
Oxford University Press in the UK and in certain other countries

© Nora Goldschmidt 2023

The moral rights of the author have been asserted

All rights reserved. No part of this publication may be reproduced, stored in
a retrieval system, or transmitted, in any form or by any means, without the
prior permission in writing of Oxford University Press, or as expressly permitted
by law, by licence or under terms agreed with the appropriate reprographics
rights organization. Enquiries concerning reproduction outside the scope of the
above should be sent to the Rights Department, Oxford University Press, at the
address above

You must not circulate this work in any other form
and you must impose this same condition on any acquirer

Published in the United States of America by Oxford University Press
198 Madison Avenue, New York, NY 10016, United States of America

British Library Cataloguing in Publication Data
Data available

Library of Congress Control Number: 2023942169

ISBN 978–0–19–286340–9

DOI: 10.1093/oso/9780192863409.001.0001

Printed and bound by
CPI Group (UK) Ltd, Croydon, CR0 4YY

Links to third party websites are provided by Oxford in good faith and
for information only. Oxford disclaims any responsibility for the materials
contained in any third party website referenced in this work.

For James, Clara, and Nina

Acknowledgements

Bits and pieces of this book have been on my mind for over a decade, and I have benefitted from the conversation, encouragement, and expertise of several people along the way. In London and Oxford, Miriam Leonard, Ingo Gildenhard, Alessandro Schiesaro, Debbie Challis, David Ricks, Fiona Macintosh, and Oliver Taplin inspired me to grow the project when it was just the seed of an idea. In Durham, I benefitted from the help of several wonderful colleagues: Amy Russell and Edmund Thomas tracked down elusive pieces of material culture; Anna Judson was generous with her extensive knowledge of Knossos; Andrea Capra kindly put me in touch with Luigi Lehnus who shared his expertise on Greek lyric; Martina Piperno was a thoughtful respondent to a paper I presented at the Centre for Visual Arts and Culture, and Christina Riggs a probing chair. I am especially grateful to Tom Stammers, whose friendship, encouragement, and knowledge of museums and collecting have been a genuine pleasure; to Jason Harding, who has been nothing but encouraging across the disciplinary divide (down to reading a full draft of the manuscript), and to Roy Gibson, who acted as my mentor and was unstintingly supportive and astute while reading drafts of several chapters during lockdown.

Initial research for this project was presented at a workshop in Durham organized by John Nash and Jason Harding in July 2013 (the results have since been published in *Modernism and Non-Translation* (Oxford: Oxford University Press, 2019)). I am very grateful to the organizers and participants at the workshop, especially Danny Karlin, Rowena Fowler, and Scarlett Baron. An early runthrough was also presented as a keynote at 'Fragmentation: Modernism and After', an international early career conference held at Princeton University in September 2016, and I owe thanks to the organizers Talitha Kearey and Kay Gabriel, and to the participants and audience members for their perceptive comments.

As my research progressed, I benefitted from the expertise of several people who very generously read drafts and helped me track down leads. Charles Martindale and Liz Prettejohn commented on an early draft, and their incisive and insightful feedback was crucial in the process of revision. Peter Agócs and Elizabeth Vandiver were gracious and attentive readers of an earlier version of the full manuscript. Roberta Mazza and Anna Uhlig kindly read a draft of my chapter on papyrology. Iman Javadi and Ron Schuchard helped me to trace Eliot's elusive copy of Diels. Abigail Baker and Andrew Parkin talked to me about archaeology, and Jim McCue helped me through bibliographical labyrinths with wit and good humour.

viii ACKNOWLEDGEMENTS

A significant part of the research for this book was conducted during the Covid pandemic when archives were closed. I was exceptionally lucky in the kindness of strangers working in archives all over the world, both those I was able to visit and those which were closed to researchers. I am particularly grateful to Adrienne Sharp at the Beinecke Rare Book and Manuscript Library at Yale University, to Fiona Orsini at RIBA Drawings & Archives Collections, to Katherine Collett at Hamilton College for providing me with Pound's transcripts and clearing up other obscure details, to Daniela Colomo at the Ashmolean Museum in Oxford for details of Grenfell and Hunt (and to Nick Gonis for transcripts of Grenfell's lectures), to Nancy Fulford at the T. S. Eliot Estate, to Errin Hussey at the Henry Moore Institute Archive, and to the archivists at the British Museum and the Tate Gallery in London. I owe a debt of thanks, too, to those who helped get the manuscript into print: the series editors, Jim Porter and Lorna Hardwick, my editors at OUP, Charlotte Loveridge and Cathryn Steele, Sandra Assersohn and Melissa Flamson, who provided expert help with securing permissions, and my copy editor Christine Ranft.

None of this would have been manageable without the generous support of an Arts and Humanities Leadership Fellowship which I held from 2020–22. The AHRC award not only enabled me to write the book, but to hold two interdisciplinary workshops in 2022 ('Talking Fragments'). The stimulating conversations we had – with Anna Uhlig, Peter Toth, Laura Swift, Edith Hall, Helen Eastman, Josephine Balmer, Rory McInnes-Gibbons, John Chapman, Bisserka Gaydarska, Lottie Parkyn, Pantelis Michelakis, Anna Garnett, Catrin Huber, and Carrie Vout – replicated the kinds of interdisciplinary dialogues I talk about in the book, and helped to confirm that I had put my finger on something real.

Of course, everything would have been completely impossible without James Koranyi and our daughters, who make me whole, and whom I love more than anything else in the world.

Contents

List of Figures	xi
Abbreviations and Note on the Text	xv
Introduction	1
1. Papyrus	17
2. Editions	45
3. Inscriptional Modernism	77
4. Modernism and the Museum: Making, Consuming, and Displaying Sculptural Fragments in the British Museum	113
5. Archaeologisms	151
Postscript: After Modernism	183
Bibliography	189
Index	217

List of Figures

1.1 'The Fayum Fragments', from H. T. Wharton, *Sappho: Memoir, Text, Selected Renderings, and a Literal Translation*, 3rd edn (London: John Lane, 1895), p.180. © The British Library Board, 11340.aaa.11. 24

1.2 Photograph of P. Oxy. I 7 in *The Oxyrhynchus Papyri*, Part I (1898), Plate II. The Bodleian Libraries, University of Oxford, R.Text GR.1-1, facing p.11. 32

1.3 Sappho, P. Oxy. III 424, containing part of Fragment 3 Lobel-Page, from *The Oxyrhynchus Papyri*, Part III (1903), p.71. The Bodleian Libraries, University of Oxford, R.Text Gr.1-3, p.71. 33

2.1 Extract from Hermann Diels, *Die Fragmente der Vorsokratiker* (Berlin: Weidmann., 1912), I.77. The Bodleian Libraries, University of Oxford, shelfmark, N.i.499a, p.89. 61

3.1 Plan of the British Museum, ground floor, *c*.1905. Antiqua Print Gallery/Alamy Stock Photo. 82

3.2 Marble stele found at Sigeum. 2.28 m. British Museum (1816,0610.107). © The Trustees of the British Museum. 84

3.3 Inscribed Roman burial chest in the form of an altar, dedicated to Atimetus. British Museum (1817,0208.2). © The Trustees of the British Museum. 88

4.1 The old Elgin Room, *c*.1920, including the 'Poseidon' torso with adjusted plaster cast. © The Trustees of the British Museum. 121

4.2 Torso of a male figure M ('Poseidon'), from the West Pediment of the Parthenon. British Museum (1816,0610.103). © The Trustees of the British Museum. 122

4.3 The Duveen Gallery, 1980s: Wikimedia Commons https://commons.wikimedia.org/wiki/File:The_Duveen_Gallery_(1980s).jpg. 123

4.4 Bernard Ashmole's 'High and Over': Black and white photograph. Historic England Archive. 125

4.5 Rodin with his collection of antiquities in Meudon, *c*.1910. Black and white Photograph. Getty Images/Hulton Archive. 131

4.6 Auguste Rodin, *Iris, Messenger of the Gods* (*c*.1895). Bronze, 82.7 cm. Musée Rodin, (S.1068): akg-images/Erich Lessing. 132

4.7 Marble statue from the West Pediment of the Parthenon, figure N ('Iris'). 135 cm. British Museum (1816,0610.96). © The Trustees of the British Museum. 133

4.8 Gaudier-Brzeska's sketch of Figures L and M from the East Pediment of the Parthenon. Graphite on paper, 23 × 14 cm. Musée National d'Art Moderne, Paris (AM 3376 D (23)). Photograph © Centre Pompidou, MNAM-CCI, Dist. RMN-Grand Palais/Hélène Mauri. 137

xii LIST OF FIGURES

4.9 Head of a horse in Selene's chariot from the east pediment and detail
from south metope. Graphite on paper, 23 × 14 cm. Musée National
d'Art Moderne, Paris (AM 3376 D (22)). Photograph © Centre
Pompidou, MNAM-CCI, Dist. RMN-Grand Palais/Hélène Mauri. 138

4.10 Head and leg of a horse from the Parthenon frieze. Graphite on paper,
23 × 14 cm. Musée National d'Art Moderne, Paris (AM 3376 D (41 a sup)).
Photograph © Centre Pompidou, MNAM-CCI, Dist. RMN-Grand
Palais/Hélène Mauri. 139

4.11 Gaudier Brzeska, *Torso I* 1914. Marble on stone base, 252 × 98 × 77 mm.
Tate Gallery, London, transferred from the Victoria & Albert Museum in
1983. Photograph: Tate. 141

4.12 *Torso III* (*c.*1913–14), Seravezza and Sicilian marble, 27.3 × 8.9 × 8.9 cm.
Image courtesy of the Ruth and Elmer Wellin Museum of Art, Hamilton
College, Clinton NY (2005.6.1). Gift of Elizabeth Pound, wife of
Omar S. Pound, Class of 1951. Photograph: John Bentham. 142

4.13 Jacob Epstein, *Marble Arms* (1923). Marble, 94 cm. Black and white
photograph: Hans Wild, The New Art Gallery, Walsall. © The estate of
Sir Jacob Epstein/Tate. 147

4.14 From A. H. Smith, *A Guide to the Sculptures of the Parthenon in the
British Museum*, revised by C. H. Smith (London: Trustees of the British
Museum, 1908), p.117. 148

5.1 Constantin Brâncuși *Torso* (*Coapsă*), 1909–10. White marble, 24.4 cm.
Muzeul de Artă din Craiova/The Art Museum of Craiova.
© Succession Brancusi – All rights reserved. ADAGP, Paris and DACS,
London 2023. 155

5.2 From the 'H. D. Scrapbook'. H. D. Papers. American Literature Collection,
Beinecke Rare Book and Manuscript Library, Yale University, YCAL MSS 24;
used by permission of Pollinger Limited on behalf of the Estate of
Hilda Doolittle. 160

5.3 The Calf-Bearer (Moschophoros) and the Kritios Boy shortly after
exhumation on the Acropolis, *c.*1865. Albumen silver print from glass
negative. Metropolitan Museum of Art, Gilman Collection, Gift of
The Howard Gilman Foundation, 2005. 162

5.4 The 'Peplos Kore', *c.*530 BCE, discovered in four pieces in 1886. Parian
marble, 1.2 m. Acropolis Museum (679). © Acropolis Museum. Photograph:
Yiannis Koulelis, 2018. 163

5.5 Two male *kouroi* ('Kleobis and Biton'). Delphi Museum (467, 1524 (statues);
980, 4672 (plinths)). Getty Images/Education Images. 165

5.6 Jacob Epstein, *Girl with a Dove* (1906–7). Pencil drawing. The New Art
Gallery, Walsall, Garman-Ryan Collection (1973.065.GR). © The estate of
Sir Jacob Epstein/Tate. 166

5.7 'The Horns of Consecration', Knossos. Photograph: Anterovium/Shutterstock.com. Copyright Hellenic Ministry of Culture and Sports (N. 3028/2002). 178

5.8 Stairs from the 'Piano Nobile' to an imaginary third storey. Photograph: Louise A. Hitchcock. Copyright Hellenic Ministry of Culture and Sports (N. 3028/2002). 179

5.9 North Entrance before 'reconstitution', from Evans, The Palace of Minos, Vol. III, p.159. © Ashmolean Museum/Mary Evans. 180

5.10 The West Portico of the North Entrance after reconstruction. Photograph: Anton Starikov/Alamy Stock Photo. Copyright Hellenic Ministry of Culture and Sports (N. 3028/2002). 180

Abbreviations and Note on the Text

AP	*Anthologia Palatina*
Cantos	*Ezra Pound, The Cantos*, London: Faber & Faber, 1986; references to this edition are given in the form of Canto number/page number.
CIL	*Corpus Inscriptionum Latinarum*, Berlin 1863–.
CP	*H. D.: Collected Poems, 1912–1944*, L. L. Martz, ed., New York: New Directions, 1983.
Eliot, *CP*	*The Complete Prose of T. S. Eliot: The Critical Edition*, R. Schuchard, gen. ed., Baltimore MD: Johns Hopkins University Press, 2021, 8 vols.
EPHP	*Ezra Pound to His Parents: Letters 1895–1929*, M. de Rachewiltz, A. D. Moody and J. Moody, eds, Oxford: Oxford University Press, 2010.
IMH	T. S. Eliot, *Inventions of the March Hare: Poems 1909–1917*, C. Ricks, ed., London: Faber & Faber, 1996.
Instigations	*Instigations of Ezra Pound: Together with an Essay on the Chinese Written Character by Ernest Fenollosa*, New York: Boni & Liveright, 1920.
LSJ	Liddell, H. G., R. Scott and H. S. Jones, *A Greek-English Lexicon*, 9th revised edn, Oxford: Oxford University Press.
Paige	*The Letters of Ezra Pound: 1907–41*, D. D. Paige, ed., London: Faber & Faber, 1951.
Pound, *Gaudier-Brzeska*	Ezra Pound, *Gaudier-Brzeska: A Memoir*, London and New York: John Lane, 1916.
Pound, *LE*	*The Literary Essays of Ezra Pound*, edited with an instruction by T. S. Eliot, New York: New Directions, 1954.
Pound, *SP*	*Selected Poems: Ezra Pound*, edited with an introduction by T. S. Eliot, London: Faber & Faber 1928, reprinted 1948.
Pound, *SPr*	*Ezra Pound: Selected Prose, 1906–1965*, W. Cookson, ed., London: Faber & Faber, 1973.
PTSE	*The Poems of T. S. Eliot*, C. Ricks and J. McCue, eds, London: Faber & Faber, 2015, 2 vols.
Lobel-Page	Lobel, E. and D. Page, eds. *Poetarum Lesbiorum Fragmenta*, Oxford: Clarendon Press.
P. Oxy.	*The Oxyrhynchus Papyri*.

Translations from Ancient Greek, Latin, and German are my own unless otherwise stated.

Introduction

> It all began with the Greek fragments
>
> H. D., *End to Torment*

Half-formed statues, lacunose poetry, novels with no clear beginning or end: the fragment is so integral to the literary and visual cultures of modernism that it borders on cliché. Scholars of modernism tend to explain the turn to fragmentary modes in the period roughly covering the first half of the twentieth century as a direct response to the pressures of modernity. In John Tytell's words, the fragment became 'one of the calling cards of modernism', largely because it corresponded to 'a new sense of the universe that began to emerge as the nineteenth century ended'.[1] The economies of industrialization made anonymous crowds a fact of daily life. New technologies – from the typewriter to the machine gun – meant that the modernist fragment was 'symptomatic', as Marjorie Perloff puts it, 'of what we might call the new technopoetics of the twentieth century'.[2] When, in the fall-out of the First World War, 'a botched civilization' seemed to sever any reliable continuities with the values of the past, the fragmented experience of modernity found a stark correlation in the broken or absent bodies that became a visceral part of everyday experience.[3]

The fragment is clearly entangled in the *modernity* of modernism, then. But for the wide circle of modernists who spent their time 'pawing over the ancients and semi-ancients', as Ezra Pound put it, the fragment was not only a marker of present experience: it was a stark fact of the remains of the past.[4] As the Postclassicisms Collective has emphasized, our relationship to antiquity is predicated on 'a constitutive relationship to loss'.[5] Recent studies have estimated that as little as 1–5% of the literature of Greece and Rome before 200 CE has survived, and the figure for material culture is likely to be even smaller.[6] From the vantage point of modernity, the classical past – despite its long-standing connections with an

[1] Tytell (1981), 3. [2] Perloff (1986), 115.

[3] Frisby (1985); Childs (1986), chapter 3; Perloff (1986); Schwartz (1988); Haslam (2002); Mellor (2011); Weinstein (2014); Kern (2017); Bruns (2018); Varley-Winter (2018). Pound lamented the 'botched civilization' which led to the war in *Hugh Selwyn Mauberley* V.4 = Pound (1920), 13.

[4] 'A Retrospect': Pound, *LE* 11.

[5] Postclassicisms Collective (2020), 129. For the practice of fragment hunting as essential to classical scholarship, see Most (1997) with Most (1998), (2011); Derda, Hilder, and Kwapisz (2017); Lamari, Montanari, and Novokhato (2020); Mastellari (2021); Ginelli and Lupi (2021).

[6] Netz (2020), 550–1, 557–9; Gibson and Whitton (2023).

Fragmentary Modernism: The Classical Fragment in Literary and Visual Cultures, c.1896–c.1936. Nora Goldschmidt, Oxford University Press. © Nora Goldschmidt 2023. DOI: 10.1093/oso/9780192863409.003.0001

2 FRAGMENTARY MODERNISM

aesthetic perfection dependent 'on the properties of harmonious parts cohering in a continuous whole'[7] – is permanently damaged and dislocated, extracted in pieces from alien contexts or dug up from the ground in disjointed shards.

Fragmentary Modernism begins from the crucial observation that the period which saw some of the most radical experiments in fragmentation in modernist art and writing also witnessed a series of breakthroughs in the discovery and dissemination of Graeco-Roman art and literature in fragments. Around the turn of the century, a revolution in the understanding of the Greek and Roman past brought unprecedented quantities of new fragments to light beyond the closed boundaries of classical scholarship. A stream of ancient Greek texts on damaged papyrus – including fragments of the lyric poet Sappho which had lain unread for thousands of years – were unleashed onto public consciousness in what historians of papyrology have called a 'media circus'.[8] Meanwhile, the new archaeology, made widely accessible through rapid developments in photography, was unearthing fragments of material culture from Archaic and pre-Hellenic periods of a kind previously unseen.[9] Teams of philologists from Germany, France, Britain, and the USA were making collections of textual fragments available in accessible formats, and in the modern museum – increasingly the site of consumption of ancient art and artefacts – a fundamental shift in historic practices of restoration put the fragment on open display as the key visual marker of antiquity.

Developments like these were foundational for the modernist fragment. A papyrus scrap of Sappho, or an Archaic torso recently unearthed from the ground, provided starting points for new artistic production. But the direction of reception also worked the other way. New forms of art and writing – and the prominence they gave to the fragment – started to modify the ways in which the ancient material itself was perceived and presented. As philologists, papyrologists, archaeologists, and museum curators absorbed the new modernist aesthetic of the fragment, they too increasingly emphasized the fragmentary status of their material, suggesting, like their modernist contemporaries, that with antiquity as with modernity completion was not always possible or even desired. Recently discovered texts and objects in fragments were thereby not only endowed with the thrill of the new because they had been freshly dug up from their long slumbers underground; they were also 'new' by association with the modern aesthetic of the fragment that was fast becoming the characteristic marker of the avant-garde. Co-opted into new developments in art and writing, the fragments of the past were invested with a borrowed modernity, as the modernist fragment came to shape the very material on which it was based.

One of the things I hope to show in this book is that what has been called the 'apotheosis of the fragment' in the first half of the twentieth century was not

[7] Tytell (1981), 4; cf. Fitzgerald (2022). [8] Montserrat (2007), 28. [9] Barber (1990).

peculiar to modernism: it was a joint cultural production shared between modernists and classical scholars engaged in bringing the fragments of antiquity to light in modernity.[10] The result has important implications both for the understanding of modernism and for the study of antiquity. On the one hand, it allows us to acknowledge that, for all its modernity, the appearance of the fragment in the literary and visual cultures of modernism was not only a hyper-modern phenomenon; it was, in important ways, a function of classical reception, predicated on a network of interactions with ancient texts and objects and the work of the scholars who deciphered and disseminated them. At the same time, it is important to face head on the extent to which modernism's intervention in classical scholarship has shaped the reception of the fragment by those who continue to study and circulate the remains of antiquity. Surrounded by white space on the page or denuded of supplementary restoration in the contemporary museum, the fragment has become the privileged form in which we consume antiquity in modernity. Acknowledging the mediating role of modernism in that construction is crucial not just to understanding the modernist fragment, but the ways in which we still engage with and disseminate the fragments of the past.

The generative dialogues between modernism and classical scholarship that I argue for here might seem counter-intuitive, not least because the two arenas are often seen as irreparably separated by what Steven Yao has called a 'traumatic breach'.[11] On one side of the divide, modernists violently denounced the 'pedagogues, philologists and professors' who promoted the stifling 'cake-icing' of classical sculpture, and obscured the vitality of ancient poetry by rendering it 'so safe and so dead'.[12] For their part, classical scholars bristled at what they saw as the amateur efforts to encroach on their professional territory. As the Chicago classicist William Gardner Hale notoriously put it in response to Ezra Pound's *Homage to Sextus Propertius* (1919): 'If Mr. Pound were a Professor of Latin there would be nothing left for him but suicide.'[13]

Yet as a groundswell of recent scholarship has begun to emphasize, despite the rhetoric of mutual rejection, modernist artists and writers turned to the remains of Graeco-Roman antiquity with an almost obsessive attraction. James Joyce's classicisms,[14] H. D.'s Hellenism,[15] Pound and Joyce's engagement with Homer,[16] Virginia Woolf's reception of Greece,[17] and the dynamics of modernist translation all – we now know in detail – formed active vectors in the development of

[10] For the expression 'apotheosis of the fragment' as applied to modernist literature, see Collecott (1999), 15 (citing Pat Moyer) and Cambria, Gregorio, and Res (2018), 29.

[11] Yao (2019), xv.

[12] Aldington (1915); Ezra Pound, 'The New Sculpture', *The Egoist* I.4, 1914, p.68; Aldington (1915).

[13] 'Pegasus Impounded', Letter to the Editor, *Poetry: A Magazine of Verse* (1919), April, 14.1, pp.52–5 (55) = Hale (1919), cited in (e.g.) Scroggins (2015), 59; Culligan Flack (2015), 20, and Yao (2019), xv–xvi.

[14] Culligan Flack (2020). [15] Gregory (1997); Collecott (1999).

[16] Culligan Flack (2015). [17] Koulouris (2011); Mills (2014); Worman (2018).

4 FRAGMENTARY MODERNISM

anglophone modernism and beyond.[18] At the same time, what Elizabeth Cowling and Jennifer Mundy have identified as the 'classic ground' on which the visual culture of the period was based has been uncovered to reveal an engagement with classical antiquity that belies the violent repudiation of the classical past which characterized the art writing of the first half of the twentieth century.[19]

Like recent studies, this book recognizes the need to reach across the perceived breach between modernism and classical scholarship by attending in detail to modernism's classical preoccupations. It builds up an interconnected picture – beyond the individual case study – of the ways in which Graeco-Roman material informed modernist fragment-making across literary and visual cultures. More specifically, it aims to show how modernist experiments in fragmentation were not predicated on antiquity *in spite of* the 'safe and dead' obfuscations of classical scholars; they were enabled by a vital creative engagement with the very scholarship that was so volubly rejected in the avant-garde rhetoric of the period. The fragmentary receptions of modernism, I argue, would have been impossible without the work of the papyrologists and philologists, epigraphists, archaeologists, and museum curators engaged in discovering, deciphering, and disseminating the fragments of antiquity for modernity.[20]

In mapping the networks of influence between modernism, Graeco-Roman texts and objects, and classical scholarship, however, *Fragmentary Modernism* also trails the spotlight to the other side of the breach. Just as modernist rejections of the work of classical scholars were often only surface deep, classicists' denunciation of modernism were rarely as hard-and-fast as they tend to be portrayed. J. P. Sullivan, who published a receptive study of Pound's *Homage to Sextus Propertius* in 1964, is often seen as the first professional classicist who was truly sympathetic to the aims of Anglo-American literary modernism. But the apparent rupture between scholarship and artistic production was often bridged and crisscrossed much earlier, and in more nuanced and less immediately obvious ways. William Gardner Hale's fatal verdict on Pound's *Propertius* is regularly held up as an emblem of the rift between modernists and classical scholars. But what tends to

[18] I mention only the most extensive and recent studies here, though the practice of explicating the classical references in modernist texts has been part of the critical history of their reception from the outset. Translation has been a particularly fruitful lens for studies of modernism and classical reception: see recently Liebregts (2019) (on Ezra Pound and Greek tragedy), and Hickman and Kozak (2019). Katerina Stergiopoulou's forthcoming work on modernist Hellenism and the translation of Greece, which focuses particularly on the later work of Pound, H. D., and T. S. Eliot, also promises key insights. Cf. also Taxidou (2021) on Hellenism in modernist theatre and theatricality.

[19] Cowling and Mundy (1990); Green and Daehner (2011); Prettejohn (2012); Martin (2016).

[20] Details about how some fragmentary Greek texts (especially Sappho) or archaeological discoveries influenced the cultural production of the period have been highlighted before, but there remains no comprehensive study of the modernist fragment and the dissemination of antiquity in fragments. See esp. Kenner (1969); Kenner (1971), 54–9; Gregory (1997), 149–50 and Collecott (1999) on Sappho and H. D.; Gere (2009) on Knossos, and Kocziszky (2015) and Colby (2009) on the general 'archaeological imagination' in modern writing.

INTRODUCTION 5

go unnoticed is the fact that even 'that fool in Chicago', as Pound called him,[21] was engaging with one of the major avant-garde literary outlets in the period. Hale was a specialist in Latin grammar, who had spent time studying at 'the universities of Deutschland' which formed the cradle of rigorous nineteenth-century classical learning.[22] Yet, strikingly, his much-cited comments on Pound's defective philology were not published in a well-respected professional journal in the field like *The Journal of Roman Studies* or *The Classical Review*.[23] They were made in the form of a letter to the editor published in *Poetry: A Magazine of Verse*: 'the biggest little magazine' and a powerhouse of cutting-edge modernism, which hosted some of the period's biggest hits, including the first outing of Pound's *Cantos* (*Three Cantos*), T. S. Eliot's 'The Love Song of J. Alfred Prufrock' and poems by James Joyce, W. B. Yeats, Marianne Moore, D. H. Lawrence, Wallace Stevens, Amy Lowell, and William Carlos Williams.[24] Hale, in other words, was actively engaging with one of the foremost outlets of literary modernism. His casual reading of *Poetry* might have failed to penetrate his textbook on Latin grammar, which arguably typifies the work of the 'pedagogues, philologists and professors' that many modernists were ostensibly trying to escape. But in several other cases the lines between what Hale called modernism's 'mask of erudition'[25] and the academic professionals who dealt with the classical material being processed by writers and artists in the period were often far more blurred. Artists and writers in the first decades of the twentieth century clearly waded into the philological and archaeological territory of those who (in W. B. Yeats' terms) 'cough in ink' and 'wear out the carpet with their shoes',[26] but professional classicists, too, were responsive to the radical changes in contemporary artistic production.

One of the aims of this book, therefore, is to remediate the perceived breach between modernism and classical scholarship, not simply by taking the classical presences of modernism seriously here and now (as Steven Yao counsels), but by showing how those interdisciplinary networks were already active from the beginning.[27] Classical reception studies is often theorized as a mode of investigation which aims to expose the fact that there is no access to antiquity 'proper', since nothing comes to us unmediated by the layers of reception that inevitably distort our understanding of the past.[28] The artistic production of the first half of

[21] Letter to Felix E. Schelling, 8 July 1922 = *L* 245.
[22] Ezra Pound, 'Provincialism the Enemy—III' in Pound, *SPr*, 289.
[23] It is characteristic of the feedback loop between modernism and classical scholarship that *The Classical Review* played a key part in the reading culture of modernist poets: see Chapter 1, pp.17–18.
[24] Carr (2012); Hale's letter was published in the issue immediately following the publication of *Homage to Sextus Propertius* (so within a month of its publication). For Harriet Monroe and *Poetry*, see Williams (1977); Carr (2012), and Ben-Mere (n.d.). Pound himself was the magazine's foreign correspondent until 1917.
[25] Hale (1919), 55. [26] W. B. Yeats, 'The Scholars', (1919), ll.7–8.
[27] Yao (2019), xvi: 'Yet with every estrangement comes an opportunity for reconciliation. And now...that initially traumatic breach has at last begun to heal.'
[28] The *locus classicus* is Martindale (1993).

the twentieth century effected a range of large-scale paradigm shifts whose legacies are still powerfully active today. Modernism has changed how we think about literature and how we think about art, and those changes necessarily colour our interpretations of the art and literature of the Greek and Roman past. For that reason alone, modernism's role in our perceptions of antiquity calls for urgent attention. More than just a lens that mediates how we look back at ancient texts and objects from where we stand now, the mediations of modernism were always entangled with the work of classical scholars and the fragmentary material they brought to light. Understanding the full extent of those interdisciplinary entanglements not only exposes a crucial driver in the emergence of the modernist fragment; it forces us to re-evaluate the extent to which modernism is baked into how we perceive, construct, and present the fragmentary texts and objects that constitute our access to the past.

Modernism

'Modernism' has recently been expanded on the geographical and temporal axes to take in an ever increasing set of texts and objects. The term has moved outwards on a global scale to encompass modernisms in locations as diverse as Turkey and sub-Saharan Africa, and it has shifted beyond the first half of the twentieth century to other moments of rupture with the past stimulated by societal and technological change, ranging as widely as the porcelain of Tang Dynasty China to the music of contemporary Afghanistan.[29] The 'modernism' covered in this book is more specific to the group of artists and writers associated with what Ezra Pound called the 'grrrreat litttttterary period' of modernism that sprung up, primarily in London, in the first decades of the twentieth century: the poetry of Ezra Pound, T. S. Eliot, H. D., and Richard Aldington, and the sculpture of Jacob Epstein and Henri Gaudier-Brzeska.[30]

One reason for that choice is that the version of modernism represented by Eliot and Pound, in particular, has become what Sean Latham and Gayle Rogers call an 'obsession' in the study of the period roughly covering 1890–1930 in British and American academia.[31] Closely associated with the term 'modernism', their work was quickly absorbed into the academic study of English, providing

[29] For the New Modernist Studies, see esp. Mao (2021) and Latham and Rogers (2021), with Mao and Walkowitz (2008), 738–42 and Jailant and Martin (2018). For global modernisms, see esp. Moody and Ross (2020). Similar transhistorical and transborder perspectives are being deployed in the discussion of 'global Classics': see esp. Bromberg (2021).

[30] Letter to T. S. Eliot, 24 December 1921 = Paige 235.

[31] Latham and Rogers (2015), 4. As the authors point out, it is partly as a consequence that the term 'modernism' is central to English-language scholarship, whereas it 'barely signifies' (4) in relation to other avant-garde movements.

INTRODUCTION 7

paradigms for Practical and New Criticism ('the theory of which the modernist movements provided the practice') that shaped the ways in which literary criticism has been conducted in English-speaking universities.[32] Scholars of modernist studies have unravelled some of those long-standing obsessions and unpicked their implications, but when it comes to modernism's cross-over into other disciplines the implications of that lasting fixation have yet to be fully examined. The modernist 'obsession' has shaped the study of classics in unacknowledged ways. It underlies practices of close reading that are used in the literary criticism of ancient texts; it is entangled in many of the theoretical models imported to study them, and it underwrites our theorization of classical reception studies itself.[33] Above all, the version of modernism studied here is tightly imbricated in the interpretation and presentation of the fragmentary material on which our access to the past is based. As the case studies in this book highlight, the ways in which we present ancient fragments on the page or display them in the modern museum are not intrinsic to the material itself. They have been, and in many ways still are, shaped by the modernist aesthetic of the fragment. Understanding that dominant intervention in the classical fragment – and the intervention of the classical fragment in the obsessions of modernism – is central to the project of this book.[34]

That is not to say that the nucleus of the story told here could not be extended in several ways. The fragmentary imperative in the first half of the twentieth century is a transcultural and transdisciplinary phenomenon that interacts with, but is in no way restricted to, cognate developments in classical reception. The fragment work of Pound and his circle was itself marked by an outward-looking 'transnational turn',[35] and a wide range of avant-garde cultures were also simultaneously turning to fragments in various forms and modes. Interest in the fragment can be seen in global modernisms from the Korean poetry of Kim Kirim to the Urdu *qit'ah* of N. M. Rashed.[36] It is there in the severed bodies of Surrealism, the broken planes of Cubism, the techno-aesthetics of Futurism;[37] it underlies Italian *frammentismo*,[38] montage techniques in film,[39] and Arnold

[32] Baldick (1996), 11 with Mao (2021), 39. Though they referred to their 'modern "movement"', the writers and artists in this book never quite called themselves 'modernist': Latham and Rogers (2015), 1 (the term 'modernism' was 'christened', as Stan Smith puts it (Smith (1994), 1) in 1927 with Robert Graves and Laura Riding's *A Survey of Modernist Poetry*). For the lasting legacy of New Criticism see, e.g., Hickman and McIntyre (2012), Part II 'Legacy and Future Directions', and for its links with modernism, see Latham and Rogers (2015), 42–52.

[33] Eliot, in particular, is frequently quoted in theorizations of classical reception studies: Hiscock (2020).

[34] For the pressing importance of the interrogation of 'intervening moments or events' that can 'shape the discipline in unnoticed ways', see Postclassicisms Collective (2020), 4.

[35] Park (2019); see also Goldwyn (2016) on the classics as world literature in Pound's *Cantos*.

[36] Moody and Ross (2020), e.g., 347–51; 253. For the fragment as characteristic of Jorge Luis Borges' 'global classics', see Jansen (2018), esp. 30–51; 101–7;122–3.

[37] Orban (1997). [38] Sorrentino (1950).

[39] See, e.g., McCabe (2005) on 'cinematic modernism' in poetry and on screen.

8 FRAGMENTARY MODERNISM

Schoenberg's 'liquidation' and other forms of fragmentation in music.[40] The fragment is a central preoccupation of classical scholarship, but it also characterizes other modes of investigation which were also important vectors in the emergence of modernism, including developments in physics, anthropology, and psychoanalysis – disciplines which, in Eliot's terms, 'made the modern world possible for art'.[41]

The story could also be extended on the temporal axis. Modernism is founded on the assumption of a radical break with the proximate past, 'a rebellion against the Romantic tradition' (as Eliot described Pound's project) and the moral and aesthetic conventions of the nineteenth century.[42] But it was not the first or the only point at which classical reception and modern fragment-making came together. Fragments and ruins were already active concepts and practices in antiquity,[43] and the fragment has surfaced and re-surfaced as a feature of classical reception at various points in its history, from Michelangelo's *non finito* to modern translations of Sappho.[44] In particular, the 'Romantic tradition' against which modernism ostensibly rebelled has been credited with engendering an apotheosis of the fragment long before modernism.[45] On Susan Stanford Friedman's analysis of the moveability of 'planetary modernism', the Romantic fragment could even be seen as a 'modernist fragment' before twentieth-century modernism ever existed.[46] It, too, was situated at the '"avant garde" of the "avant garde"',[47] emerging at a time of seismic cultural change, when the French Revolution put what Linda Nochlin calls 'the body in pieces' at the centre of the visual imagination.[48]

Yet, as multiple studies of Romantic fragmentation emphasize, the modernist fragment was put to work very differently from its Romantic predecessors.[49] Romantic fragments were of a piece with the eighteenth-century ruin industry and popular aesthetic discourses of the sublime and the picturesque.[50] They were '[n]ot necessarily [a] sign... of a broken reality' (34).[51] They did not bring 'the

[40] Schoenberg (1967), 58. For fragmentation in musical modernism, see esp. Guldbrandsen and Johnson (2015) with Bernhart and Englund (2021) on fragmentation in words and music, including the modernist period.

[41] 'Ulysses, Order and Myth' (1922), Eliot, *CP* II, 479. [42] Pound, *SP* 17 = Eliot, *CP* III, 526.

[43] Levene (1992); Azzarà (2002); Edwards (2011); Kahane (2011); Martin and Langin-Hooper (2018); Hughes (2018).

[44] For the cultural history of the fragment, see esp. Kritzman and Plottel (1981); Dällenbach and Hart Nibbrig (1984); Pingeot (1990); Ostermann (1991); Tronzo (2009); Most (2010); Pachet (2011); Harbison (2015).

[45] Mcfarland (1981), 22. [46] Friedman (2015); Mao (2021), 74–6.

[47] Lacoue-Labarthe and Nancy (1988), 133 n.2.

[48] Nochlin (1994). Cf. Lichtenstein (2009), 125 on the Romantic concept of the fragment as 'paradigmatic of what we used to call *modern*'.

[49] Mcfarland (1981); Janowitz (1990); Wanning Harries (1994); Janowitz (1999); Thomas (2008); Strathman (2006). See also Regier (2010) on Romantic fragmentation and cf. Lichtenstein (2009), 124–5 on the romantic fragment 'as a whole in itself'.

[50] Thomas (2008), 21. [51] Wanning Harries (1994), 34.

INTRODUCTION 9

dispersion or the shattering of the work into play',[52] and they tended to be future oriented and hopeful: what Schlegel called 'fragments of the future' ('Fragmente aus der Zukunft', *Athenäums-Fragmente* 22).[53] In practice, there is little connecting Keats' *Hyperion* and Coleridge's *Kublai Kahn* to the fragmentary realities of *The Waste Land* or Pound's 'Papyrus'. Still, there are continuities as well as ruptures to be found. Romantic theories and practices of the fragment from Shelley's *Ozymandias* to the Schlegel brothers set important precedents for the production and consumption of fragments, not just for the modernist writers and artists of the twentieth century who can be seen in some ways as the heirs of Romanticism,[54] but for the discipline of classical scholarship, which mediated the texts of antiquity for new generations of readers in increasingly professional, institutional, and scientific contexts.[55] The Romantic cult of the fragment established the form as a marketable commodity in scholarship and in artistic production into the nineteenth century, and its expression and evolution can be seen at various pressure points towards the end of the nineteenth century at what Jonah Siegel calls 'the threshold of Modernism', from the aphorisms of Nietzsche to Henry Thornton Wharton's popular edition of the fragments of Sappho, which were crucial to the emergence of the modernist fragment.[56]

Ultimately, the story pieced together in this book offers just one way of repairing the breach. It looks outwards beyond the major exponents of Anglo-American modernism to other avant-garde practitioners and other kinds of cultural production, and it digs down to some of the literary, artistic, philological, and archaeological developments before the twentieth century that came to shape the reception of the classical fragment in the period. But its main focus remains a specific moment of exchange 'on or about 1910', as Virginia Woolf famously put it, when the modernist cultures that came to constitute a fundamental intervention in the modern reception of the classical fragment came together with developments in classical scholarship in intensely generative ways.[57] The impact of a new modernity seemed to change 'human character', as Woolf coyly put it, and the modernist fragment was clearly a symptom of that change. But it was also implicated in a fundamental reconfiguration of the possibilities available for the reception of antiquity. It was ultimately at the junctures and interactions of two

[52] Lacoue-Labarthe and Nancy (1988), 48.
[53] In Strack and Eicheldinger (2011), 24. See esp. Janowitz (1999) on the distinction.
[54] Varley-Winter (2018), 15.
[55] Sometimes the cross-over between scholarship and art was very clear: see esp. Chapter 2, p.47 n.11 for collaborations between Friedrich Schleiermacher and the Romantic fragment-maker Friedrich Schlegel with Güthenke (2020), 72–95.
[56] Siegel (2015), 237, tracing aspects of 'the poetics of the fragment' (208) to the period 1790–1880.
[57] '[O]n or about December 1910 human character changed': *Mr Bennett and Mrs Brown* (1924). Woolf's dating corelates with Roger Fry's first Post-Impressionist exhibition held in London in November and December of 1910, but the date (and the place: 'in London about 1910'), became iconic, as Eliot later reflected, for the '*point de repère*' of Anglo-American modernism (Eliot (1966), 18). For the significance of the year, see Stansky (1996).

10 FRAGMENTARY MODERNISM

spheres of revolutionary change – in the artistic production of modernism and in the practice of classical scholarship – that the fragments of antiquity were made new.

Fragments

As Camelia Elias notes, 'much of the appeal of the fragment relies on the fact that one can never be sure of what exactly constitutes a fragment'.[58] Theorists of the fragment have used the term to cover points of tension between the part and the whole in a wide range of areas: discourse, narrative, meaning, gender, the self.[59] And while the fragment and its cognates are often identified as the central characteristic of modernism, precisely what form they are seen to take can range from the gendered embodiment of modern experience to the dynamics of practical linguistics.[60] The kinds of fragments I deal with in this book tend to be less abstract, circling around the primary sense of fracture (from Latin *frangere* 'to break').[61] The ancient fragments I look at are often fragments at the most literal level: a damaged papyrus, a broken inscription, a limbless sculpture, materially broken off from a once complete whole. But they can also be the more indirect results of the processes of breaking up: fragments more like the Latin *reliquiae*, 'leavings', embedded in the works of other authors, transmitted through broken manuscript traditions, or removed from their original sense-making contexts into new collections and collocations.[62]

Modern 'fragments' are generally produced in very different ways from their ancient counterparts. To quote the standard definition in the *Oxford English Dictionary*, they are more likely to come under the definition of 'a portion of a work left uncompleted by its author; hence a part of any unfinished or

[58] Elias (2004) 2. Cf. Ostermann (1991), 13.

[59] Kritzman and Plottel (1981); Dällenbach and Hart Nibbrig (1984); Frisby (1985); Ostermann (1991); Susini-Anastopoulos (1997); Orban (1997); Ripoll (2001); Tronzo (2009); Pachet (2011); Tracy (2020); Sojer (2021).

[60] So, for example, Varley-Winter (2018) sees the modernist fragment as 'a quasi-maternal phenomenon in which the "body" of the text contains more than one possible self, as well as a metaphorical castration in which part of the text is lost' (4). Childs (1986) sees fragmentation in Pound's *Cantos* as an issue of practical semiotics; Haslam (2002), 'assessing the fragmentation endemic to modernist writing', examines responses to modern experience of various forms in the novels of Ford Madox Ford (8), and Bruns (2018) sees the fragment in the use of language and 'mirror experiences' in James Joyce.

[61] As Glenn Most points out, the Greek and Latin words for fragment tend to refer to material artefacts, and emphasize the violence that went into creating them: Most (2010), 371; cf. Susini-Anastopoulos (1997), 2 ('Étymologiquement, le terme de fragment renvoie à la violence de la déstintérgation, à la dispersion et à la perte'). For the etymology and its later history, see Ostermann (1991), 12 with Zinn (1959).

[62] For the terms *fragmenta* and *reliquiae* (from *relinquere*, 'to leave behind'), see Dionisotti (1997) (the latter term frequently appears in Latin titles of editions of fragment collections). On fragments that survive through quotation as 'a kind of textual embrace rather than an act of shattering', see Čulik-Baird (2022), 8–29 (11).

uncompleted design' ('fragment', *s.v.* 2b) rather than 'a part broken off or otherwise detached from a whole' (*s.v.* 1). It is partly for that reason that modern fragments are often seen as fundamentally different in kind from the ancient fragments that have survived in modernity. In the meta-discourse of writing on the fragment, it has become standard practice to distinguish between ancient fragments – which were originally created as wholes – and the fragments we make in modernity. Friedrich Schlegel famously commented in one of his best-known *Athenaeum Fragments* that 'many works of the ancients have become fragments; many works of the moderns are already fragments from the time of their origin' ('Viele Werke der Alten sind Fragmente geworden. Viele Werke der Neuern sind es gleich bei der Entstehung', *Athenäums-Fragmente* 24), and that distinction is often repeated. '[C]lassical fragments are made rather than born', Carlotta Dionisotti notes, though 'they can of course be made in several different ways.'[63] Their fragmentary status is (in George Steiner's words) down to 'the mere fact that the body of classical literature as it has come down to us is a "fragment"'.[64]

That dichotomy, however, was put under pressure by the sustained interactions between classical scholarship and modernist fragment-making in the first half of the twentieth century. Modernist fragments might have been fragments 'from the time of their origin', but they often strikingly mirror the processes of fracture and mediation that have engendered the fragments of ancient text and sculpture with which they interact. They can look deliberately 'broken', like a damaged papyrus or a limbless sculpture, or they can function like *reliquiae* of bits and pieces of ancient texts, embedded in the works and words of other later writers in the form of extracts, quotations, and quotations of quotations. But what is particularly striking is that many of the modernist fragments I draw on in this book – some of which have engendered their own extensive commentary traditions to make sense of the pieces – do not simply echo the fragments of antiquity 'as they are'. Even as they sometimes fill in the gaps, reconfigure the pieces, or emphasize even more than the damaged original the lines of fracture or the realities of loss, the productions of modernism often seem to mimic not just the materials, but the tools and methods of classical scholarship, from underdotting in papyrology and the techniques of philology to the derestoration practices of museum curators and the stratigraphic techniques of archaeologists. As I argue in the chapters that follow, those similarities are no accident. They came out of an intense period of fragment making and fragment collecting that criss-crossed the notional boundaries between the literary and visual cultures of modernism and the disciplines of

[63] Dionisotti (1997), 1.

[64] Steiner (1984), 22: 'die bloße Tatsache, daß die Gesamtheit der klassischen Literatur, sowie sie uns überliefert ist, selbst ein >>Fragment<< darstellt'. Ancient authors were already aware of the potential for the future fragmentation of their own work into *disiecti membra poetae* ('the limbs of a dismembered poet'), as Horace in *Satires* 1.4.62 describes the work of Quintus Ennius (whose work has in fact survived only in fragments): see Most (2010), 371–2.

12 FRAGMENTARY MODERNISM

classical scholarship. The results of those networks of engagement made modernist fragments in some ways already 'ancient' at the time of their origin, but – in a feedback loop that worked its way back into classical scholarship – they also transformed the classical fragment into an inherently modern proposition.

Fragmentary Modernism

Fragmentary Modernism investigates the practices of the fragment that developed at the point of juncture between modernism and the disciplines of classical scholarship during the period spanning roughly from 1896, when Grenfell and Hunt made their first expedition to the Egyptian city of Oxyrhynchus, to the publication of Eliot's *Burnt Norton* in 1936. The book is divided into five chapters, each of which centres on a sub-discipline of classical scholarship, broadly defined: Papyrus, Editions, Inscriptions, Museums, and Archaeology. Each chapter takes as its starting point a particular genre of ancient fragment, tracing its role in the networks of interaction that emerged across the breach between classical scholars and modernist writers. Chapter 1 opens with papyrus, the ancient paper on which fragments of lost ancient Greek texts were sensationally discovered around the turn of the twentieth century. Traces of new fragments of Sappho and other poets can be found in modernist writing, but it was not so much the newly discovered texts themselves that had the greatest impact on modernist production. A new sub-discipline of papyrology developed virtually side by side with the modernist enterprise, and its well-publicized techniques, methods, and materials began to merge with some of the most 'modern' features of modernism. Surrounded by white space and characterized by experiments in typography, modernist fragments shared the 'look' of the papyrus fragments produced, edited, and disseminated by the new papyrologists. Assimilated into the cultural vocabulary of the early twentieth century, the material itself began to take on the aura of authentic modernity, while what media reports called the 'old rubbish heaps of Egypt' in which the most prominent discoveries had been made coalesced with the modernist preoccupation with waste paper.[65] Crucially, moreover, the influence was not monodirectional. As a burgeoning corpus of modernist fragment poetry came to dominate new writing, it shaped how papyrological fragments of ancient poetry themselves were perceived and presented in the work of classical scholars. What became known as 'the century of papyrology' has always been felt to carry the thrill of modernity. That modernity, I argue, did not just come from the fact that the papyri were new to western audiences: the new papyri came to seem modern because they themselves – and the typographical language of the discipline that

[65] *The Observer*, 7 June, 1914, p.17, col. A.

grew up to disseminate them – were programmed into the fragmentary algorithms of modernism.

Papyrus fragments were literally broken off from the lost textual whole of which they had once been a part, but most fragmentary ancient texts survive as *reliquiae*, traces left behind in summaries and quotations embedded in the work of other authors. The extant fragments of the Presocratic philosopher Heraclitus – notably edited by Hermann Diels in a ground-breaking new edition (*Die Fragmente der Vorsokratiker*, 1903) – are a prominent example. But classical philology also dealt with fragmentary texts that survived through broken manuscript traditions, like the *Satyricon* of Petronius, the notoriously ropey textual transmission of which has left the already disjointed text riddled with lacunae and abrupt transitions. Chapter 2 unpicks the striking appearance of fragmentary texts like these – mediated by the editions of classical philologists – in three of the works which came to define the anglophone modernist canon: Franz Bücheler's edition of Petronius in T. S. Eliot's *The Waste Land*; the quotation from Diels' *Vorsokratiker* in the epigraph to *Burnt Norton*, and the appropriation by Ezra Pound in what became *Canto* I of the analytic techniques which classical philologists had developed in order cut down the Homeric epics into what they considered to be their 'original' ancient nuclei. Showcasing the philology of the fragment in the texts of modernism underscored what Eliot called 'the fight to recover what has been lost/And found and lost again and again' (*East Coker*, V, 15–16 = *PTSE* I.191). But it also had unintended consequences for classical scholarship, too. The traditions of nineteenth-century philology offered an arsenal of scientific tools that had been developed in order to lay out on the page the gaps and fissures in ancient texts for the purpose of recovery. Re-focused through their new contexts, those same texts and techniques were reinvented as prototypes of fragmentary modernism, transferring the philological concern with the fragment from the domain of 'pedagogues, philologists and professors'[66] into the cultural space of avant-garde modernity.

The old Reading Room in the British Library, which was located at the centre of the ground floor of the British Museum in London, was a major site for the emergence of modernism in London, and especially for Ezra Pound and H. D. who worked there regularly for an intense period in the 1910s. As contemporary museum plans show, in order to get to the Reading Room, readers had to pass through the 'Hall of Greek and Roman Inscriptions', situated between the main hall and the library entrance. As I show in Chapter 3, in a period when Pound was advising new poets to write poetry like 'weather-bit granite',[67] the Hall of Inscriptions offered lithic reminders of the hard, spare poetry which the Imagists, characterized in early publications as a 'group of ardent young

[66] Aldington (1915).
[67] Ezra Pound, 'The Hard and the Soft in French Poetry', *Poetry* 9.5 (February 1918) = *LE*, 288.

14 FRAGMENTARY MODERNISM

Hellenists', sought to create.[68] At the same time, they also found models of their new poetic of laconic speech in the paper inscriptions of the *Greek Anthology*, a collection of epigrams whose generic origins lay in the practice of inscribing poetry on stone and other surfaces. Mediated by J. M. W. Mackail's popular *Select Epigrams from the Greek Anthology*, the *Greek Anthology* provided the starting point for some of the earliest Imagist poems, while Mackail's preface offered H. D. a personal guide for the 'lapidary precision'[69] of the new poetry before Pound and Flint had written the famous Imagist manifesto.

The epigrams of the *Greek Anthology* are unlike material fragments on papyrus, though they could be read in analogous ways. Many of the poems are no more than a few lines long, written in a suggestive mode which deliberately plays on the inability to complete the words on the page with meaning-making contexts. They also echoed the broken transmission that characterized the editions of ancient texts that were simultaneously making their way onto the modernist page. Because the *Greek Anthology* often constitutes the only a trace of otherwise lost writers – poets like Nossis, Moero, and Anyte of Tegea – it could be seen, as H. D. envisioned it, as a collection of 'fragments and references to lost fragments'.[70] Those 'fragments', broken up from their original collections or the stone on which they were once inscribed, were crucial to the Imagism that became what Eliot called the '*point de repère*' of modern poetry.[71] Even after Imagism fizzled out, Pound and H. D. continued to find that crispness and discontinuity in the quasi-fragments represented in Mackail's own selections from the *Greek Anthology* and their parallels in stone in the British Museum. Meanwhile, their engagements with the granite-like quasi-fragments of the *Anthology* reinforced precisely those elements in the subsequent reception of the collection. As Mackail himself acknowledged as early as 1916 in a review for *The Times Literary Supplement* of the Poets' Translation Series (which included translations from the *Anthology*), it had become impossible 'even for scholars' to ignore the new direction in contemporary poetry that sought to find 'something crisp, acute, discontinuous' in the fragments of the past.[72]

Chapter 4 remains in the British Museum, but moves outwards from the Hall of Inscriptions into the Greek galleries, and from literary modernism alone to the visual cultures with which it was associated. While modernist writers were

[68] The 'Imagistes' were described early on as 'a group of ardent young Hellenists pursuing interesting experiments in *vers libre*', according to a note accompanying the publication of poems by Richard Aldington in the November 1912 issue of *Poetry* (1.2, pp.39–43; with note on p.65), though Pound complained that 'the note in *Poetry* is very incorrect…There is Imagism in all the *best* poetry of the past' (letter to Alice Corbin Henderson, quoted in Carr (2009), 531).

[69] Mackail (1911), 4.

[70] 'Garland', Part III of 'Notes on Euripides, Pausanias and Greek Lyric Poets', second draft typescript, Yale Collection of American Literature, Beinecke Rare Book and Manuscript Library, YCAL MSS 254, Box 44, 1119–20 (p.132).

[71] Eliot (1966), 18. [72] [Mackail] (1916) and (1919).

gathering in the Reading Room, visual artists were enthralled by the museum's collections. As commentators often point out, the extra-European material in the museum was a prime attraction. Yet even the most cutting-edge of modernists – including Henri Gaudier-Brzeska and Jacob Epstein, 'the greatest sculptor in Europe', as Pound called him – engaged with the Greek sculpture galleries, echoing in their own work the fragmentary sculpture they had consumed there.[73] It was not just modernists in the museum who opened up dialogues between modernity and antiquity, however. In the 1920s, the British Museum itself undertook a radical re-evaluation of the ways in which it displayed the surviving fragments of Greek sculpture in its collection. Partly in response to artists like Epstein, the museum began to remove the cast additions that had filled out the fragments of broken sculpture on display in the Greek and Roman galleries, culminating in a thoroughgoing re-display of the sculptures from the Parthenon (known as the 'Elgin Marbles') which overturned a policy that had been pursued for a century to emphasize their status as fragments. Modernism – which had partly arisen from the space of the museum itself – had crossed into the territory of the professional classicists working behind the scenes to transform the broken sculptures in the Elgin Room into modern icons of the classical fragment.

Chapter 5 moves out from the fragmenting space of the modern museum to the broader interactions between modernism and archaeology. Archaeology – a discipline whose own development is often associated with modernity – is intuitively allied with modernism. By the beginning of the twentieth century, the discipline had become a fully established science, bolstered by decades of archaeological discoveries that fundamentally expanded the remit of classical scholarship. For writers and artists turning to the fragments of the Greek and Roman past as catalysts for modernity, archaeology offered access to what Ezra Pound (who had planned to write a book on early Greek sculpture) called 'a hinter-time' that is 'not Praxiteles'.[74] From Schliemann's Troy to the discovery of Etruscan art at Veii, an era of archaeologism opened up categories of the pre-classical and pre-Hellenic that shook the world of classical scholarship and facilitated a new alliance between what Gaudier-Brzeska called 'the archaics and the moderns'. The chapter investigates some of the ways in which what T. S. Eliot called 'the reassuring science of archaeology' interacted with modernism, focusing in particular on the Archaic sculpture which had been found virtually under the foundations of the Parthenon on the Athenian Acropolis and other find spots in the Greek world, and on Arthur Evans' notoriously modernist Knossos. For modernist practitioners, archaeology put pressure both on the 'fragment' and on the 'classical', offering new ways of connecting the present with the pieces of the past. Again, the paradigm-shifts

[73] Pound, 'Art Review', *The New Age* 4 March 1920, 291–2 (signed 'B. H. Dias'), reprinted in Zinnes (1980), 140.

[74] Letter to H. D. Rouse, 23 May 1935 = Paige 363.

16 FRAGMENTARY MODERNISM

effected by modernism were not hermetically sealed off from the scholars and archaeologists who dealt with the fragments of antiquity. Open to the incursions of avant-garde modernity, archaeologists themselves interpreted – and, in the case of Evans' concrete Knossos, physically 'reconstituted' – the fragments that emerged from underground to mirror the aesthetics of modernity.

Taken individually, the chapters in this book could be read as case studies in reception which offer new perspectives on the fragments of antiquity by re-focusing them through the lenses of later reception contexts. But the perspectives they offer are already strikingly familiar. That is substantially because the frag-mentary imperatives of modernism became so deeply embedded in representa-tions of the classical fragment that the two have become impossible to separate. Almost from the beginning, a mutual concern with the fragment penetrated the notional hard lines between classical scholarship in the period and modern artistic production. As the modernism represented here fast became central to twentieth-century scholarship, its modes and preferences were written into the ways in which classicists processed and presented the fragments of antiquity to their audiences. Scrutinizing the moment at which modernism and classical scholarship refocused each other's fragmentary concerns not only brings out the ways in which modernism, in important ways, 'began with the Greek fragments', as H. D. put it; it exposes one of the most influential, if largely unspoken, interven-tions in how we present and consume the classical fragment now.[75]

[75] H. D. (1979), 41.

1

Papyrus

In 1916, Ezra Pound published a short poem which he called 'Papyrus':[1]

> Spring...
> Too long...
> Gongula...

Appearing in *Lustra* alongside poems like 'Coitus' and 'In a Station of the Metro', 'Papyrus' displays some of the extreme shock-tactics of modernist fragment poetry. It is surrounded by white space; pared down to almost nothing. The syntax does not hold, and what look like ellipses at the ends of the three short lines suggest a thought cut off, a longing unfulfilled, a failure of memory and desire that cannot come to fruition in modernity.

Looked at in another way (published in another context and with different paratexts, for example), Pound's 'Papyrus' could easily pass for a mimetic translation of a fragment of an ancient Greek poem. The use of white space and ellipses are iconic markers of modernism's 'typewriter century',[2] but the same typographical techniques are also a standard feature of classical scholarship, deployed on the printed page by professional classicists to indicate the gaps and uncertainties that arise when a text has suffered damage or loss in transmission. On closer investigation, the poem's closing word, 'Gongula', a partial homonym for 'gone', looks like a transliterated Greek name associated with Sappho, one of whose pupils (and probably lovers) is recorded under the name Γογγύλα (or 'Gongyla', on modern transliteration conventions).[3] Readers who were aware of recent developments in classical scholarship might have connected Pound's 'Papyrus' more specifically with a genuine fragment of Sappho, now known as Fragment 95 Lobel-Page. It was found on a piece of parchment rather than papyrus, acquired in 1896 by the Egyptian Museum in Berlin and published in Germany in 1902. More recently, it had been re-edited with an English translation by J. M. Edmonds in the August 1909 issue of *The Classical Review*, which Pound would have found in the old

[1] Pound (1916), 49. [2] Lyons (2021), esp. chapter 4, 67–85, 'The Modernist Typewriter'.
[3] In the ancient biographical lexicon *Suda* (Sigma 107). For 'Gongula' and 'gone', see Fernald (2006), 33.

Fragmentary Modernism: The Classical Fragment in Literary and Visual Cultures, c.1896–c.1936. Nora Goldschmidt, Oxford University Press. © Nora Goldschmidt 2023. DOI: 10.1093/oso/9780192863409.003.0002

18 FRAGMENTARY MODERNISM

Reading Room of the British Library.[4] Pound had been alerted to the fragment by Richard Aldington's 'To Atthis (*After the Manuscript of Sappho now in Berlin*)', whose publication he had secured three years earlier.[5] 'To Atthis' was based on a portion of the same Sappho parchment as Fragment 95, also published by Edmonds in the previous issue of *The Classical Review*, though Aldington himself had to rely on H. D.'s transcription, as he himself was then too young to obtain a reader's ticket.[6]

In what has become a paradigmatic act of radical modernist translation, Pound ignored the better-preserved portion of the poem and homed in on the most damaged and cryptic part of the text where the top end of the parchment narrows (lines 2–4). As printed by Edmonds, the relevant portion of the Greek text looks like this:

$$\mathring{\eta}\rho' \ \mathring{a}[. \ . \ . \ . \ .$$
$$\delta\mathring{\eta}\rho a \ \tau\bar{o}[. \ . \ . \ . \ .$$
$$\Gamma o\gamma\gamma\acute{\upsilon}\lambda a \ \tau \ [. \ . \ . \ .$$

Pound famously took the top word as a contracted form of ἔαρ ('spring'), the second as δηρός ('too long'), and the last as the proper name, Gongyla. Though plausible, the choice was philologically daring: even Edmonds, who accompanied the poem with a full eighty-two-word translation, left the top two lines out of his English version completely. Several scholars ('cough[ing] in the ink' as Yeats would put it) have pointed out the flaws in Pound's 'translation', but 'Papyrus' is so compelling precisely because of the way in which it conveys the Greek text as a fragmented material object mediated on the page by the typographical techniques of classical scholarship.[7]

On the surface, the genesis of Pound's 'Papyrus' neatly encapsulates how the modernist fragment could emerge almost directly from classical scholarship onto

[4] Edmonds (1909b). Little is known about the provenance of the parchment (P. Berol. 9722), except that it was acquired by the Egyptian department of the Königliches Museum in Berlin in 1896 through 'Dr Reinhardt', the German vice-consul in Bushehr: Schubart (1902), 195. Wilhelm Schubart had previously published a transcription in 1902 along with images of the frayed parchment: Schubart (1902); Schubart and Wilamowitz (1907), 10–18. For the Round Reading Room of the British Library, then situated in the British Museum, as a site of modernism's classical receptions, see Chapters 3 and 4.

[5] Aldington's poem had been rejected by Harriet Monroe for *Poetry: A Magazine of Verse* (she had sent it to a Chicago professor who 'wouldn't stand for it': Kenner (1971), 55). It was eventually published in *The New Freewoman* Vol. 1, No. 6 (September 1, 1913), 114 under the title entitled 'To Atthis (From the Rather Recently Discovered Papyrus of Sappho Now in the British Museum)', and later included by Pound in *Des Imagistes* (1914), 19 with the corrected title: Kenner (1971), 55–9 and Goldschmidt (2019), 50–1.

[6] Edmonds (1909a); Kenner (1971), 55–9.

[7] For a philological critique of Pound's poem, see notably Seelbach (1970) with Goldschmidt (2019), 50. Aldington's 'To Atthis', though much less obviously a fragment, also ends with a succession of full points. For Aldington's poem and the Sappho parchment, see Kenner (1971), 55–9, and for Pound's typography and the underdotting used by papyrologists, see Obbink (2011), 21 n.6.

the modernist page. But this vignette of modernism's encounter in the old Reading Room of the British Library with Edmonds' articles in *The Classical Review* gives only part of a much broader picture. During the closing decades of the nineteenth century and the beginning of the twentieth, long-lost Greek texts in fragments emerged into modernity on an unprecedented scale. Damaged pieces of ancient Greek poetry which had not been read for thousands of years were suddenly made available: previously unknown fragments of Sappho (including another poem about Gongyla, published two years before Pound's 'Papyrus'[8]), lost lyric poems of Alcaeus, Ibycus, and Bacchylides ('really only a name' before[9]); new poems by Pindar; plays by Euripides and Sophocles, as well as the first-ever modern glimpse of Menander's comedies, the risqué 'Mime-iambics' of Herodas, and the elegiac and hexameter poetry of Callimachus whose 'shades' Propertius and Pound both invoked.[10]

Texts like these were found inscribed on various surfaces: parchment, wooden tablets, and, in the case of one long fragment of Sappho published in 1937, a broken piece of pottery.[11] But it was papyrus – the main form of ancient paper made from the papyrus reed (*cyperus papyrus*) that flourished in the marshes of the Nile – that instigated a 'new epoch in Greek scholarship'.[12] Ancient papyrus quickly deteriorated in the climate of Greece or Rome, but, as classical scholars were rapidly finding out, the dry, sandy climate of Egypt provided the perfect conditions for its preservation. After initial discoveries were made in the Fayum about 80 km west of Cairo in 1877, western excavators turned to what were seen as Egypt's 'Treasures from the Dust' as a precious cultural commodity.[13] What was hailed as a full-blown papyrological revolution occurred in the winter of 1896 and 1897, when, bankrolled by the London-based Egypt Exploration Fund,[14] two young Oxford classical scholars, Bernard Pyne Grenfell and Arthur Surridge Hunt, went to the city of el-Bahnasa, known in antiquity as Oxyrhynchus, 'the city of the sharp-nosed fish'.[15] Their work 'opened a papyrological floodgate',[16] bursting out of the world of classical scholarship and antiquities collecting into the media and popular culture of the early twentieth century. A brand new sub-discipline of classical scholarship was established in full public view: as *The Times*

[8] P. Oxy X 1231 fr. 15, published by Grenfell and Hunt in Vol. X of *The Oxyrhynchus Papyri* (1914), 31 with English translation on pp.42–3 (now combined with fr. 12 of the same papyrus as Fragment 22 Lobel-Page).

[9] Fearn (2010), 162.

[10] Kenner (1971), 5–6, 50–1, 69 briefly noted the 'shower' (69) of new Greek texts coming into circulation in the period, but beyond Goldschmidt (2019), on which this chapter builds, their impact on modernism – and of modernism on papyrology – remains to be fully explored.

[11] P.S.I. 1300: Norsa (1937, 1953); Finglass (2021a), 234. [12] Deuel (1965), 157.

[13] *The Observer*, 7 June 1914, No. 6420 page 17, col 1. For the market in papyri from Fayum, see esp. Davoli (2015).

[14] Cuvigny (2009), 33.

[15] Deuel (1965), 132–64; Parsons (2007); Bowman et al. (2007); Mazza (2022).

[16] Coles (2007), 7.

20 FRAGMENTARY MODERNISM

announced on Christmas Eve, 1896, a 'new field of investigation had lately been opened up in Egypt, where the papyri of a learned age have survived many generations'.[17] By 1908, Bernard Grenfell was appointed Oxford Professor of Papyrology, a 'newly recognized subject', declared the *Athenaeum*, '[p]ortentious word, but most important thing!'[18]

As Daniel Orrells observes, the emergence of brand-new texts on papyrus brought 'a thrilling modernity to Classics'.[19] But the shock of the new which the papyri seemed to carry was not simply a function of the novelty of their discovery. It was implicated in a network of reception that assimilated the new finds and their dissemination to the fragmentary aesthetics that were developing almost simultaneously in the avant-garde writing of the first half of the twentieth century. The new ancient fragments brought 'a thrilling modernity to Classics', in other words, not just because they were newly excavated by modern scholars, but because they became inextricably bound up with an aesthetic of the fragment associated with radical new developments in modern art and writing.

This chapter plots the networks of reception that formed around newly discovered Greek literary fragments on papyrus. It traces the lines of influence from the popular dissemination of the early Fayum fragments of Sappho and the media sensation created by Grenfell and Hunt to developments in the literary cultures of the period and back again. For modernist writers and their readers caught up in the media buzz surrounding the papyri, the new Greek fragments emerging from Egypt offered fresh ways of making it new from the old. In the process, the work of papyrologists became entwined with the work of literary modernists seeking new forms of expression for fragmentary modernity. As modernism drew on the work of the new papyrology, the scraps of ancient poetry published by classicists came to seem more and more modern – or even modernist – by analogy. Moving further and further away from their contexts of excavation, production, and ancient circulation, the papyri became enmeshed in ways of writing and presenting literary texts associated with the fragmentary discourse of the avant-garde, bringing the thrill of modernity to the fragmentary remains of antiquity.

I. Wharton's *Sappho* and the 'Fayum Fragments'

Before the sensational finds at Oxyrhynchus hit the press, English-speaking readers were primed for the influx of new Greek literary fragments by one crucial publication: Henry Thornton Wharton's *Sappho: Memoir, Text, Selected*

[17] Thursday 24 December 1896, issue 35,082, p.7, col. E.

[18] 'Notes from Oxford', *Athenaeum*, 27 June 1908, 788. *The Observer* (14 June 1908, p.11, col. D) likewise announced the appointment of both Grenfell to Professor of Papyrology and Hunt to Lecturer, that the two might 'be united in their work in Oxford as they have been in Egypt'.

[19] Orrells (2012), 58 on the Herodas papyrus.

Renderings and a Literal Translation, originally issued in 1885 and into its fourth edition by 1898. Wharton, a London doctor and amateur scholar, had set himself the task of making Sappho available to a wide audience 'whether they understood Greek or not'.[20] Rather than choosing only the best preserved or most well-known poems, he included 'all the one hundred and seventy fragments that her latest German editor thinks may be ascribed to her'.[21] He based his text on Theodor Bergk's scholarly edition (*Poetae lyrici Graeci*, fourth edition, 1882, the introduction and apparatus of which were entirely in Latin),[22] and published every available fragment, including the tiniest fragments which consisted of no more than a word or two. Adopting Bergk's numbering and text, for each fragment Wharton provided the Greek text, a note on origin, and a literal translation. In addition, for longer fragments, he added a series of modern 'renderings' by English writers, especially the prominent poet and cultural historian John Addington Symonds. The volume was prefaced with a medallion after Alma Tadema's painting of Sappho and Alcaeus, which had been exhibited at the popular Royal Academy summer exhibition in 1881, and a biographical 'memoir' of Sappho which brought together ancient sources and modern responses.[23] The result was a dynamic hybrid of classical scholarship and literary reception. On the one hand, it replicated and made accessible key aspects of the fragment collections that had been previously reserved for specialist classical scholars. On the other, it opened up possibilities of creative reception by intertwining the text with its literary and biographical reception.

Wharton's Sappho was crucial to the late Victorian reception of Sappho, not least because it followed Bergk's text in printing a tell-tale feminine participle in the 'Ode to Aphrodite' (Fragment 1) which made Sappho's homosexuality explicit.[24] Wharton's own accompanying translation, which clearly identified Sappho's love-object as female ('For even if she flies she shall soon follow... if she loves not shall soon love, however loth'), stimulated 'Sapphic' responses to the text among women writers that continued into the modernism of H. D. and others.[25] Reissued in a third edition in 1895, and then a fourth in 1898 with bindings designed by Aubrey Beardsley (notorious for the avant-garde

[20] Wharton (1895), 'Preface to the First Edition', xiii.

[21] Wharton (1895), 'Preface to the First Edition', xiii–xiv.

[22] Wharton (1895), 'Preface to First Edition', xvii; Bergk (1882).

[23] The painting, which Alma Tadema called 'op. ccxxiii', is now at the Waters Art Gallery in Baltimore; the medallion was produced by Wharton's friend, John Cother Webb: Prettejohn (2008), 122.

[24] Bergk printed κωὖκ ἐθέλοισα ('even if she is unwilling') in line 24 in his 1843 edition (a conjecture which later proved to have manuscript support), which explicitly gendered Sappho's beloved as female: Finglass (2021b), 255.

[25] Prins (1999), 52–73; Prettejohn (2008) (with 121 on Wharton's use of feminine pronouns); Fabre-Serris (2016), 85–6.

22 FRAGMENTARY MODERNISM

illustrations associated with Oscar Wilde and *The Yellow Book*), Wharton's *Sappho* also opened up the poet and her fragments to a new kind of modernity.[26]

When he published his first edition in 1885, Wharton concentrated on the fragments of Sappho which had survived through indirect transmission – embedded in the words of surviving writers (generally lexicographers, grammarians, or writers on literary composition) who had quoted or paraphrased Sappho in their work. But in 1887, Wharton issued a second edition with a new preface and a new appendix. By now, he had become aware that the tide of classical scholarship was beginning to turn: new fragments of lost poems – not from quotations of later authors in later copies, but preserved on the scraps of very ancient writing material – were coming onto the horizon. 'Last spring a telegram from the Vienna correspondent of *The Times* announced that some new verses of Sappho had been found among the Fayum papyri in the possession of the Archduke Rénier.'[27] A large number of Greek fragments from the Egyptian antiquities market following what became known as the first Fayum finds had ended up in possession of the Habsburg Archduke, whose collection (one of the largest in the world) was eventually given to the Austrian National Library in Vienna in 1899.[28] The new parchment finds whose discovery Wharton announced were not quite new – they had been published by Friedrich Blass in 1880 and incorporated into Bergk's fourth edition, to which Wharton had had access from the outset – but public interest had begun to perk up.[29] More new finds might be on the horizon: as Wharton put it in his preface, '[t]he rich store of parchments and papyri discovered in the Fayum has not all been examined yet'; archaeologists have detected in the air about them 'the perfume of Sappho's art',[30] and new papyri bearing lost texts might still emerge from Egypt. As Wharton remarked in 1895 in the preface to the third and last edition to be published in his lifetime, although 'to the world's sorrow' further new fragments of Sappho had not yet emerged in the intervening seven years, 'we need not yet give up all hope'.[31] Long-lost poetry on papyrus, he told his readers, had recently broken through to the present in the form of the previously unknown *Mimiamboi* of Herodas, exotically discovered 'on a papyrus-roll used to stuff an Egyptian mummy-case', and reported (as Wharton notes) in the periodical *The Academy* in 1890, and more was likely to follow.[32]

[26] Pound seems to refer to Beardsley's cover of Wharton's *Sappho* in *Canto* 74: Kenner (1971), 72.

[27] Wharton (1895), 'Preface to the Second Edition', viii–ix.

[28] Keenan (2011), 60; Loebenstein (1983).

[29] = P. Berol. 5006, now Fragments 3 (supplemented with P. Oxy. II 242) and 4. Wharton originally used only the Sappho section of Bergk (1882), iii, 82–140 (Wharton (1895), 'Preface to First Edition', xvii); the Fayum parchment had been tucked away in an appendix of anonymous fragments (Bergk (1882) iii, 704–5).

[30] Wharton (1895), 'Preface to the Second Edition', xi.

[31] Wharton (1895), 'Preface to the Third Edition', v.

[32] Wharton (1895), 'Preface to the Third Edition', vi.

If the prefaces of the 1887 and 1895 *Sappho* encouraged readers to turn to the press for news of impending discoveries, the appendix Wharton added to the second edition offered a paradigm for the kinds of fraghents they might expect to find. Towards the back of the second edition (and reprinted in subsequent editions), he included a new section showcasing the discoveries he had highlighted in the preface: 'The Fayum Fragments' (Figure 1.1). Here, Wharton's nineteenth-century optimism begins to dissolve, giving way to something much more like modernist fragmentation. Instead of the promised recovery of long-lost poems in the preface, readers were now presented with 'a tiny scrap of parchment' (181).[33] On both sides, Greek writing 'at least a thousand years old' (182) could be discerned, probably belonging to different poems.

The 'exact reproduction of photographs of the actual scraps of parchment' promised in the 1887 preface turned out to be not so exact. Produced by 'the Autotype Company', Wharton worries that the image is imperfect and 'some of the minutiae of the manuscript are lost in the copy' (181). Modern technological advances might have promised to further our access to the past, but for Wharton's readers, in a process that mimics the scribal transmission of ancient texts which were based on copies of copies of copies, they have further fragmented the precious fragments discovered in Egypt.[34] But the reason Wharton is keen to include the image is not that it shows what has been recovered, but rather what has been lost. What the image 'exhibits', Wharton asks his readers to see, is 'the manner in which it has been torn and perforated and defaced' (181) and the obstacles involved in the kinds of meaning-making 'with which those who decipher ancient manuscripts have to contend' (181–2).

As Wharton points out, the fragments are in such a state of illegibility that it isn't clear if the words are by Sappho at all. Friedrich Blass, with whom Wharton had corresponded, believed them to be by Sappho (an opinion, according to Wharton, that he reiterated in 'a letter to me' (183)), but Bergk – the 'latest German editor' who had given Wharton the confident authority for the first edition in 1885 – had (before his death in 1881) placed the new Fayum fragments in his posthumously published edition under 'authors unknown' (*fragmenta adespota*) and suggested the possibility that they might actually be by Alcaeus.[35] Still, Wharton gives the Greek text of 'the actual letters', using the typography adopted by the emerging discipline of papyrology to mark out uncertainty ('those which are not decipherable with certainty being marked off by brackets' (182)) and a succession of full points to show where text is missing. Alongside this, he gives Bergk's conjectural restoration of Fragment A which fills in several gaps,

[33] Prins (1999), 70–2 reads Wharton's appendix as part of an attempt to 'decompos[e]...the Sapphic corpus into a body of dead letters', whereby 'the text is Sappho and Sappho is the text' (72).

[34] Cf. Prins (1999), 71–2 on how Sappho is fragmented again by the processes of modern technology, 'the copy of a copy of a copy, in which the prototype, the "original" Sappho, is lost'.

[35] Bergk (1882) iii, 704–5. The fragments are now attributed to Sappho (Fragments 3 and 4).

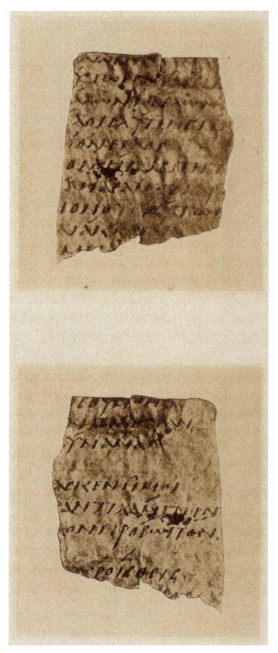

Figure 1.1 'The Fayum Fragments', from H. T. Wharton, *Sappho: Memoir, Text, Selected Renderings, and a Literal Translation*, 3rd edn (London: John Lane, 1895), p.180.

together with his own full English translation, setting the original words in italics, but supplementing to form a relatively complete sense unit (182).

When it comes to Fragment B, however, he effectively gives up the possibility of making sense: 'the restoration of fragment B. is yet more hopeless' (185). Wharton's solution to conveying what 'the words may mean' (186) is particularly striking, because, in retrospect, it reads like a proto-modernist fragment poem not unlike Pound's 'Papyrus':[36]

> *...soul...altogether...I should be*
> *able...as long indeed as to me...to flash*
> *back...fair face...stained over...*
> *friend.*

Language is uncertain and words strain and crack: 'in the absence of any context the very meaning of the separate words is uncertain' (186). But still, despite Bergk's scepticism, the essential authenticity of these fragments seems indubitable to Wharton: 'every word...makes one feel that no poet or poetess save Sappho could have so exquisitely combined simplicity and beauty' (183). By the end of the book, Wharton's *Sappho* has come a long way from the upbeat quotation of John Addington Symonds (who had died in the spring of 1893) in its opening chapter: 'so perfect are the smallest fragments preserved...that we muse in sad rapture of astonishment to think what the complete poems must have been' (32).[37] The new fragments give very little sense of 'what the complete poems must have been'. '[T]orn and perforated and defaced' (181), they emphasize, instead, the destruction of what once was. The task of 'those who decipher such manuscripts' (181–2), as Wharton's appendix illustrated for a non-specialist audience, is to gather together the 'uncertain' scraps, devoid of context, and to show not just what has been recovered, but also what is irrecoverably lost.

Poised on the cusp of a new modernity in classical scholarship and in modern artistic production, Wharton's *Sappho* played a key role in alerting a new generation of readers to the excitement of new poems from ancient Greece. As Ezra Pound advised Iris Barry in 1916 (the year 'Papyrus' was published), 'Wharton's "Sappho" is the classic achievement' which she could 'find in any library'.[38] For the many writers among Wharton's readers (Pound, H. D., Mary Barnard, and E. E. Cummings all owned copies) his *Sappho* offered new possibilities in the fractured texts emerging from the sands of Egypt, suggesting some of the ways in which the newly discovered poems from ancient Greece were not only new

[36] Wharton (1895), 186. [37] Symonds (1873), 129.
[38] Pound to Iris Barry 20? July 1916 = Paige 137.

26 FRAGMENTARY MODERNISM

because they had recently been found; they were able to express a 'torn and perforated' experience that was fundamentally modern.[39]

II. The Trackers of Oxyrhynchus

In 1895 – the year Wharton died and the year in which the third edition of his *Sappho* was published – Bernard Grenfell and Arthur Hunt went on an exploratory tour of the Fayum.[40] The following winter of 1896 and 1897, they made the critical move to the site of Oxyrhynchus, in el-Bahnasa, about 180 kilometres south of modern Cairo, which had once been a thriving city in the Roman empire, populated by Greek immigrants. According to the story told in Grenfell and Hunt's excavation reports, the remains of the city's tombs and buildings had been quarried for limestone, which left little scope for finding papyri hidden in sarcophagi or in the nooks of buildings, where they had been discovered at other sites. Disappointed with the results, so the story goes, on 11 January 1897 they shifted their work to the low mounds in the surrounding area. These turned out to be the remains of the municipal rubbish dump in which large quantities of papyrus scrap paper had been discarded in antiquity. Almost immediately, papyri containing fragments of ancient texts that had not been read for centuries emerged in quantities with which 'it was difficult to cope':[41] 'merely turning up the soil with one's boot would frequently disclose a layer'.[42]

Many of the texts found in Oxyrhynchus were 'documentary': private letters, invitations, domestic property deals, children's exercise books, horoscopes – the evocative remains of day-to-day life in the Graeco-Roman city which would fascinate European and American audiences in their own right. But the sands revealed other treasures, too: what looked like a crucial early Christian text, the *Logia Iesou* ('The Sayings of Jesus') was famously unearthed in the first season.[43] But just as sensationally, in among the scrap paper, were the remains of long-lost ancient Greek poems, including, in the very first expedition, a fragment of a

[39] Pound owned a copy of the 1885 edition (Kenner (1971), 59); the 1907 reprint of the 4th edition (which retained some elements of the bindings by Aubrey Beardsley) was owned by E. E. Cummings (Rosenblitt (2016), 335) and H. D. (Smyers (1990); Collecott (1999), 274 n.9); Mary Barnard was also given a copy for her twenty-first birthday: Barnsley (2013), 65.

[40] Grenfell had been digging with Flinders Petrie in Coptos and Gorub; he was sent with D. G. Hogarth to Kon Aushim and Umm el-Atl (Karanis and Bacchias), and then summoned Hunt, who joined him in January 1896: Turner (2007), 18; Montserrat (2007).

[41] Grenfell (1896/7), 7. [42] Grenfell (1896/7), 7.

[43] The *Logia* were identified in the 1950s as Greek versions of the Coptic *Gospel of St Thomas* (Cuvigny (2009), 36; Epp (2007), 315–16), but at the time they attracted intense public interest: Grenfell's detailed account for the American illustrated monthly, *McClure's Magazine* 9.6 (October 1897), 1022–30, included images of the two archaeologists, their digs in the desert, and the torn papyrus, and the separate pamphlet publication of the *Logia* alone (issued in June 1897) sold over 30,000 copies: Montserrat (2007), 32. For the popular reception of the Christian texts, see esp. Gange (2013), 243–56.

previously unknown poem by Sappho, the 'Nereid' poem, P. Oxy. I 7 (= 5 Lobel-Page). Grenfell and Hunt suspected the classical finds would end there ('It is not very likely that we shall find another poem of Sappho'[44]), but as it transpired, the rubbish dumps revealed far more than they had hoped. What turned out to be a missing piece of Wharton's 'Fayum fragments' (P. Oxy. III 424, identified by Grenfell and Hunt as 'a fragment of three stanzas in Sapphic metre probably by Sappho herself') was dug up in the first season and published in 1903, and several other literary finds, including more fragments of Sappho, would continue to emerge from the city's rubbish mounds.[45] By the time excavations ceased in 1907, Grenfell and Hunt had amassed the world's largest collection of papyri, much of which still remains to be deciphered today. They had unearthed pieces of ancient literature that had lain unread for centuries: lost works by Pindar, Sappho, Euripides, and Sophocles, including one of only two surviving examples of satyr play, the *Trackers, Ichneutae* (P. Oxy. IX 1174), as well as poems by Alcaeus, Ibycus, Callimachus, and Cercidas (author of satiric *Meliambi*) (P. Oxy. VIII 1082).[46]

The story of 'The Trackers of Oxyrhynchus' – as Tony Harrison would dramatize Grenfell and Hunt's excavations in his 1988 play – quickly became a foundation myth for the new academic field of papyrology, marked by the appointment of Grenfell himself in 1908 to the first-ever professorial chair in the field.[47] As recent work has revealed, however, the mythology that was constructed around the digs was very far from the full story.[48] The papyri were not miraculously discovered by the chance rescue of two Englishmen aided by the 'picks and spades of Arab workmen' who knew nothing about what they were digging.[49] As Roberta

[44] Grenfell and Hunt (1898), vi.

[45] Hunt (1903), 68, 71–2. Further Sappho finds published in the period include P. Oxy. X 1231, which yielded another poem about Gongyla (Fragment 22 Lobel-Page) as well as the famous Fragment 16 Lobel-Page ('Some say an army of horses...'), also published by J. M. Edmonds in the *Classical Review* (38.3, May 1914, 73–5), *The Times*, 4 May 1914, p.5, col. A ('New Poem of Sappho'), and the *New York Times* 14 May 1914, p.5 ('Explorers Find New Sappho Poem'). For a useful summary, see Finglass (2021a).

[46] They even found 'some Latin which is very unusual' (Parsons (2007), 16), including a fragment of Book 1 of Virgil's *Aeneid* and an epitome of a lost book of Livy's history of Rome (= P. Oxy. IV 668). The concession was relinquished when Grenfell became ill in 1908 (as he had done during the digs in December 1905), reportedly from a mental breakdown which culminated in a diagnosis of paranoid schizophrenia in 1920 (Montserrat (2007), 35), after which the Italian *Societa per la ricerca dei papiri* took over: Turner (1980), 33.

[47] For Harrison's play, which incorporates one of Grenfell and Hunt's most important finds, Sophocles' *Trackers* (*Ichneutae*), see Hall (2021), 97–122 and Parkyn (2022).

[48] For recent re-evaluations of the discipline and its colonial roots, see Bowman (2006); Fearn (2010); Orrells (2012), 58–9; Nongbri (2018), 216–46, and especially the work of Roberta Mazza (notably Mazza (2022)). Issues of ownership and provenance have recently come to the fore with particular urgency in allegations of the illegal sale of Oxyrhynchus papyri owned by the Egypt Exploration Fund (later Society), as well as problems surrounding the publication by Dirk Obbink of the so-called 'Brothers poem' attributed to Sappho: Sampson and Uhlig (2019); Sampson (2020).

[49] J. Kilmer, *The New York Times*, 14 June 1914, SM 7. For Grenfell's perpetuation of a narrative in which local diggers believed he was searching for gold, and that the idea that there 'should be any interest attaching to "old paper" is, of course, quite beyond their comprehension' (*McClure's Magazine* 9.6 (October 1897), 1029), see Mazza (2022).

28 FRAGMENTARY MODERNISM

Mazza has shown, the journals of Flinders Petrie (who had undertaken a preliminary survey of the site) reveal that excavators had already been alerted to the existence of the papyri in the mounds well before Grenfell and Hunt's 'discovery'.[50] As the young Alexandrian poet C. P. Cavafy wryly put it, 'wise men arrived from the North'[51] and took away material whose existence was in fact already locally known.

Compared to other straightforwardly 'archaeological' objects, classical literary papyri sit in the ambivalent space between text and material culture. They are not only more portable (as western excavators found out, papyri could easily fit into a crate of oranges or a tin of ginger-nut biscuits) but also more easily extractable from their contexts of discovery.[52] The Greek literary texts, above all, seemed to come directly into the present from the world of Sappho and Sophocles: as *The New York Times* announced in a two-thirds page spread on the 'wonderful mine of papyri'[53] that yielded Sappho Fragment 16 Lobel-Page ('some say an army of horses...'): 'Out of the dust of Egypt comes the voice of Sappho, as clear and sweet as when she sang in Lesbos by the sea.'[54] Embraced as new poems from the lost world of ancient Greece and valued for their textual content alone, the papyri could be removed not just physically but conceptually from the contexts of their excavation and production. A collateral result of this was that papyri which were already materially fragmented became fragmented in other ways too. The Egypt Exploration Fund relied on money from donors, and allowed those who (in the words of one private backer) had given 'a special sum towards the explorations' to 'add to the collections of the museum or university of... [their] choice'.[55] Papyri and other objects from the digs were distributed not only to various institutions in Britain and the USA, but as far afield as Melbourne and Uppsala, resulting in what Alice Stevenson calls a 'global fragmentation of the material products' of the digs.[56] Moreover, because they were (and often still are) published with little information about provenance, and because much of the media interest in the classical finds presented them as lost texts from Ancient Greece, the Oxyrhynchus and other papyri were effectively alienated from the social and historical contexts of their

[50] Petrie had met a member of a local elite family from the village of Sandafa, who 'told me that quantities of papyri were found there, & began grubbing', producing a Greek papyrus from the second-century CE: Mazza (2022) with Petrie Mss. 1.14: Petrie Journal 1896 (2–9 Dec. 1896), pp.32–3: the journals (digitized and transcribed) are available through the Griffith Institute Archive website.

[51] C. P. Cavafy, 'The Mimiambi of Herodas' (1892) ll. 6–7: Kutzko (2003); Orrells (2012), 59.

[52] On how 'the focus on the very Greekness of the content short-circuited, and therefore took precedence over, any Egyptian dimensions represented by the archaeological and cultural contexts of discovery', see Fearn (2010), 160. Cf. also Hickey (2011), 499.

[53] 'PLAY BY SOPHOCLES FOUND IN EGYPT', *The New York Times*, 19 November 1911, p.4, col. G.

[54] J. Kilmer, *The New York Times*, 14 June 1914, SM 7. [55] Schork (2008), 32.

[56] Stevenson (2015). For the problems involved in the practice, see Schork (2008); Johnson (2012); Stevenson (2019), 10–11.

production in Egypt. In Michel de Certeau's terms, the papyri became part of the 'circuit of activities characteristic of the present'.[57]

The perceived modernity of the papyri was not simply a result of their treatment by western excavators, though. The papyri were bound up in popular and artistic reception contexts that dislodged them from their lives as archaeological objects and turned them into cultural artefacts of modernity. From the outset, a media storm surrounding Oxyrhynchus and its papyri made them a public sensation. Well before the discovery of Tutankhamun's tomb in 1922, the digs at Oxyrhynchus were the subject of what Dominic Montserrat has called '[t]he first Egyptological event to create a media circus'.[58] News reports of the 'treasures from the dust'[59] reached a wide range of press outlets across the world: newspapers, magazines, and non-specialist journals from the *New York Times* to the *Illustrated London News* and the satirical *Punch* magazine.[60] Hunt was a reluctant public speaker, but Grenfell gave widely advertised lecture tours whose contents were summarized in the press.[61] Popular talks were illustrated by magic-lantern slides of photographs of the digs and close up illustrations of 'what papyri look like in the crumpled condition in which they are found'.[62] In the wake of the finds of 1906, he spoke across the UK,[63] in Brussels, and Cairo,[64] and in 1908, he took his talk to audiences in Rome, Florence (where he spoke before the Italian king and queen[65]), Paris, and Berlin.[66] Audiences in London could also go and see the objects for themselves. Setting a pattern that would be crucial to establishing dialogues between the public and the first generation of trained archaeologists, the Egypt Exploration Fund staged exhibitions of the latest finds in various venues in the city, including Burlington House, King's College, and University College London, which were also reported in print media.[67]

In effect, the 'newly recognized subject'[68] of papyrology and the fragmentary texts it revealed rapidly became a legible item in the cultural vocabulary of Britain and beyond. The 'Dioscuri of Queens',[69] with their 'partnership more lasting and

[57] Certeau (1995), 44; Hickey (2011), 499. [58] Montserrat (2007), 28.

[59] *The Observer*, 7 June 1914, p.17. [60] Montserrat (2007); Parsons (2007), 22.

[61] Montserrat (2007), 35 and 36. Hunt did, however, deliver at least one public lecture in Cheltenham in 1908: *Cheltenham Looker-On*, 21 November 1908, pp.19–21.

[62] I quote from a transcript of one of Grenfell's lectures, written after Vol. V of *The Oxyrhynchus Papyri* (published in early 1908) had gone to press. I am very grateful to Nick Gonis for sharing the transcript and details of the lecture's history with me.

[63] Including talks in Oxford, London, Birmingham, and Bristol: Montserrat (2007), 35.

[64] Montserrat (2007), 35.

[65] *Il Giornale d'Italia*, 8 January 1908; reproduced in Pintaudi (2012), 287–92.

[66] Rome (Sapienza) on 8 January; Florence (Società Leonardo da Vinci) on 11 January; Paris on 15 January, and Berlin in August: I am grateful to Nick Gonis for this information.

[67] Thornton (2015). [68] 'Notes from Oxford', *Athenaeum*, 27 June 1908, 788.

[69] The nickname is thought to have been coined by the leading German classical scholar Ulrich von Wilamowitz-Moellendorff and was frequently repeated (e.g., *Athenaeum* (27 June 1908), 788; *The Observer*, 14 June 1908, p.11, col. D).

30 FRAGMENTARY MODERNISM

at least as productive than that of Gilbert and Sullivan',[70] became a feature of popular culture. Their escapades were echoed in music hall songs, like Owen Hall's musical comedy, *A Greek Slave*, performed 349 times between 1898 and 1899, which featured the wizard Heliodorus (a version of Grenfell and Hunt, who had famously discovered ancient papyri in the wrappings and cavities of mummified crocodiles), described by the chorus as 'a marvel of a mage/Through reading the papyrus of a page/From the gummy little tummy of a rummy sort of mummy/He's the mightiest magician of the age'.[71] In Norma Lorimer's popular thriller, *The Wife out of Egypt*, reprinted twenty times between 1913 and 1922 in the UK and the USA, a dashing archaeologist shows the heroine, Stella Adair, a 'deliciously human'[72] papyrus letter taken straight out of the first part of *The Oxyrhynchus Papyri* and Grenfell's public talks.[73] The circulation of the Sappho discoveries in the high-society drawing rooms of England, meanwhile, was satirized in Ronald Firbank's *Vainglory* (1915). Firbank's novel centres on a dinner party hosted by Mrs Henedge, the widow of a bishop (77) (perhaps one of the seven bishops who had helped to fund the Egypt Exploration Fund's Graeco-Roman branch). At the dinner, 'Professor Inglepin', a version of the famous Oxford duo, reveals an 'original fragment of Sappho', discovered 'quite lately... in Egypt' (79), 'while surveying the ruins of the Crocodileopolis of Arsinoë, my donkey having – ' (91).[74] Rambler roses (echoing Meleager's description of his selection from Sappho as 'little, but all roses') decorate the house (80), and wine from Lesbos, 'procured, perhaps, in Pall Mall' (85), is served. As the papyrus fragment is finally revealed – 'Could not... Could not, for the fury of her feet!' (91) – the guests draw on a shared knowledge of other Sappho fragments, like Grenfell and Hunt's audience, familiar with Wharton's *Sappho* ('And isn't there just one little tiny wee word of hers', Mrs Calvally mutters as she fiddles suggestively with a tortoiseshell hair pin, '*A tortoise-shell*?', 92), but Inglepin staunchly

[70] Turner (2007), 18.

[71] Montserrat (2007), 28; Goldschmidt (2019), 54. The reference might have originated in Flinders Petrie's discovery of crocodiles in Hawara in 1888 and 1889 (Grenfell and Hunt's discoveries were not made until January 1900), but the connection would have been clear in retrospect. For Grenfell and Hunt's discoveries at the Crocodile cemetery in Tebtunis, see Grenfell et al. (1902), vi; Deuel (1965), 151–2, and Cuvigny (2009), 46–7.

[72] Lorimer (1913), 86.

[73] Grenfell had called the letter (P. Oxy. I 119) 'a most naïve and natural production': Montserrat (2007), 36.

[74] The location mingles Grenfell and Hunt's papyrological adventures in a crocodile cemetery with Wharton's 'Fayum Fragments' which were 'believed to have come from Medînet-el-Fayûm... near the ancient Arsinoë or Crocodilopolis' (Wharton (1895), 181). J. Johnson had also discovered a papyrus of Theocritus in the similar-sounding Antinoë in 1913–14 (*Observer* 7 June 1914, p.17, col. A). For how Grenfell and Hunt were presented (and presented themselves) in the media as 'rugged explorers facing the perils of the field, and flying the flag of scholarship in a dangerous foreign land', see Montserrat (2007), 38.

resists any suggestions of completion with an insistence on the fragment: 'we have, at most, a broken piece, a rarity of phrase' (92).[75]

As Firbank's novel highlights, it was not just what *The Times* called the 'romance of archaeology' which made the Oxyrhynchus papyri a cultural commodity.[76] The fragmentary texts themselves were disseminated with surprising success through the publication of *The Oxyrhynchus Papyri*. Instead of the usual Latin paratexts in scholarly editions, each papyrus was accompanied with an introduction and line-by-line commentary in English; the Greek text was given in a modern font,[77] and 'at the request of several subscribers to the Graeco-Roman branch' of the Egypt Exploration Fund, English translations were regularly printed below the Greek text.[78] The volume's comparative accessibility rode on the wave of media interest in the finds: the inaugural volume (which included Sappho Fragment 5 (P. Oxy. I 7) among its 'New Classical Fragments') was listed as one of *The Times* 'Books of the Week' in July 1898, where it was held up as an example to counter 'the reproach of "sterility"' that might be brought against classical scholarship.[79] As it expanded (and continues to expand) the series became a staple even among institutional libraries with no other papyrological holdings.[80]

The Oxyrhynchus Papyri – which would have been available to Pound and his circle in the British Library along with Edmonds' articles in *The Classical Review* – were not just ground-breaking in their accessibility. What was striking about the volumes, too, was that like Firbank's 'Professor Inglepin' the editors were conservative in their attempts to mitigate the fragmentary status of the material they published. Hunt later criticized Edmonds for the over-confident restorations of Sappho he published,[81] and textual reconstructions in *The Oxyrhynchus Papyri* tended to be less obtrusive.[82] Colour plates of the frayed papyri – including, in the first popular volume, Sappho Fragment 5 (P. Oxy. I 7) (Figure 1.2) – made the realities of damage and loss almost palpable. These were accompanied by transcriptions and sometimes by separate 'reconstructions'[83] in which the editors made full use of an arsenal of typographical tools to map on the page the material

[75] The dinner party in Firbank's novel would later find an analogue in Virginia Woolf's *To the Lighthouse* (1927), which seems to echo the ancient material coming into public consciousness at the Ramsays' dinner party when someone recites snippets from a poem (the Victorian 'Luriana, Lurilee') in fragments 'cut off from us all': Fernald (2006), 39. Cf. Parsons (2007), 23; Reynolds (2000), 337, 339–45; Jenkyns (1982), 81–3.

[76] 'New Poem of Sappho', *The Times*, 4 May 1914, issue 40,514, p.5, col. A.

[77] The practice was introduced for literary texts from the second volume on: Grenfell and Hunt (1899), xi.

[78] Keenan (2011), 62. [79] *The Times*, 29 July 1898, p.4, cols B–C.

[80] Van Minnen (2009), 650.

[81] Hunt (1914), responding to Edmonds' reconstruction of poems of Sappho and Alcaeus which had been published in *The Oxyrhynchus Papyri, Part X*.

[82] Cf. Finglass (2021a), 233 who notes that, while Grenfell and Hunt published what they declared to be a 'brilliant reconstruction' by Friedrich Blass of their first Sappho find, 'subsequent papyrus publications would tend to be more austere'.

[83] Hunt (1903), 'Note on the Method of Publication and List of Abbreviations'.

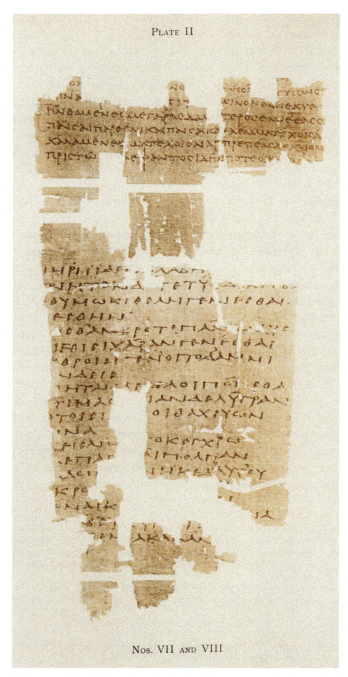

Figure 1.2 Photograph of P. Oxy. I 7 (= Sappho Fragment 5 Lobel-Page), the 'Nereid' poem, in *The Oxyrhynchus Papyri*, Part I (1898), Plate II (facing p.11).

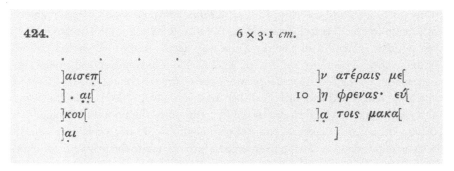

Figure 1.3 Sappho, P. Oxy. III 424, containing part of Fragment 3 Lobel-Page, from *The Oxyrhynchus Papyri*, Part III (1903), p.71.

condition of broken texts and the painstaking process involved in deciphering them (Figure 1.3). These were decoded for their non-specialist readers in a prominent prefatory note in the front matter of each volume of *The Oxyrhynchus Papyri* and partially echoed in newspaper publications of the most sensational finds:[84]

> square brackets [] indicate a lacuna...angular brackets < > the omission in the original of the letters enclosed...Dots placed outside the brackets indicate mutilated or otherwise illegible letters. Letters with dots under them are to be considered uncertain.[85]

In effect, *The Oxyrhynchus Papyri* offered a new generation of readers a textual language for expressing the 'mutilated...uncertain' and the 'otherwise illegible'. In doing so, it laid out the groundwork for a popular idiom that could be used to map out not just the losses of antiquity but the fractures of twentieth-century modernity. As its techniques began to merge with modernist experiments in typography, the new discourse of papyrology – developed as a way of deciphering the remains of antiquity – would itself come to carry some of the look and texture of avant-garde modernity. With very little contextual archaeological information given (apart from size and date), *The Oxyrhynchus Papyri* invited its readers to approach the scraps of Greek poetry printed in its pages as speaking a language of the fragment shared with modernity.[86]

[84] The technique of bracketing was explained in 'New Poem of Sappho', *The Times*, 4 May 1914, issue 40,514, p.5, col. A ('the words and letters in brackets are not to be found in the papyrus, and... there are several places where the words supplied are purely conjectural').

[85] Grenfell and Hunt (1898), xvi.

[86] From Vol. 40 onwards, inventory numbers were given, which can sometimes reveal the season in which a papyrus was excavated: Nongbri (2018), 223.

34 FRAGMENTARY MODERNISM

By the time Pound was consulting J. M. Edmonds' publication of the fragments of Sappho in *The Classical Review* in the old Reading Room of the British Library, the popular reception of Oxyrhynchus was deeply embedded in the cultural horizon of the twentieth century. By 1922 – the *annus mirabilis* of modernism (when both Eliot's *The Waste Land* and Joyce's *Ulysses* were published) – Grenfell and Hunt had edited and published their final volume of *The Oxyrhynchus Papyri* and J. M. Edmonds had produced the first edition of the popular bilingual *Lyra Graeca* for the Loeb Classical Library (which Pound would also use in the *Cantos*).[87] A spate of translations of Sappho emerged which catered to the new taste for Greek fragments by including not just the longer better-known poems, but new fragments on papyrus and parchment.[88] Crucially, papyrology had become part of the cultural landscape of the twentieth century. Developing side by side with the modernist enterprise, the new discipline presented a methodology of the fragment that cried out to be co-opted into the literary cultures of modernism.

III. Papyrologies of Modernism

Almost from the outset, ancient Greek papyrus fragments burst out of the 'sterile' sphere of classical scholarship and into the world of modern literary production. The Herodas papyrus which had led Wharton and others to hope for more in 1891 had already created a literary stir among writers like Oscar Wilde, Marcel Schwob, and C. P. Cavafy.[89] When new texts emerged a few years later seeming to answer the anticipation that more lost texts 'may still be buried beneath the sands of Egypt',[90] the revolution they engendered in classical scholarship was rapidly absorbed into the literary cultures of the early twentieth century.[91]

The process manifested itself on several different levels, from the minutiae of intertextual references to some of the most overtly 'modern' features of modernist writing. At the most basic level, the modernist networks which engendered Pound's 'Papyrus' in the British Museum Reading Room continued to riff on

[87] Edmonds (1922). Subsequent volumes of *The Oxyrhynchus Papyri* continued to be published by Grenfell and Hunt's successors and are still in progress. Arthur Hunt and the Egyptologist Campbell Cowan Edgar later also published *Select Papyri* in the Loeb series (between 1932 and 1934) and the literary papyri were published in a third volume by Denys Page: Page (1941).

[88] Reynolds (2000), 337.

[89] Kutzko (2003); Orrells (2012); Evangelista (2018); Deuel (1965), 126–8.

[90] *The Times*, 24 August 1891, issue 33,411, p.6, col. D.

[91] I focus on literary receptions in Britain and the USA here, but Oxyrhynchus had a broader cultural reach: for example, within a year of its publication in Vol. IX of *The Oxyrhynchus Papyri*, Sophocles' *Ichneutae* (P. Oxy. IX 1174) was performed in Halle in Lower Saxony (21 June 1913); it was staged in Prague in 1921, and by 1925 had shaped Albert Roussel's opera *La naissance de la lyre* in Paris, with a libretto written by the French classical scholar Théodore Reinach: Beta (2017). Cf. also Reynolds (2000), 221 for the influence of the Sappho finds in Colette's risqué brush with the law in Paris in 1907.

PAPYRUS 35

the Berlin parchment of Sappho. Aldington and H. D.'s ambitious 'Poets'
Translation Series' for the *Egoist*, which aimed to bring 'the past into the present,
the Hellenic into modernist poetry',[92] included in its first series (1915–16) a
version of Sappho by Edward Storer, later reissued with Aldington's Anyte
translations as a single pamphlet in 1919.[93] Storer relied substantially on
Wharton (there are close parallels between their translations), but he also included
Fragments 94 and 96 from the Berlin parchment on which Aldington and Pound
had drawn.[94] The same parchment – and the 'Atthis' Fragment (96 Lobel-Page) in
particular – came up again in another short poem by Pound, Ἰμέρρω, first
published as 'O Atthis' in *Poetry* magazine in September, 1916:

> Thy soul
> Grown delicate with satieties,
> Atthis
>
> > O Atthis
> I long for thy lips.
>
> I long for thy narrow breasts,
> Thou restless, ungathered.

Set out as if whole lines or words are missing, the poem (which is roughly
contemporaneous with 'Papyrus'), reads like an 'ungathered' fragment of
Sappho.[95] It riffs on juxtaposed words from Sappho ('Atthis', 'longing',
Ἀτθιδος ἰμέρῳ) and part of the narrative context (echoing Aldington's shift to
the first-person voice). From its second printing, Pound also gave the poem a
Greek word for its title – Ἰμέρρω (*imerrō*), the Lesbian-Aeolic form used by
Sappho of ἰμείρω (*himeirō*), 'I long for, yearn for, desire', a verb that characterizes
Sappho's poetry of loss and longing in both the form and the content of several
fragments.[96] A few years later, Pound again returned to the Berlin parchment for
Canto 5, where the 'hush of the older song' appears in snippets, transformed into
what Hugh Kenner calls 'fragments of a fragment'.[97]

[92] Zilboorg (1991a), 74.

[93] As No. 2 of the Poets' Translation Series, 2nd series. For Anyte, see Chapter 3. For the Poets'
Translation Series, see esp. Vandiver (2019).

[94] For linguistic echoes between Storer's and Aldington's versions, see Vandiver (2019), 12
with n.18.

[95] '[I]n keeping with the attention that Sappho's Greek commands of an early 20th-century
intelligence...Pound nowhere presents what we have of the poem entire': Kenner (1971), 66–7.

[96] The title was changed from 'O Atthis' for inclusion in *Lustra* (1916): see Kenner (1971), 61 on the
problematic printing of the Greek title word, which originally had a smooth breathing to match its form
in Sappho's Lesbian dialect, but was later changed to a rough one, perhaps via a misprinting in Liddell
and Scott's dictionary.

[97] *Canto* 5 was published in 1921, but probably complete in 1919. Ἰμέρρω also echoes the famous
Sappho Fragment 36 (preserved in the *Etymologicum Genuinum*), 'and I long and I yearn', καὶ ποθήω
καὶ μάομαι. Pound later showed interest in the details of other new fragments, notably P. Oxy. XX 2256,

36 FRAGMENTARY MODERNISM

As Aldington and Pound circled around the Berlin parchment, H. D. was haunted by the ancient fragments she had helped to bring to their attention. Despite what Eileen Gregory identified as her 'almost complete silence' about the new discoveries, H. D. (who had transcribed the text from Edmonds' publication of the Berlin parchment of Sappho for Richard Aldington) was clearly aware of the papyrological revolution.[98] She owned the 1907 edition of Wharton's *Sappho* which included the 'Fayum Fragments', and later Hunt and Edgar's edition of *Select Papyri* (1932; 1934) as well as Edwin Marion Cox's 1925 translation of Sappho, a self-styled replacement for Wharton in light of the new papyrological finds, which H. D. reviewed in May 1925 for *The Saturday Review of Literature*.[99] In her essay 'The Wise Sappho', written around 1920 (one of the alternative early titles of which was 'The Island, Fragments of Sappho'), H. D. associated Sappho's 'many, many roses' with the work of classical scholars and archaeologists, 'each fragment witness to the love of some scholar or hectic antiquary searching to find a precious inch of palimpsest among the funereal glories of the sand-strewn Pharaohs'.[100] The image conflates different kinds of text-hunting that came to prominence in the period: the discovery of lost texts in palimpsests (the sensational 'Archimedes palimpsest' was revealed in 1906), the 'hectic antiquaries' who poured over the dull texts of ancient grammarians in order to collect quotations of otherwise unknown fragments which formed the basis for collections like Bergk's and Wharton's editions of Sappho, and, above all, the well-publicized work of the papyrus-hunters digging in the desert 'of the sand-strewn Pharaohs'.[101] One of H. D.'s first published poems, 'Hermes of the Ways' (*CP* 37–9), echoes an epigram in *The Greek Anthology* and draws on the image of a stone herm marking the crossroads of which Hermes was a guardian god.[102] But with its desert imagery ('The hard sand breaks/And the grains of it/Are clear as wine' (ll. 1–3)), the poem

which contains a fragment that could be used as evidence that Aeschylus' *Suppliants* was not his earliest extant play: Liebregts (2019), 54–5. For another allusive 'silence' in Pound about the Berlin parchment and a fragment of Julius Afranius found at Oxyrhynchus, see Kahane (1999).

[98] Gregory (1997), 148. For H. D. and classical antiquity more broadly, see also Swann (1962); Rohrbach (1996); duBois (1996); Gregory (1997); Collecott (1999); Svensson (2003); Culligan Flack (2015), 162–95; Brinkman and Brinkman (2016); Hickman and Kozak (2019), part 2.

[99] = H. D. (1925). A copy of the first two volumes of *Select Papyri* is in the Bryher Library, with H. D.'s owl bookplate: Smyers (1990). Cox presented his book as an update of Wharton: 'since the publication of the book, a considerable quantity of new material has come to light in the fragmentary papyri found in the delta of the Nile. This present edition is an attempt to bring the subject more up to date': Cox (1925), 'Foreword', 7. In practice, however, he only included P. Oxy. X 1231, 'some say an army of horses', based on J. M. Edmond's Greek text, printed and translated as Fragment 3 on pp.73–8.

[100] H. D. (1982), 69; Davis (1986), 144.

[101] She may have also had Wharton's 'Fayum Fragments' in mind: Gregory (1997), 277 n.24. H. D. called one of her novels *Palimpsest* (1926). For editions of non-papyrological fragments, see Chapter 2.

[102] Chapter 2, p.85.

has also been read as a creative response to Oxyrhynchus and its sensational 'sand-strewn' discoveries.[103]

H. D.'s intertextual engagement with 'the broken sentences and unfinished rhythms' of the remains of Sappho's poetry seems to stick closely to the already well-known fragments extracted from other authors and published in Wharton's edition.[104] There is, for example, very little evidence of the new finds in her five 'Fragment' poems (published between 1921 and 1924), named after Sappho fragments and headed by Sappho epigraphs.[105] But, though the obvious absence might seem surprising, the new papyri did leave palimpsestic traces in her writing. One of Grenfell and Hunt's well-advertised finds from the remains of what must have been a discarded library discovered in 1905/6, 'some say an army of horses...' (P. Oxy. X 1231 = Fragment 16 Lobel-Page), published in 1914 in *The Oxyrhynchus Papyri, Part X* and by Edmonds in both the *Classical Review* and *The Times*, made its way into 'Why have you sought the Greeks, Eros', first published in 1920.[106] So, too, the epigraph to 'Chorus Sequence (from *Morpheus*)' (1927, *CP* 253), '*Dream—Dark-winged*', evokes a striking Oxyrhynchus fragment (P. Oxy. XV 1787 fr. 3, col. ii. 15–24 = 65 Lobel-Page), 'Dream...black...', [107] and specifically Hunt's suggested emendation 'with your black wings', μελάινα[ις πτερύγεσσιν, published in 1922 in *The Oxyrhynchus Papyri, Part XV*.[108] H. D. might have felt a 'habitual defensiveness with regard to professional scholarship',[109] but she still subtly incorporated the materials and even some of the methods of the new papyrology into the imaginative landscape of her work.

But the real impact of the papyrological revolution operated both in far less specific and also in far more wide-reaching ways. Papyrus and the poetry it brought to light became a kind of watchword for new literary discovery. Writers who wanted to emphasize their modern credentials presented their work as if it were a new-found fragment of lost Greek poetry. As Yopie Prins points out, Pound took advantage of the climate of new discoveries 'to introduce new poetry

[103] Barnsley (2013), 161. Hermes is also a central character in Sophocles' *Ichneutae*, one of Grenfell and Hunt's most important dramatic finds, and there was a cult devoted to him at Oxyrhynchus: Whitehorne (1995), 3069–70.

[104] 'The Wise Sappho' = H. D. (1982), 58.

[105] 'Fragment 113' published in *Hymen* (1921), 'Fragment Thirty-six', 'Fragment Forty', 'Fragment Forty-one', and 'Fragment Sixty-eight' published in *Heliodora* (1924). Three of these had been written as early as 1916 under different titles: Rohrbach (1996), 188–9; Martz (1983), xviii–xiv. The fragment numbers and epigraphs from Sappho in English translation (which she added in 1924: Rohrbach (1996), 189) are from Wharton's edition.

[106] Collecott (1999), 275. Culligan Flack (2015), 173 (with further references) also sees traces of the fragment in H. D.'s 'Ithaca', published in *Heliodora* (1924).

[107] Gregory (1997), 150.

[108] H. D.'s poem was first published in *A Miscellany of American Poetry* (New York: Harcourt, Brace, 1927), 99–116 and collected in *Red Roses for Bronze* (1931). Hunt suggested 'through the black night' (μελάινα[ς διὰ νύκτος) or 'with your black wings' (μελάινα[ις πτερύγεσσιν): Grenfell and Hunt (1922), 42.

[109] Gregory (1997), 150.

38 FRAGMENTARY MODERNISM

by H. D. as if he had discovered yet another Sapphic fragment'.[110] But he was not the only one. Mina Loy offered up her 'Songs to Joannes' (1917) as '*the* best since Sappho', like a new discovery not quite her own ('My book is wonderful – it frightens me').[111] Sara Teasdale, the popular American poet who would go on to win the first Columbia Poetry Prize (later the Pulitzer Prize for Poetry) in 1918, couched her poetry 'as if it were a fragment found in a sarcophagus',[112] and claimed to suffer periodic bouts of what she called 'imeros', riffing on Sappho's characteristic emotion (and Pound's poem by the same title).[113] Amy Lowell, the 'American Sappho', as E. E. Cummings called her,[114] did some 'poking around' in Sappho scholarship[115] and wrote poems which, as Jane McIntosh Snyder puts it, 'read almost like translations of some of the fragments of Sappho's poetry preserved for us by later ancient writers'.[116]

More obliquely, T. S. Eliot, too, capitalized on the climate of new discoveries. One of his early poems was called 'Fragments', the parts of which were given a set of out-of-sequence numbers (1, 2, 13, 24, 25, 41, 50) as if the source, in David Chinitz's words, 'had been preserved, like Sappho, on tattered papyrus'.[117] *Sweeney Agonistes: Fragments of an Aristophanic Melodrama* (originally issued in the *Criterion* as 'Fragment of a Prologue', (October 1926) and 'Fragment of an Agon' (January 1927)), echoed contemporary popular entertainment (the original title was '*Wanna go Home, Baby?*); but it can also be shown to have engaged in 'deliberate ironical parodies of surviving fragments of classical texts',[118] and specifically papyrus fragments of ancient popular theatre found at Oxyrhynchus, which (as Eliot would have known from his studies of Aristophanes at Harvard) had included three fragments of Greek comedy ascribed to Aristophanes.[119]

If the discourse of new papyrological discovery was co-opted into the modernist rhetoric of novelty, papyrus itself – as the material on which the new Greek fragments had been found – could function as a guarantor of cutting-edge authenticity. One of the longest running little magazines of its kind was

[110] Prins (1997), 65; Pound to Harriet Monroe: Pound, *SL* 11.

[111] Cited in Roger Conover's note to the poem in Loy (1997), 188. For Loy's links to Sappho, see Quatermain (1998), 58–9 and Varley Winter (2018), 109.

[112] Walker (1991), 65. [113] Drake (1989), 49. [114] Rosenblitt (2016), 30.

[115] Munich (2004), 15.

[116] Snyder (1997), 130–1. On Lowell and/as Sappho, see also Rollyson (2013), 4–5, 29.

[117] Eliot, *IMH*, 114; Chinitz (1999–2000), 332. [118] Unger (1961), 28.

[119] Three fragments ascribed to Aristophanes (P. Oxy. II 212) were published in *The Oxyrhynchus Papyri, Part II*, pp.20–3 = Grenfell and Hunt (1899), 20–3. Eliot was enrolled on 'Greek 2' at Harvard in 1907–8 which had Aristophanes' *Acharnians* and *Birds* on the syllabus (Jain (1992), 253), and in 1923 (as he wrote to his mother) he wanted 'to work in a desultory way on preparations for my play, which involves studying Aristophanes and learning all I can about the Greek theatre': Ricks and McCue (2015), I.785. Two heavily annotated student copies from this phase are known: W. W. Merry's edition of *Acharnians* in the Houghton Library at Harvard, and Merry's 1904 edition of *The Birds*, the current whereabouts of which is unknown, though I am very grateful to Jim McCue for sharing an image of Eliot's extensive student annotations to the flyleaf with me. Eliot also owned two other Greek texts of the complete works (Ricks and McCue (2015), I.786–7). For Eliot and Aristophanes, see also Smith (1963), 44, 58, 72.

called *The Papyrus: A Magazine of Individuality*, which ran in America between 1903 and 1912.[120] Stimulated by a 'hatred of Sham and Fake under whatever forms they may appear', *The Papyrus* – which was prominently endorsed by Ezra Pound for its ability to 'confront the castrated world of American "literature"' – self-consciously catered to '[t]he true literary spirit'.[121] One of the magazine's selling points was that for the price of $10 its subscribers could have their name inscribed on a real papyrus 'specially imported from the banks of the Nile, near Luxor, in old Egypt'.[122] Having signed up to 'The Society of the Papyrites', subscriber-members could access a variety of literary content: the editor's own prolific essays on literary and political themes as well as external contributions, including some that tapped into the climate of recent discoveries of Sappho on papyrus like Kenneth Douglas' poem 'Sappho', which evoked the ancient poet 'In glittering fragments half unseen',[123] and Sara Teasdale's sonnet, 'Aphrodite', published in the November 1910 issue, in a clear echo of Sappho Fragment 1.[124]

At the same time, the urban rubbish mounds at Oxyrhynchus where the most exciting finds had been made were congenerous with one of the most modern of modernism's innovations: the poetics of rubbish. As Tim Armstrong and David Trotter highlight, literary modernism coincided with a period of 'creative waste', when the proliferation of waste-matter began to be seen as a necessity for a consumption-driven economy.[125] Oxyrhynchus, which hit the media at a high point of urban waste-proliferation, provided a powerful ancient reminder of the value of urban litter. Whereas modern waste culture stood in stark contrast to the high literary intertexts that modernism evoked, Oxyrhynchus was a site where the junk of everyday life (organic vegetable matter, twigs, straw, and torn-up shopping lists) mingled with frayed bits and pieces of exactly the kinds of ancient texts in which modernism was interested: fragments of lost works of Sappho and Sophocles, torn scraps of Homer's *Iliad* and *Odyssey*, and bits of Virgil's *Aeneid*, broken up and eroded on torn pieces of scrap paper.[126]

[120] MacLeod (2018), 260, 357. The magazine was later revived as *Phoenix*.

[121] The quotation is from the magazine's manifesto, which appeared on the inside back cover from the first issue in July 1903 to Vol. 7, No. 6 (August 1906). For Pound's endorsement, see MacLeod (2018), 260–1. The Boston 'Papyrus Club' (which ran roughly between 1872 and 1923) was similarly associated with Bohemia and the avant-garde.

[122] The offer, which included a fifty-year subscription and annual dinner, was printed on the inside back cover of the new series (e.g., New Series, Vol. 1, No. 1, July 1907).

[123] February 1909, New Series, Vol. 4, No. 2, p.15. The editor also reviewed John Myers O'Hara's translation of Sappho: 'Sappho via Chicago', September 1907, New Series, Vol. 1, No. 3, pp.18–20.

[124] *The Papyrus*, Third Series, Vol. 1, No. 1, November 1910, p.6. Sappho's ode to Aphrodite (Fragment 1) is preserved in a quotation by Dionysius of Halicarnassus and was later also discovered on an Oxyrhynchus papyrus (P. Oxy. XXI 2288, published in 1951).

[125] Armstrong (1998), 61; Trotter (2000), 23; see also Cohen (2004) for creative modern discourses of filth.

[126] On the layer of *afsh*, 'earth intermixed with organic matter, commonly twigs and straw', in which papyri were preserved, see Johnson (1914), 174 with Grenfell and Hunt (1900), 24. One fragment of the *Iliad* had even been used as toilet paper: Spooner (2002).

40 FRAGMENTARY MODERNISM

The parallel was never explicitly made (though Jackson I. Cope once suggested that Joyce may have been referring to a description of the discovery of Christian texts in the rubbish heaps in the 'rubbages' of *Finnegans Wake*).[127] But if modernist writers and their readers had picked up almost any newspaper between 1898 and 1914, they would have been confronted at some point with news of the 'old rubbish heaps of Egypt'.[128] Oxyrhynchus could easily be absorbed into the new value placed on the broken up and the discarded, and its powerful evocation of fragments of ancient texts buried among urban detritus over several centuries resonates again and again with the ways in which modernist texts were written and received. D. H. Lawrence complained that Joyce's novels were deliberately made up of 'old fags and cabbage stumps of quotations', many of them from classical antiquity;[129] Pound's *Cantos*, as Gilbert Highet antagonistically described them, could be read as 'a dump containing some beautiful fragments'.[130] In Hope Mirrlees' *Paris: A Poem*, written in 1919 and printed for the Hogarth Press by Virginia and Leonard Woolf a year later,[131] fragments of ancient literature – Aristophanes, '[o]ld Hesiod's ghost.../Yearning for "Works and Days"' (ll.80–2), '[s]tories...[p]enned by some Ovid' – are mingled with the 'smell of / Cloacae' (ll.119–200) and the urban debris of Paris.[132] Mirrlees studied classics at Newnham College, Cambridge under Jane Harrison ('the great J. H.', as Woolf would call her[133]) and continued to live with Harrison afterwards, including periods in Paris. Like other modernist texts, the rubbish in Mirrlees' poem is inflected by psychoanalysis and the trappings of modern technology ('Freud has dredged the river and...waves his garbage in a glare of electricity' (ll.414–15)). But what Mirrlees elsewhere called 'the disparate fragments...ever forming into new patterns' crucially involved the fragments of antiquity, including the papyrological discoveries of which she would have been aware.[134]

Paris largely 'disappear[ed] through the cracks of literary history',[135] but it anticipated the poem which turned waste paper and its fragments into an icon of literary modernism: T. S. Eliot's *The Waste Land*. Published in 1922 – the year in which Joyce published *Ulysses* and Grenfell and Hunt published one of the most sensational new fragments of Sappho in *The Oxyrhynchus Papyri* – [136] the

[127] Cope (1966). [128] *The Observer* 7 June, 1914, p.17, col. A. [129] Ellmann (1987), 93.
[130] Highet (1961), 116. [131] Briggs (2005).
[132] Mirrlees' 'Brekekek coax coax we are passing under the Seine' (l.10) also alludes to the famous chorus of Aristophanes' *Frogs*, while the 'lion carved on a knife handle,/Lysistrata had one' goes back to an image in Aristophanes' play: Parmar (2011), 113; 115; Howarth (2011), 3; Tearle (2019), 55. For Aristophanes at Oxyrhynchus, see n.119 above.
[133] *A Room of One's Own* (1929), p.17.
[134] From Mirrlees' essay, 'Listening to the Past' (1926) in Parmar (2011), 85. Bernard Grenfell himself was diagnosed with *dementia praecox paranoides*, which was presented by contemporary medical sources as a disease of 'broken pieces, black rubbish heaps, yawning emptiness': Trotter (2001) 47–8 n.67 with 38–9; cf. n.46.
[135] Briggs (2007), 262.
[136] P. Oxy. XV 1787 = Fragment 58 Lobel-Page, in *The Oxyrhynchus Papyri, Part XV*.

'waste land' of Eliot's title famously evokes not just a land laid waste, but a land *of* waste.[137] As Maud Ellmann puts it *'The Waste Land* is about what it declares – waste…above all waste *paper'*.[138] Hostile contemporary reviewers turned this into a negative critical trope. Charles Powell in the *Manchester Guardian* dismissed the poem as 'so much waste paper'; Humbert Wolfe declared it 'a waste of paper'.[139] But waste paper is key to the poem's mode of operation. As David Trotter puts it, 'Eliot clearly needs his litter'.[140] Eliot's litter has been read as a response to embodied urban modernity, mass culture, and the waste involved in American capitalism.[141] But that underplays the crucial fact that Eliot's litter included the paper remains of the high literary production of the classical past and its afterlives: 'out of this stony rubbish' (I.20 = *PTSE* I.55) come the scraps of Virgil, Ovid, Sappho, and their later inheritors. Like Mirrlees' *Paris*, the results might be seen to figure the modern urban psyche: as a more sympathetic contemporary reviewer put it, '[t]he human consciousness is a rag-bag, a rubbish heap',[142] and for several generations of readers, Eliot's poem was to become 'a short-hand way of making references to modern life', both physical and psychological.[143] Yet *The Waste Land*'s waste paper also enacts a theory of culture that has much in common with the publicity surrounding the rubbish heaps of Oxyrhynchus, bringing together scraps of 'the whole of the literature of Europe from Homer',[144] with ragtime music, discarded contraception,[145] taxis and tin cans set out – in an echo of a fragment of Sappho – '[a]t the violet hour, the evening hour that strives/Homeward' (III.215; 220–1 = *PTSE* I.63).[146] When Eliot's poem was rapidly transformed into a cultural icon, 'the justification of the "movement", of our modern experiment, since 1900', as Pound called it,[147] its hyper-modern poetics of the rubbish heap made the wasteland of papyri at Oxyrhynchus, too, into a cultural commodity of modernity. What Joseph Rosenberg calls 'wastepaper modernism' – the anxiety about textual decay that litters the modernist page – might have started as a response to new technologies

[137] Ricks and McCue (2015), I.588–9.

[138] Ellmann (1987), 93. On the *Waste Land* as a poem of and as waste paper, see also Armstrong (1998), 68–74 and Rosenberg (2021), 13.

[139] Humbert Wolfe, 'Waste Land and Waste Paper', *Weekly Westminster* 1 n.s. (November 1923), 94 in Grant (1982), I, 194–5 (195). See also H. P. Lovecraft's parody 'Waste Paper: A Poem of Profound Insignificance' (probably written shortly after Eliot's poem was published); reprinted in *Books at Brown* 26 (1978), 49–52.

[140] Trotter (2001), 2. [141] Armstrong (1998), 68–74.

[142] Edmund Wilson Jr, 'The Rag-Bag of the Soul', *New York Evening Post Literary Review* 25, November 1922, pp.237–8 reprinted in Spears Brooker (2004), 77–81 (79).

[143] Miller (1977), 8. [144] 'Tradition and the Individual Talent' (1919) = Eliot, *CP* II, 106.

[145] Silk handkerchiefs (III.178) were reputedly used as contraceptives: Ricks and McCue (2015), I.651.

[146] Sappho Fragment 104 (a two-line fragment on the Evening Star quoted in Demetrius' *On Style*) is echoed in *The Waste Land*, III. 220–3 and highlighted in Eliot's mock-scholarly notes to the poem: Ricks and McCue (2015), I.663.

[147] Pound, *SL* 180 (9 July 1922).

42 FRAGMENTARY MODERNISM

of modernity, but modernism could clearly see its own future in the textual litter of Oxyrhynchus.[148]

What blurred the lines between antiquity and modernity most tangibly in the modernist reception of ancient papyri was the visual connection between the ways in which torn papyri were being presented on the page by classical scholars and the dominant 'look' of poetic modernism. Modernist poetry is characterized by an extreme emphasis on white space and radical experimentation with typography that was enabled primarily by new developments in technology.[149] But classical scholars – equally implicated in the 'typewriter century' – had been using the same technology to make available a typographical language of the fragment that spoke precisely to some of the key preoccupations of modernism. By the time modernism came to deploy new technologies of printing in its characteristic *mise-en-page*, white space, underdotting, and square brackets had been established by classical scholars as a textual idiom that provided an easily recognizable short-hand for loss, uncertainty, and the failure of communication.[150] This meant that the textual codes of classical scholarship could be readily absorbed into the typographical revolution of modernism, evoking not just modernity, but recent developments in the discovery of antiquity. As Anne Carson would later put it of her translations of Sappho in *If not, Winter*, brackets 'are an aesthetic gesture toward the papyrological event rather than an accurate record of it'.[151] Modernist practice absorbed the typography of papyrology and its cognate disciplines, often in contexts signifying loss, fragmentation, and the difficulties of communication, in a way that was sympathetic not just to the machine aesthetic of modernism, but to the publications of ancient Greek and Latin texts in fragments.[152]

Pound's 'Papyrus', the poem with which I began this chapter, is an obvious example of this kind of typographical cross-fertilization because its content clearly calls for the connection to be made. But even when the content had little to do with classical antiquity, papyrological methods of representation informed the textual practices of several writers in the period. E. E. Cummings, one of the most innovative punctuationists of modernism, complained that 'the people who object to my way of writing have never read the classics'.[153] Cummings' way of writing – characterized by irregular margins, unexpected word divisions, and rogue

[148] Rosenberg (2021) argues that anxieties about the breakdown of transmission inherent in the medium of paper on which modernist texts were printed was a response to new technologies like cinema and radio.

[149] Howarth (2011), 22–3; Hammill (2016); Brinkman (2009), and Brinkman (2016), 71–104.

[150] Before the fonts were standardized, the popular Part I of the *Oxyrhynchus Papyri* (which was a *Times* Book of the Week) also used different fonts to mirror the look of the literary papyri 'as they were written', Grenfell and Hunt (1898), xvi.

[151] Carson (2003), xi.

[152] Elements of the typographical language of papyrology are shared in other forms of classical scholarship, especially textual editions (Chapter 2) and epigraphy (Chapter 3).

[153] Norman (1972), xii; Rosenblitt (2016), 25. For Cummings' training at Harvard, see Rosenblitt (2016), esp. 18–23.

punctuation and typography – teeters on the verge of the eccentric, but as Guy Davenport observes, even in contexts that have nothing to do with antiquity, his typographical idiom was generated in dialogue with the 'frail scatter of *lacunae*, conjectures, brackets, and parentheses' which he had encountered in publications of ancient fragments of papyrus.[154] Virginia Woolf's habit of using ellipses, too, has been read as a mark of an abstract 'Sapphic modernism', 'enlisting punctuation in the service of feminism and the use of ellipses for encoding female desire'.[155] Yet modernist strategies of ellipsis like Woolf's, 'leaving something to be understood',[156] also operated on a much more basic level by tapping into the typographical language of contemporary publications of Sappho's actual texts. As Anne Toner puts it in *Ellipsis in English Literature* (2015), 'ellipsis points can be seen as a symbol of the [twentieth] century as they articulate its ever-unravelling coherence', but they were also, crucially, a visual symbol of twentieth century as 'the century of papyrology'.[157]

Papyrology had filtered into modernist writing, and once it had done so, there was no going back. The poetic productions of modernism and the papyrological scraps on which they had drawn began to take on the appearance of a shared fragmentary endeavour. By 1922, when J. M. Edmonds published *Lyra Graeca* and Eliot published *The Waste Land*, a fragment like this:

> . . . unexpectedly

could no longer be read simply as 'the voice of Sappho, as clear and sweet as when she sang in Lesbos by the sea', let alone an archaeological artefact from Graeco-Roman Egypt.[158] Papyrology had become indelibly associated with some of the most characteristic features of modernism – novelty, fragmentation, radical *mise-en-page*, mess. In turn, publications like *The Oxyrhynchus Papyri* or Edmonds' *Lyra Graeca* were read through the filter of a growing body of modernist texts. Published in formats that mirrored the typographical quirks of modernist writing and excavated from an urban rubbish dump that spoke to modernist

[154] Davenport (1980), 42–3; Rosenblitt (2016), 24–5.

[155] Marcus (1981), 187 quoted by Benstock (1994), 106. Toner (2015), 159 locates the use of ellipsis in women's exclusion from classical education.

[156] Benstock (1994), 107.

[157] Toner (2015), 151. Ellipses could hold several simultaneous functions, including mimicking psychological as well as textual discontinuity: F. S. Flint's poem 'Hallucination', for example, was published side by side with Aldington's 'To Atthis' (which uses ellipses to mark missing text at its end), but used the same typography to mark psychological strain. For the phrase 'century of papyrology', traditionally credited to Theodor Mommsen, though the source remains elusive, see Van Minnen (1993).

[158] Edmonds (1922), 211, from P. Oxy. X 1231 (first published in 1914). Edmonds' edition included 'a considerable number of restorations made *exempli gratia*' ('Preface', viii) but even these, with their arsenal of punctuation, could merge with the new discourse of the fragment.

preoccupations with scrap paper, ancient Greek poems on papyrus had become permanently inflected by the fragment cultures of modernity. If Pound's 'Papyrus' looked like one of the new fragments of Sappho edited by the new papyrologists, the work of classical scholars, too, began to look more and more like versions of Pound's 'Papyrus'.

2

Editions

The poems of Sappho found on broken pieces of parchment or papyrus (and in the case of Fragment 2 on a broken piece of pottery) are fragments in the most basic sense of the word, *fragmenta*, from Latin *frangere*, 'to break'. They are the result of physical damage to the material on which they had been inscribed. But most 'fragments' of ancient texts have come to us in a different form. They became fragments not through material causes, but through what is known as 'indirect transmission': quoted or paraphrased in snippets embedded in the works of later authors. The original, earlier text, which would usually have still been available alongside the quoting text, fell out of circulation and stopped being copied in its entirety, with the result that only the traces left in the quoting text were subsequently transmitted to modernity.

The 'great ode of Sappho' (as T. S. Eliot put it), a prayer to Aphrodite which probably opened ancient collections of her poetry, only made it to modernity because all twenty-eight lines of the poem was quoted in the first century CE to illustrate a point about style.[1] Many of her most evocative lyric fragments survived only because they happened to appear in a ninth-century lexical encyclopaedia known as the *Etymologicum Genuinum*, itself pieced together from several sources.[2] 'And I long and I yearn' (καὶ ποθήω καὶ μάομαι), words which now seem to 'crystallize one essential mood of Sappho',[3] were transmitted only because they were quoted to illustrate the fact that writers like Sappho in the Aeolic dialect use ποθήω (*pothēō* 'I long') instead of the Attic ποθέω (*pothéō*).[4] What is now Fragment 37, κὰτ' ἔμον στάλαχμον ('in my pain'), seems to sum up perfectly the ache of loss and longing in Sappho's poetry: as Mary Barnard put it in her late Imagist version:

> Pain penetrates
> Me drop
> By drop

[1] Fragment 1 Lobel-Page, quoted by Dionysius of Halicarnassus, *On Literary Composition* 23. Eliot (1993), 294; Ricks and McCue (2015), I.608. Eliot was referring to Fragment 31 rather than Fragment 1, though it, too, was a favourite among modernist poets; Pound quotes from it in a letter to Iris Barry (August 1916; Paige, 143), 'misspelling the words with the freedom of one who has them by heart': Kenner (1971), 61. A papyrus fragment from Oxyrhynchus (P. Oxy. XXI 2288, published in 1951), was later found to be from the same poem.

[2] Calame (1970). [3] Barnstone (2006), 157. [4] Fragment 36 Lobel-Page.

Fragmentary Modernism: The Classical Fragment in Literary and Visual Cultures, c.1896–c.1936. Nora Goldschmidt, Oxford University Press. © Nora Goldschmidt 2023. DOI: 10.1093/oso/9780192863409.003.0003

46 FRAGMENTARY MODERNISM

but it only emerged because the ancient lexicographer used it to exemplify the fact that pain in Aeolic is called 'a dripping' (*stalagmos*, the root of English 'stalactite'), 'for they drip and flow'.[5]

Such fragments are different from the texts inscribed on the tattered material culture emerging from Egypt. They are not physically broken off, but fragmented by later mediating voices who quoted, paraphrased, or abridged the original complete text. As such, they can be seen as the combined creation of their ancient authors and their later reception. To quote Mary Barnard's note on her translation, what we have is, in effect, a combination of '[w]hat Sappho said, or at any rate what they say she said'.[6] Fragments obtained through indirect transmission were embedded in the words of other authors, they were often quoted at second hand or further removes in texts which were themselves based on centuries of copies of copies of copies. The results are not so much *fragmenta*, broken off from a not too distant whole, but *reliquiae*, the remains left behind whose 'whole' was abandoned long ago. When H. D. wrote her 'Fragment' poems, named after poem numbers from Wharton's popular edition of Sappho;[7] when Eliot alluded to Sappho in *The Waste Land*, or when Pound used a fragment of Ibycus in 'The Spring' or Stesichorus in the *Cantos*, the words they evoked were not simply broken off from complete ancient originals on parchment or papyrus, but mined from an eclectic range of writers whose work (unlike the long-lost texts from which they quote) can still be read in modernity.[8] Fragments like these could carry some of the imaginative burden of papyrus – erosion, attrition, the failure of communication and transmission – but they could also instantiate other modernist interests, too. If the idea that 'meaning . . . is always realized at the point of reception' has become a mantra of classical reception studies, in cases like this (beyond the hermeneutics applicable to most texts), there is not only no originary *meaning* to which we have access but, quite literally, no original *text*.[9] Enmeshed in the voices of other writers, layered over centuries of time and place, texts like these provide concrete instances of the fact that antiquity is always mediated by reception, never fully recoverable.

The fact that we can read the little that is left at all, moreover, rests on an immense scholarly labour. Even more than papyrus scraps, these fragments rely

[5] Fragment 37 Lobel-Page = Fragment 61 in Barnard (1958).

[6] 'A Footnote to these Translations': Barnard (1958), 106. For the complex processes involved in creating and extracting fragments preserved in quotation (with particular reference to early Latin poets quoted in the works Cicero), see Čulik-Baird (2022).

[7] Cf. Chapter 1, p.37.

[8] Eliot alludes to Sappho Fragment 104 (a two-line fragment on the evening star quoted in Demetrius' *On Style*) in *The Waste Land*, III. 220–3; Pound's 'The Spring' is a version of Ibycus, Fragment 286, quoted by Athenaeus in the *Deipnosophistae* ('Scholars at Dinner') 13.601b, and a fragment of Stesichorus (also quoted by Athenaeus) appears in *Canto* 23/107–8: see Goldschmidt (2019), 64–6 and below, p.75.

[9] For the 'mantra' of classical reception studies, see Martindale (1993), 3; Hardie (2007); Martindale (2013), 1. On absent and fragmentary texts and the limits of reception, cf. Goldschmidt (2012), 1–2.

EDITIONS 47

on what Eliot described in *East Coker* as 'the fight to recover what has been lost/ And found and lost again and again' (V, 15–16 = *PSTE* I.191). That fight was substantially conducted during what Hugh Kenner called the 'Renaissance II' of classical studies, which took place during the nineteenth century with its epicentre in Germany.[10] An army of textual scholars set themselves the task of collecting the remains of ancient works which had survived in fragments and testimonia embedded in other ancient texts. Friedrich Daniel Schleiermacher, a close friend of the leading philologist Friedrich August Wolf and roommate of the Romantic poet and philosopher Friedrich Schlegel (the main author of the *Athenäums-Fragmente* (1798)), produced the dramatically titled *Herakleitos der dunkle, von Ephesos, dargestellt aus den Trümmern seines Werkes und den Zeugnissen der Alten* (*Heraclitus the Obscure of Ephesus, Presented on the Basis of the Ruins of his Work and of the Testimonies of the Ancients*, 1807), which paved the way for Hermann Diels' ground-breaking edition of the Presocratic philosophers.[11] Georg Friedrich Creuzer – whose study of mythology made him an archetype for Mr Casaubon in George Eliot's *Middlemarch*[12] – laid the foundation for the collection of Greek historical fragments, leading to Felix Jacoby's monumental edition.[13] Theodor Bergk produced *Poetae Lyrici Graeci* in 1843, which went on to form the basis for Wharton's popular *Sappho*.[14] August Meinecke produced an important edition of Greek comic fragments; Johannes Vahlen edited the early republican Latin poet Ennius, Otto Ribbeck the all but lost fragments of Roman tragedy, and Friedrich Marx the satirical fragments of Lucilius.

The new philology also focused its efforts on the creation of modern scientific editions of texts that survived through 'direct transmission', in manuscript copies that could, at some point in their genealogies, be traced back to a long lost 'original'. This, too, involved a dramatic scholarly fight of recovery and loss. As Tom Stoppard's imagines it in *The Invention of Love* (through the mouthpiece of the nineteenth-century Oxford classicist Benjamin Jowett), even the most straightforward process of textual transmission is fraught with degradation and erasure:

[10] Kenner (1971), 41–53; (1969). Kenner associated the nineteenth-century scholarly Renaissance with materials that 'came from underground' in the wake of Schliemann's Troy, but the new science of antiquity was also profoundly centred on philology. I discuss the much broader impact of archaeological finds in Chapter 5.

[11] Schleiermacher (1807). Cf. Most (1998), 10: Schleiermacher's friendship with Wolf seems to have begun from 1804; Schleiermacher contributed anonymously to one of the fragment collections Schlegel published (Most (2009), 16) and began his translation of Plato in collaboration with Friedrich Schlegel. For Schleiermacher and Schlegel, see esp. Güthenke (2020), 72–95.

[12] Güthenke (2020), 96.

[13] The prospectus for Jacoby's edition was issued in 1909 and began publication in 1923: Cornell et al. (2013), 5.

[14] Cf. Chapter 1, pp.20–22. Wharton gives Bergk's Greek text and fragment numbers, and often also an indication of where each fragment was quoted and why.

48 FRAGMENTARY MODERNISM

> [C]orruption breeding corruption from papyrus to papyrus, and from the last disintegrating scrolls to the first new-fangled parchment books, with a thousand years of copying-out still to come, running the gauntlet of changing forms of script and spelling, and absence of punctuation – not to mention mildew and rats and fire and flood and Christian disapproval to the brink of extinction.[15]

More than most texts, classical texts are all fragments of sorts, and the fundamental task which nineteenth-century scholars set themselves was to pick up the remaining pieces 'from the brink of extinction' in a more systematic way than ever before in order to attempt to rectify the ravaging process of textual transmission. Editors collated surviving manuscripts, grouping them into family trees or stemma that showed where one had been derived from the other, and, in the case of Karl Lachmann (who produced a radical text of Lucretius) and followers of his method, they also posited lost archetypes from which later groups of manuscripts had been derived.[16] They then chose the best version of the text from the manuscript tradition and introduced or adopted further emendations to correct errors. All this was mapped on the page using a critical apparatus supplemented by a complex typographical language of asterisks, bracketing, and Greek-lettered sigla. The result was a series of ground-breaking editions that laid bare the complex history of loss and erosion involved in the transmission of classical texts and the labour exerted by a new methodology in the attempt to rectify it. Almost every extant classical author received the systematic attention of the new philologists. In Leipzig, an influential series of affordable critical editions was rapidly produced by the Bibliotheca Teubneriana (published by B. G. Teubner) from 1849, which gained a reputation for authoritative versions of ancient Greek and Latin texts: as Ezra Pound would later complain, 'all classic authors have been authoritatively edited and printed by Teubner, and their wording ultimately settled at Leipzig'.[17] The comparable 'Oxford Classical Texts' series was founded in 1896, followed by the French 'Budé' in 1920.[18]

When modernist writers accessed Greek and Latin texts in the original languages, they generally did so through editions like these or others based on them. The Loeb Classical Library began producing simpler versions of key texts with facing-page English translations from 1911, and these tended to be picked up as they came on the scene, notably Paton's version of *The Greek Anthology* (1916–18) and Edmonds *Lyra Graeca* (1922), but Loebs were not available for

[15] Stoppard (1997), 24–5. Stoppard's Jowett uses the manuscript tradition of Catullus, which goes back to a single (lost) copy, as an example: see further Butrica (2007), 13–14.

[16] Timpanaro (2005).

[17] Pound, *LE*, 240. The series would have been available on the open shelves in the British Library Reading Room (cat. 2046–49) which Pound used as his workshop in London: Peddie (1912), fold-out table.

[18] Whitaker (2007).

all texts, and even when they were, several modernist authors regularly turned to more substantial critical editions. T. S. Eliot and Ezra Pound owned and used several scholarly editions closely enough to draw on the critical apparatus for variant readings. Richard Aldington – despite his explicit repudiation of philology in the 1915 announcement of the Poets' Translation Series – consulted German editions for his translations of the *Greek Anthology* and Hellenistic poetry, as did H. D., who, like many others in the period, was also deeply immersed in Wharton's *Sappho*, itself closely based on the text and numbering system of 'her latest German editor', Theodor Bergk.[19] E. E. Cummings' library was well stocked with scholarly editions, including Wilhelm Dindorf's *Poetarum scenicorum Graecorum* (1851) and J. A. Giles' edition of the fragments of minor Greek poets.[20] Hope Mirrlees' classical training mediated her engagement with the texts of antiquity, and Virginia Woolf's ambivalent engagement with Greek was partly negotiated through scholarly editions, one of which, Charles Blomfield's 1832 text of Aeschylus' *Agamemnon*, she carefully dissected in one of her reading notebooks, cutting it up into pieces and annotating it by hand.[21]

A profound shift in outlook, however, meant that the same editions could be produced and received in opposite directions. Where nineteenth-century scholars and their successors had generally been driven by an impetus for recovery ('what has been found'), for modernist readers, the same texts emphasized loss, erosion, and the failure of transmission or communication ('what has been lost/And found and lost again and again'). The 'scientific' trappings of the Teubner texts 'settled at Leipzig'[22] and editions like them had crucial consequences which their editors had not intended. Looked at in a different way, the very apparatus which marked out gaps, elisions, erosions, and interventions could have the effect of fundamentally destabilizing ancient texts and their transmission. Seen from the perspective of twentieth-century modernity, the scholarly productions of the nineteenth century and their legacy in the twentieth offered not so much a way to reconstruct a lost past as a way of seeing the texts of classical authors as more radically fragmented and unstable than ever before.

[19] For H. D.'s use of German editions of classical authors (which she accessed with the help of dictionaries and 'what possible translations there were'), see Gregory (1997), 55. For Aldington's use of German scholarly editions, see Zilboorg (1991a), 76; among them were Friedrich Jacobs' edition of the *Greek Anthology* (1794–1814), which he recommended to Bryher: Zilboorg (2003), 152 n.2, though it was probably the shorter 1826 edition with Latin translation.

[20] J.A. Giles, ed. *Scriptores Graeci minores*, 1831 (acquired 1948): for a full list, see Rosenblitt (2016), 333–8.

[21] Woolf's reading notebook for the *Agamemnon* is made up of cut-out sections of Blomfield's edition hand-annotated with the translation of Arthur Verrall's English and Greek edition: see Prins (2005) on Woolf's Holograph Reading Notes in the Berg Collection of the New York Public Library with Koulouris (2019) on Woolf's Greek notebooks. For Virginia and Leonard Woolf's library, which includes an extensive collection of critical editions, see King and Miletic-Vejzovic (2003), and for Woolf's deep engagement with Greek tragedy more broadly, see Worman (2018).

[22] Pound, *LE*, 240.

50 FRAGMENTARY MODERNISM

This chapter looks at how scholarly editions of fragmentary authors and other textual interventions by classical philologists played out in three of the major works of modernism: T. S. Eliot's *The Waste Land* (1922) and *Burnt Norton* (1936) (the first in the sequence of *Four Quartets*), and what became Ezra Pound's *Canto 1* (first published in 1917). Closely associated in reception with what Pound called 'our modern experiment, since 1900', all three works shaped the academic and popular reception of modernism and its legacies for decades after their publication. As such, they became crucially implicated with the work of classical philologists and the texts they edited and circulated. Eliot and Pound absorbed the outputs and techniques of editors of fragmentary and unstable ancient texts into their poems. The result – often showcased in paratextual positions – was partly to underwrite the new texts with the parallel struggle for textual and cultural recovery over loss that had long been waged by classical scholars. But the process of co-option itself also exposed the faultlines in the very scholarship it had absorbed. Transposed to new contexts, the attempt by classical scholars to develop a scientific philology of the fragment became entangled with the fragmentary concerns of modernity. Seen in a new light, the task of philology was retrospect-ively re-cast to involve not so much the production of scientifically reconstructed wholes, but fragments that mirrored the literary modes of modernism. Rooted in nineteenth-century 'Altertumswissenschaft' (the 'science of antiquity', as Wolf had influentially called it), the philology of the fragment itself came to seem less like an exercise in the textual reconstruction of the past and more like an enterprise characteristic of modernist fragment collection.

I. Bücheler, Petronius, and *The Waste Land*

Opening T. S. Eliot's *The Waste Land* for the first time in 1922, most readers would have encountered the poem prefaced by a short unidentified passage in a mixture of untranslated Latin and Greek.[23] The quotation – which still stands at the head of modern editions of *The Waste Land* and is now one of the most famous epigraphs from a classical text in modern literature – comes from Petronius's *Satyricon* (48.8):[24]

[23] Although it was omitted from the first UK version in the inaugural issue of *The Criterion* for October 1922, the epigraph was printed in the poem's American journal publication in *The Dial* (dated November 1922 but published in late October: Ricks and McCue (2015), I.563) as well as the first book version published by Boni & Liveright in December of that year, and the first UK book version, handset by Virginia Woolf and published by the Hogarth Press in 1923. The dedication, 'For Ezra Pound, *il miglior fabbro* ('the better craftsman'), a quotation in Italian from Dante's words to Arnaut Daniel in the *Divine Comedy*, was not printed until 1925: Ricks and McCue (2015), I.595.

[24] Schmeling (2011), 206 (the translation is my own: Eliot's text is untranslated). As Badenhausen (2004), 77 notes, Petronius' lines in the epigraph were originally set more conspicuously than they tend to be in modern editions of the poem, 'taking up more space than the title itself and giving them a certain prominence that is lost in contemporary editions of the text'.

> nam Sibyllam quidem Cumis ego ipse oculis meis vidi
> in ampulla pendere, et cum illi pueri dicerent: Σίβυλλα
> τί θέλεις; respondebat illa: ἀποθανεῖν θέλω.

For I saw the Sibyl at Cumae with my very own eyes hanging in a bottle, and when the boys said to her, 'Sibyl, what do you want?', she would reply, 'I want to die'.

Eliot's original choice of epigraph from Joseph Conrad's *Heart of Darkness* (1899) was not 'weighty enough' for Pound,[25] and after he rejected it, as Eliot later explained, 'the quotation from Petronius came to my mind as being what I wanted'.[26] Just what Eliot wanted in selecting Petronius has been difficult to pin down, however. While Petronius may have seemed 'weighty enough' to Eliot and Pound (who later used part of the same passage for *Canto* 64 (64/360)), as commentators often point out, the *Satyricon* would have been a 'controversial' choice in 1922.[27] As William Arrowsmith describes it, Petronius' Roman novel has tended to be seen as 'the story of a trio of picaresque perverts told by a pornographer of genius'[28] with the result that several readers have felt that 'one reads Petronius, one does not quote him'.[29] As the classicist J. P. Sullivan (who also defended Pound's Propertius) would point out in a series of cutting-edge psychoanalytical close readings published in 1968, the sexual themes of the *Satyricon*, including scopophilia and exhibitionism, are a central feature of the text.[30]

On the face of it, the risqué choice seemed to contradict Eliot's prim persona (as Auden observed the day Eliot died, 'there is a lot, to be sure, of the conscientious church-warden' about him).[31] It also went against the mood of official morality around the time *The Waste Land* emerged. In the summer before Eliot's poem was published, an obscenity charge was brought by an organization called the 'Society for the Suppression of Vice' against Boni & Liveright, the American publishers of the uncensored translation of the *Satyricon* by W. C. Firebaugh, who had also contracted to produce the first book version of *The Waste Land*.[32] Although the trial, as *The New York Times* reported in detail, was concluded in the defendants' favour, it brought the potential of Petronius' text to transgress social boundaries freshly to the fore of public discourse.[33] Viewed in this light, Eliot's selection of an epigraph from Petronius was a chance to 'cock a snook' at the 'Society for the

[25] Ezra Pound to T. S. Eliot, 24 January 1922: 'I doubt if Conrad is weighty enough to stand the citation': Ricks and McCue (2015), I.591.

[26] Eliot, letter to Grover Smith, 21 March 1949: Ricks and McCue (2015), I.591. Pound had in fact left the use of Conrad open ('who am I to grudge him his laurel crown?': Letter to Eliot, January (28?) 1922 = Paige 237; Ricks and McCue (2015), I.591).

[27] Schmeling and Rebmann (1975); Miller (2005), 98. [28] Arrowsmith (1960), xiv.

[29] Sullivan (1968), 15. [30] Sullivan (1968), 232–53.

[31] Auden (1965); Schmeling and Rebmann (1975), 393–4.

[32] Schmeling and Rebmann (1975), 405–6, citing Paul S. Boyer, *Purity in Print* (New York, 1968), 82.

[33] Schmeling and Rebmann (1975), 410 n.47.

52 FRAGMENTARY MODERNISM

Prevention of Vice' and the benighted outlook it represented.[34] Unlike the later epigraphs to *Burnt Norton*, which take pains to cite not only the ancient author but the edition used, the ancient text was left unidentified, and this sets a silent trap for Eliot's readers. The unwitting prudes who refused to acknowledge that 'we think more highly of Petronius than our grandfathers did' (as Eliot had observed in 1920),[35] would be forced to read the offending text without knowing it – or perhaps even understanding it.[36]

For those who did read Petronius' Latin, however, the most striking feature of the *Satyricon* would not only have been the novel's radical content but its radical form. The *Satyricon*'s journey from antiquity to modernity was a fraught one.[37] As we have it, Petronius' work (if it is by 'Petronius' at all) is a collection of fragments from a much larger whole. The full content or even the length of the original remains unknown. Around 35,000 words have been transmitted, perhaps accounting for as little as one-sixteenth of the original ancient text.[38] The portion that has survived, moreover, is itself highly fragmentary, not so much a text as 'a collection of disjointed pieces, mutilated excerpts'.[39] Though a long section known as the *Cena Trimalchionis* ('Trimalchio's Dinner Party') remains largely intact, much of what we have of the text of Petronius is the result of what looks like deliberate fragmentation through abridgement and bowdlerization, compounded by a series of losses and discoveries which scribes and scholars over several centuries have tried to resolve, often exacerbating the problems they encountered in the process. Crucial copies were found and then lost again along the journey, muddying the manuscript tradition unalterably.[40] 'New' fragments 'discovered' in the seventeenth century and the turn of the nineteenth century promised to fill the gaps, but were later found to be forgeries.[41] As a result, the text of the *Satyricon* as we have it is radically unstable. Written in a mixture of consciously experimental prose and verse, the narrative often cuts off mid-swing, as its glaring gaps and omissions continually leave the reader stranded. The intended order of events is uncertain, and if further 'fragments' gleaned at second hand through quotations

[34] Schmeling and Rebmann (1975), 407. The risqué Petronius had appealed to others, including the author of a 1902 translation attributed to 'Sebastian Melmoth', a pseudonym used by Oscar Wilde. For the sensationalizing translation which traded on Wilde's reputation in the wake of his arrest, see Boroughs (1995).

[35] 'Euripides and Gilbert Murray: A Performance at the Holborn Empire', *Art & Letters* 3.2 (1920), 36–8; 43, reprinted as 'Euripides and Professor Murray' in *The Sacred Wood* = Eliot, *CP* II, 195–9 (198).

[36] Schmeling and Rebmann (1975), 407. Eliot also used Petronius several times in his prose works: Schmeling and Rebmann (1975), 394–5, 401–2.

[37] Müller (2003), iii–xxvii; Vannini (2010), 39–63; Schmeling (2011), xviii–xxi.

[38] Opinions vary as to the length of the original (the low percentage is suggested by Rimell (2002), 2), as well as the source of the extant fragments: Vannini (2010) imagines that what we have are fragments from a hypothesized second volume containing Books 13–24, while Books 1–12 are completely lost.

[39] Schmeling (2020), 23. [40] Schmeling (2011), xviii–xxi, (2020), 22–49.

[41] Ryan (1905), which Eliot read, tells the story of the forgeries: xix–xx. See also Schmeling (2011), xi and Laes (1998).

EDITIONS 53

from other authors and appended to editions of the *Satyricon* might have held hope of resolving some of the difficulties, most seem to have no place in the narrative as we know it. Readers of the *Satyricon* are faced with a fundamentally fragmentary text, which – not unlike a high-modernist poem like *The Waste Land* – continually thwarts our desire to make it whole, as 'the reading mind fights against the fragmentary state of the text'.[42] All this is compounded by the fact that Petronius' text did not just become fragmented through the perils of textual transmission. In some ways, 'crazy and surrealist',[43] it seems to have been written as one. Even in the sections which are relatively well preserved, the novel as it stands continually baffles anyone looking for wholeness and it is not even clear whether it was ever to be gained. As Michael J. Ryan summed it up in his 1905 translation (which Eliot referred to in his undergraduate copy of the text): '[f]rom the fragments we possess there appears to have been no strict plot or logical connection in the *Satirae*'.[44] The narrative, as Froma Zeitlin puts it, seems to have been 'undertaken with the deliberate intention of defeating the expectations of an audience accustomed to an organizing literary form'.

Eliot was careful to emphasize that he had gone back to the Latin text in choosing his epigraph. As he wrote to the publisher Giovanni Mardersteig when he was preparing the Officina Bodoni edition of *The Waste Land* (1962) (by this time happy to reveal the source of the now well-known epigraph): 'Certainly, if you wish, put "Petronius, Satiricon" after it...I must defend my use of the quotation by saying that I have read the Satiricon, or most of it.'[45] Michael Heseltine's 1913 Loeb translation had 'presaged a spate of references' in contemporary writing, and it may be that in reading 'most of it' Eliot had consulted Heseltine, since he owned a number of Loebs.[46] But it would not have been the Loeb edition in which Eliot encountered the obscene Petronius who had come to public prominence when he inserted the epigraph in 1922. Less bold than Firebaugh, when it came to the raunchy parts of the text, Heseltine and his publishers resolved the issue by printing the Latin twice, once on the left and once on the right in place of the facing-page English translation, often for stretches of several pages in a row.[47]

[42] Slater (2009), 17. For modern critical readings of Petronius mirroring *The Waste Land* itself, cf. Rimell (2002), 3 n.14.

[43] Rimell (2002), 7.

[44] Ryan (1905), xx. Cf. Zeitlin (1971), 635. For the thematics of disintegration in Petronius, see Rimell (2002) and Connors (1998). Eliot lists Ryan's translation in the notes in his copy of Petronius in the pasted note after the second title page. For his edition, see pp.54–55 below.

[45] 15 June 1961. Eliot felt he needed to 'defend' his direct use of the Latin partly because Dante Gabriel Rossetti ('I think it is quoted somewhere by Dante Gabriel Rossetti') had adapted the same passage of Petronius in his notebook fragments: Ricks and McCue (2015), I.593.

[46] Smith (1974), 303–4. For the conjecture that Eliot used the Loeb, see, e.g., Lees (1966), 340.

[47] Heseltine (1913), 32–7, 168–73, 294–7 312–13, 316–19; see also Lawton (2012), 185–9. Ryan similarly bowdlerized the text, explaining that 'a few unnecessarily coarse passages have been avoided' in his translation along with *double entendres* 'which must be read in the Latin' (Ryan (1905), viii).

54 FRAGMENTARY MODERNISM

As Gareth Schmeling and David Rebmann decisively showed in an important article published in 1975, Eliot relied on Franz Bücheler's 1904 critical edition of the Latin text. He had bought a copy as an undergraduate at Harvard, probably in preparation for Clifford Herschel Moore's Latin Literature course in 1908–9 ('The Roman Novel: Petronius and Apuleius') on which he was enrolled, though he may also have studied the text at some point with E. K. Rand.[48] Eliot made extensive notes on Bücheler's edition, which he later presented to John Davy Hayward ('Wd you care to add to your library my Harvard (undergraduate) Petronius and Apuleius?', as he put it in the note pasted on the flyleaf of the book), now part of the Eliot archive material at King's College, Cambridge.[49] The edition is heavily annotated. *Satyricon* 48, from which *The Waste Land* epigraph comes is unmarked (though it was at some point marked with a sewn-in ribbon bookmark[50]), but other parts of the work are extensively annotated, probably from when they were worked up in preparation for Moore's classes at Harvard. Eliot pasted seven pages of paper notes into his copy, including a reading list of secondary literature, commentaries, and translations, and a list of passages to prepare. He also marked up the text itself, including *Satyricon* 83 (highlighted in pencil), which he later quoted in an epigraph for his essay collection *The Sacred Wood* in 1920, and *Satyricon* 118–124 (heavily marked), which contains Eumolpus' comments on the education and social value of poets and an intentionally incomplete verse passage ('which hasn't received the final touches', *nondum recepit ultimam manum*, 118.6), which Eumolpus claims to have composed, featuring strong intertextual links (as Eliot highlights in his notes) with Lucan's *Pharsalia*.

What is strikingly different about Bücheler's edition compared with Heseltine's Loeb is not just the fact that the work is unbowdlerized, but that the fraught conditions of transmission and non-transmission are written into the text itself in ways that would not have been obvious to a reader relying on the right-hand page of the Loeb.[51] More than any other text available in the period, Franz Bücheler's critical edition encodes within it 'the active struggle'[52] by classical scholars over the centuries to reclaim Petronius' fragmentary text for modernity. Bücheler, who first published the *editio maior* of Petronius in 1862, represents the first modern scholar to have produced a major critical edition which fully takes into account and tries to make sense of the work's complex manuscript history in what is still

[48] Ricks and McCue (2015), I.593–4. Eliot's secretary replied to a letter in 1963 to the effect that Eliot had 'certainly' studied Petronius with Rand, though it is possible that he misremembered.

[49] King's College Library, Cambridge (HB/B/22). [50] Schmeling and Rebmann (1975), 401.

[51] The Loeb Latin text, prepared by H. E. Butler and based on Bücheler, includes the more fragmentary parts of the work and some critical notes at the base of the Latin text, but – particularly on the right hand English page – the translation minimizes the disruptions of textual transmission.

[52] Slater (2009), 17.

EDITIONS 55

seen as the first 'consistently scientific approach' to the *Satyricon*.[53] Yet even as Bücheler takes pains to make systematic sense of the text, his edition foregrounds issues of loss and fragmentation. Bücheler never pretends the *Satyricon* survives anywhere near complete. Like most editors, he divides the text into two main parts, the main section found in most translations (including 'Trimalchio's Dinner Party', the best known and best preserved part of the text), which he calls 'excerpts' (*excerpta*), and the *fragmenta*, the citation fragments from other ancient authors quoting or summarizing parts of the *Satyricon*. The *fragmenta* are the more obviously 'fragmentary' parts of the text, often extracted from quotation from other authors, often at second-hand or further removes. But in Bücheler, in particular, the longer *excerpta* – from which Eliot's epigraph from the *Cena* comes – visibly evince the conditions of loss and the effort of recovery. His text is visually marked by the scholarly labour that has gone into producing it. Like most critical editions, the bottom of the page contains an extensive critical apparatus detailing emendations by textual critics past and present or variants found in the manuscripts discarded by the editor along the way. Far more explicitly than Heseltine's Loeb, Bücheler uses interventionist typography and spacing to mark out the text itself as mediated and fragmented. Asterisks and white space stand in where text is lost, or seems to be lost. Different manuscript traditions – symbolized by the letters L, O, and H (the first two of which, as Bücheler's list of sigla explains, represent hypothesized manuscripts based on copies discovered centuries ago but then lost again) – are unusually marked by annotations in the margins and vertical bars in the text itself.[54]

For Eliot reading Petronius in Bücheler with the guidance of the Classics faculty at Harvard, the fragmentary reality of Petronius' text would have been inescapable. Clifford Herschel Moore, whose course on Petronius and Apuleius Eliot took, was known as a textual editor (he was involved in producing an edition of Horace in 1902 and one of Euripides' *Medea* in 1899),[55] while E. K. Rand took on the life-long task of editing the textual labyrinth of what became known as the 'Harvard Servius'. In keeping with what he called his '(undergraduate) Petronius', Eliot's annotations to his copy of Bücheler pick up issues of vocabulary and intertextuality, colloquial language, and contextual issues of interpretation

[53] Schmeling (2011), xxi. Although the fourth edition owned by Eliot does not print Bücheler's long introduction (in Latin), Eliot also used Walters edition of 'Trimalchio's Dinner Party' (referred to in the pasted notes of his edition and on p.32), which gives a summary of the manuscript history from Bücheler's first edition (p.xviii) as well as Collignon's *Etude sur Pétrone* (1892) (referred to on p.60, p.85, and in the pasted notes), which similarly explains the outline of the manuscript history and Bücheler's methods (pp.2–3).

[54] Though commentators on Eliot have impressionistically observed of the *Satyricon* that '[t]he work is a fragment' (Bacon (1958), 298) whose 'partial state seems suited to *The Waste Land*, itself a self-conscious assemblage of fragments' (Booth (2015), 33), none have significantly linked this with Bücheler.

[55] Moore revised Frederic De Forest Allen's edition of Euripides' *Medea* (1900) and edited Horace's *Odes and Epodes* (1902). He also had a side interest in the Oxyrhynchus papyri: Moore (1904).

56 FRAGMENTARY MODERNISM

(at *Satyricon* 32, for example, Trimalchio tucks a purple napkin around his neck, as Eliot dutifully notes, because he 'does not dare to wear noble dress with purple collar'). But Eliot also engaged with the critical apparatus (underlined on p.56) and read the *fragmenta* section of the edition, two of which (Fragments 29 and 38) he marked in pencil.[56] In the words of Albert Collignon, from whose *Etude sur Pétrone* Eliot took notes, for modern readers, the mutilation and gaps ('sa mutilation et les lacunes') – as Eliot could clearly see from Bücheler's text – mean that, unless new fragments were somehow to emerge, 'un certain mystère' will always characterize Petronius' incomplete novel.[57]

When Eliot came back to Petronius in the 1920s, the *Satyricon* – mediated through his undergraduate critical edition – offered itself as a paradigm of textual fragmentation in *The Waste Land*. Commentators have often noted the aptness of the Petronius epigraph to *The Waste Land*: its mixture of Greek and Latin in a poem notable for its extreme heteroglossia and frequent code switching;[58] the parallels between Neronian Rome and contemporary London;[59] the longing for death it expresses, echoing the multiple death drives in Eliot's poem, and above all, the figure of the Sibyl.[60] As a prophet sitting between life and death, the Sibyl is of a piece with Tiresias ('the most important personage in the poem', according to Eliot's published notes) and Madame Sosostris, the 'famous clairvoyante' (l.43 = *PTSE* I.56) who functions as the modern urban equivalent of the ancient oracle.[61] The Sibyl mirrors Eliot's poem on a metaliterary level, too, because she is known for communicating in textual fragments. Her prophesies were said to have been inscribed on palm leaves placed at the entrance to her cave.[62] As Lemprière's popular classical dictionary put it, 'it required particular care in such as consulted her to take up those leaves before they were dispersed by the wind, as their meaning then became incomprehensible'.[63]

Inscribing her words in fragments on the verge of incomprehensibility, the Sibyl chimes in with one of the most famous lines of *The Waste Land*, 'These fragments I have shored against my ruins' (l.430 = *PTSE* I.71). Already made iconic shortly after its publication when it was referenced by Pound in the *Cantos* ('these fragments you have shelved (shored)', 8/28)), Eliot's line has become an emblem of fragmentation in *The Waste Land* and of modernism as a whole. An

[56] Eliot also refers to other fragment collections: 'Baehrens *Fragmenta Poetarum Romanorum* Page 368' (top of p.61), and 'Buecheler *Carmina Epigraphicum* (Latin anthology)' in the notes on the pasted page between pp.22 and 23.

[57] Collignon (1892), 358. Collignon, to whom Eliot refers on the second and fifth pages of pasted notes after the title page and again on p.60 and p.85 of his copy of Bücheler, also includes a long appendix on the *fragmenta* (pp.361–76).

[58] Rainey (2006), 75.

[59] Miller (2005), 99 with Martindale (1999) on Rome as a silent presence in the poem.

[60] See also Formichelli (2002), 57–99 on issues of gaze and voice.

[61] Worthington (1949), 14; Booth (2015), 34–6 (on the Sibyl poised between mortality and immortality).

[62] Cicero *Div.* 2.112; cf. Servius on *Aeneid* 3.444. [63] Lemprière (1912), s.v. 'Sibyl'.

earlier draft makes the connection to the Sibyl's fragments even stronger: Eliot initially wrote 'These fragments I have spelt into my ruins'; the more famous variant, 'shored against', was written above the line, but Eliot held onto the earlier phrase (which he did not cross out in the drafts) until he got to the typescript.[64] The parallel with the Sibyl, then, must have captured something fundamental in and about the poem: just as the prophetess spells her oracles into palm leaves, so Eliot's poem operates on fragments written on fragments. The Sibyl figure in Trimalchio's account is a deliberate allusion to the Cumean Sibyl in Book 6 of Virgil's *Aeneid*, a work which, as the cuts from the typescript show, was clearly on Eliot's mind when he wrote the poem.[65] For this reason it is often suggested that for Eliot, Petronius was a stand-in for Virgil, of whom Pound virulently disapproved.[66] Yet unlike the *Aeneid* which survives in some of the oldest and best-preserved manuscript copies of any classical text, the text of Petronius – like *The Waste Land* – is profoundly fragmented.

Epigraphs are always fragments, evoking at once the presence and the absence of the whole from which they have been excerpted.[67] As an epigraph, the quotation from Petronius heading *The Waste Land* does this too, fragmenting one of the few surviving longer portions of the *Satyricon* even more than it needs to be. But that is also partly a consequence of how the poem as a whole operates. Like the volumes of ancient grammarians which preserve snatches of lost works within them, *The Waste Land* is composed of excerpts of other texts.[68] The Petronius epigraph sets off a series of other partial quotations and citations of ancient texts, many of which are also mediated by nineteenth-century critical editions: scenes from Ovid's *Metamorphoses* (Eliot owned the 1897 Teubner edition[69]); a tiny one-word fragment of Virgil (*laquearia*, II.92); a phrase from the *Pervigilium Veneris* via Bücheler's Teubner edition of the *Anthologia Latina* (*quando fiam uti chelidon*, V.428);[70] a fragment of Sappho quoted in Demetrius' *On Style* in 'the evening

[64] Kenner (1973), 42. The original title of Part II of *The Waste Land* was 'In the Cage', which Valerie Eliot recognized in her notes to the facsimile as an allusion to the Sibyl in the epigraph (Ricks and McCue (2015), I.621). 'Cage' was a frequent translation of *ampulla* (including in Michael Heseltine's Loeb), but (as Eliot was probably aware: Ricks and McCue (2015), I.593) the word is more accurately translated as 'bottle'. *In the Cage* is also a title of a short story by Henry James published in 1898, which may also lie behind the cancelled title.

[65] For Eliot's allusions to Virgil (including Book 6), which Pound cut from the typescript, see Reckford (1995–6a) and (1995–6b) with Reeves (1989). For allusion to Virgil, Aeneas, and the Sibyl in Petronius, see Connors (1998), 33–6.

[66] Kenner (1973), 43; Reeves (1989), 46–8; 167 n.29. [67] Elias (2004), 244–8.

[68] For Roman fragments in Eliot, see Martindale (1999); for the poem's fragmentary mode, seeTytel (1981), 6–7 and Latifi (2019).

[69] *Metamorphoseon Libri XI*, ed. J. van der Vliet, Leipzig, 1897: the copy, signed 'T. S. Eliot, 1907' and partially annotated, is held at King's College, Cambridge.

[70] *Anthologia Latina, sive Poesis Latinae Supplementum*, 2nd edn, Leipzig, 1897, edited by Franz Bücheler and Alexander Reise: Eliot used *ceu* for *uti* following a textual emendation from this edition: Ricks and McCue (2015), I.705.

58 FRAGMENTARY MODERNISM

hour' (III, 220–3).[71] Yet while the texts of Ovid or Virgil (from which Eliot quotes long sections in the notes) just about survive complete, the 'whole' which the Petronius excerpt evokes is only ever partially available. As Federico Fellini would later see it, the *Satyricon*'s '[d]isconcerting modernity' lies in the fact that it is 'fragmentary to the point of never being reconstructed again', like 'the potsherds, crumbs and dust of a vanished world'.[72] But long before Fellini's quintessentially modern Petronius, Eliot, too, located in Petronius' text a disconcerting modernity in the dust of a vanished world. Bücheler's critical edition – which had the effect of fragmenting even as it aimed to reconstruct – offered him a way of spelling those fragments into ruins.

II. Diels, Heraclitus, and the Epigraph to *Four Quartets*

Between 2,600 and 2,400 years ago, a group of Greek thinkers, including Heraclitus and Parmenides, Empedocles, Zeno, and Democritus, made some of the earliest moves in what came to be the study of philosophy and natural sciences. None of their work survives intact: their words and opinions are known almost exclusively from fragments extracted from quotations and reports (or 'testimonia') in later authors.[73] What we have of their work relies on the labour-intensive process of fragment collection by classical scholars. In 1573, Henri Étienne (better known by the Latin version of his name, Henricus Stephanus) anthologized several fragments in his *Poesis philosophica*. But it was not until the early nineteenth century as part of the larger climate of enthusiasm for fragment collection that scholarly interest really escalated.[74] Friedrich Daniel Schleiermacher produced an influential volume of Heraclitus' fragments 'from the ruins of his work', Eduard Zeller published *Die Philosophie der Griechen* (1844–52), the first volume of which was devoted to what he called 'Presocratic philosophy' (*Vorsokratische Philosophie*), and even Karl Marx, who wrote his doctoral dissertation on Democritus and Epicurus, at one point considered producing a collection.[75]

In 1903, a comprehensive modern edition was published by the German classical scholar Hermann Diels: *Die Fragmente der Vorsokratiker*. Dedicated to Wilhelm Dilthey, Diels' edition, which included modern German translations of

[71] Sappho Fragment 104a Lobel-Page. As Eliot was probably aware, the Sibyl's words in Petronius (ἀποθανεῖν θέλω, 'I want to die') echo a fragment of Sappho (94 Lobel-Page), τεθνάκην δ' ἀδόλως θέλω, 'truly I wish I were dead', from the same Berlin parchment as Pound's 'Papyrus' and Aldington's Atthis poem.

[72] Fellini (1978), 18, 19 with Wyke (1997), 331 on the analogy with archaeology; for Fellini and Petronius, see also Paul (2009).

[73] Some papyrus finds have more recently contributed to the picture, notably the Strasbourg papyrus of Empedocles (published in 1999) and the Derveni papyrus (found in 1962): Runia (2008), 31–2.

[74] Most (1998). [75] For Marx, see Burkert (1999), 171 with n.9.

the fragments, quickly became the popular standard edition.[76] Building on his earlier *Doxographi Graeci* (Berlin, 1879), a systematic collection of surviving testimonies about the philosophers, Diels divided the traces of the Presocratics into three categories. Each author was given an A section, containing testimonia on his life, writings, and opinions, and a B section, containing verbatim fragments gleaned from other sources, and in some cases also a C section, with brief texts showing later imitation of the philosopher's thoughts or words. While all three sections played an important part in Diels' project of collecting the variety of traces of the lost works and lives of the Presocratics, the B sections – containing the words of each philosopher – and, in particular, the way in which Diels chose to present them, were ground-breaking. Unlike previous editors who had tried to join together the pieces of the jigsaw, unless there were clear indications in the transmission or content of a fragment, Diels largely presented them alphabetically according to the author of the work from which they were taken, with dubious fragments collected together at the end of the B sections.[77] Though this method in itself might bring up other issues, the essentially random ordering it produced had the effect of heightening the fragmentary experience of reading the Presocratics. From where we stand, 'the Dielsian achievement is as staggering as its legacy is pervasive',[78] and the numbering system developed by Diels and continued by his student Walter Kranz, who took over editorial revisions from the 5th edition onwards (1934), along with the term 'Presocratics' which Diels' edition helped to popularize, is still largely standard in modern scholarship.[79]

The heightened sense of fragmentation in Diels' edition is especially acute for Heraclitus of Ephesus. For most of the Presocratics, Diels seems to have used some level of interpretative filtering in the arrangement of the fragments.[80] When it comes to Heraclitus, however, the edition stops short. All but the first two fragments, whose position is clear from their transmission history, are presented alphabetically by source.[81] Diels' radical refusal to impose any order onto the fragments of Heraclitus acknowledges the unknowable gaps created by their transmission history: around 120 short fragments survive, usually of no more than a sentence or two in length. But it also reflects the fact that Heraclitus – already nicknamed 'the obscure' (ὁ Σκοτεινός) in antiquity – was in some ways

[76] Diels referred to the volume, which quickly sold out, as his 'popular edition' ((Volks) Ausgabe), and from the second edition (which Eliot owned) deliberately divided the material into two volumes so that the crucial first volume would be cheaper to buy: Burkert (1999), 177.

[77] Diels (1903), vii. [78] Runia (2008), 31.

[79] The term 'Presocratics' (probably coined in its modern currency by J. A. Eberhard in 1788: Laks (2018), 1), has been much debated: see esp. Laks (2018), 19–34. For Diels' popularization of the term, see Burkert (1999), 170.

[80] Diels (1903), vii. Runia (2008), 29.

[81] Fragment 1 is placed first on the basis of a comment by Aristotle, and Fragment 2 is linked by the quoting source to Fragment 1.

60 FRAGMENTARY MODERNISM

always a fragmentary author.[82] His aphoristic pronouncements are deliberately crafted to be open to multiple interpretations. They often engage in cryptic wordplay, which has led his sayings to be compared to oracles, the ancient genre which they most resemble: 'the Lord whose oracle is at Delphi neither reveals nor conceals, but gives a sign', so one fragment (B93) goes, and it is easy to read Heraclitus' sayings in the same light. Like Apollo at Delphi, or his surrogate the Sibyl of Cumae, whose prophesies were spelt into palm leaves, Heraclitus' work seems deliberately to operate on fragmented understanding which, like the Sibyl's voice, 'carries over a thousand years' (B92).[83] 'Nature loves to hide', Heraclitus remarked in a fragment that has been read as a metaliterary reflection of his own work (B123): neither concealed nor revealed, his words, already 'fragmentary' from the outset, seem to present a series of disjointed signs.[84]

Heraclitus' aphoristic, quasi-fragmentary sayings had appealed to many in the Romantic period and after, including Hegel and Coleridge, Pater and Nietzsche, often mediated through Schleiermacher's edition.[85] Diels' new edition, however, offered much more radical paradigms for modernist fragmentation. *Die Fragmente der Vorsokratiker* encourages us to read the text as a set of fragments not only composed as such at their inception but radically augmented in transmission. Where Schleiermacher had embedded Heraclitus' words and the testimonia about him in his own sense-making prose, Diels not only presented the fragments in an effectively random order in the B sections but marked them visually as fragments on the page. Each is indented and introduced by no more than a number and an abbreviation of the citing source, followed by the Greek text with an unembellished German translation at the foot of the page (Figure 2.1). Published on the threshold of modernism, the result was a text that could provide a striking parallel to the renewed valorization of the fragment and the disjointed experiences of modernity. Effectively, for twentieth-century readers, Diels' edition turned the ancient philosopher into a modern Presocratic, for whom 'the fairest universe is like a dust-heap piled up at random' (B124)).[86]

[82] For Heraclitus' nickname, see Diogenes Laertius 9.6. It also had a prominent place in the title of Schleiermacher's influential edition, *Herakleitos der dunkle, von Ephesos* (*Heraclitus the Obscure of Ephesus*, 1807).

[83] Cf. Fragment B92 'the Sibyl's voice...carries over a thousand years through the god'.

[84] As Eliot would write later about the use of Heraclitus in the epigraph to 'Burnt Norton', 'The value of such an epigraph is partly due to the ambiguity and the variety of possible interpretations': To Raymond Preston, 9 August 1945. For Heraclitus and issues of fragmentation, see also Elias (2004), 33–70.

[85] Blissett (2001), 29–30 offers a short cultural history of responses to Heraclitus. For Coleridge, 'the divine Heraclitus', and Schleiermacher's edition, see Coburn's note (Coburn (1973), 4352). For Nietzsche, see Waugh (1991). On the 'close lexical borrowings' which suggest that Walter Pater consulted Schleiermacher's edition as well as the work of his friend Ingram Bywater, see Whiteley (2017), 264.

[86] Diels (1903), 79. For Heraclitus as the 'Postmodern Presocratic', see Waugh (1991). Other twentieth-century writers who turned to Diels include Martin Heidegger, who saw the edition as revolutionary and used it in his famous essay on the Anaximander fragment as well as in *The Heraclitus Seminar 1966/7* with Eugen Fink, and Paul Celan, who constructed his modern fragmentary poems partly on the influence of Wilhelm Capelle's 1935 German translation, based on Diels' edition. For Celan and the Presocratics, as well as his reliance on Capelle, see Tobias (2006), 29; 126 n.9, and for Capelle and Diels, see Christof Rapp's foreword to the 9th edition, Capelle (2008), xv–xvi.

EDITIONS 61

<div align="center">B. FRAGMENTE. 52—62.</div>

89

58. [57, 58] — — καὶ ἀγαθὸν καὶ κακόν [näml. ἕν ἐστιν]. οἱ γοῦν 70
ἰατροί, φησὶν ὁ Ἡ., τέμνοντες, καίοντες πάντη, βασανί-
ζοντες κακῶς τοὺς ἀρρωστοῦντας, ἐπαιτέονται μηδὲν ἄξιοι
μισθὸν λαμβάνειν παρὰ τῶν ἀρρωστούντων, ταὐτὰ ἐργα-
5 ζόμενοι, τὰ ἀγαθὰ καὶ τὰς νόσους.

59. [50] — — γναφείωι ὁδὸς εὐθεῖα καὶ σκολιὴ (ἡ τοῦ ὀργάνου
τοῦ καλουμένου κοχλίου ἐν τῶι γναφείωι περιστροφὴ εὐθεῖα
καὶ σκολιή· ἄνω γὰρ ὁμοῦ καὶ κύκλωι περιέρχεται) μία ἐστί,
φησί, καὶ ἡ αὐτή.

10 **60.** [69] — — ὁδὸς ἄνω κάτω μία καὶ ὡυτή.

61. [52] — — θάλασσα ὕδωρ καθαρώτατον καὶ μιαρώτατον,
ἰχθύσι μὲν πότιμον καὶ σωτήριον, ἀνθρώποις δὲ ἄπο-
τον καὶ ὀλέθριον.

62. [67] — — ἀθάνατοι θνητοί, θνητοὶ ἀθάνατοι, ζῶντες 71
15 τὸν ἐκείνων θάνατον, τὸν δὲ ἐκείνων βίον τεθνεῶτες.

58. Und Gut und Schlecht *ist eins.* Fordern doch die Ärzte, wenn sie
die Kranken auf jede Art schneiden, brennen *und schlimm quälen,*
noch Lohn dazu *von den Kranken,* während sie doch durchaus nicht
verdienten, solchen zu erhalten, da sie ja nur dasselbe bewirken,
d. h. durch ihre Guttaten die Krankheiten nur aufheben.

59. Der Walkerschraube Weg, grad und krumm, ist ein und derselbe.

60. Der Weg auf und ab ist ein und derselbe.

61. Meerwasser ist das reinste und scheußlichste: für Fische trinkbar
und lebenerhaltend, für Menschen untrinkbar und tötlich.

62. Unsterbliche sterblich, Sterbliche unsterblich: sie leben gegenseitig
ihren Tod und sterben ihr Leben.

3 ἐπαιτιῶνται μηδὲν ἄξιον μισθὸν Paris.: verb. Bernays 4 ταὐτὰ Sauppe:
ταῦτα Paris. vgl. 12 C 1, 16 5 τὰ ἀγαθὰ καὶ τὰς νόσους] schlechte Paraphrase
Hippolyts. Heraklit meint, sie fügen ja auch Böses zu, tun also dasselbe wie die
Krankheit und brauchen daher keinen besondern Lohn. Prächter: 'Man tilge
das Komma nach ἐργαζόμενοι: »da sie das Gute als das nämliche wirken wie die
Krankheiten« d. h. die Heilung, die schmerzvolle, ist nicht besser als die Krank-
heit. Daher sollen die Ärzte nichts bekommen.' Die schnöde Polemik gegen die
Ärzte haben die Briefe unerträglich ausgesponnen 6 γναφείωι Bernays: γρα-
φέων Paris. Erklärung s. * Sonderausgabe des Heraklit (1909) 7 γναφείωι
Bernays: γραφείῳ Paris. 15 τὸν δὲ κτλ.] θνήσκοντες τὴν ἐκείνων ζωήν Heraclit.
Alleg. 24, ähnlich Max. Tyr. 12, 4 τεθνεῶτες] τεθνήκαμεν Philo, Hierocl.

Figure 2.1 From Hermann Diels, *Die Fragmente der Vorsokratiker* (1912), I.89. Eliot
put a double marginal line against the German translation of Fragment B60 in his copy
of this edition.

62 FRAGMENTARY MODERNISM

Eliot was (in his own words) 'very much influenced by Herakleitos'.[87] He studied the Presocratics when he was preparing for a doctorate in philosophy in Harvard between 1911 and 1914,[88] and it was a remark comparing Heraclitus to the late medieval French poet François Villon that brought him to the attention of Bertrand Russell, who was visiting Harvard to deliver the Lowell Lectures in 1914.[89] Annotations in Eliot's library show that he studied Heraclitus carefully. He made notes from G. T. W. Patrick's *Heraclitus of Ephesus* (1889) on scholars' opinions,[90] and annotated his copy of J. Burnet's *Early Greek Philosophy* (1892) and *Greek Philosophy, Part I, from Thales to Plato* (1914), as well as Charles M. Bakewell's *Source Book in Ancient Philosophy* (1907), where he underlined and marked the English translation of Fragment B60, 'The way up and the way down is one and the same', which would later interweave *Four Quartets*.[91] As Eliot remembered it, however, 'when I was a student of these matters', Diels' *Vorsokratiker* was the standard text.[92] At some point after 1912, he acquired a copy from the same New York bookseller from whom he had also bought Bücheler's *Petronius*.[93] As he noted to the philosopher and Plato scholar A. E. Taylor, 'anyone who at all specialises in Greek philosophy must know German', and though modest about 'my own attainment', he mentions accessing Diels in German as a point of pride.[94] The extensive annotations in Eliot's copy of Diels back this up: he frequently marked the German translations as well as the Greek text, and seems to have used Diels' relatively simple German in tandem with the Greek.[95]

Late in 1935, when it came to finding an epigraph for 'Burnt Norton' – the poem that was to become the first of *Four Quartets* – Eliot returned specifically to Diels:[96]

[87] Letter to Nicola Coppola, 28 January 1960: Ricks and McCue (2015), I.907.

[88] Eliot took a course in early Greek philosophy with James Haughton Woods (1911–12): Jain (1992), 300 n.131.

[89] Miller (2005), 200–1. [90] Jain (1992), 198 (from 1911–12).

[91] Eliot's annotated copies of Burnet's *Early Greek Philosophy* (2nd edition, 1908), which he acquired in 1913, and *Greek Philosophy, Part I: Thales to Plato* (1914), acquired in 1914, are both held at Magdalene College, Cambridge (M.12.328 and M.12.329). His annotated copy of Bakewell is in the Houghton Library at Harvard. Given the idiosyncratic grammar, Diels' translation of B60 ('Der Weg auf und ab ist ein und derselbe') probably lies behind Bakewell's English version of this line.

[92] Letter to E. M. Stephenson, 8 October 1945, 'Diels' Fragmente der Vorsokratiker is, I believe, still considered the standard text of the pre-Socratic philosophers; at any rate it was when I was a student of these matters': Ricks and McCue (2015), I.906.

[93] Eliot's copy of the two-volume 1912 edition and the 1910 index volume compiled by Walter Kranz is part of the Valerie Eliot Collection, held by the T. S. Eliot Estate. The same printed sticker in blue and white from 'G. E. Stechert & Co. New York' is found in the inside back cover of the first volume of Diels and Eliot's copy of Bücheler. I am very grateful to the archivist, Nancy Fulford, for granting access to the material.

[94] 10 January 1930: 'I take for granted that anyone who at all specializes in Greek philosophy must know German (my own attainment you would consider very low, but I possess Diels, Siebeck, and Heinrich Meier)': reprinted in Eliot (2015), 30.

[95] *PTSE* I.177; Diels (1912), I.77; 89.

[96] T. S. Eliot's epigraph to Burnt Norton, in *Collected Poems, 1909–1935* (London: Faber & Faber, 1936), p.211.

τοῦ λόγου δ'ἐόντος ξυνοῦ ζώουσιν οἱ πολλοί
ὡς ἰδίαν ἔχοντες φρόνησιν.

I. p. 77. Fr. 2.

ὁδὸς ἄνω κάτω μία καὶ ὠυτή.

I. p. 89. Fr. 60.

Diels: *Die Fragmente der Vorsokratiker* (Herakleitos).

Eliot selected two quotations from the B sections of Heraclitus. The first (Fragment B2), he underlined in the Greek in his copy of Diels and marked the German translation with a double marginal line. In Eliot's own 'very rough' translation, the portion of the text quoted in the epigraph (the surviving fragment is about twice as long) reads '[a]lthough the Logos is common the majority of men live as if they had an individual understanding'.[97] The second (Fragment B60), which Eliot marked in Diels with a double line against the German ('Der Weg auf und ab ist ein und derselbe'), translates broadly as 'the way up and the way down are one and the same' (ὁδὸς ἄνω κάτω μία καὶ ὠυτή). Almost all the other annotations to Eliot's copy are in pen, but the Heraclitus annotations are much briefer pencil markings, which may well suggest that Eliot returned to these pages around 1935 when he was writing *Burnt Norton* and Diels was fresh on his mind.[98]

Unlike the epigraph to *The Waste Land* which gives no information about the source, Eliot provides full citation details to the *Burnt Norton* epigraph, specifying not only the ancient author but the edition from which he is quoted. In fact, the citation details take up almost an equal amount of space on the page as Heraclitus' Greek. While Heraclitus' name is relegated to parentheses, moreover – 'Diels: *Die Fragmente der Vorsokratiker* (Herakleitos))' – the edition, as well as the famous numbering system Diels introduced, take centre stage.[99] On the surface, the citation of a German-language edition of a famously obscure Greek philosopher gleaned from even more obscure sources, whose words are left untranslated, followed by a sequence of potentially baffling numbers and letters, could easily be seen to play on Eliot's ambivalent attitude to scholarship (as Hannah Sullivan suggests, '[t]his epigraph might be read as an instance of the mock-scholarly "subtlety or effrontery" seen in the notes to *The Waste Land*, that Eliot later confessed to in his lecture "The Classics and the Man of Letters"').[100] But Diels'

[97] To Hermann Peschmann, 12 September 1945 (Ricks and McCue (2015), I.906–7). Eliot notes that 'the word Logos', something approximating 'the Word', 'is almost untranslatable'. Diels (1912), I.77 translates it as 'Wort (*Weltgesetz*)'.

[98] Eliot also marked Heraclitus Fragments B2, B36, and B53 in pencil in his copy.

[99] Eliot gives page numbers from the 1912 two-volume edition which he owned and uses Diels' transliteration of the Greek name.

[100] Sullivan (2011), 172.

64 FRAGMENTARY MODERNISM

edition was not just a mock-scholarly smokescreen: it played a crucial part in the kind of 'Heraclitus' with which *Four Quartets* interacts. As John Burnet complained in the English translation of the Presocratics which Eliot also owned and annotated, Diels had 'given up all attempt to arrange the fragments according to subject', making it seem as if 'Herakleitos wrote like Nietzsche'.[101] For Eliot, Diels' edition was attractive precisely because it makes it seem as though Heraclitus wrote in the kind of fragmentary forms that could speak to modernity. As Eliot explained to Hermann Peschmann in 1945, it is the 'delightful obscurity' of Heraclitus as we have him that drew him to the epigraph,[102] or as he told Raymond Preston:

> The fragments of Herakleitos as we know them have extraordinarily poetic suggestiveness and I have sometimes wondered whether his essays would not lose in value if we had his complete works and saw the sentences in their context.[103]

It is because they are fragmentary and detached from their original context that Heraclitus' words – further fragmented by Eliot – acquire their 'extraordinarily poetic suggestiveness', and in that sense Diels himself was already a modernist.

For the few readers who followed up Eliot's precise references, it would also become clear that Diels' fragments are not fragments in the way that a Sappho papyrus found in the scrap heaps of Oxyrhynchus might be, but carefully extracted from the works of other authors. Diels ordered the fragments alphabetically by source, introducing each one by an abbreviated reference to the work from which it was taken. The fragments Eliot cites come from two sources even more 'delightfully obscure' than the fragments of Heraclitus: Sextus Empiricus (second-century CE), a proponent of Pyrrhonian scepticism, and the Christian theologian Hippolytus of Rome's *Refutation of all Heresies*. In the wake his conversion to Anglicanism and naturalization as a British citizen in 1927, Eliot's interpretation of Heraclitus in *Four Quartets* was powerfully filtered through later developments in philosophy and Christian theology, and one of the things Diels' edition, in a quite literal sense, made clear was that Heraclitus' words were already embedded in the cultural developments of later centuries.[104]

[101] Burnet (1908), 146: 'In his edition, Diels has given up all attempt to arrange the fragments according to subject, and this makes his text unsuitable for our purpose. I think, too, that he overestimates the difficulty of an approximate arrangement, and makes too much of the view that the style of Herakleitos was "aphoristic." That it was so, is an important and valuable remark; but it does not follow that Herakleitos wrote like Nietzsche.'

[102] 12 September 1945: Ricks and McCue (2015), I.906.

[103] 9 August 1945: Ricks and McCue (2015), I.906.

[104] For Eliot and scepticism, see Jain (1992), 11–12 and Skaff (1986). More recent editorial practice now makes the mediations of transmission more explicit by embedding fragments transmitted by other authors more fully within their citation contexts: see, e.g., Graham (2010) and the 'Postscript' below, pp.185–6 on fragment collections after modernism.

As the publication history of *Four Quartets* suggests, the Heraclitus–Diels epigraph was probably intended to serve for the whole sequence as it developed. The other parts of *Four Quartets*, which were written later (between 1939 and 1942), have no epigraphs, and in the Faber proofs for the 1944 complete publication, Eliot circled the epigraphs for transfer from under the title *Burnt Norton* to the facing blank page (the verso of the contents page), which suggests that they were meant to stand for the whole sequence.[105] *Four Quartets* is not the same kind of fragment poem as *The Waste Land*. As Cleo McNelly Kearns describes it, even through the breaks in syntax, which can be as strained as that of *The Waste Land*, the series functions on the 'subvocal murmur' of repeated fragments and phrases that act as 'a form of meditation'.[106] In some ways, the epigraph, mediated by Diels, sets up Heraclitus' words as a crucial 'subvocal murmur' in the series.[107] '[S]tanding at the gateway' of the poem's philosophical endeavour,[108] the riddling B2 is quoted pretty much directly in *The Dry Salvages* ('And the way up is the way down, the way forward is the way back', *The Dry Salvages* III, 6 = *PTSE*, I.197), and appears again in various permutations ('Neither movement from nor towards,/Neither ascent nor decline', *Burnt Norton* II, 19–20 = *PTSE* I.181; 'This is the one way, and the other/Is the same', *Burnt Norton* III, 33–4 = *PTSE* I.183). B60 ('although the *logos* is common, the many live as though they had a wisdom of their own') is embedded – like some of the fragments of Heraclitus – in later Christian traditions, as *logos* becomes fused, as Eliot explained, with 'word in the sense which was developed for the first chapter of St. John', for whom Christ was the *logos* made flesh.[109]

Broken up and embedded in the layers of time present and time past, the words of Heraclitus – as exposed through Diels' edition – underwrite the effort in *Four Quartets* to make words 'reach/Into the silence' (*Burnt Norton* V.3–4). By the time *East Coker* was published, Britain had entered the Second World War ('History is now and England', *Little Gidding* V, 24 = *PTSE* 1.208), turning the sequence effectively into a war poem.[110] In a world where '[w]ords strain,/Crack and sometimes break...perish/Decay' (*Burnt Norton* V, 13–16 = *PTSE* I.183–4), and, as was becoming increasingly clear, not just words, Diels' edition offered an even more compelling parallel to the composition of poetry in the 'unpropitious...conditions' of modernity (*East Coker* V, 16–17 = *PTSE* I.191). The effort of 'trying to unweave, unwind, unravel/And piece together the past and

[105] Ricks and McCue (2015), II.488. The material was published as an epigraph to the whole collection in 1979 and Ricks and McCue have taken the decision to set it as the general epigraph to *Four Quartets*: Ricks and McCue (2015), I.177.

[106] McNelly Kearns (1987), 265; Tracy (2020), 25–6.

[107] Warner (1999), 27–30, 61; Clubb (1961); Le Breton (1965); Smith (1974), 255–6; Reibetanz (1983), 19–22; Xiros Cooper (1995), 148–51; Blissett (2001).

[108] Warner (1999), 28.

[109] Letter to Hermann Peschmann, 12 September 1945: Ricks and McCue (2015), I.906–7.

[110] MacKay (2007), 71–90.

66 FRAGMENTARY MODERNISM

the future' (*The Dry Salvages* I.41–2 = *PTSE* I.194) may be ultimately futile ('the past is all deception,/The future futureless', I.43–4 = *PTSE* I.194). But in the end it was, paradoxically, the rigours of German philology, emanating from what Ezra Pound would ambivalently call 'the universities of Deutschland',[111] that offered a way of beginning to collect up some of the pieces.

III. Fragmenting Homer in *Canto* I

Pound's *Cantos* open with a rendering of the calling-up of the ghosts of the dead from Hades in *Odyssey* 11, the so-called *Nekyia* episode. Sailing on his 'swart ship', Odysseus comes to the edge of the world, imagined as flat and encircled by the river Oceanus, on the other side of which, far in the west, lies the land of the dead. Following instructions given by Circe, Odysseus and his men perform an ancient ritual. He digs 'an ell-square pitkin', and pours libations 'unto each the dead', sacrificing the sheep he had brought with him and letting the blood flow into the pit for the dead to drink (I/3). As the '[d]ark blood flowed in the fosse', the shades of the dead crowd thickly around the living. Odysseus and his companions catch sight of their friend and companion Elpenor, who had been left unburied on Circe's island, and Odysseus sees his mother Anticlea ('whom I beat off', I/4). Finally, they see the prophet Tiresias, whose advice they had come to seek, before Anticlea returns and they continue their journey 'by Sirens and thence outward and away/And unto Circe' (I/5).

Originally positioned as the third Canto (the earlier version is sometimes referred to as Ur-Canto III), Pound's version of the *Nekyia* episode was shifted forward around 1923 to open the whole poem. In a well-known letter to W. H. D. Rouse, Pound later explained the importance of the passage: '[t]he Nekuia shouts aloud that it is *older* than the rest, all that island, Cretan, etc., hinter-time, that is *not* Praxiteles, not Athens of Pericles, but Odysseus'.[112] Pound's expressed desire to reach back to a 'hinter-time' in literary terms is regularly cited in scholarship on the *Cantos* and has become key to defining the poem. By foregrounding the Odyssean *Nekyia* – which became the paradigm for epic *katabaseis* from Virgil to Dante and beyond – Pound's *Cantos* dig down to a deep cultural 'hinter-time' well before the 'Athens of Pericles' and the establishment of the western canon. With its alliterative stress metre adapted from the Anglo-Saxon 'The Seafarer' (which Pound had studied at Hamilton College and translated in 1911) combined with deliberately archaic vocabulary on Old English roots and overlayed with early modern Latin translations of Homer (notably the Renaissance translation of the *Odyssey* by Andreas Divus and a translation of the

[111] 'Provincialism the Enemy – III' in Pound, *SPr*, 289. [112] 23 May 1935 = Paige 363.

Homeric Hymns by Georgius Dartona Cretensis), the poem has been seen to engage in a literary archaeology that enables its author to 'open communication with dead masters'.[113] On this reading, the *Nekyia*, for Pound, becomes 'a metaphor for the summoning of the voices of literary history underlying his poem'.[114] As T. S. Eliot put it in his introduction to Pound's *Selected Poems*, Pound is 'often most "original" in the right sense, when he is most "archaeological" in the ordinary sense'.[115] By digging down to a Homeric 'hinter-time', the Canto brings together literary tradition and the individual talent in one of the most innovative – or in Eliot's terms most '"original" in the right sense' – productions of high modernism.

At the same time, Pound's *Nekyia* is also underwritten by archaeology 'in the ordinary sense'. As he was writing and re-writing the *Cantos*, classical scholars were engaged in a widespread parallel search for fragments of the lost past buried under the earth. As Hugh Kenner importantly brought to the fore in 'Homer's Sticks and Stones', 'the Homer of Joyce's time was the archaeologist's'.[116] In the aftermath of Heinrich Schliemann's discoveries at Troy, the analysis of the Homeric epics was marked by a renewed interest in realia: the position of a house, the cut of a spear, details which in turn made their way (through various intermediaries) into Joyce's *Ulysses*.[117] As I show in Chapter 5, Schliemann's digs were part of a broad range of sensational discoveries that shaped the archaeological imagination of the period, and some of these also underly Pound's understanding of the *Nekyia*. The evocation of an 'island, Cretan . . . hinter-time' directly echoes the excavation of a Bronze Age civilization by Arthur Evans at Knossos in Crete.[118] Evans himself had adevertised Knossos as a mythological ante-type to the world of Homer, arguing that Homeric epic – including 'the essentials of Ulysses' adventures' – were prefigured 'some five centuries before the Homeric poems took shape'.[119]

But the idea that the *Nekyia* along with the other 'essentials of Ulysses' adventures' might be seen as a fragment of the *Odyssey* 'older than the rest' was being debated with particular intensity by textual scholars engaged in their own version of philological archaeology. Pound came to read Homer during a period of rapid development and radical controversy in Homer scholarship. The 'Homeric Question', brought to the fore in the eighteenth century, was being debated with

[113] Kenner (2006), 31. 'The Seafarer' was first published in *The New Age* 10.5, 30 November 1911, p.107.

[114] Culligan Flack (2015), 36. [115] Pound, *SP*, 10–11.

[116] Kenner (1969), 291. [117] Kenner (1969), cf. also (1985).

[118] Gere (2009); Momigliano (2020): see further Chapter 5, p.157; pp.172–182.

[119] Evans (1912), 291, 289. Minoan and Mycenaean material was later influentially brought to bear on Homer by Martin P. Nilsson in *The Minoan-Mycenaean Religion and its Survival in Greek Religion* (London, 1927), *The Mycenaean Origin of Greek Religion* (1932), and *Homer and Mycenae* (London, 1933), which drew on Mycenaean archaeology to argue for the poems' roots in a time long before Homer.

68 FRAGMENTARY MODERNISM

renewed force. Who was Homer? Did the same person compose the *Iliad* and the *Odyssey*? Are the epics – which appear to date from around the eighth century BCE and without the significant aid of writing – even the work of a single individual 'Homer', or has the original ancient kernel of the poem been augmented by several others over time?[120]

In an attempt to resolve this last question, the so-called 'Analysts' were cutting out large chunks of text considered later than the ancient core of the poems, and the *Nekyia* was at the heart of the controversy. Already partially athetized as suspect in antiquity by the Hellenistic scholar Aristarchus (lines 568–627),[121] the episode caught the attention of two influential nineteenth-century classical scholars who shaped much of the subsequent debate. In *Die Homerische Odyssee und ihre Entstehung* ('The Homeric *Odyssey* and its Origins'), first published 1859 and expanded in 1879, Adolf Kirchhoff argued that a primitive *Odyssey* centring on Odysseus' travels lay behind the modern Homeric text, the evidence of which is palpable in the inconsistencies of the modern text of Homer.[122] This original 'kernel' itself had been composed of later additions and an earlier, archaic part, which included a primitive version of the *Nekyia* we now have.[123] For Kirchhoff, 'redactors' had pieced together later interpolations with the original ancient material to form the modern text of the *Odyssey* and it was the scholar's task to dig through that material to get as close as possible to the ancient core of the poems.[124] Kirchhoff's work, which included a radically reduced edition of the *Odyssey*, was taken up by the renowned philologist, Ulrich von Wilamowitz-Moellendorff, in *Homerische Untersuchungen* (1884) and *Die Heimkehr des Odysseus* (1927). Building on Kirchhoff's *Odyssey*, Wilamowitz discerned an even earlier Ur-*Odyssey* behind the poem; although most of the *Nekyia* as we have it was, he argued, a later interpolation, the ancient Ur-*Odyssey* also included a version of a visit to Tiresias in the underworld.[125] These conclusions, which effectively fragmented the two most crucial ancient poems surviving from antiquity, were energetically rejected by the 'Unitarians', who defended what they believed to be the poetic integrity of the Homeric epics against what Andrew Lang called the 'congeries of fragments' imagined by Kirchhoff and his successors.[126] In Britain, a middle ground was influentially popularized by Gilbert Murray in *The Rise of the Greek Epic* (1907), which went into several reprints and editions.[127] Arguing that the *Iliad* and the *Odyssey* were 'traditional poems'

[120] See, e.g., Turner (1997). [121] Petzl (1969).

[122] Kirchhoff (1879) combines and expands the original essay with *Die Komposition der Odysee* (1869).

[123] Kirchhoff (1879), vii–x. [124] Kirchhoff (1879), 302.

[125] Wilamowitz-Moellendorff (1884), 230.

[126] Lang (1893), 249. Lang, who with S. H. Butcher was responsible for the standard prose translation of the *Odyssey*, also provided a summary of the debate for English-speaking readers in *Homer and the Epic* (London, 1893), 248–59.

[127] Stray (2007), 54.

augmented and perfected by generations of bards, and drawing on a range of archaeological and anthropological evidence, Murray allowed for the search for deep strata in the *Iliad* and the *Odyssey* while also defending the integrity and quality of the poetry: 'generation after generation of poets, trained in the same schools', he argued, 'shaped themselves to the spirit of this great poetry' in the oral tradition.[128]

Murray had focused primarily on the *Iliad*, but in 1914 James Alexander Ker Thomson, Murray's protégé, published *Studies in the Odyssey*.[129] Influenced by Murray as well as Jane Harrison's work on early Greek religion and James Frazer's *The Golden Bough* (1890), Thomson sought to tackle the Homeric Question from the angle of anthropology, religion, and myth.[130] Like Murray, he believed the *Iliad* and the *Odyssey* to be 'traditional', evolving over time as they were handed down through generations of bards.[131] Rejecting the techniques of the Analysts, on the one hand, and the dogmatism of the Unitarians, who argued for single authorship in a single period, on the other, Thomson hoped that the identification of the deepest cultural origins of the Homeric tradition would allow 'the question' to 'resolve... itself',[132] and this allowed him to argue for the antiquity of the *Nekyia*. Implicitly defending Book 11 against the Analysts' excisions while also accounting for their sense that the passage must have had a place in the Ur-*Odyssey*, Thomson asked: 'is the Visit to the Dead an original part of the Odysseus saga? The answer is, yes; THERE IS NO PART OLDER THAN THAT', for '[w]hatever else is original in the myth of the Odyssey, the Visit to the Dead is so'.[133] Jane Harrison had observed in *Prolegomena to the Study of Greek Religion* (1903) that the Homeric *nekuomanteion* demonstrated 'a clear reminiscence of the ghost-raising that went on at many a hero's tomb'.[134] Thomson expanded Harrison's suggestion by arguing that Odysseus' visit to Tiresias in Hades had its origins in 'an actual, very ancient Boeotian tradition', evidenced in traces of archaic grave rites at a site near Tilphossa in Boeotia, and it is around this that, for Thomson, the story of the *Odyssey* eventually formed.[135] As Ronald Bush importantly suggested, Pound could well have encountered Thomson's work

[128] Murray (1907), 226. Similar arguments had been put forward in German by Eduard Meyer and in English by Richard Jebb and Walter Leaf: see Dodds (1968), 3. For a history of discussions of the *Nekyia* specifically, see Gazis (2018), esp. 80–2.

[129] Thomson (1914); for Pound and Thomson, see Bush (1989), 127–9; for Murray and Thomson, see McManus (2007).

[130] Bush (1989), 126–9. [131] Thomson (1914), v. [132] Thomson (1914), v.

[133] Thomson (1914), vii; 95. Denis Page, influenced by Thomson, later argued that the *Nekyia* was the most ancient part of the poem, and was later combined with the rest by a redactor (Page (1955), 47). For the idea in modern scholarship that the *Nekyia* is one of the oldest elements in the poem dating to Mycenaean times, see, e.g., Sourvinou-Inwood (1995), 15–39.

[134] Harrison (1903), 75.

[135] Thomson (1914), 26. Thomson prefigures the work of Evans and Nilsson (note 119, above), who drew on Mycenaean archaeology to recast aspects of the Homeric Question.

70 FRAGMENTARY MODERNISM

either at first hand or through his friend the polymath poet Allen Upward, which may have influenced his thinking.[136] As Bush pointed out, 'whether Pound (or Upward) actually read the book cannot be ascertained',[137] though it is tempting, like Bush, to see Thomson's arguments behind Pound's conception of the *Odyssey*: Pound ritualized the *Odyssey* 'in a parallel manner' to Thomson, displaying an interest in a deep antiquity linked to cyclical chthonic forces.[138]

Whether or not he read Thomson's *Studies in the Odyssey*, Pound's identification of the *Nekyia* as a fragment from the earliest temporal layer of the epic 'older than the rest' would have been underwritten by the traditions and methods of Homeric philology that had set the terms of the debate. It would have been difficult to read Homer in the late nineteenth century and the first decades of the twentieth without some awareness of the struggles surrounding the Homeric Question. Pound was introduced to Homer at Cheltenham Military Academy (where he found his teacher's recitations from the *Odyssey* 'more valuable than grammar'[139]), and though he was not officially enrolled, he was still 'plugging away' at Greek as a student at Hamilton College.[140] Although he never took an examination in Greek (he was enrolled on the Latin-Scientific rather than the Classical programme), in December 1904 he was working hard to 'make up some Greek this vacation & take it in the next couple of terms',[141] possibly with Edward Fitch (or 'Little Greek', as Pound called him in his letters to his parents), a protégé and correspondent of Wilamowitz.[142] At the same time, Pound's work in Romance philology (he graduated from the University of Pennsylvania with an MA in Romance Languages in 1906 and was registered for a PhD) trained him in methods analogous to the Homeric Analysts, which involved sifting out older passages from 'later graft[s]', an approach which would also have coloured his reading of Homer.[143] Moreover, if he used any kind of commentary to help him – such as the standard commentary of Merry and Riddell on the *Odyssey*, which

[136] Bush (1989), 128–9. [137] Bush (1989), 128.

[138] Bush (1989), 129. Bush also points to the possibility of a direct influence on Pound of Jane Harrison's work: Bush (1989), 126–9.

[139] *Guide to Kulchur* = Pound (1952), 145. Cf. *Cantos* 80/526, 'and it was old Spencer (H.) who first declaimed me the Odyssey'.

[140] According to student records stored in the college archives, Pound was not officially enrolled in Greek or Latin courses at Hamilton (Merit Register HAM COLL HG R24m 1897, 29): I am very grateful to the archivist, Katherine Collett, for making them available to me. For his claim to be independently 'plugging away at Greek', see his letter of 17 December 1904: *EPHP* 38. For a discussion of Pound's classical education, see also Liebregts (2010) and Dingee (2019), 82–3.

[141] 11 December 1904: *EPHP* 37.

[142] Pound seems to have been working with someone ('handed in my Greek sentences', 17 December: *EPHP* 38); the faculty was small, comprising eighteen or nineteen members between 1903 and 1905 when Pound studied there, and Fitch and Herman Ebeling were the only Hellenists. Details of the Hamilton faculty and courses can be found in Root (1898), 295 and the annual registers of the college. For Fitch and Wilamowitz, see Calder (1979).

[143] Quoted by Ullyot (2017), 53, from Pound's notes on Joseph Bédier's *Roman de Tristan par Thomas* in the Beinecke Library in Yale. Although Ullyot locates 'Pound's attempts to reveal the *Ur-nekyia* or the *Ur-Odyssey* that Homer himself could not fully comprehend' in the philology of Bédier

EDITIONS 71

picks out several points including parts of the *Nekyia* where 'the genuineness of the passage is open to doubt', or Walter Leaf who inspired Murray's theories on the *Iliad* – he would have been confronted, if not with the extreme version of the Homeric Analysts, at least with some of the issues surrounding the stratification of the Homeric poems into earlier parts and later additions, just as, later in life, he would be aware of Milman Parry's breakthrough theories of oral-formulaic composition.[144]

Whatever the specific details he picked up, in *Canto* I, Pound engages in his own idiosyncratic version of the 'Homeric Question'. '[W]hen I do sink into the Greek', he later said (chivvying W. H. D. Rouse to translate the *Odyssey* while bowing out of the task himself), 'what I do get is too concentrative; I don't see how to get unity of the *whole*'.[145] The *Cantos* show no interest in getting the 'unity of the *whole*'. Instead, in a parallel move to the Homeric Analysts sifting through the strata of later additions to identify the ancient core of the poems, Pound sought to find the concentrative nucleus of Homer, reaching back to a time as close as possible to that of Odysseus. The result is a much more radical fragmentation of the *Odyssey* than anything classical scholars had suggested. Taking up the ritual elements from the *Nekyia* and the meeting with Tiresias, Pound cut much of the rest of the episode, paring down his poem as the drafts evolved.[146] The original 1917 versions published in *Poetry* and the American edition of *Lustra* contained a long introduction and included Odysseus' meeting with his mother Anticlea ('Came then Anticlea, to whom I answered:/"Fate drives me on through these deeps. I sought Tiresias."/Told her the news of Troy. And thrice her shadow/ Faded in my embrace'), as well as a version of the catalogue of women ('Then had I news of many faded women – /Tyro, Alcmena, Chloris – /Heard out their tales by that dark fosse').[147] In April 1918, Pound published a revised version of the *Canto* in the London periodical *The Future*.[148] Cutting the introduction to three lines, he now called his augmented Homer fragment 'An Interpolation taken from the Third Canto of a Long Poem', mirroring the analytical terminology of 'interpolation' used in Homeric scholarship to suggest that the poem itself, like

(Ullyot (2017), 59), Pound's 'debt to philology' crucially extends to the classical philology on which Bédier's own techniques were modelled. On Pound's engagement with Romance philology, see also Riobó (2002) and McMullan (2017); and on his interest in the textual history of Old English (he published his version of 'The Seafarer' with a long 'Philological Note' on manuscript history: *The New Age* 10.5, 30 November 1911, p.107): see Robinson (1993). See also Birien (2012), Pryor (2016), and Dingee (2019).

[144] Merry and Riddell (1886), 447; Murray (1907), 4. Parry's theories date from the 1930s and were importantly developed by Albert Lord in the 1960s, but as Culligan Flack (2015), 29 notes, it is unclear when Pound became aware of them before he discussed them with Hugh Kenner in the 1960s (Kenner (1971), 559).

[145] To H. D. Rouse, 23 May 1935: Paige 363.

[146] For the evolution of the drafts, see Bush (1989) with Taylor (1997), 247.

[147] *Poetry* 10.5, August 1917, 248–54; Bush (1989), 192–3, 301. The *Lustra* Cantos were republished in *Quia Pauper Amavi* (1919) with marginalia.

[148] Bush (1989), 301.

72 FRAGMENTARY MODERNISM

the Homeric *Nekyia*, was a fragment extracted from a larger project. By 1925, when the poem was published in its current form in *A Draft of XVI Cantos* (1925), Pound's version of the *Nekyia* (or 'Νεκυομαντεία' (*nekuomanteia*), as he now called it in a Greek marginal note[149]) had become a 'concentrative' analogue to the kind of Ur-Homer the Analysts had sought to produce. Tiresias' speech had been curtailed from the outset and Pound now cut it further.[150] The meeting with Elpenor remained,[151] but little else was left, including the details of the meeting with Anticlea and the catalogue of women (long suspected as an interpolation by the Analysts).[152]

Crucially, too, Pound's *Nekyia* was now emphatically framed as a fragment. Repositioned as *Canto* 1 to open the collection, the introduction, which had been shrunk to three lines in *Future*, had completely gone. The poem now started *in medias res* (like the *Iliad* and the *Odyssey*), beginning dramatically with the words 'And then'.[153] As Hugh Kenner observed, 'And then', 'points to absence, raising the question "What comes before 'And'?"'. The answer is perhaps, as Kenner puts it, a time '[i]n mankind's past, before even Homer, a foretime; a foretime even before the dark rite of confronting shades which Pound thought older than the rest of the *Odyssey*'.[154] Yet the new opening pointed not only to an absence in time but to an absence of text. Combined with a new coda, 'So that:', the Canto was powerfully framed to suggest that part of it was missing. Like 'Papyrus', which also borrowed the techniques of classical scholarship to turn an already fragmented text into an extreme fragment, Pound's new *Nekyia* reads like a textual fragment surviving from antiquity which the labour of philology had worked hard to extract.[155]

At the same time, Pound's Ur-*Odyssey* was also fragmented in ways that the Analysts' Ur-Homer had never been. Whereas Homer scholars were searching for fragments mediated by later material from within the Homeric poems themselves, Pound mediated his fragment of Homer not through other, 'later' parts of the

[149] The term was also used by Thomson (1914), 24.

[150] The part of the speech in which Tiresias 'foretold me the ways and the signs' which Pound removed from the earlier versions in *Poetry* and *Future* has also been seen as superfluous by analytical commentators on Homer, since Odysseus later receives the information he needs about his journey from Circe: Sourvinou-Inwood (1995), 73.

[151] Modern commentators on Homer similarly note that this episode, 'which has so often been seen as a late addition, is an essential element in the *Nekuia*': Heubeck and Hoekstra (1989), 80.

[152] When Odysseus recounts his journey to Penelope (23.322–43) he only tells her about meeting Tiresias, Anticlea, and his companions. For the catalogue of women as an interpolation, see Kirchhoff (1879), 338–9 and Page (1955), 35–9. Pound also shifted the rest of Odysseus' narrative from the first-person account in *Three Cantos* into the third person ('And he sailed, by Sirens and thence outward and away/And unto Circe' (Pound (1925), 6) which some scholars (notably Kirchhoff) had argued was the episode's original, most ancient form.

[153] An alternative attempt at a translation of the opening (which Pound included in quotation marks in the 1917 *Poetry* version) began 'Down to the ships we went'.

[154] Kenner (1971), 349.

[155] The words 'So that' would be repeated at the opening of *Canto* 17.

Odyssey, but through the epic's transmission and translation history. Tacked onto the Canto's end is a fragment from the *Homeric Hymns*. Known in manuscripts simply as Ὁμήρου ὕμνοι ('the hymns of Homer'), this collection of hexameter poems addressed to deities was once believed to be by Homer and was regularly bound together with the Homeric poems in early modern editions.[156] In a parallel to the conflation of the manuscript tradition, Pound combined elements of the first and second *Hymn to Aphrodite* 'one of the oldest in the collection',[157] and merged it with his version of the *Odyssey*. As becomes clear towards the end of the Canto, both the *Odyssey* and the *Hymns* have come into the poem not directly from the original Greek, but through early modern Latin translations: Andreas Divus' 1538 translation of Homer, which was printed with a Latin translation of the *Hymns* by Gregorius Dartona Cretensis ('the Cretan') in a copy Pound said that he had picked up in a Paris quai some time between 1906 and 1910.[158] Divus' translation – which follows the Greek text line-by-line and word-for-word – was meant as a crib in Latin to be set beside the Greek.[159] Pound claims that he used it that way, too ('permitting a man to read fast enough to get the swing and mood of the subject, instead of losing both in a dictionary', *LE* 264), but the poem also elevates Divus as a singer of tales in his own right. Like the ancient bards behind the transmission of Homeric epic, Divus is instructed to 'lie quiet' after he drinks the blood that enables him to produce a later iteration of the *Odyssey* that is 'even singable', which Pound then incorporates (or 'interpolates' as he put it in his essay on Divus) into his Homer poem (*LE* 262).[160]

As Pound complained in 'Notes on Elizabethan Classicists', serialized in *The Egoist* in 1917 shortly after the first appearance of what became *Canto* 1, by the early part of the twentieth century 'all classic authors have been authoritatively edited and printed by Teubner, and their wording ultimately settled at Leipzig'.[161] Among the Leipzig-based Bibliotheca Teubneriana's series of authoritative editions of ancient texts was Arthur Ludwich's two-volume Teubner edition of the *Odyssey* (1889–91). Yet as Pound saw it, the Teubner philologists were not the gatekeepers of the classical tradition: 'all questions concerning "the classics" are not definitely settled, cold-storaged, and shelved'.[162] Part of the function of Divus' text in Pound's Canto, therefore, was to bring Homer out of 'cold storage' and away from the fixed text studied by classicists by approximating the mediatory function played by the manuscript tradition in transmitting ancient texts. In an effective replacement of the work of the Teubner editors who collated later

[156] The first printed edition of the *Homeric Hymns* was published in 1488 in Florence together with the *Iliad* and *Odyssey*.

[157] Faulkner (2011), 14.

[158] 'Translators of Greek', *Instigations* 334–5. Pound's copy is held at the Harry Ransom Center at the University of Texas at Austin (PA 4024 A3 1537 PND).

[159] Divus says as much in his preface 'Ad lectorem': Divus (1538); Cè (2019).

[160] *LE* 262: 'as I have interpolated it in my Third Canto'. [161] *LE* 240. [162] *LE* 240.

74 FRAGMENTARY MODERNISM

manuscripts and sought out variants (Ludwich introduced a number of new manuscripts into the tradition dating from the 8th to the 15th centuries), Pound endorsed an alternative history of texts and transmission to produce his own creative 'edition' of the *Odyssey*. This is reflected in the deluxe, hand-processed issue of *A Draft of XVI Cantos*, where the Canto itself was, as Pound put it, 'jacked up to somewhere near the level of a medieval mss',[163] complete with illuminated initial letters done in red ink with black-and-white stylized figures by Henry Strater.[164] Like the medieval and early modern manuscripts on which ancient texts rely, the mediating early modern 'manuscripts' also left traces in the *Cantos*' version of Homer. Divus' Homer, printed along with Gregorius' *Hymns* in Paris in the workshop of Andreas Wechelus ('In officina Wecheli, 1538'[165]), acquires a material presence in Pound's text, and parts of Gregorius' Latin are interpolated, untranslated '[i]n the Cretan's phrase', into Pound's Homer fragment ('Venerandam', 'Cypri munimenta sortita est', 'orichalchi'[166]). A new variant reading even seems to have come into the text in the process, as Tiresias greets Odysseus with the unaccustomed words 'A second time?' (I/4) translating Divus' *cur iterum* (Why again?) at *Odyssey* 11.93 rather than the emphatic τίπτ' αὖτ' ('Why on earth?') in Homer.[167]

Pound's decision to reposition the *Nekyia* to the beginning of the *Cantos* has been explained in various ways. The move shifts the focus away from the narrator and towards the characters; it places Odysseus as a structuring figure and Homer's *Odyssey* as a structural model at the heart of the *Cantos*, a decision perhaps influenced by Pound's reading of early chapters from Joyce's *Ulysses*.[168] Above all, Canto I is seen to foreground issues of translation and literary inheritance, as the blood for the ghosts poured by Odysseus provides an analogue for the processes of translation and poetic composition by which the poet brings blood to the literary figures of the past in order to make them to speak from the dead.[169] These are all-important issues in the *Cantos*, and, particularly in its earlier

[163] Pound, letter to Kate Buss, 12 May 1923 = Paige 256.

[164] The copy of Divus' Homer owned by Pound also has intricately ornamented initial capitals. For Gladys Hines' illustrations of *A Draft of Cantos 17–27* (1928) similarly looking back to medieval and Renaissance traditions while also looking forward to modernity, see Bornstein (2005), 153–4. As McGann (1991) notes, Pound carefully oversaw the printing of both *A Draft of XVI Cantos* (1926) and *A Draft of Cantos 17–27* (1928) (34) and paid 'the closest attention to the semiotic potential that lay in the physical aspects of book and text production' (44). For the decorative initials 'an act of cultural allusion', see McGann (1991), 138.

[165] The first version of the Canto kept the Roman numerals from the title page of the original: 'In Officina Wecheli, Paris,/M. D. three X's, Eight'.

[166] The earlier version also included Gregorius' *auream coronam habentem* ('with the golden crown'), as Pound went on to translate it.

[167] It is sometimes argued on the basis of *Odyssey* 11.92 that Divus himself was using a corrupt edition of Homer (Terrell (1980), 2; Stoicheff (1995), 122), though the line in question, omitted in most Homer manuscripts, appears neither in Divus' translation nor in Pound's version.

[168] Bush (1989), 193–7.

[169] See, e.g., Kenner (1969); Kahane (1999); Culligan Flack (2015); Cè (2019); Beasley (2019), 82.

versions, *Canto* I clearly meditates on translation, non-translation, and the literary past. Yet Pound's opening Canto does not just turn on the processes involved in the creation of texts and their transformation through translation: it enacts the processes which have brought those texts (or failed to bring them) to modernity. The *Cantos* are shot through with bits and pieces of ancient texts extracted from the work of classical scholars and re-embedded in Pound's new fragment-poem. In *Canto* 23, an extract of Stesichorus' *Geryoneis* found in Athenaeus' *Scholars at Dinner* is broken down into smaller pieces: bits of the Greek are cut out and replaced with Johann Schweighäuser's 1804 Latin translation; references to textual variants and multiple dictionary entries obstruct the path of the 'original' into modernity even more than the obstacles it had actually passed to get there ('Derivation uncertain', 23/107).[170] Throughout the *Cantos*, snatches of classical texts are broken up and dispersed: a name from Ovid is repeated in different grammatical cases ('Itys, Ityn' 4/16–17); a fragment of Sappho from a broken piece of parchment leaves a trace in *Canto* 5 (Fragment 96 Lobel-Page; 5/18[171]); a snippet of Ibycus extracted from Athenaeus is re-embedded in *Canto* 39 (Fragment 286; *Canto* 39/193); a phrase of Heraclitus ($\pi\acute{a}\nu\tau a$ $\acute{\rho}\epsilon\hat{\iota}$, 'everything flows') runs through *Cantos* 76 and 80 like one of the extracts from Diels' *Vorsokratiker*. Classicists may have 'obscur[ed] . . . the texts with philology', deserving a special place in Pound's version of hell (*Canto* 14/63). But, in the end, it was the methods and materials in their 'piles of stone books' which Pound creatively appropriated to make antiquity new.[172]

The examples foregrounded in this chapter are paratextual, and as such they expose the particular dynamics of the philology of the fragment at work within the poems they frame. But because *The Waste Land*, *Four Quartets*, and the *Cantos* rapidly became benchmarks for dominant twentieth-century constructions of modernism, their interventions had important consequences not just for modernism, but for Classics. By showcasing classical philology in what were to become *the* flagship texts of modernism, Eliot and Pound effectively shifted it from what Richard Aldington called the exclusive domain of 'pedagogues, philologists and professors'[173] into the arena of cutting-edge artistic production. One of the unintended results of this is that the activities of classical philologists began, in reception, to overlap with the modernist project. In the wake of Eliot's epigraph in

[170] Johann Schweighäuser, *Athenaei Naucratitae Deipnosophistarum libri quindecim* (Societas Bipontinae, 1804), Vol. 4, 237–8. See Liebregts (2004), 187–9; Culligan Flack (2015), 51–2; Goldschmidt (2019), 64–5.

[171] For Pound, Aldington, and the publications of J. M. Edmonds of this fragment, see Chapter 1, pp.17–18 and pp.34–5.

[172] Pound gave philologists a place in hell in the *Cantos* 'pets-de-loup, sitting on piles of stone books,/obscuring the texts with philology': Ullyot (2017). Cf. *LE*, 240: 'When the classics were a new beauty and ecstasy people cared a damn sight more about the meaning of the authors, and a damn sight less about their grammar and philology.' See also Dingee (2019) on Pound's *Propertius* and classical philology.

[173] Aldington (1915).

76 FRAGMENTARY MODERNISM

Four Quartets it became more and more acceptable – and even desirable – for Heraclitus to write 'like Nietzsche';[174] after *The Waste Land*, Petronius could be fully embraced as the radically fragmentary writer we now value, and despite Pound's virulent anti-philology, the *Cantos* themselves validate the techniques (if not the texts) of the Teubner editors he denounced. Modernism gave a new value to the classical fragment *as fragment*, and the result shaped not only the literary production of the twentieth century but the ways in which editions of ancient texts in fragments could be produced and read. Critical editions like Bücheler's Petronius, and especially fragment collections like Diels' *Vorsokratiker*, which already shared some of the fragmentary imperatives of modernism, were re-figured as analogues of the twentieth-century fragment. Programmatically embedded in what became the defining texts of Anglophone modernism, classical philology crossed the rhetorical 'traumatic breach'[175] between classical scholarship and modernity. In effect, the philology of the fragment practiced by classical scholars was reinvented as both model and example of fragmentary modernism.

[174] Burnet (1908), 146. [175] Yao (2019), xv.

3

Inscriptional Modernism

C. P. Cavafy's 'In the Month of Athyr' ('Ἐν τῷ Μμηνὶ Ἀθύρ', 1917) self-consciously mimics an inscription on a broken ancient stone:

ΕΝ ΤΩΙ ΜΗΝΙ ΑΘΥΡ

Μὲ δυσκολία διαβάζω στὴν πέτρα τὴν ἀρχαία.
«Κύ[ρι]ε Ἰησοῦ Χριστέ». Ἕνα «Ψυ[χ]ὴν» διακρίνω.
«Ἐν τῷ μη[νὶ] Ἀθὺρ» «Ὁ Λεύκιο[ς] ἐ[κοιμ]ήθη».
Στὴ μνεία τῆς ἡλικίας «Ἐβί[ωσ]εν ἐτῶν»,
τὸ Κάππα Ζῆτα δείχνει ποῦ νέος ἐκοιμήθη. 5
Μὲς στὰ φθαρμένα βλέπω «Αὐτὸ[ν] ... Ἀλεξανδρέα».
Μετὰ ἔχει τρεῖς γραμμὲς πολὺ ἀκρωτηριασμένες·
μὰ κάτι λέξεις βγάζω — σὰν «δ[ά]κρυα ἡμῶν», «ὀδύνην»,
κατόπιν πάλι «δάκρυα», καὶ «[ἡμ]ῖν τοῖς [φ]ίλοις πένθος».
Μὲ φαίνεται ποῦ ὁ Λεύκιος μεγάλως θ' ἀγαπήθη. 10
Ἐν τῷ μηνὶ Ἀθὺρ ὁ Λεύκιος ἐκοιμήθη.

With difficulty I read upon the ancient stone:
'LO[R]D JESUS CHRIST.' I discern a 'SO[U]L'
'IN THE MON[TH] OF ATHYR 'LEUCIUS WAS LAID TO SL[EE]P.'
Where the age is mentioned 'HE LI[VE]D TO THE AGE OF'
the Kappa Zeta shows he was laid to sleep so young.
In the abraded part I see 'HI[M] ... ALEXANDRIAN.'
There follow three lines quite mutilated;
but I make out some words like 'OUR T[EA]RS' and 'SUFFERING'
and then once more 'TEARS' and 'TO [U]S HIS FRIENDS BEREAVEMENT.'
It seems to me the love for Leucius was deep.
During the Month of Athyr Leucius was laid to sleep.[1]

The poem – which was published in English by E. M. Forster in 1923 (around the time Cavafy was coming to T. S. Eliot's attention, too) – evokes the materiality of a stone inscription, illegible in places where the monument has been damaged or

[1] Greek text and translation from *C. P. Cavafy: The Collected Poems*, trans. E. Sachperoglou, ed. A. Hirst (Oxford, 2007), 92–5.

Fragmentary Modernism: The Classical Fragment in Literary and Visual Cultures, c.1896–c.1936. Nora Goldschmidt, Oxford University Press. © Nora Goldschmidt 2023. DOI: 10.1093/oso/9780192863409.003.0004

78 FRAGMENTARY MODERNISM

the letters rubbed away.[2] Set in two columns as if cut into a lithic monument, the poem is couched as an epitaph for Leucius who, we are told, died during the month of Athyr, in the late autumn of the Egyptian calendar. The reference to 'L[O]RD JESUS CHRIST' and the date abbreviation suggest that the imaginary 'ancient stone' ($\pi \acute{\epsilon} \tau \rho \alpha \ldots \alpha \rho \chi \alpha \acute{\iota} \alpha$) – or what is left of it – comes, like some of the Christian texts from Oxyrhynchus, from the early Christian period in Greco-Roman Egypt. As Gregory Jusdanis puts it, Cavafy's poem performs a parallel act to the work of classical scholars, as both speaker and reader 'approach . . . antiquity as an epigrapher, searching for inscriptions beneath romanticized layers of textual scholarship'.[3] Like the marks used by classical scholars to signal lost or conjectured text – or the dotted punctuation which Pound had used in 'Papyrus' a year earlier – Cavafy's brackets and ellipses hint at what is lost or what is only to be guessed, a quality brought to the fore by the words $M\grave{\epsilon}$ $\delta \upsilon \sigma \kappa o \lambda \acute{\iota} \alpha$ $\delta \iota \alpha \beta \acute{\alpha} \zeta \omega$ ('with difficulty I read', line 1) in the opening, and the 'very smashed' ($\pi o \lambda \acute{\upsilon}$ $\mathring{\alpha} \kappa \rho \omega \tau \eta \rho \iota \alpha \sigma \mu \acute{\epsilon} \nu \epsilon \varsigma$) verses in line 7.

Cavafy's imagined stone is locally specific to Alexandria, but his epigraphic interests were paralleled by his anglophone contemporaries. While Cavafy was visiting the Museum of Alexandria to look at stone inscriptions (including a dedicatory inscription by a sailor named 'Leucios' which may have inspired 'In the Month of Athyr'[4]), literary modernists active in London were also consuming Greek and Roman inscriptions as part of their daily experience. The old Round Reading Room of the British Library, a key space for the emergence of modernism in London, was housed on the ground floor of the British Museum in Bloomsbury (the library was later decoupled from the museum and moved to St Pancras in 1997). To reach it, ticket holders – including Ezra Pound and H. D., Virginia Woolf, T. S. Eliot, and W. B. Yeats – would pass through an extensive collection of inscribed ancient stone, much of it fragmentary, held in the 'Hall of Greek and Latin Inscriptions'. The material displayed in the hall, which Pound and his circle walked past almost every day for an intense period in the 1910s, had a significant, if unacknowledged, impact on the poetry written in or near the library. In a period when Pound was urging his contemporaries to write poetry like 'weather-bit granite'[5], the Hall of Inscriptions offered concrete monuments to parallel the stone they sought to emulate in their poetry.

[2] Forster included an English translation by George Valassopoulo in *Pharos and Pharillon*: Forster (1923), 96, and Cavafy's 'Ithaca' was published by Eliot the following year in the *Criterion* 2.8 (July 1924), 431–2.

[3] Jusdanis (2004), 42. See also Nagy (2010) for issues of fragmentation and loss in the poem.

[4] For the suggestion that Cavafy, who visited the museum frequently, drew on the Leukios inscription, see Kocziszky (2015), 71 with n.151. The inscription itself is reproduced in Breccia (1911), no. 243, pp.33–4.

[5] Ezra Pound, 'The Hard and the Soft in French Poetry', *Poetry* 9.5 (February 1918) = Pound, *LE* 288.

INSCRIPTIONAL MODERNISM 79

At the same time, even as the British Museum (or the Museum of Alexandria) provided real-world examples of lithic inscriptions on weather-beaten stone, modernist engagements with inscriptional poetry were significantly focused through the collection of epigrams found in the *Greek Anthology*. The word epigram (from *epi-gramma*, 'mark-upon') originally referred strictly to a verse inscription on stone or other surfaces, but over time, the short poetic form stopped being exclusively written for direct inscription and undertook a process of 'delapidarisation'.[6] No longer primarily written for stone, epigrams shifted to the written page, but in the transition often retained their deictic references to the stone from which they had been severed. Mediated through John William Mackail's popular *Select Epigrams from the Greek Anthology*, which ran to several editions (1890; 1906; 1911), and later William Roger Paton's five-volume translation for the Loeb Classical Library (1916–18), the *Greek Anthology* became a foundation text for what T. S. Eliot called 'the group denominated "imagists" in London about 1910' and the '*point de repère*' of modernism.[7]

The encounter with the *Greek Anthology* against the backdrop the Hall of Inscriptions in the British Museum was closely bound up with modernist interests in the fragment. Literally cut into stone, lapidary inscriptions in the Hall of Inscriptions, like Leucius' tombstone or the degraded texts on papyri from Oxyrhynchus, could be fragments on a basic material level: the matter on which they were inscribed is vulnerable to breakage, leaving gaps and uncertainties in texts which had once been fully legible. But the short, condensed form of epigram could also work *like* the broken-down texts on stone or papyrus. All poems are fragments in one way or another: they require a certain amount of completion and supplementation by their readers to fill in the hermeneutic gaps in a sense-making pact that is more or less signposted by the text.[8] But the typically short, stripped-down, and suggestive mode of epigram means that the poems operate on the processes of readerly completion – and readerly inability to complete – that is characteristic of more explicit fragmentary writing.[9] The poet F. S. Flint, who co-authored the first *de facto* Imagist manifesto with Pound, famously declared that '[t]he day of the lengthy poem is over – at least for this troubled age': now, instead, 'to the poet who can catch and render a fragment of his soul's music, the future lies open'.[10] What Kathryn Gutzwiller would come to call 'the miniature, the intricate, and the fragmented' mode of Greek epigram, like Japanese haiku, could provide the ideal classical paradigm for the stripped-down fragments of the future the new poetry sought to produce.[11]

[6] Baumbach, Petrovic, and Petrovic (2010), 17–18; Rawles (2018), 58.
[7] Eliot (1966), 18. [8] duBois (1996), 53.
[9] On epigram as a mode of fragment-writing in modern literature, see Elias (2004).
[10] *The New Age* 3.11, 11 July 1908, 213.
[11] Gutzwiller (1998), 4. On haiku and modernism, see Hakutani (2009).

80 FRAGMENTARY MODERNISM

The fragmentary experience of epigram was compounded by the fact that the epigrams found in the *Greek Anthology* had become what H. D. called 'fragments and references to lost fragments' through the processes of excerption and textual transmission.[12] The collection, which contained over 4,000 epigrams spanning almost a millennium and a half, preserved the only traces that remain of poets like Anyte of Tegea, Zonas, or Nossis, often in the form of just one or two poems from what were once extensive corpora. 'Fragments' like these were not broken down because of the degradation of the material on which they had been inscribed, but broken up in the fragmenting processes of excerption, selection, and loss – further augmented by the selection process in Mackail's *Select Epigrams* – that was written into the history of the collection. Taken together with the short, quasi-fragmentary mode in which epigrams were composed, and emerging, through Mackail, in an era buzzing with the thrill of other kinds of ancient fragment hunting, the poems of the *Anthology* took on the seductive aura of the fragment. Severed from their origins on stone and broken up from their original collections on paper, the short-form poems allowed the *Anthology* to be re-conceived as 'Being', as one contemporary editor entitled it, 'a Collection of Fragmentary Specimens of Poetry'.[13]

This chapter traces the ways in which modernist concerns with the fragment intersected with an attentiveness to ancient inscription, both on stone and on paper, with a particular focus on H. D., Richard Aldington, and Ezra Pound. Beginning in the Hall of Inscriptions, I show how the emergence of the Imagist movement – which anecdotally took place in a café in or near the British Museum – was fundamentally underpinned by an inscriptional poetics predicated on an engagement with the stone-like sparseness of Greek and Roman epigraphic material like that held in the anteroom to the old Reading Room of the British Library. From inscriptions on stone to inscriptions on paper, the chapter then moves to investigate the intense modernist interest in the *Greek Anthology*. Before the famous publication of the tenets of Imagism by Pound and Flint appeared, H. D. discovered in Mackail's *Select Epigrams from the Greek Anthology* a quasi-manifesto for Imagism, and, as her unpublished essay 'Garland' makes explicit, she saw in the *Anthology* a collection of 'fragments and references to lost fragments' whose gaps and cesurae she exploited in her poetry. For Ezra Pound, who walked past the inscriptions in the British Museum almost every day in this period, the *Greek Anthology* was reinvented as an inscriptional prototype, itself anthologized and mediated over centuries, for the kinds of fragmented poetics he would develop in the *Cantos*.

[12] 'Garland', Part III of 'Notes on Euripides, Pausanias and Greek Lyric Poets', second draft typescript, Yale Collection of American Literature, Beinecke Rare Book and Manuscript Library, YCAL MSS 254, Box 44, 1119–20 (p.132).

[13] Edwy Wells Foster called his edition *The Greek Anthology: Being a Collection of Fragmentary Specimens of Poetry*: the typescript (*c.*1900) is held at the Widener Library at Harvard University, KG 1033.

Crucially, in the process, the long line of collectors and editors of epigram on paper and stone who mediated the poems of the *Anthology* were put to work in the service of modernism's inscriptional poetics of the fragment. What John William Mackail himself came to recognize as a 'revolution in English poetry' had been effected, based, in part, on the appropriation of the work of classical scholars who laboured to decipher bits and pieces of ancient texts on paper and stone.[14] But rather than rendering their work obsolete, modernism's radical reinvention of the *Greek Anthology* recognized the entanglement of classical scholars like Mackail in the ancient and modern history of the text and deployed them as partners in the attempt to catch and render new forms of fragmentary expression for modernity.

I. The Hall of Inscriptions

'As to Twentieth century poetry, and the poetry which I expect to see written during the next decade or so', Ezra Pound announced in 1912, '[i]t will be as much like granite as it can be'.[15] The declaration was made during what Pound would later call the 'British Museum era' (*Cantos* 80/520), a period during which he was working regularly in the Round Reading Room of the British Library, then located in the British Museum in London. He had joined the library for one week during a visit to London in 1906, and when he moved there two years later (he would spend the next twelve years in London), the Reading Room in the museum became a foundational site for the emergence of literary modernism.[16] For Pound, 'seated on one of the very hard, very slippery, thoroughly uncomfortable chairs of the British Museum main reading room, with a pile of large books at my right hand and a pile of somewhat smaller ones at my left hand', the British Library, 'that focus of learning', became a crucial working space.[17] From 1911 when H. D. moved to London, she, and later Richard Aldington (who could only obtain a reader's ticket when he reached the minimum age requirement of twenty-one in 1913), joined Pound as regular readers passing through the Hall of Inscriptions to sit among '[t]he bent heads and rustling noises/In the great dome' (as Aldington described it in 'At the British Museum').[18] In December 1914, T. S. Eliot, too,

[14] [Mackail] (1919).

[15] Ezra Pound, 'Prolegomena', *The Poetry Review* 1.2, February 1912, 72–6 (76).

[16] For a detailed discussion of Pound's library habits, see Arrowsmith (2011), 58 and 58–64; Moody (2007), 68, 180, and Paul (2002), 65–139.

[17] Pound (1952), 53. Pound's usual seat 'on the left side of the reading-room' ('How I began' (*T. P.'s Weekly* 6 June 1913, reprinted in Pound (2005) 214)) was almost directly opposite the open-shelf Classics books (catalogued 2044–49). For the Reading Room open shelves, see the map in Peddie (1912), 12.

[18] Published in *The Egoist* 1 June 1915. The three lived in Church Walk, Kensington at the end of 1911 and the spring of 1912: Moody (2007), 180. H. D. was granted a reader's ticket on 17 October 1911: Carr (2009), 370.

82 FRAGMENTARY MODERNISM

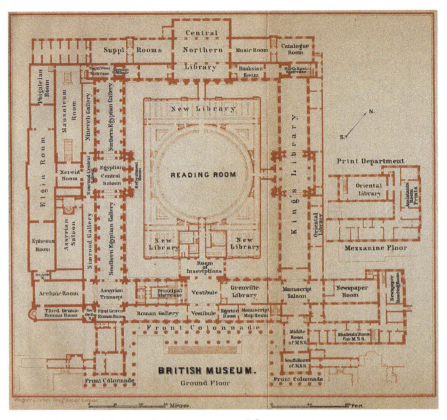

Figure 3.1 Plan of the British Museum, ground floor, c.1905.

acquired a ticket,[19] and the library became part of the imaginative landscape for others as well, including W. B. Yeats,[20] Virginia Woolf (who applied for a reader's ticket in November 1905),[21] and E. M. Forster, for whom the old Reading Room became a thematically important structuring device in novels like *The Longest Journey* (1907).

In order to reach the Reading Room, ticket-holders coming from the main entrance would walk directly ahead through the front colonnade, through the entrance, and on into the Hall of Greek and Latin Inscriptions, which led to the cloakroom and the library (Figure 3.1).[22] The hall functioned somewhere between

[19] Coyle (2016), 36, with reproduction.
[20] Yeats obtained his reader's ticket on 29 June 1887: Finn (2004), 46.
[21] Bernstein (2014), 147–83.
[22] Versions of the map are found in several contemporary guides, e.g., *A Guide to the Exhibitions and Galleries of the British Museum (Bloomsbury)*, 11th revised edn, 1912 (London: Trustees of the

INSCRIPTIONAL MODERNISM 83

an anteroom to the library and an exhibition space for pieces that didn't quite fit elsewhere in the collections: it contained portrait busts of ancient philosophers and notable literary figures like Euripides (no. 1833) or the muse Thalia (no. 1685), as well as what the guide book called 'miscellaneous Graeco-Roman sculptures' of 'subordinate interest',[23] among them an elaborate statue of the emperor Hadrian in armour (no. 1895).[24] Its main function, however, was to showcase the museum's collection of Greek and Latin inscriptions on stone. On the left was a massive marble commemorative stone pillar or 'stele' from Sigeum found near the site of Troy, its inscription rubbed off in several places, and a deep chunk missing from the front left-hand edge (no. 1002: Figure 3.2).[25] Beside it was an inscribed pilaster from the Temple of Athena Polias at Priene (no. 399), which had been broken into several fragments;[26] on the floor in the centre of the room was a cast of an early archaic inscription from the Roman Forum, so ancient that the Latin (written in Greek letters) could barely be understood,[27] and on the right-hand wall stood a Greek verse epitaph from the fifth-century BCE (no. 37), composed in elegiac couplets and cut into the base of an otherwise lost funeral monument for the Athenian soldiers who died at the battle of Potidaea near Thrace ('air received their souls and earth their bodies').[28]

In September 1912, in an episode that was later mythologized as a turning point in the history of modernism, H. D. met Ezra Pound (to whom she had been briefly engaged) 'in the Museum tea room', just to the left of the Round Reading Room in the British Museum.[29] She had plucked up the courage to show Pound some of her poems, and Pound famously cut them down into sparser fragments, as he 'slashed with a pencil: "Cut this out, shorten this line..."'. Then, at the bottom of the page, he 'scrawled "H. D., Imagiste"'.[30]

The nom de plume – itself evocative of capital letters cut into stone – may already have been on the page when Pound signed it off, but after the meeting it

British Museum), fold out map (item 3) (a copy is held in the British Museum, Central Archives). The room is generally called 'The Hall of Greek and Latin Inscriptions', 'Hall of Inscriptions' or 'Room of Inscriptions'.

[23] Smith (1912), 112, 116–18.

[24] For the content of the room, see Smith (1912), 112–18 and Smith (1917), 11–43 (reprinting contemporary labels on display in the museum). The numbers given in brackets refer to the catalogue numbers found in contemporary guides; up-to-date museum numbers for some of the objects are given in the notes.

[25] 1816, 0610.107. [26] 1870,0320.88: Smith (1917), 19.

[27] Smith (1912), 113–14. [28] Smith (1912), 114–15 = IG I³ 1179.

[29] There are slightly conflicting accounts of the meeting, all of them written decades later: H. D.'s memoir, *End to Torment* (H. D. (1979), 18) places it 'in the Museum tea room'; the Pearson papers in the Beinecke Library (based on an interview with H. D. probably dating from the 1940s or 1950s) locate it in 'a tea-room opposite the British Museum', while Aldington, who seems to have been present, remembered it taking place vaguely 'in a teashop – in the Royal Borough of Kensington': Aldington (1941), 134; Friedman (1991), 36–7; Collecott (1999), 292 n.21.

[30] H. D. (1979), 18; Guest (1984), 40–1.

Figure 3.2 Marble stele found at Sigeum. 2.28 m. British Museum (1816,0610.107).

quickly became her official pen name.[31] A month after their meeting in the tea room, Pound was praising the poetry of 'H. D.', its 'laconic speech' and its 'Greekness', to Harriet Monroe, the editor of *Poetry* magazine:[32]

> London, October
>
> Dear Harriet Monroe: I've had luck again, and am sending you some modern stuff by an American, I say *modern*, for it is in the laconic speech of the Imagistes, even if the subject is classic... Objective – no slither; direct – no excessive use of adjectives, no metaphors that won't permit examination. It's straight talk, straight as the Greek! And it was only by persistence that I got to see it at all.

Harriet Monroe was just about to print three of Richard Aldington's poems in the November 1912 issue of *Poetry* magazine, including ΞΟΡΙΚΟΣ ('Choricos', named after the choral songs in Greek tragedy, which she would later identify

[31] According to the Pearson Papers in the Beinecke Library, H. D. later remembered that she already had 'my initials on the page for no reason' and that Pound merely added the word 'Imagiste'. Cf. Hollenberg (2022), 48.

[32] To Harriet Monroe, October 1912: Paige 45.

as 'the first imagist poem ever printed'[33]), accompanied by a biographical note at the back of the issue describing Aldington as one of 'a group of ardent young Hellenists', known as the 'Imagistes'.[34] But it turned out to be H. D. who led the way in the Hellenizing aesthetic of Imagism. Three of her poems, 'straight as the Greek', were published in the January 1913 issue of *Poetry*: 'Hermes of the Ways', 'Priapus, Keeper of Orchards' (later just 'Orchard'), and 'Epigram (*After the Greek*)'.[35]

H. D.'s early *Poetry* publications appeared under the heading 'Verses, Translations, and Reflections from "The Anthology"', and all three had taken material from J. W. Mackail's *Select Epigrams from the Greek Anthology*.[36] But they also crucially tapped into aspects of her experience in the British Museum, 'where', she told her mother, 'I spend my mornings'.[37] 'Hermes of the Ways', for example, riffs on real or imaginary inscriptions on herms or statues of Hermes she found in the *Greek Anthology*, including a poem by Anyte of Tegea (*AP* 9.314) and an anonymous inscription (*AP* 10.12) which Mackail headed 'Hermes of the Ways'.[38] But 'Hermes of the Ways' (which Aldington described as 'like nicely carved marble'[39]) would also have been informed by examples of real herm boundary markers in stone in the British Museum collections.[40] Similarly, 'Priapus, Keeper of Orchards', which expands an epigram by Zonas in the *Anthology* (*AP* 6.22), would also have resonated with the genuinely inscriptional material in the British Museum collections, which included a second- or third-century dedicatory inscription to Priapus acquired in 1859, broken into two pieces (no. 910).[41]

But the most obviously inscriptional of the three poems published in *Poetry*, and the one most closely approximating stone, is 'Epigram (*After the Greek*)':[42]

> The golden one is gone from the banquets;
> She, beloved of Atimetus,
> The swallow, the bright Homonoea:
> Gone the dear chatterer;
> Death succeeds Atimetus.

[33] Monroe (1926), 295.

[34] ΞΟΡΙΚΟΣ was printed with 'Au Vieux Jardin' and 'To a Greek Marble' (probably based on the Townley Venus in the British Museum: see Chapter 4, p.128) in *Poetry* 1.2, pp.39–43, with the biographical note on p.65. Pound later complained that 'the note in *Poetry* is very incorrect...There is Imagism in all the *best* poetry of the past' (letter to Alice Corbin Henderson, quoted in Carr (2009), 531). H. D. and Aldington married in October 1913.

[35] *Poetry* 1.4, January 1913, pp.118–22.　　[36] Cf. Gregory (1997), 169.

[37] From a postcard to her mother, 17 November 1911: Zilboorg (1991a), 92, n.7.

[38] Mackail (1911), 196–7 ('Hermes of the Ways'); 207 (Anyte).

[39] Richard Aldington, 'Modern Poetry and the Imagists', *Egoist* 1.11 (11 June 1914), 201–3 (202).

[40] Gregory (1997), 240. The herm imagery has also been linked to the work of Jane Harrison: Swann (1962); Collecott (1999), 274–5 n.9; Svensson (2003), 125; Carr (2009), 494–5.

[41] 1859,1129.59.

[42] The text follows that printed in *Poetry* and *CP* 309; the final line was omitted in *Des Imagistes* (1914), but is reinstated by Martz in *CP*.

86 FRAGMENTARY MODERNISM

Even though the poem is couched as a sepulchral inscription, it is generally thought to be modelled, as Steven Yao puts it, 'on the epigrammatic forms of the *Greek Anthology*, probably on the sepulchral epigrams of Book VII in particular'.[43] H. D. had indeed drawn on a sepulchral epigram she found in Mackail, but the poem is unusual because it is not from the original *Greek Anthology* at all. It comes from a transcription from a real stone inscription – an anonymous sepulchral epigram to Claudia Homonoea – which Mackail had included in his *Select Epigrams* along with other genuinely inscriptional material from Georg Kaibel's *Epigrammata Graeca ex lapidibus conlecta* ('Greek Epigrams Collected from Stone'), 1878:[44]

<div style="text-align:center">

XLVI

ON CLAUDIA HOMONOEA

AUTHOR UNKOWN

</div>

I Homonoea, who was far clearer-voiced than the Sirens, I who was more golden than the Cyprian herself at revellings and feasts, I the chattering bright swallow lie here, leaving tears to Atimetus, to whom I was dear from girlhood; but unforeseen fate scattered all that great affection.

The epigram has what Mackail called in his note 'a very curious' history.[45] The original epitaph (in Greek) was discovered on an elaborately decorated marble tomb structure with writing on three sides (*CIL* 6.12657): the Greek text (which is authentic) is carved on the front and framed by a Latin introduction and further 'completed' by twenty-six lines of Latin elegiac couplets on the left and right faces, written alternately in the voices of Homonoea and her grieving husband Atimetus, who (in typical inscriptional mode) ask the passer-by to stop and read their story (*siste gradum...verbaque pauca lege*, 'stop...and read these few words'). As Mackail warned in his note, with the exception of the Greek epigram on the front, 'the whole monument is a Renaissance forgery', put together to pad out a genuine fragment of antiquity.[46] What Mackail called the 'really ancient' Greek fragment on the front was composed in an epigrammatic mode which deliberately left gaps for readers to fill – and which the early modern grave-forger clearly couldn't resist.[47] The speaker points to a tomb ($\check{\epsilon}\nu\theta$' Ὁμόνοια/κεῖμαι, 'I Homonoea lie here') whose shape and location is left entirely to the imagination, like the story of the 'great affection' ($\tau o\sigma a\acute{v}\tau\eta\nu$... /$\varphi\iota\lambda\acute{\eta}\nu$) between the deceased and the mysterious Atimetus who is left behind.

[43] Yao (2002), 265 n.41.

[44] Kaibel (1878), 236–7 (no. 562); Mackail (1911), 164. The source was identified by Babcock (1995), 208, and followed by a brief reference in Gregory (1997), 248.

[45] Mackail (1911), 367. [46] Mackail (1911), 367. [47] Mackail (1911), 367.

INSCRIPTIONAL MODERNISM 87

As David Ayers puts it, H. D.'s version is 'even more epigrammatic' than the Greek text she found in Mackail.[48] In 'Hermes of the Ways' and 'Priapus, Keeper of Orchards', H. D.'s method was to complete the few words provided by the ancient texts. But in 'Epigram' she takes the opposite strategy.[49] Already stripped down by classicists from its later Latin fillers, the Greek epigram is radically pared down. All references to the Sirens and to Aphrodite have been removed, achieving a sparse lapidary quality that outdoes the Greek original itself in what Pound called in his letter to Harriet Monroe its 'straight talk': 'no excessive use of adjectives, no metaphors that won't permit examination'.[50]

While H. D. removed or condensed other references, 'Atimetus', who is mentioned in the original only once by name in an oblique case as the recipient of tears (Ἀτιμήτῳ δάκρυα λειπομένη), is named twice in the original *Poetry* publication.[51] The decision has puzzled commentators.[52] But one answer might be found in the Hall of Inscriptions, where, among the objects H. D. may have seen was a Roman burial chest (*c.*100 CE) prominently inscribed with the Latin ATIMETI, the genitive form of Atimetus, carved in the shape of an altar (Figure 3.3).[53]

The chest is decorated with a relief image of a male figure, naked to the waist; he is half supported by a female figure, while two children are positioned at the foot of the couch. The text inscribed below reads:

D(is) M(anibus) s(acrum) Atimeti Aug(usti) l(iberti) a supell(ectile) castrensi(s) fecerunt Flavia Dada coniug(i) b(ene) m(erenti) et Fortunatus Aug(usti) l(ibertus) parent(i) optimo

Sacred to the spirits of the dead and of Atimetus, imperial freedman, keeper of the furniture of the imperial palace. Flavia Dada dedicated this to a well-deserving husband, and Fortunatus, imperial freedman, to the best of parents.

Commissioned by a woman rather than spoken in her voice from the dead, the Latin inscription is much more pedestrian than its mirror in Mackail's *Selections* (a keeper of imperial furniture was an important role, but it is not a particularly thrilling one). It is probable that – if she did see it on display in the hall – H. D. would not have stopped to decode the writing on the stone beyond glancing

[48] Ayers (2004), 4. [49] Babcock (1990), (1995).

[50] It is unclear how much Pound was involved in these cuts: the autobiographical notes in the Beinecke Library suggest that it was not 'Epigram', but 'Hermes of the Ways', 'Acon', and 'Orchard' that Pound edited at their famous meeting in the tea-room: see Louis Silverstein's *H. D. Chronology*: https://www.imagists.org/hd/hdchron1.html.

[51] The line was removed in later publications, but is restored in *CP* 309: see note 42, above.

[52] Jeanne Heuving misreads the masculine 'Atimetus' as a female name ('the woman Atimetus'), and sees the figure as a cover for H. D.'s lover Frances Gregg: Heuving (2016), 60–1.

[53] No. 2353, Smith (1904), vol. 3, pp.343–4. It is not clear whether the item was displayed in the Hall of Inscriptions at the time; the 1908 guidebook omits 2353, but it restricts itself only to 'the most interesting' inscriptions on display.

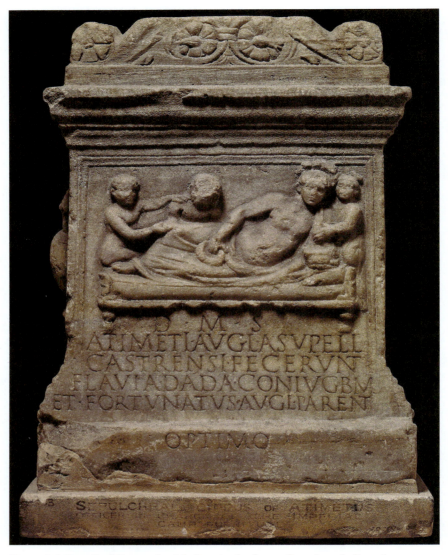

Figure 3.3 Inscribed Roman burial chest in the form of an altar, dedicated to Atimetus. British Museum (1817,0208.2).

at the image and the prominently positioned name. Yet the physicality of the stone could function as a material stand-in for the missing monument from which Mackail's Homonoea inscription had been severed, as well as the poetry she was striving to inscribe. On Pound's formula, H. D.'s 'Epigram' is even more 'like granite' than either the original Greek epigram on which it was based or its analogous monument in the British Museum. The poem cuts its models right

down to the stone itself to become a paradigm for the kinds of rock-hard concision Pound's Imagism would aim to achieve. While the other two poems in the *Poetry* sequence were each signed simply 'H. D.', it is probably no typographical accident that 'Epigram (*After the Greek*)' was prominently signed off 'H. D., "Imagiste"'.

II. 'fragments and references to lost fragments': H. D., Mackail, and the *Anthology*

Greek epigrams were originally written to be cut into stone or other surfaces, but around the third century BCE epigram had become a flourishing genre in its own right, often linked with its origin on stone, but not necessarily composed for direct inscription. These literary inscriptions circulated in poetry books by individual authors, but in the first century BCE, Meleager of Gadara produced what is probably the first anthology 'proper', which he named *Garland* (*stephanos*) for the way in which he interwove the poets he selected in association with different flowers or plants. The collection included about 1,000 epigrams by forty-eight poets, including several epigrams by Meleager himself. Together with the *Garland* of Philip (first century CE) and other later epigram collections, Meleager's *Garland* was absorbed into an extensive compilation of over 4,000 epigrams which became known as the *Greek Anthology*.[54]

Most anglophone readers accessed the *Greek Anthology* through John William Mackail's *Select Epigrams from the Greek Anthology*, which was first published in 1890 and 'became an instant classic'.[55] Wharton's *Sappho* (published five years before Mackail's first edition, and already into its third by 1895) had successfully mediated the fragments of Sappho to modern audiences and primed them for the advent of the new finds. Like Wharton's 'classic achievement', as Pound called it, Mackail's *Selections* sought to popularize in English material drawn from nineteenth-century advances in German classical philology. He based his selections on the formidable scholarly edition and commentary by Friedrich Jacobs, choosing around 500 epigrams from the *Anthology*, which he interspersed with real inscriptions – like the one on which H. D. based 'Epigram (*After the Greek*)' – from Kaibel's edition of lapidary inscriptions.[56] Presented 'in such a form as would appeal to the lover of literature and not be ungrateful to the scholar' (vii), Jacobs'

[54] For a comprehensive study with full details of the sources and manuscripts, see Cameron (1993).
[55] Nisbet (2013), 264 with 236–64 on the profound influence of Mackail. *Select Epigrams* was also issued in pocket-sized forms containing only the English or Greek text: Nisbet (2013), 282.
[56] As well as Kaibel, Mackail (1911), 9 specifies his sources as *Anthologia Graeca sive Poetarum Graecorum lusus ex recensione Brunckii; indices et commentarium adiecit Fredericus Iacobs*, Leipzig, 1794–1814, and *Anthologia Graeca ad fidem codicis olim Palatini nunc Parisini ex apographo Gothano edita; curavit epigrammata in Codice Palatino desiderata et annotationem criticam adiecit Fredericus Iacobs*, Leipzig, 1813–1817'. Jacobs in turn had based his work on Richard François Philippe Brunck's *Analecta veterum poetarum Graecorum*, Strasbourg, 1772–6.

90 FRAGMENTARY MODERNISM

Greek text was accompanied on the same page with Mackail's own English translation, grouped by theme and given interpretative titles ('To Priapus on the Shore' (133), 'Hermes of the Ways' (196–7)), which, along with Mackail's extensive introduction and explanatory notes, significantly influenced their reception.

Paton's complete Loeb translation (enthusiastically reviewed by Virginia Woolf in the *Times Literary Supplement*) appeared between 1916 and 1918, but Mackail's *Selections* remained closely associated with the *Anthology*.[57] Woolf's brother Thoby had given her a copy of Mackail for her twentieth birthday ('Nothing to my mind could be more Greek');[58] Pound recommended it in his reading list for Iris Barry;[59] T. S Eliot read Mackail and modelled the 'Phlebas the Phoenician' episode of *The Waste Land* on the many epitaphs for drowned sailors in the *Anthology*,[60] and it was probably through Mackail that Yeats in his early work tried to 'write like the poets of the Greek Anthology'.[61] In the USA, Wallace Stevens discovered Mackail ('I must have the Mackail book'),[62] and it was on the basis of *Select Epigrams* that Edgar Lee Masters wrote his *Spoon River Anthology* (published in 1915), which Pound quickly praised in terms similar to the directness he had found in H. D.'s Imagism, 'capable of dealing with life directly, without circumlocution, without resonant meaningless phrases'.[63] Even C. P. Cavafy – 'a one-man Greek Anthology' – whose tomb poems interact with the *Anthology* as well as real inscriptions, owned a copy of Mackail's edition.[64]

H. D. had three copies of Mackail's *Select Epigrams* in her library, and she extensively annotated the 1911 edition.[65] As Eileen Gregory puts it, Mackail's translation and selection functioned as a kind of 'bible' for her.[66] The impact on the emergence of modernism of her first published poems in *Poetry* – written in dialogue with Mackail – is still regularly underplayed. H. D.'s early poems are still seen as the practice that 'demonstrate[s] the methods Pound outlined'.[67] But, in fact, things worked the other way around: it was H. D.'s poetic practice, and its engagement with the fragments of the *Greek Anthology* in Mackail's edition, which was instrumental in shaping the 'the laconic speech of the Imagistes', as Pound came to define it.[68] When H. D. took her poems to show Pound in the

[57] Kolocotroni (2012), 423; Riikonen (2008), 184. [58] Woolf (1993–4), 1.46–7.

[59] 'worth reading...2/': Letter to Iris Barry [?20] July 1916, reprinted in 'Letters to a Young Poet from Ezra Pound': *Poetry* 76.6 (Sep., 1950), 342–51: Paige 137.

[60] Sullivan (2011), 177. [61] Yeats (1961), 495.

[62] Stevens (1977), 184. Stevens wrote in his journal in 1907 that he had 'complete a careful reading of Mackail's "Select Epigrams from the Greek Anthology"', and noted later that 'I have for a long time wanted a photograph of Professor Mackail, of Oxford': Stevens (1977), 183–4, 235.

[63] Ezra Pound, 'Webster Ford', *The Egoist* (1 January 1915), p.11.

[64] Raphael (2014) ('one man Greek Anthology'); Caires (1980); Ricks (2007); Tzouvelēs (2016), 63–9.

[65] H. D.'s annotated copy is held in the Beinecke Rare Books and Manuscript Library, Yale University: Za D721 Zz911G.

[66] Gregory (1997), 169; cf. Babcock (1995) and Carr (2009), 796. [67] Mackay (2011), 56.

[68] See esp. Pondrom (1985), 74 on how 'H. D.'s early poems were models which enabled the precepts of Imagism to be defined'; cf. Zilboorg (1990), 26.

tearoom in or near the British Museum, she could not have seen the seminal 'Imagisme' and 'A Few Don'ts by an Imagiste' written by Pound and F. S. Flint, urging modern poets to aim for 'direct treatment of the "thing", whether subjective or objective' and 'To use absolutely no word that did not contribute to the presentation', which was not published until the March issue of *Poetry* of that year.[69]

What she *had* read – and marked in her copy – was Mackail's introduction to *Select Epigrams from the Greek Anthology*, the book which underwrote all three 'Verses, Translations and Reflections from "The Anthology"', as the headnote in *Poetry* described them.[70] Pound's later writings on Imagism called for a poetry 'like weather-bit granite', pursuing the '[d]irect treatment of the "thing"' and using 'no superfluous word, no adjective, which does not reveal something'. But H. D. found in Mackail's *Selections* a manifesto for an inscriptional poetics couched in strikingly similar terms.[71]

As Mackail presented them in his introduction, the epigrams in the *Anthology* offered a model of poetry that, in retrospect, was revolutionary. In a passage marked by H. D. in her copy, Mackail argued that what distinguished ancient epigram was the 'lapidary precision' (p.4) that separated it from other short verse forms:

> epigram in its first intention may be described as a very short poem summing up as though in a memorial inscription what it is desired to make permanently memorable in a single action or situation. It must have the compression and conciseness of a real inscription, and in proportion to the smallness of its bulk must be highly finished, evenly balanced, simple, and lucid.[72]

Mackail, who selected what he called the 'best' epigrams, dismissed many of the Byzantine examples which had been added to the collection later in the tradition. As he put it in a passage H. D. also marked, the 'best' epigrams show no 'natural verbosity' that 'weakens the force and directness of the epigram' because they

[69] 'Imagisme', *Poetry* 1.6, March 1913. The essay is attributed to F. S. Flint, but it is known to have been essentially written by Pound; it was followed by Pound's 'A Few Don'ts by an Imagiste' (pp.200–6).

[70] The importance of Mackail's introduction for H. D.'s poems has been briefly noted in a paragraph by Babcock (1995), 213; Nisbet (2013), 285–6 also comments on how '[t]he rhetoric of his introduction, which packaged the Anthology as the unmediated transcription ('straight talk') of humble and healthy Greek life, was swallowed wholesale'.

[71] As Aldington later complained 'imagisme, as written by H. D. and me, was purely our own invention and was not an attempt to put a theory into practice. The "school" was Ezra's invention': Letter to Herbert Read, January 1925, in Thatcher (1970), 18.

[72] The passages are both marked in pencil in H. D.'s copy of the 1911 edition, held in the Beinecke Rare Books and Manuscript Library, Yale University: Za D721 Zz911G. The book is inscribed 'Hilda Aldington'.

92 FRAGMENTARY MODERNISM

rigorously avoid the 'repetition of idea not necessary to the full expression of the thought, or some redundance of epithet or detail too florid for the purest taste'.[73]

If H. D. discovered in Mackail's late-Victorian selection a manifesto for the 'laconic speech' of twentieth-century inscriptional modernism, she also found in Mackail's *Anthology* a way of reading and understanding the epigrams of the *Anthology* as fragments. In the famous preface to his *Garland* (the first item from the *Anthology* printed in Mackail), Meleager presented his editorial activity as a gathering of flowers, associating each poet with a particular flower or other kind of plant, which he had woven together with his own into a garland:

> Meleager made it, and wrought out this gift as a remembrance for noble Diocles, inweaving many lilies of Anyte, and many martagons of Moero, and of Sappho little, but all roses, and the narcissus of choral Melanippides budding into hymns, and the fresh shoot of the vine-blossom of Simonides; twining to mingle therewith the spice-scented flowering iris of Nossis, on whose tablets Love melted the wax.[74]

Yet even the original *Garland* of Meleager itself had not quite survived: the 'many' poems of Moero he promised in his preface (*AP* 4.1.5), like the characterizing love poems of Nossis, did not materialize in the few poems in the surviving manuscript iterations of the *Anthology*.[75] Several poets – Anyte, Zonas, Nossis – have left only a handful of epigrams from much larger corpora, the only known traces of which are found primarily in the *Anthology*. As Mackail put it, 'To some broken stones, and to the chance which has saved a few hundred manuscripts from destruction, is due such knowledge as we have to-day.'[76]

In her unpublished essay 'Garland', held in the Beinecke Library in Yale, H. D. combines Meleager's act of flower-gathering with the realities of textual loss.[77] For H. D., Meleager, 'the be-getter of the whole collection' (128), was a preserver of fragments, who saved precious scraps of poetry from annihilation, 'collected the last flowers of beauty before they should be trampled out ruthlessly by some Juggernaut of the later religion' (128) when ancient texts were copied – or

[73] Mackail (1911), 2. [74] Mackail (1911), 93.

[75] Only two epigrams of Moero survive: *AP* 6.119 and *AP* 6.189. Moero later makes an appearance in Hipparchia's story in H. D.'s novel, *Palimpsest* (1926).

[76] Mackail (1911), 88. Mackail himself was an anthologizer, selecting only about 500 epigrams from Jacobs' edition interspersed with selections from Kaibel's edition of surviving inscriptions on stone.

[77] The essay appears in Part III of 'Notes on Euripides, Pausanias and Greek Lyric Poets'. Page numbers given in the text in brackets refer to the second draft typescript, Yale Collection of American Literature, Beinecke Rare Book and Manuscript Library, YCAL MSS 254, Box 44, 1119–20 (on the various manuscripts and their history, see Davis (1986), 144). It is not clear when the essay was written, though probably in the 1920s: see Gregory (1997), 58 with n.52 p.266, and certainly after publication of F. A. Wright's *Poets of the Greek Anthology* (London, 1924), which H. D. mentions several times in the essay.

not copied – from papyrus to parchment in the monasteries of Europe.[78] The *Garland*, for H. D., effectively became a treasury of fragments, and particularly the fragments of otherwise lost female poets like Anyte, Nossis, and Moero: 'there are fragments and references to lost fragments, and to some twenty women-poets of Greece' (132).

Part of H. D.'s creative response to the 'fragments' of the *Anthology* was to complete the missing pieces. While scholars offered conjectural emendations to the text or suggested contexts of inscription or publication now long lost, H. D.'s method was to select a 'fragment' from the *Anthology* (generally via Mackail) and imaginatively inhabit it. This would become her method in the 'Fragment' poems written from around 1916, which amplified the surviving pieces of Sappho,[79] but the strategy was particularly effective as a response to the poems of the *Anthology* because the impulse for completion was already written into the epigrams themselves. Sappho's poems as we have them are fragments created by chance breakages or randomly preserved in the quotations of grammarians or other writers with other agendas. By contrast, literary epigram was already self-consciously composed to play on the reader's exposure to presence and absence. As Peter Bing and others have argued, once epigram became a literary genre and lost its deictic referents to the sites of real inscription, ancient readers were encouraged to enter a game of completion and supplementation (*Ergänzungsspiel*), filling in the gaps, supplying the missing monument, imagining the lost landscape.[80] In the process, the 'empty spaces' (*Leerstellen*) left behind became a locus of readerly activity, functioning as semantic 'blanks' which readers were encouraged to complete in the epigram's process of meaning-making.

In reception, the game of readerly completion continued: now detached not only from stone but from the ancient world within which they once functioned, the activity of filling the blanks left by the original could take on new and more radical forms, as the reader's role transformed into an imaginative recovery not only of 'lost' inscriptional contexts but of a lost world.[81] For H. D., part of the process of gap-filling meant reinvesting the short poems in the *Anthology* with her version of 'the whole spirit of the Aegean and Ionian islands' ('Garland' 130) from which she felt they had been severed. In her early *Poetry* publications, 'Epigram (*After the Greek*)' is unusual in that it cut the original right down, recalling the stone on which the words were once incised (or imagined as incised) as well as the stones she saw in the British Museum's Hall of Inscriptions. But the other two

[78] Wright (1924), 96, similarly laments the fact that 'the prudery of monks has robbed us of the more passionate verses...which Meleager wove into his *Garland*'.

[79] Babcock (1990).

[80] For the *Ergänzungsspiel* involved in Hellenistic epigram, see Bing (2009), 85–106 with Meyer (1993), and for earlier examples, see Baumbach, Petrovic, and Petrovic (2010), esp. 17–18.

[81] For the suggestion that 'readers...ancient as well as modern' are complicit in filling in the gaps of epigram, see Baumbach, Petrovic, and Petrovic (2010), 18.

94 FRAGMENTARY MODERNISM

poems with which it was published instantiate H. D.'s emerging practice not only of Imagism (which the poems only partially fulfil) but of fragment completion. 'Hermes of the Ways', often singled out as a paradigmatic Imagist poem, picks up details from an anonymous epigram, set in an analogous pastoral landscape, to which Mackail had given the title 'Hermes of the Ways' (*AP* 10.12; Mackail (1911), 196–7), but it takes as its basis a four-line poem by Anyte of Tegea (*AP* 9.314: 'The Orchard-Corner', Mackail (1911), 207):

> Ἑρμᾶς τᾷδ᾽ ἕστακα παρ᾽ ὄρχατον ἠνεμόεντα
> ἐν τριόδοις, πολιᾶς ἐγγύθεν ἀϊόνος,
> ἀνδράσι κεκμηῶσιν ἔχων ἄμπαυσιν ὁδοῖο·
> ψυχρὸν δ᾽ ἀχραὲς κράνα ὕδρω προχέει.

I, Hermes, stand here by the windy orchard in the cross-ways nigh the grey sea-shore, giving rest on the way to wearied men; and the fountain wells forth cold stainless water.

Anyte's poem is spoken in the first person by an imagined statue of Hermes or a herm, at the base of which the inscription is imagined. The inscription is localized 'here' (τᾷδ᾽) in the cross-ways (ἐν τριόδοις) where herm boundary-markers were typically placed, near the grey sea-shore (πολιᾶς ἐγγύθεν ἀϊόνος). The epigram invites the reader notionally 'passing by' to give the words material life: a statue of Hermes, a windy orchard, a spring, a grey sea-shore. There is no further information about the location or the purpose of the inscription, and it is possible that the poem (which may have originally been intended for actual inscription) once also had a programmatic function within a poetry book, inviting readers into the metaphorical shelter of the epigram collection.[82]

H. D. shifts the speaker to the third person, inhabiting the role of the reader-passer-by enlisted to complete the ancient epigram over two millennia ago. In eleven chiselled verse paragraphs, 'Hermes of the Ways' recreates the missing context. Each paragraph focuses on the 'luminous detail' which Pound extolled, but which is also germane to the 'lapidary precision' of epigram:[83] the far off sea-shore, the dunes of 'coarse, salt-crusted grass' which 'whips round my ankles', the 'Apples on the small trees', 'the small-leafed boughs' and the statue of Hermes itself, 'Dubious/facing three ways,/welcoming wayfarers' (*CP* 38). Printed next in the sequence in *Poetry*, 'Priapus, Keeper of Orchards' (again often seen to 'demonstrate the methods Pound outlined'[84]), similarly expands another broadly pastoral inscription from the *Anthology*, a dedicatory inscription by Zonas

[82] For Anyte's epigram book, see Gutzwiller (1993).

[83] 'The artist seeks out the luminous detail and presents it. He does not comment': Ezra Pound, *I Gather the Limbs of Osiris* (1911–1912), reprinted in Pound, *SPr*, 23; 'lapidary precision': Mackail (1911), 4.

[84] Mackay (2011), 56.

(*AP* 6.22; Mackail (1911), 142), also set in an orchard and imagined as an inscription below a statue of Priapus. Outdoing the ancient epigram's 'force and directness' and tapping into its 'delicate feeling for nature', as Mackail put it,[85] H. D.'s expansion focuses on the sensory detail ('I saw the first pear/as it fell', *CP* 28), evoking the orchard fruits in hyphenated compounds that echo Mackail's translation, dedicated to the 'rustic-staked Priapus' (ἀγροιώτῃ τῷδε μονοστόρθυγγι Πριήπῳ), the 'rough-hewn/god of the orchard'.[86]

The three poems published in *Poetry* were just the beginning of an intense engagement with the *Anthology* and Mackail's *Selections* in H. D.'s poetic career.[87] Her first collection of poems, *Sea Garden* (1916), included 'Hermes of the Ways', 'Priapus, Keeper of Orchards' (under its new title 'Orchard') as well as 'Hermonax' (*AP* 6.223) and 'The Shrine' (which draws on another poem by Anyte, *AP* 9.144, entitled 'The Shrine by the Sea' in Mackail[88]), all of which 'completed' epigrams from the *Anthology* to underwrite a version of what H. D. saw as the 'spirit of the Aegean and Ionian islands' ('Garland', 130), and above all, its numinous seascape. 'Hermonax', in particular, probably also written in 1913 and also first published in *Poetry* magazine in 1914, engages with the poems of the *Anthology* as fragments. It takes its starting point from 'this broken fragment of sea-wandering scolopendra' by the fisherman 'Hermonax' to the sea gods Palaemon and Ino ascribed to Antipater of Sidon (second half of the second century BCE).[89] In H. D.'s version the fragmentary sea-creature becomes, as Eileen Gregory puts it, 'a metonym for the broken, fragmentary, imagist poem',[90] which also functions as a symbol of H. D.'s own processes of fragment retrieval in her reading of the *Anthology*. In the imagined dedicatory fragment, Antipater's λείψανον ('piece left', 'remnant', *LSJ s.v.*), can be read both as the sea creature and the poetic inscription itself.[91]

The female authors preserved in the *Anthology* came to represent a kind of poetic sisterhood for H. D.[92] 'The women writers suffered particularly' in the process of textual transmission, as she put it in 'Garland', and the *Anthology* – with

[85] Mackail (1911), 322.

[86] Cf. 'fresh-downed', 'fresh-stripped', 'thick-clustered', 'grape-bunch' in Mackail (1911), 142, with H. D.'s 'honey-seeking', 'rough-hewn', and 'red-purple' in 'Priapus, Keeper of Orchards'. For Zonas in this poem, see Babcock (1995), 206–7. For a reading that sees 'Orchard' as particularly emblematic of Pound's Imagist prescriptions, see Mackay (2011), 56.

[87] Gregory (1997), 168 reads H. D.'s interest in the *Anthology* as falling into two distinct periods: 1913, the first year of her career, and again throughout the 1920s in the aftermath of the war and the breakup of her marriage to Aldington. She was, however, still using the *Anthology* in between those periods in poems like 'The Cliff Temple', published in January 1916 in the *Egoist* (cf. *AP* 6.251), and 'I Said', published in 1919 (cf. *AP* 7.248 and 7.249).

[88] Gregory (1997), 234; Mackail (1911), 211. [89] *AP* 6.223; Mackail (1911), 132.

[90] Gregory (1997), 171.

[91] For an extended close reading of the poem, see Gregory (1997), 169–71, and for an extensive list of references to the *Anthology* in H. D.'s work, see Gregory (1997), 167–8 with 253–8 under individual ancient authors.

[92] As Bowman (2019), 77 notes, 'No ancient genre preserves as many female-authored poems as epigram.'

96 FRAGMENTARY MODERNISM

Meleager's *Garland* at its core – came to represent for her a treasury of the remaining 'flowers' by women writers saved from oblivion in 'fragments and references to lost fragments' (132). Sappho is not securely represented in the *Anthology*, and H. D., though she riffed on Meleager's phrase 'little, but all roses' in her engagement with Sappho, would turn directly to fragments from other sources in Wharton's edition, brought to the fore by the papyrus and parchment discoveries in Egypt which she was transcribing for Aldington in the British Museum.[93] But the *Anthology* contained other, all but forgotten, women poets, whose work survived in no other contexts but the collection itself. In Meleager's preface, it is not Sappho, but Anyte of Tegea (active at the turn of the 4th to the 3rd century BCE) who is given pride of place as the first poet to be mentioned: 'Meleager begins his Garland with the name of Anyte and offers her lilies' (132). Yet as Mackail pointed out in his note, the *Anthology* contains just about the only traces of Anyte left to modernity (as Mackail puts it, 'surprisingly... we know all but nothing of her from external sources' (1911), 311). When H. D. turned to *AP* 9.314 for 'Hermes of the Ways' and to a lesser extent to *AP* 9.144 on Aphrodite 'the Cyprian' (later translated by Ezra Pound and Richard Aldington) in 'The Shrine', she was not only filling in the *Leerstellen* engineered by the ancient epigrams' call for readerly supplementation: by inhabiting and amplifying the scant poems which Anyte left behind, H. D. was also filling in the blanks left by textual transmission.

Anyte's lilies complement the iris of Nossis, a self-declared belated rival of Sappho (*AP* 7.718) from Magna Graecia, active around 300 BCE.[94] In her essay, H. D. aligns Nossis, 'the later Greek poet... with her recrudescence of that passion at the very end of the Greek city-state period', with her earlier precursor, Sappho, as a victim of textual loss: 'The fiery utterances of both these poets were destroyed... by bands of ghoulish monks' who in deciding which texts to discard 'turned with particular offensiveness... upon these spiritual emotional Greek women' (131–2). Like Aldington, H. D. thought the loss of the work of poets like Sappho and Nossis was down to active Christian censorship of 'spiritual emotional' female eroticism rather than simple neglect or omission by scribes, who were generally more interested in theology and therefore less inclined to copy the manuscripts of their poems. Sappho fared better in the long run ('to Meleager there seemed "but little" though to us, in a... more barren age, there seems much'), but of Nossis' poetry, all we have are the eleven epigrams in the *Anthology*.[95] Her work as a love poet, for which she was celebrated in antiquity, is represented in just one four-line erotic epigram, *AP* 5.170 (Mackail (1911), 97),

[93] The three epigrams ascribed to Sappho in the *Palatine Anthology* (*AP* 6.269, 7.489, and 7.505) were not in Mackail's selection and H. D. knew them to be spurious from Wharton's edition. For H. D.'s transcription of Sappho fragments for Aldington, see Chapter 1, p.17.

[94] *AP* 7.718; Mackail singles out this detail in his biographical note on Nossis (314) and mentions that some of her epigrams are 'only inferior to those of Anyte'.

[95] 'The Wise Sappho', H. D. (1982), 68. H. D. is deliberately misreading Meleager's selection of Sappho as a form of fragment collection; as Bowman (2019), 82 suggests, Meleager clearly knew of more Sappho epigrams than he included in the *Garland*.

which is also one of only two epigrams by the poet included by Mackail in his selection.[96]

Published in 1924 in *Heliodora* (a collection which took its title from a cycle of epigrams by Meleager in the *Anthology*), H. D.'s poem 'Nossis' (*CP* 155–7) dramatizes the moment 'a hundred years or two or three' after Nossis' death when the fragments of the poet's 'fiery utterances' were saved from oblivion by Meleager. The poem is couched as a dialogue between two figures: a version of Meleager, apparently in the early stages of composing the preface to his *Garland*, and an unnamed speaker, perhaps the mysterious 'Diocles' whom Meleager names in his preface. As H. D.'s 'Nossis' begins, the Meleager-figure is engrossed in the idea of commemorating 'Nossis . . . a flame' (5). At first, the speaker is sceptical: 'a girl that's dead/some hundred years;/a poet – what of that?' (7–9). But 'Meleager' persists, declaring that he 'want[s] a garden', not, as the speaker initially assumes, a commemorative *hortus*, 'a terrace on a hill' (for 'men forget' (25; 23)), but 'a shelter/wrought of flame and spirit' (35). At this point, the poem shifts into italic type, incorporating directly material from the *Anthology* in the form of a version of the preface to the *Garland*, followed by *AP* 5.170, as H. D. explained in her note at the beginning of *Heliodora*, 'a poem of Nossis herself in the Greek Anthology':[97]

> *". . . He sought for Moero, lilies,*
> *and those many,*
> *red-lilies for Anyte,*
> *for Sappho, roses,*
> *with those few, he caught*
> *that breath of the sweet-scented*
> *leaf of iris,*
> *the myrrh-iris,*
> *to set beside the tablet*
> *and the wax*
> *which Love had burnt,*
> *when scarred across by Nossis:"*

when she wrote:

> *"I Nossis stand by this.*
> *I state that love is sweet:*

[96] The other is the epitaph on Rhinthon: Mackail (1911), 180. In speaking of Nossis, H. D.'s essay uses the imagery of Meleager's preface, 'the scented iris and upon her writing-tablets love melted the wax' (131), taken almost verbatim from Mackail's translation.

[97] As Babcock (1990), 44 observes, in contrast to reactions to Pound or Eliot, '[t]he failure of [H. D.'s contemporary] critics to recognize the sources of her work or to treat her writing as a serious engagement with a literary tradition may have led H. D. to begin explicitly detailing sources in her later books'.

> *if you think otherwise*
> *assert what beauty*
> *or what charm*
> *after the charm of love,*
> *retains its grace?*
>
> *"Honey," you say:*
> *honey? I say "I spit*
> *honey out of my mouth:*
> *nothing is second-best*
> *after the sweet of Eros."*
>
> *I Nossis stand and state*
> *that he whom Love neglects*
> *has naught, no flower, no grace,*
> *who lacks that rose, her kiss."*

H. D.'s version of Meleager's preface is tendentiously 'edited': all the male authors have been removed (she cuts out Melanippides and Simonides and skips over the forty-eight-line list of poets which follows in the extant preface), representing the *Anthology* explicitly as a repository of lost women poets, and of Nossis in particular. The poem then splices directly to *AP* 5.170, connecting the epigram grammatically and thematically with Meleager's preface ('when she wrote' (60)), and mingling his flowers with hers.

At some point, Nossis' original epigram was probably the opening of her own poetry collection,[98] and its four lines are a powerful expression of poetic self-positioning, programmatically foregrounding Eros as a subject, and naming the author as the speaking voice of the inscribed literary artifact ($\tau o \hat{\upsilon} \tau o \lambda \acute{\epsilon} \gamma \epsilon \iota$ Νοσσίς, 'Nossis says this'):

> Ἅδιον οὐδὲν ἔρωτος· ἃ δ' ὄλβια, δεύτερα πάντα
> ἐστίν· ἀπὸ στόματος δ' ἔπτυσα καὶ τὸ μέλι.
> τοῦτο λέγει Νοσσίς· τίνα δ' ἁ Κύπρις οὐκ ἐφίλασεν
> οὐκ οἶδεν τήνας τἄνθεα, ποῖα ῥόδα.

Nothing is sweeter than love, and all delicious things are second to it; yes, even honey I spit out of my mouth. Thus saith Nossis; and he whom the Cyprian loves not, knows not what roses her flowers are.

As commentators point out, and as H. D., who herself was powerfully steeped in the legacy of Sappho probably knew, the poem sets up Nossis as a poet in the Sapphic tradition. Its allusion to Sappho Fragment 16.1–4 ('Some say an army of horses...') wouldn't have been clear until the publication of the Oxyrhynchus

[98] Luck (1954); Skinner (1989), 7–8; Gutzwiller (1998), 75.

fragment in 1914 which H. D. would echo in 'Why have you sought the Greeks, Eros', first published in 1920), but the image of the poet self-consciously 'spitting out' the honey which had been used as a figure for mellifluous song by male poets from Hesiod onwards in favour of the rose as amatory emblem echoes another short fragment, 146 Lobel-Page, found in Wharton's *Sappho*, on which she would centre 'Fragment 113', published in 1921.

Unlike the inscriptions of Anyte, the words Nossis could once 'stand and state' were not inscribed on stone like carved words in a garden memorial or an epigram on a stele, but 'scarred across' a wax tablet. In the end, though, the medium made little difference to their permanence. Almost two millennia after her death, most of the flowers of Nossis' poetry had been destroyed, not by Eros who metaphorically burns the writing tablet as soon as her poem is scored into it, but by the end of the civilization in which she lived and the destruction of its cultural production on stone and on paper. In 'Nossis', H. D. imaginatively returns to the moment before that destruction, when Meleager gathered up the last fragments of her flame. In 'Nossis' and in her other versions of the 'lapidary precision' of the poems from the *Anthology*, the modern poet-gatherer selects the remnants from the pages of the *Anthology*, filling in the gaps around the 'fiery utterances' that had once been scored on wax or stone in her own memorial verse garden.

H. D.'s poetic voice had emerged through an engagement with the 'fragments and references to lost fragments' which she found in the *Anthology*, and from the make-shift manifesto for Imagism she discovered in Mackail's introduction. Like Meleager's flowers, her own poems, including the early engagements with the *Greek Anthology*, were anthologized in *Des Imagistes* (1914) and *Some Imagist Poets* (1915, 16 and 17), collections themselves partly modelled on Meleager's *Garland*.[99] Crucially, the literary revolution effected by Imagism and 'the starting point of modern poetry'[100] it came to represent, was centred on the traces of antiquity found in the *Greek Anthology*. Staged before the British Museum's Hall of Inscriptions, and mimicking the 'lapidary precision' of epigram, it was H. D., above all, who found in Greek inscriptions – mediated by Mackail's *Select Epigrams* – the fragments from which a new poetry could be written.

III. Paper Trail: Pound's 'Homage to Quintus Septimius Florentis Christianus' and the Delapidarisation of Epigram

H. D. wasn't the only one looking for an inscriptional modernism of the fragment in the *Greek Anthology*. Her creative and personal relationship with Richard Aldington circled around the *Anthology*.[101] 'Nossis', and especially 'Heliodora',

[99] For the 1915 collection as partly modelled by Aldington on Meleager's *Garland*, see Zilboorg (1991a), 70.
[100] Eliot (1966), 18. [101] Zilboorg (1990), 27.

100 FRAGMENTARY MODERNISM

which features two rival poets translating a pair of epigrams by Meleager, have both been seen to dramatize their creative collaborations between 1913 and 1916.[102] The *Egoist's* Poets' Translation Series, the 'joint venture' which they established together in this period, was also importantly framed by the *Greek Anthology*.[103] The project was inaugurated with Aldington's own version of the epigrams of Anyte of Tegea, including *AP* 9.314, which H. D. had used two years earlier and which Aldington, too, called 'Hermes of the Ways';[104] it closed with Aldington's *The Poems of Meleager of Gadara* (published in 1920 as number 6 of the second and final set), among which were translations of the 'Heliodora' epigrams that H. D. would appropriate in a dramatization of their creative process.[105] H. D. split from Aldington in 1919, and her relationship with the novelist Winifred Ellerman, known as 'Bryher', whom she met in the summer of 1918, too, began as an 'erotic rivalry encrypted in ancient texts',[106] with the *Greek Anthology* at its core.[107] She quickly set Bryher to look up and translate the flower names in the *Anthology*,[108] and shortly afterwards Bryher herself published 'Nine Epigrams' (1919), a translation of the poet Zonas from the *Greek Anthology*, including the same epigram that had formed the basis of H. D.'s 'Orchard'.[109]

Ezra Pound's interest in the fragmentary dynamic of inscriptions on stone and on paper in the *Greek Anthology* was both independent of and connected to H. D.'s.[110] Like H. D., Pound may not have paid particularly close attention to the stones he walked past in the Hall of Inscriptions on his regular visits to the library in London, but their presence as ancient lithic memorials clearly helped to instigate an inscriptional poetics in his work during the 'B. M. era' (*Cantos* 80/520) and beyond, from the early 'Epitaph' (a two-line poem on the sexual life of 'Leucis'

[102] Collecott (1999), 214–15; Zilboorg (1990), 38, (1991b). 'Heliodora' has also been read as a dramatization of Meleager himself and another rival: Yao (2002), 108.

[103] Zilboorg (1991a); Vandiver (2019).

[104] *Egoist* 9.2, September 1915, 139–40, republished in pamphlet form in 1919 with Edward Storer's translations of Sappho. For verbal echoes of H. D.'s version in 'Hermes of the Ways', see Zilboorg (1991a), 76. Aldington also translated *AP* 9.144 which she used in 'The Shrine'.

[105] For how Meleager assumed, for Aldington, 'the status of the ideal bard, the poet who was at once lover, writer, and editor', see Zilboorg (1991a), 70 with (1990) more broadly for the creative dialogue between H. D. and Aldington. Despite the liberation of the 'ambisexual Meleager' (Collecott (1999), 215), Aldington in fact omitted thirteen poems including 5.208; 11.223, and 12.86 which he describes as 'obscene': Chisholm (1996), 90 n.3.

[106] Collecott (1999), 203.

[107] In her autobiographical novel *Asphodel*, the Bryher figure (Beryl de Rothfeldt) writes to Hermione (H. D.): 'it meant so much to me to see you yesterday...You can't understand. I never met anyone who knew the *Greek Anthology*': H. D. (1992), 171. For their intense personal and artistic relationship, see McCabe (2021) and Hollenberg (2022), esp. 73–140.

[108] Collecott (1999), 204.

[109] Bryher, 'Nine Epigrams of Zonas', *The Nation*, 22 February 1919, 615. Bryher also proposed a translation of the *Anthology* to the publishers of H. D.'s *Sea Garden*: Collecott (1999), 203.

[110] Guest (1984), 40 assumes that it was Pound who introduced H. D. to the *Greek Anthology*, but there is no clear evidence for this.

first published in 1913) to the *Cantos*.[111] Pound's 'Stele', which appeared in *The Little Review* in 1918 as Part VI in a cycle of eight interlinked short poems which Pound called 'Moeurs contemporaines', echoes the discourses of classical epigraphy:

<div align="center">

VI

Stele

After years of continence
he hurled himself into a sea of six women.
Now, quenched as the brand of Meleagar,
he lies by the poluphloisboious sea-coast.

Παρὰ Θῖνα Πολυφλοῖσβοιο Θαλάσσης
SISTE VIATOR

</div>

'Moeurs' has been read as autobiographically inflected, and 'Stele' within it as the author's mocking autoepitaph.[112] Pound later called Wyndham Lewis' portrait of him a 'classic stele', and the title of this poem has also been linked with Henri Gaudier-Brzeska's *Hieratic Head of Ezra Pound* (1914, 'my bust by Gaudier' also mentioned in Part VII of 'Moeurs').[113] Yet 'Stele' also speaks to Pound's experience in the Hall of Inscriptions which he encountered en route to his favourite working space in London. Like Aldington (who had written his own 'Stele' published two years earlier),[114] Pound would have regularly seen inscribed stone blocks (stelae) on his way to the library, including the monumental Sigeum stele, discovered near the site of Troy, which stood at well over 2 metres high (Figure 3.2). The titular 'Stele' evokes the bulk of stone not just as a parallel to sculptural or pictorial mass, but as a locus of inscription. That sense is reinforced by further epigraphic gestures in the poem borrowed from ancient stone which reflect the literary habits of ancient epitaph-writers. The poem signs off with a Latin tag, set, like most Roman lithic inscriptions, in capital letters: *SISTE VIATOR* ('stop, traveller'), one of the most common Latin tombstone inscriptions from antiquity on.[115] The mythological reference to mortality, too, is common in ancient verse inscriptions (Meleager was not just the name of the first anthologist of Greek epigram: his namesake in Greek myth was said to have been destined by the Fates to live only as long as a certain log remained unconsumed by fire), and well-known lines or formulae from Homer (παρὰ θῖνα πολυφλοίσβοιο θαλάσσης,

[111] For the broader interest in inscriptions in the *Cantos*, see Myers (2006) with Culligan Flack (2015), 39 on an inscriptional epitaph for Elpenor, which Pound interpolated into the *Odyssey*. Pound was also interested in non-European inscriptions, and published two 'Epitaphs' in *Blast* I (June 20 1914), 45–50 on Fu I and Li Po: Riikonen (2008), 190.
[112] Dickey (2012), 160–1. [113] Dickey (2012), 160–1. [114] Aldington (1916), 14.
[115] Blänsdorf (2008). The formula even appears in John Locke's epitaph and was used by the Renaissance Neo-Latin poet Andrea Navagero in lines which Pound had translated in 1910: Ruthven (1969), 173.

102 FRAGMENTARY MODERNISM

'along the shore of the loud-sounding sea', which Pound leaves 'untranslated and untranslatable') are also commonly found on stone.[116]

Alongside stone monuments, Pound was also interested in the *Greek Anthology*. One of his earliest published poems was entitled 'Greek Epigram' in *A Quinzaine for his Yule* (1908), and in 'The Cloak', published in January 1912, he spliced together two epigrams of Asclepiades, one centred on the image of the cloak of love which hides two lovers (*AP* 5.169; 'Laus Veneris', Mackail (1911), 96) and another urging a woman not to be stingy with her virginity (*AP* 5.85; 'Dust and Ashes', Mackail (1911), 233).[117] Pound had officially stepped back from Imagism from the summer of 1914,[118] but the movement – and its inscriptional poetics – continued to underwrite his later work. In 1915, he published the epigrammatic 'Phyllidula' (1915), couched as a translation from the *Anthology*,[119] and he was still recommending Mackail's *Selections* to Iris Barry in July 1916.[120]

Around the same time (and around the time he was also working on 'Papyrus'), Pound produced his most sustained engagement with the *Greek Anthology* in 'Homage to Quintus Septimius Florentis Christianus', published in the September 1916 issue of *Poetry* as well as *Lustra,* published in the same year.[121] For H. D. and Aldington the *Anthology* – which for them meant largely Meleager's *Garland* – was a means of getting back to the fragments of the 'fiery utterances' and ancient landscapes which they felt the epigrams represented before the advent of the 'Juggernaut' of Christianity. By contrast, Pound was interested in the *Anthology* as what he called 'the florilegium of a long series of decades',[122] not restricted to Meleager's act of salvation and the period before it, but encompassing material that spanned almost a millennium and a half, from as far back as Archilochus (*c.*700 BCE) to tenth-century Byzantium, compiled and recompiled, excerpted and augmented by a long series of anthologists.

As Pound would have known from Mackail's introduction (pp.20–1), the *Anthology* goes back to around 900 CE, when a Byzantine archpriest (*protopapas*) named Constantine Cephalas combined material from earlier anthologies

[116] *LE* 250: I discuss the dynamics of non-translation in the poem in Goldschmidt (2019), 58–9.

[117] 'The Cloak' was first published in *North American Review* 115, 674 (January 1912), p.75. Ruthven (1969) links it with the image of the garment of dust by Julian the Egyptian in *AP* 7.32, not in Mackail. Pound had also compared the *Greek Anthology* with the poetry of the troubadours in *The Spirit of Romance* 1910 (p.90). For the pervasive influence of the *Greek Anthology* on Pound, down to the use of Greek and Greek-sounding personal names in his poems, see Riikonen (2008).

[118] Kenner (1971), 180–6, 191; Pondrom (1985), 74.

[119] *Others* I.5 (November 1915), 84. Pound wrote out the epigram by Parrhasius on the limits of art (= Mackail (1911), 193) on the MS typescript and included a note (which he cancelled) stating that the poem was a translation of the otherwise unknown 'Antipater of Cos': Ruthven (1969), 193. The handwritten autograph MS (YCAL MSS 43: Ezra Pound Papers, Yale Collection of American Literature, Beinecke Rare Book and Manuscript Library), also has the heading 'From Antipater of Cos'.

[120] Pound to Iris Barry [?20] July 1916 = Paige 137.

[121] *Poetry* 8.6, September 1916, 280–1. The poem was published almost simultaneously in *Lustra* (1916), 113–14, which contained some typographical errors. The text quoted here is from *Poetry*.

[122] Letter to Harriet Monroe, 27 March 1931: Paige 312.

from the Hellenistic and Roman periods available to him: primarily Meleager's *Garland*, the *Garland* of Philip, and the 'Circle' (*Cyclos*) of Agathias 'Scholasticus' (sixth-century CE), a large collection of contemporary epigrams, including some which he had written himself. Cephalas' original collection, like the anthologies on which he drew, is lost: our knowledge of them (along with our knowledge of 'virtually the entire history of the classical epigram'[123]) comes through two later selections: the mid-tenth-century *Palatine Anthology* (*Anthologia Palatina*), named after the Bibliotheca Palatina in Heidelberg where it was discovered in 1606, and another compilation by the thirteenth-century monk Maximus Planudes, for a long time the only known version of the *Anthology* available to modernity.[124] While Cephalas' original collection can, more or less, be reconstructed from the two surviving versions, the *Greek Anthology* as it stands is a long way from Meleager's carefully put together *Garland* of flowers, let alone the author-centred poetry books on which he himself had probably drawn: it is a compilation made from compilations of compilations of short poems which at one point had an inscriptional bias, extracted long ago from their original contexts of meaning.

Ancient epigram naturally vacillates between what Peter Bing calls 'the scroll and the marble'.[125] For the poems of the *Anthology*, the 'delapidarisation' of epigram – the process which shifted it from a mode of writing notionally connected with stone to one that was primarily meant for papyrus scroll – was crucially augmented by the chain of excerption and transmission which increasingly turned epigrams into paper artefacts. In reception, that process was exponentially intensified: from the moment Planudes' text was printed in 1494 (one of the first classical texts ever to be published in print), the *Anthology* was seized on by scholars, translators, and compilers, who selected, rearranged, and imitated its content, leaving a paper trail that took the epigrams even further from the inscriptional contexts to which they had once been anchored, even as many of them still gestured towards imagined contexts of inscription. As we have it in reception, the *Anthology* is an artefact much more embedded in its history as scroll or codex than the stone on which early epigram was carved.

Friedrich Jacobs' edition of the *Greek Anthology*, on which Mackail based his *Selections*, had sought systematically to gather up all the traces of the authentic text of the 'original' poems, and would have been available to Pound, who was a competent reader of critical editions, in the non-circulating collection of the British Library. But instead of using Jacobs or even, exclusively, Mackail's *Select Epigrams*, Pound turned to the work of the sixteenth-century scholar and

[123] Cameron (1993), 16.
[124] Planudes' text, which contains material not in in the *Palatine Anthology*, is problematically bowdlerized: as John Addington Symonds put it, he 'amended, castrated, omitted, interpolated, altered, and remodelled it to his own sweet will' (Symonds (1873), 344).
[125] Bing (2009).

104 FRAGMENTARY MODERNISM

translator Florent Chrétien (1541–96), who published under the Latinized name Quintus Septimius Florens Christianus. Chrétien was plugged into humanist circles: he studied Greek with the famous Henri Estienne (Henricus Stephanus), and served as librarian to Henry IV; among his prolific translation work (which included a Latin version of Euripides' *Cyclops*) was a selection and translation into Latin from the *Greek Anthology*, *Epigrammata ex libris Graecae Anthologiae*, published posthumously by Estienne's son Robert in 1608.[126]

Pound's choice of Chrétien's Latin translation could be put down to a 'characteristic perversity' which made him seek out the eclectic and obscure.[127] But the choice also worked productively. Like Divus' Homer in *Canto* 1, Chrétien's intermediary text brings to the fore issues of translation, non-translation, and mistranslation, and the few treatments of Pound's 'Homage to Quintus Septimius Florentis Christianus' that exist in Pound scholarship have tended to focus on this aspect of the poem.[128] Yet, as Pound declared, 'I am also aware that certain lines in this poem and in some of the others bear no particular relation to the words or meaning of the original and, Damn, the grammarians.'[129] Like most of his translations, 'Homage' is not an exercise in linguistic accuracy. From the start, the name 'Florentis' ought to appear as 'Florens' in the poem's title, and Pound's subtitle, *Ex libris Graecae*, taken from Chrétien's title page, is grammatically incomplete (*Anthologiae* needs to be understood), even as it powerfully evokes the materiality of the early modern book as well as the scrolls (*libris*) of the ancient anthology. Overall, the 'daring' translation practice in the poem can be seen as a precursor to the better-known *Homage to Sextus Propertius*, capturing, despite and even because of its philological errors, more of the meaning than the words of the target text, with results that are often 'far more effective and pointed than a literal handling of the original can be in English'.[130]

Yet taken together the sequence also works cumulatively as an exercise not just in radical translation, but in reception, transmission, and fragment collection. Working in the spirit of the long tradition of compilation and recompilation that underpins the *Anthology*, Chrétien (who died before the discovery of the Palatine manuscript) selected and augmented the text as he had found it, even, like the anthologists behind the ancient collection, interpolating his own epigrams (written in Greek with translations into Latin by his publisher) into the selection

[126] For the broader Neo-Latin reception of epigram, including the *Greek Anthology*, see Nisbet (2014).

[127] Nisbet (2013), 285.

[128] Riikonen (2008); Espey (1972). Espey goes so far as to claim that 'Pound selected his six epigrams for the variety of verbal opportunities they offered' (p.72).

[129] Typed marginal note in the autograph MS and typescript of 'Homage to Quintus Florentis Christianis', n.d., Yale Collection of American Literature, Beinecke Rare Book and Manuscript Library, YCAL MSS 43, Series IV). The first part of the sentiment was repeated in the back of *Poetry* 8.6 (329) with slightly different wording.

[130] Riikonen (2008), 187; Espey (1972), 69–70. See also Goldschmidt (2019), 60–1 for issues of translation and non-translation in the poem.

(p.32v and p.49r). His text includes not only epigrams from the *Greek Anthology* but an appendix of selected fragments and translations of Greek poets drawn from quotations in Athenaeus' *Scholars at Dinner* (pp.107r–109r) as well as a translation of *Hero and Leander* (which Pound knew from Marlowe's version[131]), ascribed to Musaeus (pp.109v–115r). The result is a sort of eclectic fragment collection fundamentally alienated from the early inscriptional contexts of epigram, a 'florilegium of the ages', based on the *Anthology* and its centuries of paper reception, but not completely confined to it.

In 'Homage', Pound makes his own selection from Chrétien's selection, anthologizing the anthology of the *Anthology* and translating not from the Greek but from Chrétien's Latin. Rather than attempting to capture the fragments of lost 'originals' from the *Anthology,* Pound's 'Homage to Quintus Septimius Florentis Christianus' implicitly charts the slippage from stone to paper in the *Anthology*. The poem is an homage to Chrétien. It engages with the Latin translation on a close linguistic level (sometimes punctuated by 'school-boy' mistakes),[132] but it also deliberately interacts with Chrétien's version as a link in the chain of the life of the *Anthology* as a series of compilations of texts that shifted epigram further and further from its original connection to stone inscription and more and more in the direction of a collection of fragmented voices from different time periods from the books of the *Greek Anthology, Ex Libris Graecae Anthologiae.*

Although the overall sequence deliberately resists interpretative narratives, by tracing the motility of epigram from marble to scroll over the long history of its compilation, Pound's poem implicitly plots a move from the inscriptional poetics of Imagism to the kind of multivocal and multitemporal fragmentation that would come to characterize Pound's particular brand of modernism in the *Cantos*. Following the order in which they appear in Chrétien, Pound picks out six epigrams ranging all the way from the 6th–5th century BCE to 6th-century CE. The sequence begins with early epigrams that could originally have been inscriptions on stone. An epitaph for Theodorus (*AP* 10.105) – uncertainly ascribed to Simonides (6–5th century BCE) but marked as *incerti auctoris* in Chrétien – which 'may well be inscriptional',[133] is followed by a dedicatory epigram of Anyte of Tegea (*AP* 9.144, Chrétien p.14r) to the goddess Aphrodite, associated with the land of Cypris:

<div align="center">

II

This place is the Cyprian's, for she has ever the fancy
To be looking out across the bright sea;
Therefore the sailors are cheered, and the waves

</div>

[131] Pound, *LE*, 227. [132] Espey (1972), 71. [133] Chrétien (1608), p.13r; Page (1982), 297.

106 FRAGMENTARY MODERNISM

> Keep small with reverence,
> > beholding her image.
>
> *Anyte*

Of all the poems in the selection Pound makes, Anyte's epigram is the closest to the original function of epigram as inscription. It is tied deictically to a real-world space in which the imagined stone is situated: 'This place' (οὗτος ὁ χῶρος; *hic locus*), the 'bright sea' (λαμπρὸν ... πέλαγος; *nitidum ... mare*) and the statue of Aphrodite ('her image', λιπαρὸν ... ξόανον; *illustrem statuam*) beneath which the poem is imagined as inscribed. The same epigram had been translated by Aldington for the Poets' Translation Series the previous year (entitled 'Engraved on a Statue of Aphrodite', in the *Egoist* 9.2, September 1915, 139) and formed the basis of H. D.'s 'The Shrine'. Pound's version metapoetically signals itself as an Imagist endeavour in the closing line ('beholding her image'), and focuses on the 'waves' that 'keep small' and the 'bright sea', in a high Imagist mode that echoes the dialogues with the *Anthology* produced by H. D. in particular.

But the 'Homage' progressively moves away from the Imagist immediacy of localized inscription and the possibility of accessing what H. D. called the 'fiery utterances' of the pre-Christian world. Parts III and V (*AP* 10.59 and 11.381, Chrétien (1608), pp.21$^{\rm r}$ and 31$^{\rm r}$) present a version of a pair of epigrams by the late antique pagan epigrammatist Palladas of Alexandria (*c*.400 CE).[134] Though ignored by H. D. and Aldington, Palladas is one of the best represented poets in the *Anthology*: Mackail counted 151 epigrams as genuinely his and included sixteen in his selection and Chrétien included thirteen in his *Epigrammata*. Traditionally associated with 'the coarse and bitter dregs of antiquity',[135] Palladas' epigrams reflect what Tony Harrison described in the preface to his own translations as 'the last hopeless blasts of the old Hellenistic world, giving way reluctantly, but without much resistance, before the cataclysm of Christianity'.[136] His poems come from a point in the development of the genre when authors of epigram would still often gesture to or play with the inscriptional origins of the genre (and genuine inscriptional poems continued to be composed), but they often shifted increasingly to a wide variety of other themes, expressed in the form of short, and often witty or satirical (or 'skoptic' from the Greek *skoptein* 'to satirize, mock') pieces that build up to a punchline or a 'pointe'.[137]

[134] On Palladas of Alexandria, see, e.g., Baldwin (1985); Wilkinson (2009); Braden (2016) (on reception).

[135] Peter Levi, quoted in Baldwin (1985), 268.

[136] Harrison (1975), 134. Cf. Mackail (1911), 329–30: 'His sombre figure is one of the last of the purely pagan world in its losing battle against Christianity'. Casaubon – as Mackail pointed out in the notes in the back of *Select Epigrams* – famously called him *versificator insulsissimus*, 'the coarsest of verse-makers', and Paton lamented in his introduction to Book Nine of the *Anthology* that it 'contains a good deal of Palladas, most of which we could well dispense with'.

[137] On the traditions of skoptic epigram, see Nisbet (2003).

AP 10.59, the first of Palladas' epigrams which Pound includes, was also printed by Mackail (despite Mackail's proto-Imagist claim that 'No good epigram sacrifices its finer poetical substance to the desire of making a point; and none of the best depend on having a point at all') under the title 'Parta Quies':[138]

<div style="text-align:center">

III

A sad and great evil is the expectation of death
And there are also the inane expenses of the funeral;
Let us therefore cease from pitying the dead
For after death there comes no other calamity.

Palladas

</div>

Mackail noted how '[f]or the most part his sympathy with the losing side is only betrayed in his despondency over all things', and it was probably in relation to this poem that Pound later spoke of 'the charm of Palladas' impartial pessimism' (1930).[139] The epigram's Epicurean take on the afterlife is couched in a way that could still conceivably read as an ancient funeral inscription. It draws on epitaphic tropes, the call to the passer-by to stop lamenting and the alleviation of death by the reminder that it is common to all, urging readers to 'cease from pitying the dead'.[140]

The second Palladas epigram, Part V of Pound's 'Homage' (*AP* 11.381), is much more in line with epigrammatic traditions far removed from stone:

<div style="text-align:center">

V

Woman? Oh, woman is a consummate rage, but dead or asleep she
pleases,
Take her—she has two excellent seasons.

</div>

As Eliot wrote in his introduction to Pound's *Selected Poems* (1928), 'Mackail's selections from the *Greek Anthology* are admirable except for being selections: that is, they tend to suppress the element of wit, the element of epigram, in the anthologists'.[141] Palladas' poem is precisely the kind of epigram Mackail was careful to omit from his *Select Epigrams*. The original probably goes back to an iambic poem by Hipponax (*c*.550 BCE), but the epigram has a famous afterlife of its own, when the balanced pentameter (ἐν θαλάμῳ ... ἐν θανάτῳ, *en thalamoi, en*

[138] Mackail (1911), 5, 292; Chrétien (1608), 21ʳ.

[139] Mackail (1911), 330; Ruthven (1969), 82; Pound, 'Horace', *Criterion* January 1930, 218, reprinted in *Arion* 9.2/3 (Summer–Autumn, 1970), 178–87 (179).

[140] Cf. Lattimore (1942), 17–20, 250. Pound 'mistranslates' the second line, *scilicet hoc lucri funus inane facit* ('to be sure, this is the profit that empty death brings'), as 'the inane expenses of the funeral': Espey (1972), 70–1.

[141] Pound, *SP*, 16.

108 FRAGMENTARY MODERNISM

thanatoi) combined with misogynistic posturing made it a favourite of translators, including not only Chrétien (who, followed by Pound, reversed the order of the lines) but Samuel Johnson, who translated it into Latin, as well as a whole range of English translators including several who followed in Pound's footsteps.[142] The poem's 'bitter force'[143] clearly appealed to Pound, for whom sardonic posturing – which can also be seen in the epigrammatic *Moeurs contemporaines* – was a standard poetic pose that also went on to inform the invective modes he would soon deploy in the *Cantos*.

Between the two Palladas epigrams comes an eight-line poem by Agathias 'Scholasticus' (*AP* 9.153, Chrétien (1608), 23r), the forgotten sixth-century CE anthologizer whose collection of contemporary epigrams formed part of the core of Cephalas' *Greek Anthology*. Where H. D. and Aldington focused on Meleager as 'the be-getter of the whole collection' ('Garland', 128), Pound, who includes no references Meleager at all in this poem, homes in on his obscure later successor whose name has all but disappeared from memory.[144] Instead of being couched as a lasting monument made 'permanently memorable'[145] in the form of an inscription on material culture, the epigram, composed on the stock rhetorical theme of the fall of Troy, commemorates its loss: the 'gilded shrines' and 'the works of your home-born sculptors', have all disappeared together with the world-famous ancient city that once gave them their contexts. In Pound's version, the epigram's pay-off, 'Time's tooth is into the lot' (*omnia tempus edax, bellumque, invictaque fata abripuere*), like the similar line in *Homage to Sextus Propertius* ('Death has his tooth in the lot', IX.2), stands as a comment on the fate not only of Troy but of the material and textual loss of antiquity in modernity.[146]

The sequence closes with a two-line epigram ascribed to Nicarchus (which Pound misspelled as Nicharcus), though it may perhaps be Callicter:

<div align="center">

VI

Nicharcus upon Phidon his doctor
</div>

Phidon neither purged me, nor touched me,
But I remembered the name of his fever medicine and died.

Like several real inscriptions, the epigram is spoken in the voice of the deceased, and like many inscriptional epitaphs, it mentions the cause of the entombed's death.[147] But like the Palladas epigram which precedes it, it also clearly sits within

[142] For the reception of the poem, see Braden (2016), 110–12. Peter Jay includes a run of examples which appeared after Pound (Jay (1973), 379–8).

[143] Mackail (1911), 330.

[144] The *Lustra* version misspells the name as 'Agathas': Pound (1916), 122.

[145] Mackail (1911), 4. [146] Espey (1972), 71.

[147] Epitaphs often mention the cause of death (Lattimore (1942), 142–58) and doctors are sometimes blamed specifically: Lattimore (1942), 152.

skoptic traditions of mockery that have more in common with Martial's Latin epigrams than those of Anyte (some mock whole categories of people including doctors). In the original and in Chrétien, the occupant of the tomb is not specified. Pound's heading, 'Nicharcus upon Phidon his doctor', turns the anonymous 'inscription' into the putative tomb of the poet himself on which his last words, spoken from the dead, are traced (the other poems in the sequence place the authorial attribution after the text). In Pound's paper version mediated by Chrétien's Latin selection, the distance between the putative tomb and the delapidarised text – between the marble and the scroll – becomes even more conspicuous. Nicharcus' material tomb has long disappeared – for readers of Pound's *epigrammata* even more than for ancient audiences. Yet the poet's words, as Pound's 'Homage' testifies, have made it through the mediations of reception and the processes of fragment gathering over centuries represented by the *Greek Anthology* and its afterlives. Though it might lack the closing 'triumph' as a translation, extracted from Chrétien, the closing epigram offers a fragmented voice from antiquity sitting between traditions of literary epigram '*Ex Libris*' to the kinds of real-world tomb inscriptions, hard 'like granite', which Pound encountered in the Hall of Inscriptions at the British Museum.

The *Greek Anthology* was more than 'a loose totemic inspiration'[148] for Pound: it was one of the key texts in his repertoire. Like the materially fragmented ancient texts to which he turned, the *Anthology* offered short texts that appealed to a crystalline poetics of concision which Pound had promoted in the theorizations of Imagism he never wholly left behind. The *Anthology* became the basis for what Eliot defined as 'a class of Pound's poems which may be called the Epigrams' in his early work, which 'occur *passim* throughout *Lustra*'.[149] But as a collection, it also offered a prototype for the kind of modernism which he was developing in the emerging *Cantos*. For Aldington and H. D., the *Anthology* was a means of gathering the surviving flowers of the classical past 'fragments and references to lost fragments'; for Pound, it functioned as a repository of 'a long series of decades' of voices, characters, and texts, mediated over centuries and expressed in quasi-fragmentary modes, from inscriptions like those he saw on the stelae on the way to the Reading Room to the satirical vituperations of Palladas.

H. D.'s statement in her memoir, *End to Torment*, that '[i]t all began with the Greek fragments'[150] tends to be linked with the fragments of Sappho.[151] But it was not – or at least not initially – with Sappho's poetry that the modernist preoccupation with the classical fragment began. Ultimately, Imagism and the modernism it inaugurated, emerged from a dialogue with the *Greek Anthology* against the

[148] Nisbet (2013), 285.
[149] Eliot, 'Introduction' to *Ezra Pound: Selected Poems* = Pound, *SP*, 16.
[150] H. D. (1979), 41. [151] See, e.g., Prins (1999), 5.

110 FRAGMENTARY MODERNISM

background of the Hall of Inscriptions in the British Museum. H. D.'s first published poems came 'from "The Anthology"'; it was with the *Anthology* that Aldington inaugurated the Poets' Translation Series, and it was in the *Anthology* and the stone inscriptions he saw on the way to the Round Reading Room of the old British Library that Ezra Pound, too, discovered an inscriptional poetics of modernism. Whether as flowers to be gathered, gaps to be filled, or fragments to be broken down, the inscriptional modes of the *Anthology*, recalling the 'weather-bit granite' from which they originated, fed into the fragmentary preoccupations which became the 'calling card'[152] of modernist writing.

Inevitably, the result transformed the ways in which Greek epigram could mean in reception, too. Mackail's *Select Epigrams* and the tradition of inscriptional writing it represented (or misrepresented) was absorbed into experiments as diverse as Pound's 'Homage', H. D.'s 'Epigram', and Edgar Lee Masters' *Spoon River Anthology*. Broken up and broken off, the *Anthology* – mediated by J. W. Mackail – was reinvented as a fragment collection that could allow modern writers to create a new inscriptional poetics from epigram. That is not to say that a collection as diverse as the *Anthology* could not also be invented and reinvented in various ways.[153] But though Imagism as a movement had dissolved by 1917, the poetry its writers developed in dialogue with the *Anthology* and the Hall of Inscriptions had brought into relief a mode of reading and writing, already latent in Mackail, through which the multiple 'fragments' of the *Anthology* could be re-inscribed with 'lapidary precision' in modernity.

The influence also travelled the other way. In 1916, *The Times Literary Supplement* published a review of the first set of Aldington and H. D.'s Poets' Translation Series, 'a bit of propaganda', as Aldington called it, for Imagism, which included Aldington's translations of Anyte and the strikingly Imagist versions of choruses from Euripides' *Iphigeneia at Aulis* by H. D.[154] The reviewer was John William Mackail, editor of *Select Epigrams from the Greek Anthology*.[155] Mackail was careful to point out the 'defects of scholarship...some wanton mistakes and apparently deliberate distortions' in the translations, particularly those of Storer and Aldington. But despite 'the wranglings of grammarians'

[152] Tytell (1981), 3.

[153] Nisbet (2013), 286–322, for example, traces a 'pastoral Anthology' in the translations of the 1920s (286).

[154] For an excellent discussion of the Poets' Translation Series, including Mackail's reviews in the *TLS* from the point of view of modernist translation practice, see Vandiver (2019). For the links between Imagism and the conception of the series, see Vandiver (2019), 9. H. D.'s translations of Euripides have been extensively discussed, see esp. Kozak and Hickman (2019), 63–128, the whole of Part II of which is dedicated to H. D.'s Euripides, and Varney (2010) on the dynamics of Imagism in the translations.

[155] Carr (2009), 796; Vandiver (2019), 12–16. Like most reviews in the *TLS* in the period, the essay was published anonymously.

defensively anticipated by the editors in the announcement to the series,[156] the result, Mackail openly acknowledged, offered something that could cross the divide between classical scholarship and modern writing. In the wake of 'the roar of guns' and despite clear errors of grammar and vocabulary:

> the renderings are nevertheless vivid, arresting, stimulating, even for scholars, and still more for those who, whether scholars or not, have a feeling for the common spirit, the essential kinship, of all poetry.[157]

By 1919, when Mackail published a second anonymous review for *The Times Literary Supplement* of the new set of the Poets' Translation Series, he had taken stock of the value 'even for scholars' not just of modernist translation but of the full-blown 'revolution in English poetry'.[158] When he wrote his last review:

> The *Risorgimento* of English poetry had indeed already begun; for several years its progress had been noted and was in truth abundantly manifest. But it was then immensely and astonishingly accelerated. Since then, the output has been continuous and ever increasing. Poetry, or what is meant for and passes as such, has become, one might say, the daily and customary speech of the new generation.

Despite his reservations about modern poetry ('or what is meant for and passes as such'), and 'the crudest blunders' in the translations he was reviewing, Mackail, who had also held the post of Oxford Professor of Poetry from 1906–11, had found something valuable in the 'customary speech of a the new generation':

> What the modern spirit seems to be searching after and calling for is the language of some new Impressionism; something crisp, acute, discontinuous.

The 'new world', for all its desire 'to discard and trample down the old', was clearly turning to antiquity. '[T]he most extreme revolutionaries cannot, even if they would, cut themselves off from the past', and classical scholars had a duty to contribute to the rapidly unfolding literary revolution:

> The instinct for the classics, even though blind, exists. To give it eyes, to guide it, to furnish it with the necessary training, is the task which lies before those who are responsible for the national education.

The tone might have modulated into the kind of patronizing pedantry (the 'intense if ignorant thirst for the classics') that modernists riled against, but

[156] Aldington (1915). [157] [Mackail] (1916). [158] [Mackail] (1919).

112 FRAGMENTARY MODERNISM

Mackail clearly sought to implicate classical scholarship in modern poetry's impulse to make it new from the old. Though Mackail might not have been directly aware of it when he wrote the review, the search for 'something crisp, acute, discontinuous' at the heart of modernism had come out of a dialogue with classical scholarship, and with the epigrams on paper and stone in the *Greek Anthology* mediated by his own earlier work as the editor and translator of *Select Epigrams*. The 'speech of the new generation' had importantly come out of what Pound called the 'laconic speech of the Imagists', forged in dialogue with the 'lapidary precision' of *Select Epigrams*.

Three years later, in 1923, when the 'astonishing' progress of modernism had become even more 'manifest', Mackail was elected president of the Classical Association – a society which he had helped to found in 1903.[159] The mission of the new institution of 'the advancement of education' and its aim 'to increase public awareness of the contribution and importance of the classics to education and public life' made the imperative to speak to 'the daily and customary speech of the new generation' more pressing than ever.[160] Modernism had something to offer 'even for scholars', and that realization would later become an institutional fact when T. S. Eliot was appointed president of the Classical Association in 1942.[161]

Modernism may have begun with Greek fragments, but the results were impinging back on the world of classical scholarship. Emphasizing the acute, the discontinuous, the fragmentary, a new mode of artistic production was changing the speech of a generation. From papyrology to philology to the inscriptional poetics of the *Greek Anthology*, it had found inspiration in the fragmentary discourses of classical antiquity and the work of classical scholars. The consequent sea-change in modern poetry had become impossible to ignore – 'even' for classical scholars like Mackail. As I argue in the chapters that follow, the feedback loop of mutual influence was active not only in the literary cultures of the period but in visual culture too. For it was in the British Museum – where the Hall of Inscriptions simultaneously accompanied the emergence of a new kind of poetry – that modernism and the museum found one of their most productive sites of exchange.

[159] See the entry on 'Mackail, John William' by Cyril Bailey, rev. by Richard Smail in the *Oxford Dictionary of National Biography* (2004).

[160] The quotation is taken from the Classical Association constitution. For the history of the Classical Association, see esp. Stray (2003a) and (2003b).

[161] Eliot's presidential address, 'The Classics and the Man of Letters', was delivered on 15 April 1942 = Eliot, *CP* VI, 295–309.

4

Modernism and the Museum

Making, Consuming, and Displaying Sculptural Fragments in the British Museum

The British Museum was not just a creative space for modernist writers working in the old Reading Room during what Pound called the 'B. M. era' in London in the 1910s (*Cantos* 80/520): it was a magnet for visual artists, too. From Wyndham Lewis, who liked to make sketches on the back of request slips in the old British Library, to Pablo Picasso, who visited in 1919, the museum drew some of the most innovative artists into its orbit.[1] They came searching for something new, and they found it substantially – as commentators often point out – in the extra-European material from Asia, Africa, and the Pacific Islands. Alongside the Egyptian and Assyrian holdings, an extensive ethnographical collection took up almost the whole of the top floor of the East Wing,[2] and, until 1940, a pair of large-scale statues from Rapa Nui could be seen in the neoclassical entrance portico.[3] The appetite for transcultural traditions tends to be seen, in line with the rhetoric of modernists themselves, as a way of performatively side-stepping the classical canon of European art in favour of alternative genealogies that stretched eastwards, southwards, and westwards. This seemed to be summed up in February 1914 by Ezra Pound (who was then in the process of realigning his allegiances from Imagism to Vorticism and from poetry alone to visual culture), when he urged 'all rightly constituted young futurists', to violently reject classical sculpture as mere 'cake-icing and plaster of Paris',[4] in favour of 'world-sculpture'.[5]

[1] Wyndham Lewis was issued a reader's ticket on 9 November 1906: Caracciolo (1996), 278 n.29; for his drawing, 'Reading Room' (1915), made on a book requisition slip, see Michel (1971) pl. 38, p.361. For Picasso, see, e.g., Richardson (2007), 117.

[2] Locke (2011), 86–7. The material was moved to the Museum of Mankind in Burlington Gardens in 1970.

[3] Arrowsmith (2011), 6–8. For modernism and world art in the museum, see also Qian (2003) ('Pound and Chinese Art in the "British Museum Era"'), 3–21 and Cohen (2020), 37–8, 141. Generally on modernism's 'transnational turn', see Mao and Walkowitz (2008), 738–42; Jailant and Martin (2018), and Park (2019).

[4] Ezra Pound, 'The New Sculpture', *The Egoist* I.4, 1914, p.68.

[5] *The New Age*, 4 February 1915, 409–11: Zinnes (1980), 16. Pound uses 'futurists' as a generic term: he commented in *Blast* 1, 1914–15 ('The Melodrama of Modernity' 143–4) that '[o]f all the tags going, "Futurist" serves as well for general application for the active sculptors of today' and 'in England does not mean anything more than a painter . . . showing a tendency to rebellion against the domination of the Past'. For Pound's crucial involvement in the visual cultures of modernism, see esp. Humphreys (1985), Beasley (2007), Arrowsmith (2011).

Fragmentary Modernism: The Classical Fragment in Literary and Visual Cultures, c.1896–c.1936. Nora Goldschmidt, Oxford University Press. © Nora Goldschmidt 2023. DOI: 10.1093/oso/9780192863409.003.0005

114 FRAGMENTARY MODERNISM

As Rupert Richard Arrowsmith puts it, 'western modernism' as represented by Pound and the circle of artists around him, effected 'an aesthetic and technical revolution with its origins very far indeed from classical Greece' in dialogue with the collections of the British Museum.[6]

But modernism's transnational turn did not involve the wholesale rejection of classical antiquity that it loudly announced. Writers and artists branched out to discover alternative modes of art – and other parts of the British Museum – but they continued to take the classical material seriously as part of a rehierarchized and reconfigured portfolio of artistic influences. Despite the rhetoric, 'those *damn* Greeks', as the sculptor Henri Gaudier-Brzeska called them,[7] were absorbed into modernist aesthetics in fundamental ways, and often by the very same artists who vocally rejected them. The turn to classical antiquity was not just a case of a post-war 'return to order', *rappel à l'ordre,* with which it is conventionally associated, though the severed and mutilated bodies of the First World War did feed into post-war visual discourse.[8] It was central to modernist art-making before as well as after the war, and it involved not just what Ana Carden-Coyne identifies as a rhetoric of 'peaceful repose and sanitized beauty' aimed at post-war reconstruction,[9] but a visual language of fragmentation and incompletion that mirrored the acute interest in the classical fragment that was burgeoning in the literary cultures of the period.[10]

What made the British Museum so compelling as a space of engagement for fragmentary modernism, moreover, is that the dialogue with antiquity also worked in the other direction: from modernism back to the museum, and to the archaeologists and curators in charge of the museum collections. The restoration and display of Greek and Roman sculpture in the British Museum became the subject of radical re-evaluation in the 1920s and 1930s, culminating in the re-display of the so-called 'Elgin Marbles', the iconic sculptures from the Parthenon in Athens, which placed a new emphasis on their status as fragments. As I argue in this chapter, the curatorial re-evaluation which took place behind the scenes in the museum was predicated on the emphasis that was being placed on the fragment form by modern artists and writers.

The more contemporary artists and writers evoked the fragments of antiquity – many of which they had seen in the museum – in their new production, the more those ancient fragments began to seem increasingly modern, not only to the

[6] Arrowsmith (2011), 23; cf. Qian (2003), 3–21. [7] Pound, *Gaudier-Brzeska*, 23, 33.

[8] The phrase *rappel à l'ordre* is usually attributed to Jean Cocteau's 1926 essay, but it was probably coined earlier by André Lhote: Ziolkowski (2015), 44–5. For the post-war return to order with which modernist engagements with classical art are regularly linked, see esp. Cowling and Mundy (1990); Silver (2010); Ziolkowski (2015); Martin (2016).

[9] Carden-Coyne (2009), 21.

[10] Fundamental on modernism and classical art beyond flashpoints such as the *rappel à l'ordre* is Prettejohn (2012), though she does not focus on fragmentation or the museum; Vout (2018), 221–42 contains important discussion of the continued life of classical art in the twentieth and twenty-first centuries, and Squire, Cahill, and Allen (2018) focuses on contemporary art.

general public who consumed them but also to those responsible for display and restoration practices in the museum. Modernism's interest in the classical fragment re-focused the ways in which the material in the museum itself was read. From the Reading Room to the Elgin Room, the 'apotheosis of the fragment' effected by artists and writers in the first decades of the twentieth century penetrated even the most apparently impenetrable academic spheres inhabited by curators of Greek and Roman antiquities. The results fundamentally changed the ways in which fragmentary classical sculpture is displayed in the British Museum – and ultimately the fabric of the building itself.

I. 'a fraud upon the public': Restoration and Derestoration

In 1921, Jacob Epstein – whom Ezra Pound had recently called 'the greatest sculptor in Europe'[11] – wrote a letter to *The Times* to complain about the restoration of classical antiquities in the British Museum. The object in question was the statue of Demeter of Cnidus in the Greek Ante-Room on the ground floor of the museum. The seated figure, which had been discovered in south-western Turkey in 1858 with her arms broken off above the elbow, her legs damaged from the knee down and her nose partly missing, had been recently 'completed' with a plaster nose.[12]

> Sir,—All those who care for antique sculpture will view with astonishment and dismay the present policy followed by the British Museum authorities in restoring the Marbles, that is working them up with new plaster noses, &c.
>
> I have remarked with growing alarm marble after marble so treated during the last year. I felt the futility of protesting, and so held my peace, but now the incredible crime of 'restoring' the head of Demeter of Cnidus has at last been committed, the atrocity calls for immediate protest.
>
> No doubt the Museum authorities do not like the Marbles in their possession, but why they should translate the masterpieces into something approaching the Albert Moore ideal of Greek passes understanding... Other important pieces 'improved' are the marble boy extracting a thorn from his foot, and the very fine priestess from Cnidus, so altered as to give an entirely different effect from that it originally had. How long are there vandals to have in their 'care' the golden treasury of sculpture which at least they might leave untouched.
>
> Yours respectfully,
> JACOB EPSTEIN

[11] 'Art Review', *The New Age*, 4 March 1920, 291–2 (signed B. H. Dias), reprinted in Zinnes (1980), 140.
[12] 'Ancient Marbles: Policy of Restoration', *The Times* 2 May 1921, 42709, p.12, col. E. The letter is dated 29 April 1921.

116 FRAGMENTARY MODERNISM

The following day, an anonymous correspondent for *The Times* took the museum's position in a strongly worded defence.[13] Epstein's letter, the correspondent reported, had drawn a crowd who came to see the sculpture 'and judge for themselves'. According to the correspondent, the public liked what they saw: 'the most dignified figure in marble becomes ludicrous when it loses its nose, and a nose of plaster is better than none at all', and besides, 'the restoration of statuary has been a general practice for centuries'. A more circumspect response was given by Percy Gardner, an Oxford professor of Classical Archaeology and Art, who waded into the debate in his own letter to *The Times*. 'To restore the Demeter of Cnidus is no doubt venturesome', he wrote: 'I should have preferred to leave the figure as it was found, and to place beside it a cast of the head, restored and tinted.'[14] For Gardner, however, some restoration was necessary in order to prevent ancient sculptures looking like modern amputees: 'When statues have been wrongly restored in marble in past days, and the additions have to be removed, some fresh supplements are necessary; or our museums would look like a surgery in a battlefield.' Broken bodies – amputated limbs, badly damaged faces – had become an increasingly visible part of everyday life in the aftermath of the First World War. But while contemporary art and writing had responded to the new fragmentary experiences of modernity, classical sculpture, so some still felt to varying degrees, should be offered to the public in what Ezra Pound called a 'caressable' form, its scars and breakages removed or smoothed over.[15] As Jacob Epstein complained, the practice was in danger of blunting the broken edges of ancient fragments, not so much into what they once might have been, but to the soft-edged visions of antiquity which had populated nineteenth-century painting.[16]

Within two years, however, the museum had revised its assumptions about public taste. Epstein's call for immediate protest inspired a certain Bernard Smith (who seems to have been well-known for his practical jokes) to demonstrate the dissatisfaction with Demeter's prosthetic nose by squirting it with raspberry jam from a syringe.[17] By February 1922, 'in light of the experience', the sculpture's new nose, along with a number of other nasal completions that had been fitted in

[13] 'The False Nose of Demeter', *The Times*, 3 May 1921, issue 42710, p.9, col. C.

[14] Percy Gardner, 'Ancient Marbles', Wednesday, 4 May 1921, issue 42711, p.6, col. E.

[15] Ezra Pound, 'The Caressability of the Greeks', the *Egoist*, I, 6, 1914, p.117; 'Affirmations: Jacob Epstein', *The New Age*, 21 January 1915, 311–12, reprinted in Zinnes (1980), 10–15. On the reconstructive healing uses to which classical art and classical monuments were put, see Carden-Coyne (2009), 110–59.

[16] Though Epstein singles out Albert Moore in his letter, he was not quite doing justice to him: Moore's representational paintings on classical themes have themselves been read 'on much the same the same level terms as those of the great abstractions of the twentieth century': Prettejohn (2007), 126.

[17] 'Jam on Nose of a Goddess', *Daily Herald*, 10 July 1922, p.5, col. B; Epstein (1940), 207. Not much is known about Bernard Smith, though he is reported to have played a hoax on a professor of metallurgy by throwing a meteor through his window and claiming it had been a thunderbolt: 'Some Other "fools"!', *Derby Daily Telegraph*, 1 April 1930, issue 15142, p.4, col. E.

the previous two years under Arthur Smith, was finally removed, and the goddess was returned to the fragmentary state in which she had been discovered.[18]

Epstein's explosive exchange with the British Museum brought to the fore tensions rumbling beneath the surface surrounding the display of fragmentary ancient sculpture. Throughout the 1920s and 1930s the display of the Greek and Roman collections was being transformed. Plaster casts were removed from the main galleries (the museum opened a temporary cast gallery in a large shed where the New Wing now stands in 1909 but it was dismantled and dispersed by 1935),[19] and fewer pieces were put on show in the previously crowded galleries, now set off by lighter, more 'modern' coloured walls.[20] At the same time, a debate was raging around the display of the museum's prized collection, the sculptures from the Parthenon known as the 'Elgin Marbles'. When the sculptures first arrived in the British Museum in 1816, they were put on display in the fragmentary state in which they had been acquired.[21] At the time, the major museums of Europe, despite some advocates against the practice, regularly 'completed' what were often considered the unsightly mutilations of fragmentary ancient sculpture with new marble additions.[22] In Munich, the Aegina Marbles (discovered in 1811 and purchased by Crown Prince Ludwig of Bavaria following an international bidding war with institutions including the British Museum) were sensationally restored by the Danish sculptor Bertel Thorvaldsen (1770–1844) and put on show in the Glyptothek at its opening 1830.[23] Thorvaldsen, a leading neoclassical sculptor, followed contemporary restoration practices by leaving no gaps in the damaged sculpture;[24] he worked with such skill that many of his contemporaries (and on some accounts even Thorvaldsen himself) claimed that the original could not be distinguished from the restoration.[25]

[18] 'Statues with Plaster Noses: British Museum Experiment Abandoned', *The Times*, 22 February 1922, issue 43272, p.8, col. A ('Plaster noses have been tried for two years on some of the statues, but the Trustees of the British Museum recently reconsidered the situation in light of the experience and decided that the noses must go'). The promised picture on p.14 seems to have been withdrawn before final publication.

[19] Jenkins (1992), 229, 214; Wilson (2002), 239. Pryce (1913) details the content of the cast room.

[20] Jenkins (1992), 229.

[21] I focus here on the display of the sculptures in Britain rather than their removal from Greece, though it is clear that at least some damage was caused by Elgin's own agents (they cut off the backs of some of the thicker slabs) and in transit (the second shipment was shipwrecked and had to be recovered from the bottom of the sea): Greenfield (1996), 63–5; St Clair (2022).

[22] On the history of the restoration of antiquities and the complex debates surrounding the practice, see esp. Grossman, Podany, and True (2003) and Kunze and Rügler (2003).

[23] See esp. Wünsche (2011), 57–144.

[24] King Ludwig of Bavaria, who had commissioned the restorations, even suggested that Thorvaldsen use 'surplus' marble fragments to complete the damaged figures in the east pediment: Wünsche (2011), 113.

[25] Wünsche (2011), 153–5. On the politically motivated derestoration of the sculptures in the 1960s, see Diebold (1995). Casts from the Aegina marbles could be seen in the Phigaleian Room of the British Museum in the first half of the twentieth century: Jenkins (1992), 63, 65–6; Arrowsmith (2011), 5.

118 FRAGMENTARY MODERNISM

Yet along with the Venus de Milo, purchased by the Louvre in 1821 (which went on display in its fragmentary state largely due to the fact that no consensus could be reached about the disposition of the arms),[26] the sculptures from the Parthenon in the British Museum were left unrestored. It was acknowledged that the lack of restoration would probably de-value them in monetary terms (as the government Select Committee reported, in an art market which still preferred polished and restored antiquities, their 'mutilated state' would be 'little adapted for the decoration of private houses').[27] But although Elgin himself had tried more than once to have them restored,[28] it was decided that the 'Elgin Marbles' should be shown, in pieces, as the fragments they had become.[29] Some viewers remained shocked by the results, complaining of 'disgust rather than pleasure ... to see parts of limbs, and bodys & stumps of arms & c.',[30] but for many the combination, in Keats' words, of 'Grecian grandeur with the rude/Wasting of Old Time', fed directly into the new value placed on broken and partial forms by Romantic poets and the cult of the ruin.[31]

By the early twentieth century, however, the practice of acquiring casts of the missing pieces held in other museums meant that the marbles were on show in a much more complete state. Elgin had brought back some casts from Athens, which were initially displayed in the museum side by side with the originals in an aesthetic arrangement that sought to create a sense of balance and harmony.[32] When the collection was moved to the 'Elgin Room' in 1832, plaster casts were used to fill in the missing pieces in a more accurate archaeological picture, and the programme was enthusiastically continued under Arthur Smith, Keeper of Greek and Roman Antiquities from 1909 to 1925.[33] By 1915 (when the sculptures were packed up and removed for safety to Aldwych Tube Station during the First World War), only about 58 per cent of the frieze on show was original, with 42 per cent made up of plaster casts.[34] There were plaster additions on the Metopes and the West Pediment,[35] and while casts were used to fill in whole missing sections of the frieze, the pediments, and the metopes, they were also 'adjusted' to

[26] Hales (2002); Curtis (2003); Cohen (2015), 479; Prettejohn (2006); Wünsche (2011), 157.
[27] Brewer (1997), 227–31. [28] Rothenberg (1977), 163–89; St Clair (1998), 149–50.
[29] Briefel (2006), 87 notes that one of the motivations behind the fragmentary display was to provide a visual reminder of the dangers from which the sculptures had ostensibly been rescued.
[30] Ballantyne (1988); Briefel (2006), 85.
[31] *On Seeing the Elgin Marbles*, ll.12–13. On the Romantic fragment and its differences from modernist practice, see 'Introduction', pp.8–9, with Mcfarland (1981); Janowitz (1990); Wanning Harries (1994); Janowitz (1999); Strathman (2006), and Thomas (2008).
[32] Jenkins (1992), 79; Payne (2021), 48–50.
[33] Jenkins (1992), 81–2, 224–5; Payne (2021), 49–50.
[34] Officer's Report (A. H. Smith), 5 February 1915: British Museum Central Archives. The report specifies that only 'about 247 feet out of a total of 420 feet, or 58 per cent' of the frieze on display was original.
[35] 'Suggestions for the New Exhibition of the Sculptures of the Parthenon', dated September 1929: British Museum Central Archives, Building Records, Duveen Gallery, 1928–32 (Folder 2: Duveen Gallery 1929).

the human figures: missing heads, arms, and feet, part of a shoulder or a neck were regularly completed with fragments cast from pieces held in other European museums to give the impression of a more complete whole.[36] The drive for completion in plaster was still being pursued in 1924 (even as the Parthenon itself was being controversially rebuilt on site in Athens by Nikolaos Balanos[37]) when Arthur Smith arranged to strike new casts of the missing pieces of the frieze from existing moulds and commissioning new ones from Athens to join to the display.[38] With little to distinguish the original from the cast additions (the plaster seems to have been coloured and retouched), the public was presented with an image of the Parthenon that attempted to partially obscure its strikingly fragmentary form in modernity and reconstruct its original architectural completeness.[39]

In 1928, however, a radical re-exhibition of the sculptures from the Parthenon in the British Museum was proposed. In 'a reversal of the policy that had been pursued for about a hundred years', as Smith (now retired) described it,[40] John Davidson Beazley (Lincoln Professor of Classical Archaeology and Art at Oxford), Donald Robertson (Regius Professor of Greek at Cambridge), and Bernard Ashmole (who would become Keeper of Greek and Roman Antiquities himself in 1939) presented a fundamentally different outlook in their report on the projected new display for the Royal Commission on National Museums and Art Galleries.[41] In contrast to Smith's drive to present the Parthenon as a complete architectural unit through cast additions, the modern preference for the fragment form was about to dramatically infiltrate the museum's policy. 'The Parthenon sculptures, being the greatest body of sculpture in existence, and unique monuments of its first maturity, are primarily works of art', the signatories of the report explained.[42]

[36] Beard (2002), 163. Smith (1892), 101–93 details a number of casts taken from the missing pieces from Athens, Paris, and Copenhagen, which were adjusted to the marble sculptures in the British Museum. On some of the 'joins' made by the masons, see Jenkins (1990), 98–9.

[37] On the restorations of the Parthenon and other sites on the Acropolis by Kavvadias and Balanos, see Mallouchou-Tufano (1994), (2007b); Bouras (1994); Loukaki (2008), 208–14.

[38] Jenkins (1992), 224–5 (casts ordered from Athens); see also Officer's Report, 19 February 1924: British Museum Central Archives, for the incorporation of new casts.

[39] For the retouched and coloured plaster, see Robertson, Beazley, and Ashmole, 'Suggestions for the New Exhibition of the Sculptures of the Parthenon', dated September 1929: British Museum Central Archives, Building Records, Duveen Gallery, 1928–32 (Folder 2: Duveen Gallery 1929) and Forsdyke 'Notes on the Exhibition of the Sculptures of the Parthenon' (probably late 1929: Marshall (2012), 47 n.12), on the metopes ('where these are coloured to match the originals, it is not possible to see which is which'). Smith later put it down to natural discoloration of the plaster: *Memorandum on the Proposed New Elgin Room*, privately printed; 24 October 1930: British Museum Central Archives, Building Records, Duveen Gallery, 1928–32, pp.6–7.

[40] *Memorandum on the Proposed New Elgin Room*, privately printed; 24 October 1930, p.1: British Museum Central Archives, Building Records, Duveen Gallery, 1928–32.

[41] 'Suggestions for the New Exhibition of the Sculptures of the Parthenon', dated September 1929: British Museum Central Archives, Building Records, Duveen Gallery, 1928–32 (Folder 2: Duveen Gallery 1929). For discussion, see Jenkins (1992), 225–9 and Marshall (2012), 35–7.

[42] 'Suggestions for the new exhibition of the sculptures of the Parthenon', dated September 1929: British Museum Central Archives, Building Records, Duveen Gallery, 1928–32 (Folder 2: Duveen Gallery 1929).

120 FRAGMENTARY MODERNISM

The pediment statues in particular 'are a series of extremely beautiful fragments' and '[c]are must be taken to reveal the excellence of each piece'. As to casts and restoration, '[i]t goes without saying that outline restoration of the missing figures is a gross error of taste'. Going further than Georg Treu, who had often replaced the missing limbs and heads of the derestored sculptures in the Albertinum in Dresden with casts of what he felt to be archaeologically compatible pieces from other museums, in the British Museum this extended to the removal of plaster casts of the known missing pieces.[43] '[T]he present retouched and coloured plaster' urgently needed to go. It was not 'honest', and 'the attempt to disguise the difference of material...is a falsification...and a fraud upon the public'.[44]

Various plans for the new display, to be funded by Joseph Duveen, were considered before a design by the American architect John Russell Pope was approved in revised form. Pope's design had its problems (not least because it did not quite fit the 'unobtrusive and unpretentious building...exist[ing] for the sake of its contents' which the signatories of the report had stipulated), but it importantly allowed for the display of the marbles in a way that conformed to a new aesthetic value which placed them as fragmentary works of art. The sculptures from the Parthenon in the British Museum could now be fully embraced not simply as relics representing the architectural experience of the ancient temple, but as modern fragments. As the Tübingen archaeologist Ferdinand Noack wrote in response to the proposal for new plans, a fragmentary sculpture like the Poseidon Torso on the West Pediment (Figures 4.1 and 4.2) 'today only has its effect as an isolated fragment of sculpture'. Allowing them to be seen as such would be a public boon: 'for them, and ultimately for the specialist too, it is the powerful appeal of the individual figure that really matters...[and i]t will not be archaeologists alone who will be thankful for this'.[45]

In practice, the building of the new gallery was not completed until early 1939, when the sculptures had to be removed almost as soon as they were installed in the general evacuation of the museum during the Second World War. And yet despite the delay, the new aesthetic, based, as Smith complained in his report, 'on the assumption that the right way to do due honour to the marbles is to exhibit them

[43] Knoll (1994a), (1994b), (2003), (2011); Pinelli (2003).

[44] 'Suggestions for the New Exhibition of the Sculptures of the Parthenon', dated September 1929: British Museum Central Archives, Building Records, Duveen Gallery, 1928–32 (Folder 2: Duveen Gallery 1929). John Beazley had been undertaking his own programme of derestoration in the cast gallery of the Ashmolean Museum in Oxford, where he removed the cast restorations from antiquities including Thorvaldsen's completions of the Aegina marbles almost forty years before the process would be undertaken in Munich: see Kurtz (2000), 292.

[45] F. Noack to Lord D'Abernon (Sir Edgar Vincent, first Viscount d'Abernon, chair of the 1928 Royal Commission on National Museums and Galleries) 7 July 1929: British Museum Central Archives, Building Records, Duveen Gallery, 1928–32 (Folder 2: Duveen Gallery 1929, containing both the original German and English translation). Noack was in favour of keeping the cast additions on the frieze, however, to prevent them seeming 'too fragmentary'.

Figure 4.1 The old Elgin Room, c.1920, including the 'Poseidon' torso with adjusted plaster cast of the matching piece from Athens.

divorced from all supplements in plaster', ultimately won out.[46] When it was finally opened to the public in 1962, Pope's building deliberately emphasized aesthetic over archaeological factors, showing the Parthenon inside out, with the frieze running along the walls of the gallery and the pediments raised on platforms at either end. Although he had initially planned to retain the plaster completions to the pediment sculptures, under pressure from the report's authors, the plans were changed to remove all the casts.[47] Whereas the pediment sculptures, and especially the metopes, had previously been set significantly higher up, Pope had responded to the call that 'all the sculpture of the Parthenon must be set on the level of the eye'.[48] The result was that they could now be seen 'in isolation', at

[46] Arthur Hamilton Smith, *Memorandum on the Proposed New Elgin Room*, privately printed; 24 October 1930, p.2.

[47] Pope had initially proposed to retain casts in the pediments and metopes, but after John Forsdyke (then Assistant Keeper of Greek and Roman Antiquities and soon to be appointed Keeper (1932–36)) noted that casts 'must certainly go from the Pediments, where they are disfiguring, useless, and even misleading', they were dropped: see Edgar John Forsdyke, 'The Proposed New Elgin Room', May 1930: British Museum Central Archives, Building Records, Duveen Gallery, 1928–32 (Folder 3: Duveen Gallery 1930).

[48] 'Notes on the Exhibition of the Elgin Marbles' (30 November 1928), British Museum Central Archives, Building Records, Duveen Gallery, 1928–32 (Folder 1: Duveen Gallery 1928); 'Suggestions for the New Exhibition of the Sculptures of the Parthenon', p.2.

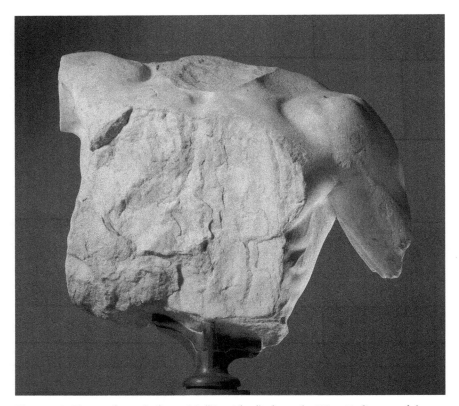

Figure 4.2 Torso of a male figure M ('Poseidon'), from the West Pediment of the Parthenon. British Museum (1816,0610.103).

eye level, with plenty of lateral space for viewers to get a full sense of each piece, and, crucially, free of plaster additions.[49] The new Duveen gallery was closed for repairs after bomb damage, but the sculptures were put back in the old Elgin Room in the meantime – finally divorced from the casts which had previously completed them.[50]

The painstaking effort to piece together the sculptures from the Parthenon in the British Museum into a reconstructive vision of architectural completeness, pursued by the museum for over a century, had been decisively reversed.

[49] The importance of seeing each part of the sculptures 'in isolation' is stressed in most of the contemporary reports. In a parallel move in Paris in 1927, the Nike of Samothrace was similarly brought forward five feet and the walls cleared of competing images to show it in isolation at the top of the Daru staircase in the Louvre: Newhouse (2005), 47–50. (The goddess's right hand, discovered in 1950, now stands in a glass case beside the statue.)

[50] Ashmole (1949); Jenkins (1990) 112 and (1992), 228. Although there were plans to display the casts elsewhere, they never substantially materialized: Jenkins (1990): 89.

Figure 4.3 The Duveen Gallery, 1980s.

No longer presented as a series of pieces in the puzzle of Ancient Greece accurately reconstructed inside the walls of the British Museum, the 'Elgin Marbles' became fragments for modernity. In Alöis Riegl's terms, their 'historical value' – as archaeological objects prized for their precise documentation of the past as it was – became

124 FRAGMENTARY MODERNISM

subordinate to their 'age value', a timeless state whose 'immediate emotional effect depends on neither scholarly knowledge nor historical education'.[51]

Why did the museum change the policy it had pursued 'for about a hundred years'? One answer lies in what Ian Jenkins called 'the cult of modernism'.[52] As Jenkins pointed out, an Art Deco aesthetic was beginning to influence the overall look of the Greek and Roman rooms, evident in the lighter coloured walls and the new replacements for the dark marble Victorian pedestals ('to reduce the monotony'), which set off a more selective and symmetrical arrangement of the works on show.[53] But a more radical shift in taste – driven by a more radical modernist aesthetic – also underwrote changes to the display. In 1929, the same year in which he signed the report to the Museum Commission denouncing any form of completion as 'a gross error of taste', Bernard Ashmole commissioned what was hailed as 'the first truly modern house in England' for his family, 'High and Over', in Amersham, Buckinghamshire.[54] Designed by Amyas Connell, the New Zealand-born architect whom Ashmole had met while he was director of the British School in Rome, 'High and Over' (Figure 4.4) was self-consciously cutting edge.[55]

The house was built in the modernist style of Le Corbusier (whose *Vers une architecture*, 'Towards a New Architecture', had been translated into English in 1927), and was designed to showcase a revolutionary aesthetic.[56] Like Arthur Evans' radically modern concrete 'reconstitutions' at Knossos, 'High and Over' was one of the first domestic buildings in Britain to use a reinforced concrete frame, 'partly', in Ashmole's words, 'to demonstrate that this was an economical method of construction and had a great future'.[57] The interior was streamlined and the walls left bare. As the short newsreel produced by British Pathé not long after the house was complete declared, the overall effect was one of radical modernity: 'one leaves this house feeling that a courageous thing has been done and a purpose fulfilled'.[58] In the words of a contemporary architectural

[51] Riegl (1903), 24. That is not to say that educative material was completely abandoned: the museum published several guides (including early audio guides), and reconstructive material was shown in two anterooms to the gallery to allow audiences to 'adjust the mind' to the gallery itself (though these were included at Pope's insistence): Marshall (2012), 44.

[52] Jenkins (1992), 229. [53] Jenkins (1992), 229; Locke (2011), 89.

[54] *Architect and Building News* (30 January 1930, p.12): 'the first truly modern house in England. One has dreamed of the ultra-modern house in England...here it is.' For 'High and Over', see Kurtz (1994), 51–61. For the house's status as arguably the first modernist house in Britain, see Sharp (2007), 118 and Ballantyne (2013), 52.

[55] Connell was heavily influenced by architectural modernism, but he had also carefully studied the layout of the buildings in the Capitol in Rome by Michelangelo: Kurtz (1994), 51.

[56] Le Corbusier had famously juxtaposed images of the Parthenon with images of modern motor-cars: Le Corbusier (1927), 124–5 ('Let us display...the Parthenon and the motorcar so that it may be clear that it is a question of two products of selection in different fields', 130).

[57] Kurtz (1994), 55.

[58] 'The House of a Dream' (1931), British Pathé, 1036.26: https://www.britishpathe.com/asset/64540/ (last accessed 23.3.23). 'High and Over' later appeared in John Betjemen's *Metroland* (BBC, 1973).

Figure 4.4 Bernard Ashmole's 'High and Over', 'the first truly modern house in England' (*Architect and Building News* (30 January 1930, p.12).

126 FRAGMENTARY MODERNISM

magazine, which reported on the building while it was still in construction: 'the blow is falling: prepare to meet the shock'.[59] As Nicholas Pevsner later explained in *The Buildings of England: Buckinghamshire* (1960), 'The bare concrete walls, the sharply cut-in horizontal windows, the meeting of unrelieved cubic shapes, the fully glazed staircase, all these are now familiar features – they were shockingly new in England then'.[60]

The shock of the new in the Parthenon gallery with which Ashmole was simultaneously involved might not have delivered the hammer blow of 'High and Over', but the building design by John Russell Pope crucially absorbed new currents in architectural modernism. As the architectural historian Christopher Marshall puts it, compared with contemporary developments like the Greek and Roman antiquities galleries in the Metropolitan Museum of Art (designed from 1912 and completed in 1939), the Duveen gallery was 'strikingly modern within its own frame of reference', manifesting a 'unique blend of scrupulously academic neo-classicism combined with an equal emphasis on an incipient modernism that acts to simplify forms, reduce detailing and exaggerate the abstract purity of the colossally scaled galleries'.[61] As Ezra Pound put it in 1920, 'it would take a bold government or a private firm to entrust its choice of buildings to Wyndham Lewis or to myself', or let their 'door-heads and capitals' be made by Henri Gaudier-Brzeska.[62] But the abstract purity of Pope's design and the space it gave to the sculptures as fragments was not quite so radically different from the aesthetic promoted by the first generation of modernist artists and writers who frequented the museum space.

Joseph Duveen, who had a powerful influence on the design of the gallery which would prominently and controversially bear his name, shared at least some of Pound's tastes in modern art. '[T]he most spectacular art dealer the world has ever known',[63] Duveen is known for his trade in Old Masters and opulent aristocratic interiors. But he was also deeply invested in the contemporary British art scene. In 1926, in correspondence published in *The Times*, he wrote to Prime Minister Stanley Baldwin in a plea for state support of contemporary British artists: '[v]ast sums are paid for the works of Old Masters', he complained, but modern work 'lingers on the walls of many a studio, awaiting the purchaser who does not come'.[64] While he was working with Pope on the new Parthenon display in the British Museum, Duveen also sponsored major new building work to house

[59] *Architect and Building News* (30 January 1930), p.12. The house was also featured in *Country Life* (September 19 1931; reproduced in Kurtz (1994), 217–22).

[60] Kurtz (1994), x. [61] Marshall (2012), 45.

[62] 'The Curse', *Apple (of Beauty and Discord)*, January 1920, 22, 24: reprinted in Zinnes (1980), 158–60 (160).

[63] Secrest (2005), 4.

[64] 'Contemporary Art: Mr Baldwin and Public Support', *The Times* 22 January 1926, issue 44176, p.10, col. C.

modern art at the Tate Gallery in London.[65] In 1930 he published *Thirty Years of British Art*, a manifesto advocating the importance of modern art in Britain, which, while not an out-and-out plea for modernism, singled out some of the most cutting-edge artists of the period, including Jacob Epstein (83, 161), Edward Wadsworth (98, 164), Eric Gill (147), Paul Nash (88, 93, 97; 142–5), and Henri Gaudier-Brzeska, with whom Duveen was so impressed ('undoubtedly a genius', 83, 85), that he co-opted him as a British artist.[66] Artists like these were not just at the centre of a separate project to promote modern British art, 'his own private enterprise – a hobby, if you like'.[67] The revolution in taste they helped to effect clearly underwrote the new modern display of the sculptures from the Parthenon in the British Museum he sponsored.[68] Stripped of the 'fraud' of the plaster additions which had been carefully pieced together by Smith and his predecessors for a century, and shown in 'isolation' as fragments, the new setting reinvented the sculptures from the Parthenon in London as modern icons of the classical fragment.

II. 'those *damn* Greeks': Modernists in the Museum

What makes these interactions even more significant is that the 'public' against whom Bernard Ashmole and others felt plaster additions to ancient fragments in the British Museum had perpetrated a 'fraud' included some of the major practitioners of literary and visual modernism. Although it is often left out of institutional histories of the museum, 'the Pound era', as Hugh Kenner influentially called it, overlapped with 'a B.M. era' (*Cantos* 80/520). Particularly in the years around the First World War, the British Museum was a key site of modernist social, literary, and artistic exchange. Nestled at the centre of the ground floor of the museum, the old Reading Room of the British Library functioned as a kind of literary club for writers in the period.[69] As I showed in Chapter 3, the 'Hall of Inscriptions' which H. D. and Pound passed through daily on their way to the Reading Room informed the inscriptional poetics of Imagism. But the broader visual culture of the museum in which the Reading Room was housed also formed

[65] Secrest (2005), 329–30; Spalding (1998), 48–50. On the evolution of the Tate design and its modern afterlives, see Marshall (2011).
[66] Duveen (1930). [67] From Martin Conway's preface to Duveen (1930), 1.
[68] I discuss the scandal surrounding the 'cleaning' of the sculptures which seems to have been primarily directed by Duveen to make them fit with the aesthetic of the new building below on pp.144–5.
[69] Recent museum theory has emphasized the importance of museums more broadly as sites for the cultures of sociability and the ways in which social interactions shape audience engagement with museum collections: Tröndle et al. (2012); Jafari, Taheri, and vom Lehn (2013) (on sociability); Fyfe (2006) and Hooper-Greenhill (2006) (on visitor behaviour). Cf. Paul (2002), 76 with n.33 on the importance of human contact in the museum environment and Rees Leahy (2012) for the physicality of museum experience.

128 FRAGMENTARY MODERNISM

a key part of modernism's dialogue with the building.[70] 'The Louvre and British Museum hold one together, keep one from going to bits', H. D. wrote in her autobiographical novel *Asphodel*.[71] When she and Pound held the legendary meeting that inaugurated Imagism in September 1912 in the tea shop in or near the British Museum, according to Barbara Guest, H. D. was probably taking a break from studying the Greek friezes that fascinated her during this period.[72] The museum is the imaginative setting for he unpublished short story 'The Greek Boy', which unfolds around the pediment sculptures in the Elgin Room, where a Greek boy, 'riding on the Parthenon frieze' (p.3) materializes among the exhibits to make the 'broken old stained marble things' (p.2) a culturally grounded reality for an American boy who has come to the museum to see them.[73] The seated goddess 'with wide feet on a wide plinth' (*CP* 111) who speaks in H. D.'s 'Demeter' (a poem published in *Hymen* in the same year as Epstein's letter to *The Times* decrying her new nose), too, is based on the Demeter of Cnidus in the anteroom to the Greek and Roman galleries.[74]

H. D. was not the only poet to branch out from the Reading Room into the sculpture galleries. Richard Aldington's first Imagist poems included 'To a Greek Marble', which addresses a version of the Townley Venus, the well-known Parian Marble statue ('O silence of Paros'), completed with a new pair of arms in the eighteenth century, which was on display in the Second Graeco-Roman Room to the left of the library on the Ground Floor.[75] T. S. Eliot's 'Afternoon', probably written shortly before he acquired his reader's ticket in 1914, is set in 'the hall of the British Museum' (l.2), as the 'ladies who are interested in Assyrian art...fade beyond the Roman statuary' (ll.1, 7) on the ground floor.[76] Like H. D., W. B. Yeats evoked 'Demeter's image near the British

[70] Recent scholarship has emphasized the engagement of writers and artists in the period with various parts of the Museum outside the Greek and Roman Rooms: see esp. Paul (2002), 65–139 (on Ezra Pound and the Reading Room); Qian (2003), 3–21 (on Chinese Art); Arrowsmith (2011) (on extra-European art); Bernstein (2014), 147–83 (on Virginia Woolf and the Reading Room); Coyle (2016) (on T. S. Eliot's 'Afternoon'). See also Locke (2011) for the consumption of classical as well as ethnographical material by modern British sculptors in the museum to the present day.

[71] H. D. refers specifically to the headless Nike of Samothrace in the Louvre (cf. n.49, above), and 'seeing the Elgin Marbles this morning' (*Asphodel*, 41 = H. D. (1992)). The novel also features the Nereid room in the British Museum as a site of encounter for her courtship with 'Darrington' (Aldington) (p.136).

[72] Guest (1984), 40, cf. p.34. For the meeting in the café, see Chapter 3, p.83.

[73] Collecott (1999), 123; Zilboorg (1991a), 71 with note and summary on pp.72–3. The manuscript is in the Beinecke Library, Yale University, Box 37, Folder 954, 'Early Stories II'.

[74] Gregory (1997), 240. For the lure of Demeter of Cnidus in the British Museum in the literary imagination in Britain, particularly in Walter Pater, Jane Harrison, and E. M. Forster, see Radford (2007), chapter 4. Forster mentions seeing her 'broken nose' in 1904: Radford (2007), 173.

[75] Though Aldington's Greek marble has not previously been identified, the marble goddess addressed by the speaker as πότνια ('lady', 'queen') is likely to be the Venus in the museum. For a reading of the poem as 'undoubtedly like those among the marbles in the British Museum where Aldington, H. D., and Pound spent so much time in these years', see Pondrom (1985), 81–2.

[76] The poem was sent to Conrad Aiken on 25 February 1915 and is tentatively dated to 1914: see Coyle (2016); Ricks and McCue (2015), I.297–8, 1147–8; *IMH* 203–7.

MODERNISM AND THE MUSEUM 129

Museum reading room door', probably conflating the Demeter of Cnidus with a statue of a female figure on display in the Hall of Inscriptions.[77] And when William Carlos Williams came to visit Pound in 1910, he 'turn[ed] Bill loose on the Parthenon marbles'.[78]

While literary modernists were occupying the Reading Room, the British Museum space was also a major centre for visual artists. They used the museum less and less as a 'drawing school',[79] and were attracted by the allure of the extra-European holdings, but they also regularly returned to the Greek and Roman sculpture galleries. The Archaic Greek Sculpture Room and copies of Archaic sculpture in the cast collections offered examples of direct carving that, as I discuss in Chapter 5, provided a way of circumventing the high 'classical' past by turning to what Pound (who planned to write a monograph on pre-classical Greek sculpture) called a 'hinter-time' before the 'Athens of Pericles'.[80] But the classical material – and the 'Elgin Marbles' in particular – were still the main attraction.[81] This was partly because, despite the plaster completions and the crowded environment in the old Elgin Room, the sculptures from the Parthenon in the British Museum remained among the most culturally significant classical sculpture in a European museum to be shown largely without restoration.[82] Even with the assimilated cast additions, where what Thomas Hardy described as 'the gloom/ Of this gaunt room' was accentuated by coal residue from the London air, what was most striking about the 'Elgin Marbles' in the museum was the fact that they were on show with no 'arms and legs and heads'.[83] The fragmentary pediment sculptures had some plaster adjusted to them and the frieze on the wall was made up of more plaster than marble, but the old Elgin Room also contained disjointed fragments in stone or in plaster, whose precise connection to the main display could not be clearly made: a right arm, a left thigh 'above life size', a missing head, part of a foot, a fragment of a wing.[84]

While curators behind the scenes were still energetically putting together the pieces in an attempt to recreate the lost ancient whole, the artists who came to the

[77] Yeats, *Autobiographies* 121; Finn (2004), 47–8. The copy of the Athena statue in the old Elgin Room also seems to resurface in Yeats' descriptions of Maude Gonne: Finn (2004), 49–50.

[78] Letter to his mother, 6 March 1910: *EPHP*, 223. [79] Jenkins (1992), 31.

[80] Pound, Letter to H. D. Rouse, 23 May 1935: Paige 363.

[81] Cf. Locke (2011), 85: 'the appeal of the Elgin Marbles, the jewel in the British Museum's crown, was undiminished by this; rather, everything else was elevated'.

[82] It was the comparatively unrestored display of the Parthenon and other ancient sculptures in the British Museum which had inspired Georg Treu's derestorations in Dresden in the 1890s: Knoll (1994a), 131.

[83] For the effect of the London atmosphere and poor lighting on the viewing experience, see Locke (2011), 89. Hardie's 'Christmas in the Elgin Room' subtitled 'The British Museum: Early Last Century', imagines the sculpture's first experience of their setting in the museum; Hardy began the poem in 1905, returned to it in 1926, and finally published it in *The Times* on Christmas Eve, 1927, shortly before the Royal Commission on National Museums and Art Galleries instigated a review of the display: on the poem, see Ford (2016), 262–5.

[84] Smith (1892), 194–215.

130 FRAGMENTARY MODERNISM

museum were re-focusing what they saw through a modern preference for the fragment. What Albert Elsen influentially termed the 'partial figure' in modern sculpture emerged from the work of Auguste Rodin, but it also emerged from the fragments of classical sculpture in the British Museum.[85] Rodin was far from the first maker of partial figures, but as Elsen notes, '[i]n his sculpture, Rodin recapitulated much of the prior history of the partial figure, established its validity as a complete work of art, and influenced its development and ramifications'.[86] As Bénédicte Garnier and others have emphasized, Rodin's work is rooted in an intense engagement with Greek sculpture, and in particular with Greek sculpture in the British Museum.[87] As Rodin told an interviewer for *The Daily Chronicle*, '[i]n my spare time I simply haunt the British Museum'.[88] From 1881, when he first visited the British Museum, and even before that when he encountered plaster casts of the frieze as a boy in Paris and later in the Louvre, the Parthenon sculptures became 'an obsession which never left him'.[89] Though he never went to Greece, Rodin made a series of increasingly frequent visits to London, in 1882 and 1886, and then every year between 1902 and 1907, with two long stays in 1913 and 1914.[90] When not in London, he attempted to replicate his experience of the Elgin Room in the British Museum at home. He collected photographs of the pediment and frieze fragments, and regularly visited the Parthenon fragments in the Louvre.[91] When Rodin began collecting antiquities himself in 1893, he deliberately chose pieces that reflected what he had seen in London (Figure 4.5).[92]

In his studio-house in Meudon, which became a site of pilgrimage for artists, writers, and cultural figures in his lifetime, Rodin would experiment with his own collection of antiquities, caressing them, juxtaposing them with his own pieces, and testing out the effects of various lighting.[93] For Rodin, the Parthenon sculptures in the Elgin Room and their replicas in Meudon seemed to provide palpable access to the creative energy of antiquity, not in spite of their condition as fragments, but because of it.[94] As Rainer Maria Rilke (who worked as Rodin's private secretary between 1905 and 1906) described a broken torso of Apollo

[85] Elsen (1969), 16–28. [86] Elsen (1969), 16.

[87] See esp. Garnier (2013) and Farge, Garnier, and Jenkins (2018), a catalogue of a major exhibition in the British Museum, 'Rodin and the Art of Ancient Greece' (26 April–29 July 2018), which juxtaposed Rodin's work and antiquities collection with pieces from the museum. For Rodin and antiquity, see also Mitchell (2004), 135–59 and Picard (2013).

[88] *The Daily Chronicle*, 2 March 1903: Garnier (2018), 40.

[89] See Garnier (2018), 34, and *passim* for a detailed study of Rodin's relationship to the Parthenon.

[90] Rodin planned a visit Athens in 1907, but his plan never materialized: Garnier (2018), 42.

[91] Farge, Garnier, and Jenkins (2018), 86.

[92] Garnier (2013), (2018), 30; Farge, Garnier, and Jenkins (2018), 152.

[93] Rodin publicly exhibited his own work next to his antiquities collection in 1913 at the Faculté de Médecine, Paris.

[94] For a similar role played by the sculptures and casts from the Parthenon which Rodin saw in the Louvre, as well as other European museums, see Garnier (2018), 39–40.

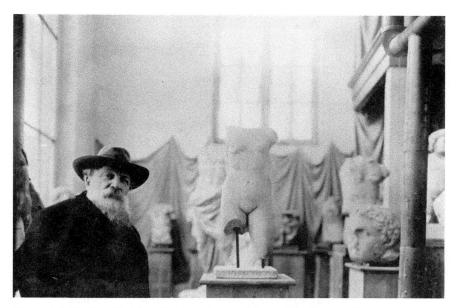

Figure 4.5 Rodin with his collection of antiquities in Meudon, c.1910.

which he had probably seen in the Louvre, the power of a sculptural fragment could 'burst forth from all its contours'.[95]

The fragments Rodin had seen in the museum inspired some of his most influential fragmentary sculptures. *Iris, Messenger of the Gods* (Figure 4.6), first exhibited in its final form in 1898, for example, engages in conversation with the limbless, headless female pediment figure Rodin had seen in the Elgin Room, now generally identified as Iris (Figure 4.7).[96]

The Greek sculpture has lost the bronze wings that were once fitted to its back; the head, left arm from the shoulder, right arm just below the shoulder, and lower legs are also missing, and the remaining torso (which was reunited with its right thigh and left knee not long before Rodin's first visit to the museum) requires a

[95] 'brächte...aus alle seinen Rändern aus', 'Archaische Torso Apollos', (1908). Rilke's precise source – if there was one – is ultimately impossible to locate (Groddeck (1999)), but the poem is often linked to the Miletus torso (excavated in 1872) in the Louvre: Hausmann (1947) with Neumann (1984) on the fragmentary aesthetic of the poem.

[96] For the explicit link, see esp. Farge, Garnier, and Jenkins (2018), 206–9, though Rodin may not have known the fragment as Iris: the torso is now placed as figure N on the West Pediment, but around 1890 there was some controversy about its placement and identification (Smith (1892), 110–11, 111–13): it was positioned on the East Pediment as figure J and identified as 'Nike', while another figure was tentatively identified as 'Iris', (G, East Pediment). Contemporary photographs show no obvious labels, however, and Rodin may well have dispensed with museum guides (*A Guide to the Exhibition Galleries of the British Museum, with Maps and Plans, Produced by Order of the Trustees* (London, 1892), explains the issue on pp.20–1).

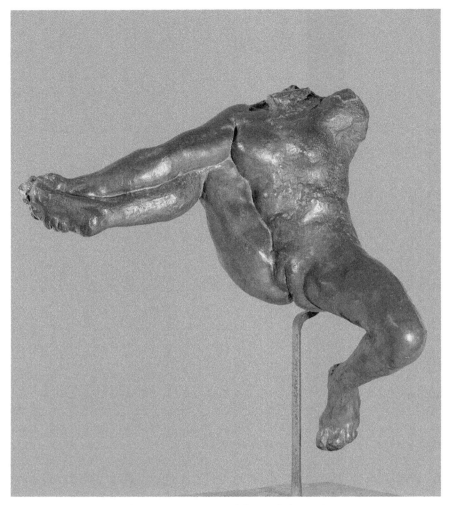

Figure 4.6 Auguste Rodin, *Iris, Messenger of the Gods* (c.1895). Bronze, 82.7 cm. Musée Rodin, (S.1068).

metal bracket to prevent it from toppling over.[97] Yet despite – or perhaps because of – the missing body parts, the Parthenon 'Iris' exudes a powerful kinetic energy. The drapery skims the body as if the figure were rushing at speed through the air; the torso twists slightly at the waist, the powerful thighs are spread apart, and what remains of the right upper arm is raised at a tilt, as if mid-run.

[97] The figure's right thigh was identified and added in 1860 and the left knee in 1875: Smith (1892), 113. The old Elgin Room also held a cast of the so-called 'Laborde head' from the Louvre, which had been suggested as a possible missing piece for this figure (Smith (1892), 198), and now completes the cast in the Acropolis Museum in Athens.

MODERNISM AND THE MUSEUM 133

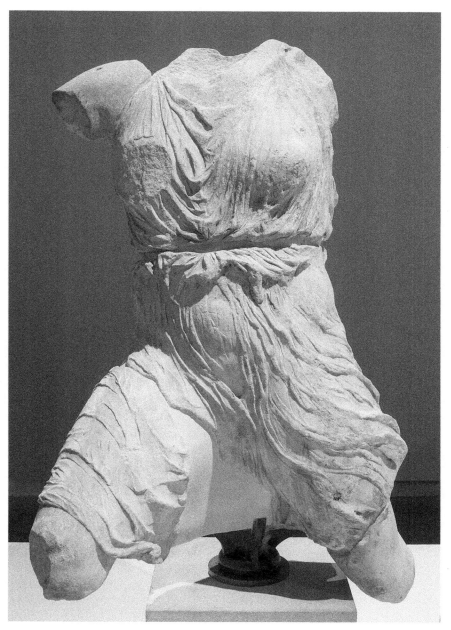

Figure 4.7 Marble statue from the West Pediment of the Parthenon, figure N ('Iris'). 135 cm. British Museum (1816,0610.96).

134 FRAGMENTARY MODERNISM

When Rodin began his *Iris* around 1893–4 as part of the reformulation of the monument to Victor Hugo, the sculpture was conceived as the 'genie du XVIIII siècle',[98] complete with a head, a full set of limbs, and a pair of wings.[99] In 1894, however, Rodin enlarged *Iris* to stand alone as a separate sculpture. The process transformed it from an emblem of the nineteenth century to a prophet of the twentieth, but it also brought the sculpture into much closer dialogue with its fragmentary ancient counterpart in the British Museum. In an accelerated mirroring of the ancient marble's transformation to its current form, Rodin removed the wings, the head and the left arm at the shoulder, so that his *Iris*, too, now required a metal support to prevent her from falling.[100] Moreover, in a radically exaggerated version of the parted thighs of the sprinting Greek goddess, whose short, draped chiton gathers at the crotch, Rodin drastically shifted the position of the legs of his original *Iris* to reveal the genitalia ('that centre where the passion burned', as Rilke put it).[101] The overall effect mirrored the ancient fragment, but it was scandalously and conspicuously modern.[102] Yet despite some resistance to the explicit pose (the Museum of Fine Arts in Boston was eventually forced to dispose of the bronze copy it had acquired in 1909), the result was publicly and commercially popular, and Rodin cast at least eight copies in quick succession.[103]

Known as the 'French Phidias' by his contemporaries after the world-renowned classical Greek sculptor associated with the Parthenon, Rodin deliberately cultivated a connection to antiquity, down to the way he posed for photographs.[104] But the effect could also work the other way: Rodin's modernity could retrospectively cast the Parthenon sculptures in the British Museum, which unlike the fragments in the Louvre remained largely unrestored, as modern fragment sculptures themselves.[105] As the radical art critic Reginald H. Wilenski put it in in *The Meaning of Modern Sculpture* (1932), an attack against the classical Greek paradigm in modern art which he reprised in a BBC radio debate with Bernard Ashmole in the same year:[106]

[98] Mayo Roos (1986), 650, citing Rodin's letter to Larroumet.

[99] Le Normand-Romain (2007), 454.

[100] Elsen (1963), 181. Images of the Elgin Room *c.*1890 in the British Museum Central Archives show a metal support encased in a plain white surround.

[101] 'zu jener Mitte, die die Zeugung trug', *Archaische Torso Apollos* l.8. The earlier version of Iris was similarly posed, but her position on the larger monument would have meant that the effect was more of 'a private joke': Mayo Roos (1998), 100.

[102] As Arthur Symons put it in 'Les Dessins de Rodin', *La Plume* 268 (1900), 383, 'the principle of Rodin's work is sex' (Getsy (2010), 1): see Getsy (2010) on sex and modernity in Rodin, with Wagner (1993), esp. 219–20 on *Iris*. Rodin also gestured to the poses of can-can dancers: the Meudon reserve holds several limbless versions on the theme which may be related to *Iris*: see Elsen (1981), 144.

[103] Le Normand-Romain (2007), 454–5.

[104] Garnier (2018), 46–7. The connection was made explicit when Kate Simpson, whose bust Rodin sculpted, presented him with a postcard of one of the female figures from the east Pediment inscribed 'My bust/group of the Parthenon': Musée Rodin archives, Ph. 2565, reproduced in Garnier (2018), 43–4, fig. 8.

[105] See Haskell and Penny (1981), 103 on the restoration in the Louvre.

[106] Prettejohn (2012), 172–4.

The appreciation of Rodin's sculptural fragments would have been quite impossible if the Elgin Marbles, like all 'antique' sculpture before them, had been known to the world only after the restorers had added arms and legs and heads...and refashioned the drapery into nice neat edges.[107]

In a turn of events that, Wilenski claimed, would have horrified a 'professional propagandist for Greek sculpture in the nineteenth century', the fragments from the classical past on display in the British Museum had opened the door to crucial developments in modern sculpture. A Rodin torso and a torso from the Parthenon pediments have much in common, but that did not necessarily make Rodin's partial figures look old, as much as it made the Parthenon fragments look new. Particularly after 1900, as Rodin's position as 'the father of modern sculpture' became established, the partial figures he created left a powerful legacy on museum culture as well as on modern artistic practice. Institutions like the Albertinum under Georg Treu, where Rodin's fragment sculptures were shown in the same building as the derestored antiquities, and, eventually, the British Museum in London, which had inspired Rodin's fragments in the first place, increasingly presented their collections of ancient sculpture as fragments free of what Bernard Ashmole called the 'fraud' of any modern completions, including plaster casts of extant missing pieces.[108] Meanwhile, for new sculptors establishing their careers in his wake, Rodin's partial figures became an inescapable benchmark for new production.[109] Rodin was a modeller, not a direct carver, and his work was not 'dry and hard' in T. E. Hulme's formulation.[110] But though Ezra Pound vituperatively told modern sculptors to 'spit out the later Rodin',[111] his partial figures – and their prototypes in the British Museum – were not far behind the marble fragments produced by some of the hard-edged modernists who visited the British Museum.

One of the most radical of them all, Henri Gaudier-Brzeska, is best known as the 'savage messiah' whose abstract sculptures like *Red Stone Dancer* (1913) and *Head of Ezra Pound* (1914) revolutionized the London art scene.[112] In 1911 – while Pound

[107] Wilenski (1932), 26.

[108] Treu exhibited several of Rodin's fragment sculptures, including 'Inner Voice' and 'Male Torso' at an international exhibition of contemporary art in Dresden in 1897 (detailed in the official exhibition catalogues, *Offizilele Katalog der internationale Kunstausstellung, Dresden 1897*, 1 July 1897, Dresden-Blasewitz). Rodin himself also engaged in restoration debates, notably writing in protest at the restoration of the Parthenon in Athens in 1905: Rodin (1905); Farge, Garnier, and Jenkins (2018), 40–2.

[109] Elsen (1963), 173, (1969), 16. For fragmentation in Rodin's work, see Elsen (1969), 16–28; Steinberg (1972), 361–71; Pingeot (1990), and for Rodin as a pivotal influence on modern sculpture, see Curtis (1999).

[110] 'Romanticism and Classicism' (1936) = Hulme (2003), 75.

[111] 'Et faim sallir le loup des boys', l.9, *Blast* 2 (July 1922), 22: reprinted in Zinnes (1980), 153.

[112] For the date of *Red Stone Dancer*, see Silber (1996), 267 Cat. 69. As Elizabeth Prettejohn points out, the portrait of Ezra Pound was made in Pentelic marble imported from Greece – the same material as the Parthenon sculptures: Prettejohn (2012), 213.

136 FRAGMENTARY MODERNISM

was making himself into a modernist in the British Library Reading Room – Gaudier moved to London to fashion himself as an artist.[113] By the time of his death in June 1915 (he was killed fighting for the French army in Neuville-Saint-Vaast shortly before his twenty-fourth birthday), Gaudier had become a major player in the London avant-garde art scene, one of 'Pound's artists',[114] and a co-creator of Vorticism. Perhaps surprisingly, however, he started out as an admirer of Rodin and an advocate of classical reception. 'We shall never see a greater sculptor than Rodin, who exhausted himself in efforts to outvie Phidias, and did outvie him', he wrote in in 1910, repeating a common trope of Rodin's reception in France.[115]

Rodin's efforts to 'outvie' antiquity were probably on Gaudier's mind when, on 17 April 1909, he made a stop-over in London en route to Nuremberg from Cardiff.[116] Mirroring Rodin's regular pilgrimages to London to see the sculptures from the Parthenon, he spent the afternoon at the British Museum, where he seems to have gone directly to the Elgin Room. He took a Windsor & Newton sketchbook with him, in which he made seven pages of studies of the pediment sculptures of the Parthenon, the frieze, and the south metopes (the only images in the sketchbook traceable to the museum).[117] The sketches are carefully labelled in language that echoes the cheaper museum guide.[118] They show two male torsos, including the reclining male figure ('Ilisos'); the sculpturally massive seated female figures ('the Fates') now identified as Dione and Aphrodite, which would also influence Picasso (Figure 4.8); a close up of a male leg and drapery; two horse heads from the frieze, and the head of Selene's horse 'descending below the horizon', drawn on the same page as a torso from one of the south metopes (Figures 4.9 and 4.10). These drawings reveal an interest in the stumps of broken limbs that would have reminded Gaudier of Rodin's partial figures, which he reprised in *Workman Fallen from a Scaffold* (1912). As the sketches progress, they also show a clear engagement with the movement, pattern, and power of the musculature of both the human and the animal figures, which Gaudier progressively systematized and abstracted in an adumbration of the principles of Vorticism he would go on to develop.[119]

[113] In January 1911: Cole (1980). [114] Humphreys (1985).

[115] Letter to Dr Uhlemayer, 1 January 1910: Ede (1971), 20.

[116] Ede (1971), 25; Silber (1996), 16.

[117] O'Keefe (2004), 29; Silber (1996), 16; Arrowsmith (2011), 97. The sketchbook from the Kettle's Yard Foundation is held at the Musée National d'Art Moderne in Paris archive (AM 3376 D). The date of 17 April is given in Gaudier's handwriting under his sketch of a male figure from the frieze ('British Museum on day I left England for Germany, 17/ april 1909'), though it may have been the day before: Cole (1978), 11 with n.10 p.18 citing Gaudier's letter to his parents of 20 April 1909, Kettle's Yard, Cambridge University.

[118] Though the language echoes the guide of 1908, it may be that Gaudier copied the museum's own labels directly: O'Keefe (2004), 29–30; Arrowsmith (2011), 97–8.

[119] Like Rodin, Gaudier also sought out similar material in Paris museums, including the Winged Nike of Samothrace: Ede (1971), 16; Arrowsmith (2011), 98.

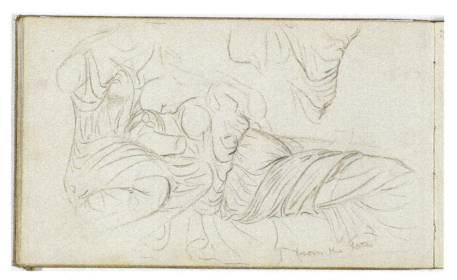

Figure 4.8 Gaudier-Brzeska's sketch of Figures L and M from the East Pediment of the Parthenon. Graphite on paper, 23 × 14 cm. Musée National d'Art Moderne, Paris (AM 3376 D (23)).

In some ways, as Arrowsmith argues, Gaudier's interest in the remains of classical antiquity 'had all changed completely by November 1912'.[120] He met Jacob Epstein in the early summer of 1912,[121] a moment that has been mythologized as revolutionizing his approach to sculpture. According to an anecdote told to Horace Brodzky and retold by Pound, Epstein asked Gaudier if he carved directly in stone rather than modelling in clay first (the process thought to lie behind Roman copies of Greek sculpture as well as Rodin at what Pound called his 'plaster-castiest'[122]). '"Most certainly!" said Gaudier, who had never yet done anything of the sort', and immediately spent the next few days making direct carvings in preparation for Epstein's visit to his studio.[123] It is probably under Epstein's influence that Gaudier began to discover Assyrian and Egyptian material in other parts of the British Museum, and started to distance himself from Rodin.[124] In his prose, Gaudier became one of the loudest voices in modernism's emphatic repudiation of Greek models in the visual arts. He played a central part in the self-conscious spat staged between Pound and Aldington about the value of

[120] Arrowsmith (2011), 98.
[121] Cole (1980) dates Gaudier's visit to Epstein's studio to June 1912.
[122] Ezra Pound, 'The New Sculpture', the *Egoist*, I, 4, 1914, pp.67–8 (67).
[123] Pound, *Gaudier-Brzeska*, 87; Arrowsmith (2011), 96. The story of the meeting is problematic, not least in its narrative of turning away from classical models as well as in the simplification of the sculptural methods of both artists: Silber (1996), 59, 92–4, 247–9.
[124] Arrowsmith (2011), 193.

138 FRAGMENTARY MODERNISM

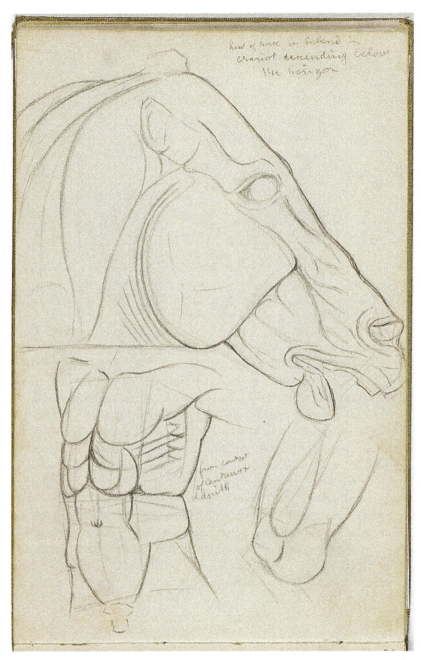

Figure 4.9 Head of a horse in Selene's chariot from the east pediment and detail from south metope. Graphite on paper, 23 × 14 cm. Musée National d'Art Moderne, Paris (AM 3376 D (22)).

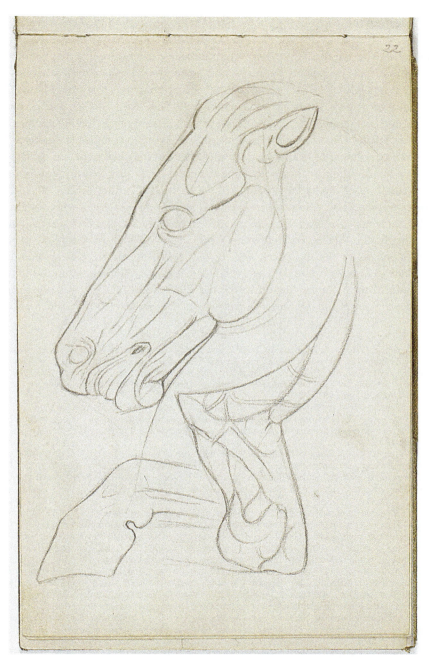

Figure 4.10 Head and leg of a horse from the Parthenon frieze. Graphite on paper, 23 × 14 cm. Musée National d'Art Moderne, Paris (AM 3376 D (41 a sup)).

140 FRAGMENTARY MODERNISM

classical sculpture in the pages of the *Egoist*, railing against 'those *damn* Greeks'.[125] In the Vortex issue of *Blast* in 1915, he not only appeared as one of the main signatories to the manifesto[126] but contributed an essay himself which amounts to an outright rejection of classical Greek sculpture: 'The fair Greek saw himself only...HIS SCULPTURE WAS DERIVATIVE...The absence of energy lasted for a hundred years.' According to Gaudier, 'VORTEX IS ENERGY', and classical antiquity now seemed like it had little to offer a modernist revolution in sculpture.[127]

Yet despite the emphatic rejections, things had not completely changed.[128] Around the end of 1913 and possibly into 1914, not long before he was declaring that modern sculpture 'has no relation to classic Greek, but that it is continuing the tradition of the barbaric people of the earth',[129] Gaudier produced at least three fragmentary torsos, two in marble (Figures 4.11 and 4.12) and another in clay, later cast in plaster and subsequently in bronze.[130] Posed by the artist Nina Hamnett, the figures are deliberately cut off at the base of the neck, at the arms just below the shoulders, and the legs below the pelvis, their broken-off limbs and heads echoing the energy in fragments that Gaudier had found in the sculptures from the Parthenon in the old Elgin Room.[131] One was purchased by Ezra Pound and Dorothy Shakespear in December 1913,[132] and another

[125] Pound, *Gaudier-Brzeska*, 23, 33. For 'his and Aldington's perpetual, acrimonious, and fundamentally amical dispute as to whether Greek art and civilization were worthy of serious consideration. Aldington being all for "Hellas"' publicly staged with Pound in the pages of the *Egoist*, see Pound, *Gaudier-Brzeska*, 22–3 and the detailed discussion in Collecott (2000) with Chapter 5 below, p.170.

[126] *Blast* 1, 20 June 1914, 43.

[127] Gaudier-Brzeska, 'Vortex', *Blast* 1, 20 June 1914, 155–8 (156). Pound later announced that Gaudier's essay 'would become the textbook in all academies of sculpture before our generation has passed from the earth': 'Affirmations: Gaudier-Brzeska', *The New Age*, 4 February 1915, 409–11: Zinnes (1980), 19.

[128] Gaudier kept on going to the British Museum, though he expanded the range of material he saw there, including Assyrian art and Japanese *netsuke* (O'Keefe (2004), 110; Arrowsmith (2011), 98–102) and was still interested enough in Rodin in November 1912 that, he told Sophie Brzeska, after a trip to 'the Museum', he 'plunged with vigour' into a book on Rodin and 'read it all...passionately': Ede (1971), 110.

[129] 'Mr Gaudier-Brzeska on "The New Sculpture"', the *Egoist*, I.6, 16 March 1914, pp.117–18 (118).

[130] There is some doubt about the precise date of the torsos. Gaudier's own list of his works (Ede (1930), 191–206; Briend and Lemny (2009), 171–94) lists the two marble torsos under 1914, but at least two must have been produced in 1913. Pound claimed ('if I remember rightly') that Gaudier had just finished one, which he bought in December 1913, and was working on the version destined for the Victoria and Albert Museum shortly after they met at the Allied Artists Association Exhibition in the Albert Hall in the Summer of 1913 (Pound, *Gaudier-Brzeska*, 46); Gaudier only met Nina Hamnett (the model for at least two of them) after the exhibition (Hamnett (1932), 39), which means that he must have produced at least one torso around the end of 1913 and possibly continued working on them into 1914.

[131] Hamnett named her memoir *Laughing Torso* (New York, 1932) after the experience, and included Walter Benington's photograph of *Torso I* also used by Pound as her frontispiece. She tells the story on pp.38–40.

[132] Probably from prize money from *Poetry* magazine: Witemeyer (1996), 22; O'Keefe (2004), 206. For Pound's purchase of the torso (which ended up in the collection of his mother-in-law, Olivia Shakespear), see his letter to William Carlos Williams, 9 December 1913: Witemeyer (1996), 22: 'Have just bought to [*sic*] statuets [*sic*] from *the* coming sculptor Gaudier Brzeska', and to Dorothy Shakespear, 6 December 1913 and 30 December, in Pound and Litz (1984), 286 and 288, with Beasley (2007), 78 and Silber (1996), 264–5.

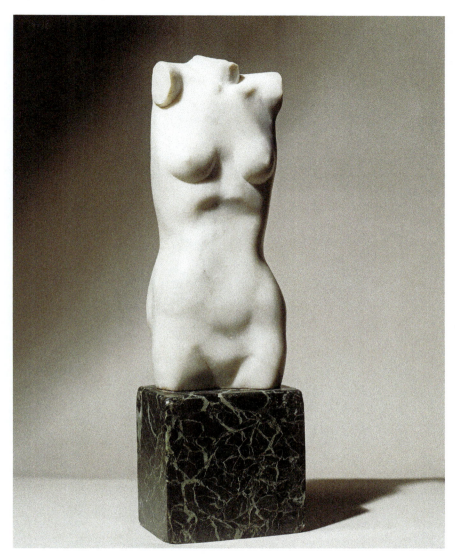

Figure 4.11 Gaudier Brzeska, *Torso I* 1914. Marble on stone base, 252 × 98 × 77 mm, Tate Gallery, London (T03731).

displayed in the Victoria and Albert Museum, which also owned works by Rodin.[133] Far from rejecting 'the pretty works of the great Hellenes' (a narrative

[133] Pound, *Gaudier-Brzeska* lists two of Gaudier's torsos: one 'Naturalistic torse marble, destined for South Kensington' (160 and Plate XII), now in the Tate Gallery, and 'Another torso, marble, plumper, not so strong. (Possession of Mrs H. H. Shakespear)' (160). For the fate of the third Torso (*Torso II*), which was probably destroyed after two plaster casts were taken, see Briend and Lemny (2009), 26.

142 FRAGMENTARY MODERNISM

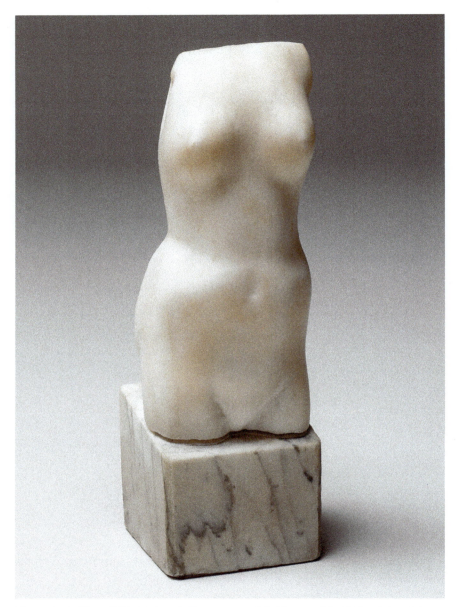

Figure 4.12 *Torso III* (*c.*1913–14), Seravezza and Sicilian marble, 27.3 × 8.9 × 8.9 cm, Ruth and Elmer Wellin Museum of Art, Hamilton College.

that tends to resurface in art-historical studies of Gaudier's work), the torsos directly employ the visual currency of the fragmentary Greek marble sculptures on display in modern European museums. As Pound pointed out to John Quinn they are 'very beautiful from certain points of the compass, even to admirers of

"THE GREEK"'; in fact, they are even 'VERY like the Venus de Milo from certain angles'.[134]

Gaudier's strikingly anomalous Greek-style fragment torsos have been explained in various ways. Pound saw them 'as a sort of expriment [*sic*]'.[135] Gaudier himself said he had made 'a marble statue of a girl in the natural way, in order to show my accomplishment as a sculptor', while his friend the sculptor John Cournos similarly explained that '[h]e would shape a marble torso exquisitely, in the Greek spirit, just to show that he could do it'.[136] The result could be seen as experimental juvenilia, technical showpieces which would have been left behind had the artist not died so young, and scholarly efforts to redate a number of works from 1913 and 1914 partly stem from a desire to force Gaudier's work into this kind of tendentious narrative of linear development.[137] Yet Gaudier was still thinking of his Greek torsos shortly before his death. He wrote to Pound's mother-in-law, Olivia Shakespear, from the front in April 1915 (using a nickname for *Torso III*, 'Mlles. G.'): 'If I ever come back I shall do more "Mlles. G...." in marble.'[138] Much later Pound, too, singled out the torsos as a highlight of Gaudier's career: 'if stone can be perfect/Gaudier has left us three Ninas' (*Cantos* 107/775). This retrospective valorization of Gaudier's Greek marbles might signal a version of *rappel à l'ordre* in Pound and Gaudier himself: the First World War put a stop to Vorticism, and British artists like Percy Wyndham Lewis and Edward Wadsworth went back to naturalistic and classicizing styles, echoing the moves of their European counterparts.[139] But though he expressed a desire which he never fulfilled to 'follow "the Greeks"' when he returned from the war,[140] it is difficult to tell that kind of narrative about Gaudier-Brzeska. As the correspondent for the *Egoist* put it in the month Gaudier wrote his letter from the front, he was difficult to pin down, 'influenced now by Rodin, now by Mr Epstein, now by primitive Gothic, by Chinese and Maori models'.[141] The result looks less like a condensed artist's career trajectory than a parallel to the literary works simultaneously taking shape in the Round Reading Room in the British Museum, in which fragmented pieces of classical antiquity could be evoked side by side with a dynamic collection of other sources, models, and influences. As Pound

[134] Letter to John Quinn, 11 August 1915: Materer (1975), 323.

[135] Letter to John Quinn, 11 August 1915: Materer (1975), 323.

[136] Casson (1928), 177; John Cournos, 'New Tendencies in English Painting and Sculpture', *The Seven Arts* 2.6, 1917, 762–8 (773).

[137] See Silber (1996), 249 on the history and biases of scholarly dating of the artist's works based on 'preconceived notions of stylistic development', that should really be seen as 'part of Gaudier's recurrent dialogue with the classical tradition'.

[138] Pound, *Gaudier-Brzeska*, 75.

[139] Cowling and Mundy (1990); Silver (2010), and on Pound's naturalism in the 1950s, see Materer (1975), 324. In an essay 'written from the trenches' for the War issue of *Blast*, pp.33–4, Gaudier declared '**MY VIEWS ON SCULPTURE REMAIN ABSOLUTELY THE SAME**' (33), despite a preference for 'a gentler order of feeling' (34).

[140] Aldington (1941), 167. [141] *The Egoist* 4.2, 1 April 1915, 'The London Group', p.61.

144 FRAGMENTARY MODERNISM

conceded in 1915 shortly after Gaudier's death, the modernist paradigm could allow for multiple receptions to co-exist. Reconfigured as part of what Pound called 'world-sculpture', classical antiquity still had a place in that paradigm: '[w]e have kept, I believe, a respect for what was strong in the Greek, for what was sane in the Roman'.[142]

Like Gaudier, Jacob Epstein was set squarely against the 'Hellenic' and the 'caressable' in the rhetoric of modernism. Works like *Female Figure in Flenite* (1913), directly carved in stone, or *Rock Drill* (1913), a plaster figure sitting on top of an actual rock drill, which later gave its name to a section of the *Cantos*, deliberately circumvented Greek models in favour of African art, or 'absolute copies of Polynesian work' (as Gaudier described it), and the aesthetic of the modern machine. Yet, while the majority of Epstein's work rejected 'the dead hand of Athens',[143] he too continued to turn to 'what was strong in the Greek', and found it primarily in the British Museum in London. According to the autobiography he published in 1940, when Epstein considered relocating from Paris to London 1905, 'a visit to the British Museum settled the matter for me'.[144] 'It was at this period I visited the British Museum and whenever I had done a new piece of work, I compared it mentally with what I had seen in the Museum.'[145] To begin with, that meant classical Greek material, and the Elgin Room in particular: '[e]arly on, about 1910, I was tremendously interested in the Elgin Marbles and Greek sculpture, and later in the Egyptian rooms and the vast and wonderful collections from Polynesia and Africa'.[146] Epstein quickly became known particularly for his interest in world art.[147] Over his lifetime, he built up one of the largest private collections of ethnographic artefacts in Britain, inspired by the British Museum's extensive collection, which informed the techniques and aesthetic of some of his best-known work.[148]

Yet although the dominant narrative suggests a decisive rejection of the classical Greek and Roman sculpture in which he had once been immersed, Epstein clearly continued to go out of his way to see the Greek material on the ground floor of the British Museum. His letters to *The Times* suggest he was looking at the Demeter of Cnidus in 1921 closely enough to notice the restoration and compare it to his earlier memories of the same sculpture.[149] Almost twenty years later in

[142] *The New Age*, 4 February 1915, 409–11: Zinnes (1980), 16. Apollinaire similarly saw contemporary art as drawing simultaneously on 'every kind of plastic script – the hieratic Egyptians, the refined Greeks, the voluptuous Cambodians, the production of the ancient Peruvians': Breunig (1972), 38. For the aggressively heterosexual dimension of modernism's debate about the use of classical art which Pound's language echoes here ('sane', 'strong'), see Tickner (1993) and Collecott (2000).

[143] Arrowsmith (2011), 4–23. [144] Epstein (1940), 21. [145] Epstein (1940), 23.

[146] Epstein (1940), 23.

[147] Pound, 'Affirmations: Gaudier-Brzeska', *The New Age*, 4 February 1915, 409–11: Zinnes (1980), 18.

[148] Though it is rarely pointed out, Epstein's extensive art collection also contained several Greek and Roman pieces, including broken-off heads and a fragment of a foot: see the catalogue in Bassani (1989), 203–5.

[149] In another letter to *The Times* ('Cleaning of Marbles', 25 May 1939, issue 48314, p.12, col. D), Epstein defended himself against accusations that he remembered a plaster replacement of the sculpture during the First World War, 'My memory of the Demeter goes back to 1904.'

1939, again through letters to *The Times*, he became a dominant voice in the press scandal that accompanied the discovery of the 'cleaning' of the sculptures from the Parthenon in preparation for their re-display in the new Duveen Gallery, which had destroyed the surface 'patina' of the sculptures to obtain a smooth white finish.[150] The new look of the Parthenon fragments fit the clean lines of Duveen and Pope's design, but the old darkened and rougher surfaces – like the fragmentary state of the sculptures – had themselves been associated with radical modernism, and in particular with the work of Epstein himself. Reginald Wilenski connected the 'rough and varied surface' of the marbles, which would be 'smoothed' a few years after he published his book, with the rough surfaces of Rodin's bronze statues and, in particular, with the portrait bronzes Jacob Epstein produced from around 1916, many of them (like the fragments in the Elgin Room) cut off at the arms, torso, or neck: '[t]he propagandists for the Elgin marbles', he noted, 'would have been...horrified if they had realised that the taste which they were creating...was opening the door to an appreciation of the bronze portraits of Jacob Epstein in our day. But that also, in fact, is what happened.'[151]

It is clear that the fragmentary sculptures Epstein saw in the Greek and Roman galleries continued to feed into his work well beyond his intense period of study around 1910. The rough surfaces of the bronzes noted by his contemporaries were part of that process, but the most powerful legacy of the classical sculptures he saw in the museum was their fragmentary condition. Throughout his career, Epstein made partial figures in stone, clay, or bronze: bodies with missing arms (such as *Angel of the Annunciation*, 1923[152]), disembodied heads, broken-off arms and hands. When Gaudier went to see him in November 1912, he found 'No picture, nor image, nothing on the large white walls, only the torso of a woman, half-broken, in a corner',[153] and photographs of Epstein's studio show a whole collection of studies of arms, hands, and heads.[154]

Epstein's well-documented engagement with Rodin, whom he visited in Paris and declared 'the greatest master of modern times', partly accounts for his own interest in fragment-making.[155] But closer to home, he also went back to the source of Rodin's fragmented bodies in the British Museum, and to the Elgin Room in particular. Shortly after he triumphantly noted that the restoration of Demeter of Cnidus in the Greek and Roman Galleries had been removed, Epstein

[150] The process seems to have been led primarily by Duveen (Neils (2003), 508; Kurtz (1994), 69). For the cleaning and its reception, see St. Clair (1998), 281–313 and Jenkins (2001). Epstein had detected something similar in the restoration of Demeter, claiming that 'the whole face has been scraped and cleaned, thus destroying the mellow golden patine of centuries', though the museum denied it: 'The False Nose of Demeter', *The Times*, 3 May 1921, issue 42710, p.9, col. C.

[151] Wilenski (1932), 26–7. [152] Buckle (1963), plate 201. [153] Ede (1971), 125.

[154] Ireland (1956). For Epstein and the 'partial figure', see Elsen (1969), 41–2.

[155] Haskell (1932), 125. Rodin sent Epstein a Christmas card in 1904: Henry Moore Institute Archives, EPS C1/12, 1–2.

146 FRAGMENTARY MODERNISM

produced *Marble Arms* (1923), exhibited in the Leicester Galleries in 1924 (Figure 4.13).[156]

The sculpture can be read autobiographically: a year before Epstein made it, his lover (and later wife), Kathleen Garman, was sensationally shot in the shoulder with an antique shotgun by Margaret Epstein, his wife at the time.[157] But *Marble Arms* also represents an intimate dialogue with the kinds of fragments Epstein saw on display in the old Elgin Room at the British Museum. Carved on 'a heroic scale' at 94 cm long,[158] the sculpture is emphatically fragmentary. An outstretched female left arm, broken off just above the shoulder, lies beside a larger, male right arm, cut off mid-humerus, its cupped marble hand cradling the smaller marble hand. The 'break', which runs across the point where the two arms join, remains roughly hewn, suggesting that the arms have been severed from a larger whole (outstretched poses are particularly vulnerable to archaeological breakage).[159]

As commentators point out, given Epstein's reputation as a radical modernist, *Marble Arms* is 'surprisingly classical'.[160] But it is not the classicism of harmonious balance and completion with which the classical mode in the years after of the First World War is conventionally associated.[161] Like the broken pieces of ancient sculpture which – as Percy Gardner wrote in response to Epstein's criticism of the restored Demeter in the British Museum – had the potential to make 'our museums ... look like a surgery in a battlefield', *Marble Arms* is, above all, a fragment.[162] At the time of Epstein's visits to the old Elgin Room, the display comprised not just the strikingly broken pediment sculptures, but a storehouse of marble fragments of body parts that could not be reunited with their torsos.[163] These included broken arms from lost figures from the pediment whose dimensions would roughly match Epstein's sculpture (Figure 4.14), including 'part of colossal right arm of female figure', as Smith's contemporary catalogue put it (perhaps from the lost figure G of the West Pediment), or the '[r]ight arm of female figure, slightly bent, formed of two fragments united at the elbow' ('This may, perhaps, belong to figure F of the west pediment').[164]

[156] Haskell (1932), 188; Elsen (1969), 42; Silber (1986), 152, cat. 136; Buckle (1963), 122–3; Silber, MacDougall, and Dickson (2006), 21; Gilboa (2009), 170–1. Buckle (1963), 122–3 notes that this was 'his first carving since he had finished with Vorticism in 1916'; cf. Gilboa (2009), 170. Epstein may have made another 'unfinished' version, perhaps much later, which was auctioned by Sotheby's in 2009 https://www.sothebys.com/en/auctions/ecatalogue/2009/british-and-continental-pictures-20th-century-british-art-l09695/lot.45.html (last accessed 19.5.2022).

[157] For the female arm modelled on Kathleen's, see Buckle (1963), 122; Silber (1986), 48. For Margaret, see Gilboa (2009), 169–70.

[158] Buckle (1963), 121.

[159] Gilboa (2009), 170 compares the sculpture to 'antique classical fragments ... deprived of a body'.

[160] MacDougall and Dickson (2006), 21. [161] See esp. Carden-Coyne (2009).

[162] *The Times*, Wednesday, 4 May 1921, issue 42711, p.6, col. E. [163] Smith (1908), 116–34.

[164] Smith (1908), 117–18 nos. 330 and 332. Epstein's other interests may have informed this work, too – he might have seen a colossal granite arm in the Egyptian galleries, for example (Silber (1986), 48) – but the naturalistic white marble of *Marble Arms* has significantly more in common with the Parthenon material.

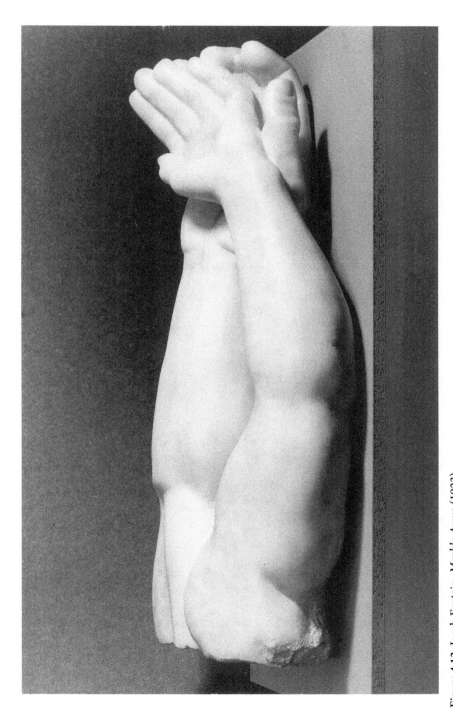

Figure 4.13 Jacob Epstein, *Marble Arms* (1923).

148 FRAGMENTARY MODERNISM

Fig. 39. Marble Fragments in the British Museum, 330–338.

Figure 4.14 From A. H. Smith, *A Guide to the Sculptures of the Parthenon in the British Museum*, 1908, p.117.

Ultimately, *Marble Arms* does not attempt to heal the fractures of modernity or the rifts of personal biography. Mirroring the damage and displacement represented by the arms, legs, and torsos in the British Museum, it homes in on the kinds of sculptural fragment which the artist kept on revisiting in the Greek galleries of the museum.

When Epstein complained to *The Times* a year before he produced *Marble Arms* that recent attempts by the British Museum authorities to pretend that the classical past had survived in anything other than fragments were an 'atrocity', he

MODERNISM AND THE MUSEUM 149

was not just rehearsing old debates about the restoration and derestoration of antiquities. He was tapping into a valorization of the fragment form which had become so widespread in the avant-garde art and writing of the period that it was a standard marker of the modern. By 1928, when Bernard Ashmole and his co-signatories called the plaster additions in the Elgin Room 'a fraud upon the public', the lessons of fragmentary modernism had crossed over from the audience in the sculpture galleries to decisions behind the scenes. By the time the Second World War was raging, items from the British Museum's cast collection – once lovingly cherished for their potential to make fragments into wholes – were considered dispensable enough to use for military shooting practice.[165] Modernism had silently won the aesthetic battle it saw itself as waging, not by rejecting the classical past outright, but by transforming the parameters within which classical antiquity itself was displayed and consumed.[166]

Hugh Kenner once allusively suggested that '[s]ensitivity to detailed sculptural forms makes tolerable – cherishable – in our museums fragments a former generation would have eked out with more plaster than marble'.[167] That observation was quite literally borne out in the museum culture of the first half of the twentieth century, and above all in the British Museum. There had always been a current of resistance to the practice of restoration, but in the space of the British Museum in London, modernism and the museum actively came together in the joint enterprise of fragment-making. While in the Reading Room a new literature of the fragment was emerging in response to damaged scraps of Sappho and the remains of epigram in the *Greek Anthology*, in the sculpture galleries even the most radical of modern sculptors were turning to the fragments left behind by 'those *damn* Greeks'. Despite the rhetoric of vehement rejection, as Pound conceded (implicitly reconfiguring the hierarchies of the British Museum's own diverse collections), 'out of a lot of remnants and fragments there remain certain masterpieces to be set apart and compared with other masterpieces from Egypt and from India and from China and possibly from the South Seas and other districts equally remote'.[168] Along with a growing interest in a broad range of world art, despite the performative anti-classical rhetoric, the 'remnants and fragments' held in the old Elgin Room and the Greek and Roman galleries were still crucially 'set apart' by the most avant-garde of sculptors.

[165] Arrowsmith (2011), 19. For the 'century of decline and rejection' (Frederiksen and Marchand (2010), 1) that faced cast collecting more broadly, see esp. Beard (1994); Born (2002); Frederiksen and Marchand (2010).

[166] A combination of the Wall Street crash of 1929 and the change in public taste for fragments also meant that the art market for pristine-looking, restored classical sculptures of the kind favoured from the eighteenth century all but collapsed by 1930 when the famous Lansdowne marbles were sold: Reitlinger (1963), 243–6.

[167] Kenner (1971), 67.

[168] 'The Caressability of the Greeks', *The Egoist* 1.6, 16 March 1914, 117, Zinnes (1980), 184–6 (186).

That is an important point to make, not just because of what it says about classical reception in modern sculpture or what it contributes to the genealogy of the partial figure in modern art. The new fragments produced in dialogue with the museum were implicated in a broader criss-crossing network of influence between artistic practice and classical scholarship that can be seen across literature and the visual arts. Conceived or created partly within the walls of the British Museum itself, modernism inevitably crossed over into the curatorial decisions behind the scenes. Though it was never openly acknowledged by what Epstein called the 'museum authorities', the new aesthetic paradigm set by the modernist fragment ultimately shaped the decision to strip off the plaster casts that had been added to the sculptures from the Parthenon in the British Museum for more than a century. Modernism did not just take inspiration from the classical fragments in the museum; by infiltrating the domain of the professionals who mediated them, it helped to transform the fragments of antiquity into classical fragments for modernity.

5

Archaeologisms

Writing in the influential journal *Cahiers D'Art* in 1926, Georges-Henri Rivière declared a new era of 'archaeologism' in modern art:

> *The Greek miracle* was alive. Sleeping under the foundations of the Parthenon of Maurras and Winckelmann were *kouroi* with Khmer smiles; archaeology woke them – archaeology which has overturned the museums... archaeology presides over digs which present us with the Thinite dynasties of Egypt, Pre-Columbian America, the ancient empires of China. If it removes Minos's halo of legends, it is in order to give him back his palaces, their treasures, their frescoes.[1]

The Parthenon in Athens and its broken sculptures in the museums of Paris and London had represented the dominant aesthetic model for far too long. Now modern art had woken up to a revolution in archaeology which was overturning the hierarchies of the modern museum and offering alternative models for new artistic creation.[2] These came from regions remote in space: the Thinite period of Egypt, Pre-Columbian America, the ancient empires of China, remnants of the ancient civilizations of Assyria, Mesopotamia, and Babylon. But they also came from deep temporal layers on more familiar ground.

During the nineteenth century and into the first decades of the twentieth, the repertoire of visual culture available from the Greek and Roman world was rapidly expanded in what the German classical scholar Adolf Michaelis famously called 'a century of archaeological discoveries'.[3] As Hugh Kenner influentially observed, 'Schliemann had been to Troy, and a cosmos had altered.'[4] But Heinrich Schliemann's attempts to link the world of Homer with Mycenaean culture with the discovery of Troy represented only a fraction of the archaeological material that was altering the modernist cosmos. In Italy, discoveries at Veii seemed to

[1] Rivière (1926), trans. M. Tiews. For Rivière and the modernist turn to archaeology, see esp. Schnapp, Shanks, and Tiews (2004), 6–9. On the influence of *Cahiers d'Art* and the work of its editor, Christian Zervos, in promoting Greek art as a modern paradigm, see Green (2011).

[2] Rivière himself would soon become director of the ethnographical collections at the Trocadéro and 'France's most energetic ethnographic museologist': Clifford (1981), 546–7; see also Kelly (2007).

[3] Michaelis (1908). Michaelis' influential book was originally published in German in 1906 and the title is translated from that of the second edition, *Ein Jahrhundert kunstarchäologischer Entdeckungen* (Leipzig, 1908). Michaelis died in 1910 and did not foresee some of the major discoveries that came after his death: see also Rumpf (1953), esp. 92–123; Barber (1990); Etienne and Etienne (1992); Dyson (2006).

[4] Kenner (1973), 42. For the reception of Heinrich Schliemann's archaeological digs, see esp. Gere (2006) and Baker (2019).

Fragmentary Modernism: The Classical Fragment in Literary and Visual Cultures, c.1896–c.1936. Nora Goldschmidt, Oxford University Press. © Nora Goldschmidt 2023. DOI: 10.1093/oso/9780192863409.003.0006

152 FRAGMENTARY MODERNISM

confirm the essential 'modernity of Etruscan Art'.[5] Renewed digs at Pompeii by Giuseppe Fiorelli re-invigorated interest in the wall paintings, 'so archaic – so great – so modern',[6] and brought the consciousness of the destruction of the city and the neighbouring Herculaneum (which was also a source of fragmentary papyri) newly to the fore: 'we know crack of volcanic fissure,/slow flow of terrible lava', as H. D. would put it, comparing the Blitz of 1940 and 1941 to the eruption of Vesuvius.[7] Perhaps most sensationally, 'on classic soil', as Micahelis put it,[8] exotic-looking Archaic Greek *kouroi* 'with Khmer smiles' were unearthed in the 1880s in various locations in the Greek world including the Athenian Acropolis itself, and, in Crete, the pre-Hellenic palaces, treasures, and frescoes of King Minos at Knossos were excavated by Arthur Evans, triggering a period of widespread 'Cretomania'.

This chapter investigates some of the ways in which modernism interacted with the influx of archaeological discoveries that shook the world of classical scholarship in the closing decades of the nineteenth century and the opening decades of the twentieth. The new archaeology filtered into the archaeologisms of modernism on a broad scale. But there were also particular pressure points where the work of modernists and the work of archaeologists interacted in especially productive ways. In this chapter, I focus on two examples, both incidentally highlighted in Rivière's archaeological call to arms: the discovery of Archaic Greek art found almost literally 'beneath the foundations of the Parthenon', and the excavation and imaginative reconstruction of what Arthur Evans dubbed 'Minoan' civilization at Knossos in Crete. Discoveries like these – as Ulrich von Wilamowitz announced – threw into 'chaos' the previously circumscribed boundaries of the study of antiquity, shifting the ways in which the classical itself could be conceived and understood.[9] Archaeology put pressure on the 'classical' by opening up categories of the pre-classical and pre-Hellenic that allowed artists and writers – like the archaeologists with whom they found affinity – to dig down to a time before the classical past ever existed and discover new paradigms for modernity.

In all this, the fragment plays a complex role. In principle at least, archaeology is what T. S. Eliot called 'the reassuring science',[10] which joins the pieces of the past back together. '[T]he shattered remnant invites us to reconstruct, to suppose that which is no longer there', Mike Pearson and Michael Shanks explain, and for archaeologists, the fragments of the past are often an invitation to restore a notional whole by reconstructing physically or conceptually the totality that has been lost.[11] In that sense, modernists stand as a countertype to professional

[5] Bandinelli (1930); cf. Piperno (2020).
[6] Rather (1993), 215 n.66, citing the American sculptor Arthur B. Davis in 1910.
[7] H. D., 'Trilogy', *CP* 510. [8] Michaelis (1908), chapter 9.
[9] Wilamowitz (1884), 415–16; Ziolkowski (2008), 13.
[10] T. S. Eliot, 'Tradition and the Individual Talent' (Part I), *The Egoist* 4.6, September 1919, 54–5 (54).
[11] Pearson and Shanks (2001), 94.

archaeologists because they were often more interested in taking the pieces apart, extracting shards of 'buried beauty' (as Pound put it in the *Cantos*, 7/25), and juxtaposing them with the modern. Yet attitudes to the archaeological fragment did not always play out as a simple dichotomy. On the one hand, while modern artists and writers responded to archaeology by making fragments, they did not always adopt archaeological objects necessarily or primarily as fragmentary objects. The Hellenistic Nike of Samothrace, discovered in 1863, became a visual icon of the classical fragment, but the sculpture, 'aloft on her pedestal-prow' in the Louvre, was shunned by Ezra Pound and pronounced by the Futurist F. T. Marinetti to be less beautiful than a roaring motorcar.[12] For many modernists, the discoveries of archaeology offered not just material fragments that could parallel the fragmentary preoccupations of modernity, but temporal fragments that opened up what Pound, in his parallel interactions with philology, called a 'hinter-time' before the 'Athens of Pericles'.[13]

The activities of archaeologists, meanwhile, were not always quite so 'reassuring'.[14] The often unprecedented material discovered underground was less and less likely to go through the kinds of neoclassical restorations seen in previous generations, which had systematically completed damaged sculptures with new arms, legs, and heads.[15] Even when the new discoveries were pieced back together, they often bore the scars of the breakages and fractures sustained in their lives as objects – breakages which had sometimes already been inflicted in antiquity through processes of deliberate fragmentation.[16] In the case of Arthur Evans' Knossos, archaeological reconstruction involved not so much a reassuring science of putting the pieces back together in an accurate recreation of the past; at Knossos, archaeology itself became a creative process that resulted in the construction of modern concrete fragments which crossed the boundary between the 'science' of archaeology and the rival territory of contemporary modernist creation.

Again, the direction of influence did not only work in one way. Stanley Casson noted in *Some Modern Sculptors* (1928) that the tendency to 'archaeologize' could be seen as 'the enemy of modern art because it always lays down the law'.[17] But as

[12] 'Manifesto of Futurism' (1909), point 4. For the shortcomings of the sculpture 'aloft her pedestal prow' see Ezra Pound, 'Affirmations: Jacob Epstein', *The New Age*, 21 January 1915, 311–12, reprinted in Zinnes (1980), 10–15 (11).

[13] Paige 363.

[14] For the ordering processes of archaeology themselves as, paradoxically, a means of producing further fragmentation, see Balm (2015).

[15] Barber (1990). Daehner (2011), 47 suggests that one reason why restoration declined in the twentieth century is that a preference for the fragment 'coincided with the arrival in museums and galleries for the first times of specimens of Cycladic and Archaic sculptures, which no artist wanted (or knew how) to restore to completeness'.

[16] More recent developments in fragmentation theory in archaeology analyse the ways in which ancient communities themselves deliberately fractured, exchanged, and deposited the objects which were meaningful to them in a process of 'enchainment': see esp. Chapman (2000).

[17] Casson (1928), 17.

154 FRAGMENTARY MODERNISM

Casson might have known (he was a former Reader in Classical Archaeology at Oxford), modernism, too, could 'lay down the law' for archaeologists. As archaeological excavation filtered into modernist practice, professional archaeologists, in turn, found themselves interpreting the remains of the past in an aesthetic climate that was progressively dominated by the artistic paradigms of modernism. The fragments unearthed by the excavator's spade were not simply subject to 'the reassuring science' of archaeology, untainted by the mediations of new artistic production. Rather, it was often the case that the discourses and practices of modernism – themselves partly drawn from a dynamic interest in archaeology – came to shape the ways in which archaeologists interpreted and gave value to the pieces of the past.

I. Modernist Archaeologies

Visual culture in the modernist period is marked by the almost obsessive proliferation of incomplete bodies. These appear again and again in multiple contexts of meaning: the armless plaster cupids of Cézanne and the cut-off compositions of Impressionism, the anatomical studies of Orpen and the disembodied Apollos in the canvases of De Chirico or the Surrealist photographs of Man Ray. As Linda Nochlin notes, it is difficult to generalize about the fragment in visual representation. Each individual instance of fragment-making should be seen on its own terms, in a 'a series of discrete, ungeneralizable situations' that mimics the fragmentary mode of its making.[18] Yet there is an important thread – which runs through literary as well as visual culture – that connects fragment-making in the first decades of the twentieth century with the fall-out of the era of archaeologism and its popular dissemination.[19]

Just as poets in the early twentieth century were taking advantage of the papyrological moment to present their work as if it had recently been discovered on scraps of ancient paper buried underground, so modern sculptors tapped into the grammar of excavation to give the aura of fresh 'discovery' to new productions. The beautifully moulded torsos of artists like Auguste Rodin, Antoine Bourdelle, and Camille Claudel carried 'the grace of a mutilated antique excavated from the earth'.[20] But modernist fractures could be much more severe. Constantin Brâncuşi's 'torso' fragment sculptures, one made in 1909–10

[18] Nochlin (1994), 56.

[19] Cf. Barber (1990). For the broader affinities between sculpture and archaeology, see esp. Bonaventura and Jones (2011).

[20] Goldscheider (1996), 126. Pingeot (1990), 133–57, highlights several examples of torso sculptures by these artists and others, including the elegant *Torso* (1890) by Alphonse Legros (a friend of Rodin and Professor at the Slade School of Art in London), which echoes a cast of *Aphrodite of Cnidus* which he had seen at the *École des Beux-Art* in Paris: Pingeot (1990), 140–1.

ARCHAEOLOGISMS 155

(now in the Craiova Art Museum in Romania, Figure 5.1) and another in 1912 (now in the Staatsgalerie in Stuttgart) look less like the showpieces in the major museums of Paris or London, and more like the broken bits of sculpture catalogued in archaeological digs. Even for audiences accustomed to the partial

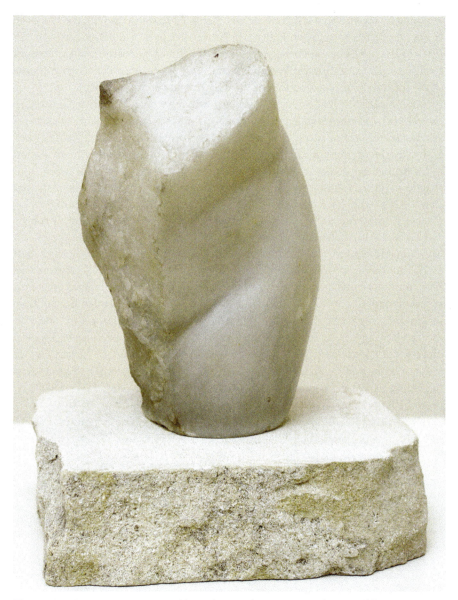

Figure 5.1 Constantin Brâncuși *Torso* (*Coapsă*), 1909–10. White marble, 24.4 cm. Muzeul de Artă din Craiova, Romania.

156 FRAGMENTARY MODERNISM

torsos of Rodin or Bourdelle, Brâncuşi's 1909–10 torso (Figure 5.1), in particular, would have seemed shockingly fractured.

The sculpture tends to be known by the title *Torso*, but when it was first exhibited in 1912, Brâncuşi gave it the Romanian title *Şold şi coapsă* ('hip and thigh'), and it is still known as *Coapsă* today.[21] Tilted slightly forward though somehow still retaining its balance as if it had never been designed to stand upright, the sculpture is not so much a torso as an apparently broken off part of a pelvis, hip, and top part of a thigh. The place of breakage accounts for almost half of the small sculpture's total surface area, so that visual emphasis falls just as much on the rough contours of the fractured marble as on the imaginary remnants of the body part.

Not long after he made *Coapsă*, Brâncuşi would become known for the smooth abstract torsos and heads he would go on to make. Three of his famous ovoid sculptures were shown at the Allied Artists Association in 1913, where they enthralled Jacob Epstein and Gaudier-Brzeska,[22] and later inspired Ezra Pound to try his hand at sculpture, when he 'acquired two pieces of stone as nearly egg-shaped as possible, hit them with hammers and then laid them about on the floor'.[23] Yet with its emphasis on extreme fragmentation, the more figurative *Coapsă* is also crucially modernist in its way.[24] As a marble fragment, it echoes some of the mismatched body parts displayed in the old Elgin Room in the British Museum and replicated by Rodin (in whose studio Brâncuşi had briefly worked in 1907). But the sculpture is far removed from the classical art typically displayed on plinths in museums and its modern imitations. '[A] mutilated fragment from an archaeological excavation',[25] Brâncuşi's torso blurs the lines between the multiple scraps and fragments dug up by archaeologists and the sculpture on show in the modern gallery. If 'big museums', as Will Rea puts it, turn archaeological objects, displaced from their contexts of excavation, into 'the possession of museum curators ... subject to the museological gaze',[26] Brâncuşi's *Coapsă* turns the museological gaze, accustomed to the displaced fragments of archaeology, onto the fragmentary art forms of modernism.[27]

While artists like Brâncuşi were replicating the fragmentary condition of archaeological objects, archaeology itself, as a discipline which promised to make sense

[21] Varia (1986), 183.

[22] The catalogue lists only one sculpture by Brâncuşi, in bronze (probably the *Sleeping Muse*), but Roger Fry saw at least three 'ovoid forms' in the exhibition: Magid (1975). Brâncuşi's work, including the second fragmentary *Torso* made in 1912, also appeared in America in the International Exhibition of Modern Art in New York in the same year: Rather (1993), 101.

[23] Beasley (2007), 176 (citing Ford Madox Ford).

[24] Tronzo (2009), 119; Burström (2013), 316.

[25] Lichtenstein (2009), 119; Bach, Rowell, and Temkin (1995), 100. [26] Rea (2011), 22.

[27] Brâncuşi left chisel marks on the back of the torso, a move which may have been intended to signal the artist as a modern direct carver (unlike Rodin), but, as I discuss below, it also echoes the same processes detected in the archaic Greek sculpture sensationally unearthed by archaeologists in the closing decades of the nineteenth century.

of fragments, presented an attractive proposition for literary modernists. As Sasha Colby writes:

> archaeology ... was not just a discipline: it was a series of imaginative templates – a sequence of methods or approaches enriched by the constant oscillations between the object and the civilization it evoked, the fragment and the totality it called into being, solid earth and the layers that belied it.[28]

What Colby calls a 'poetics of excavation' can be seen to characterize the literature of modernism on a broad scale.[29] Several modernist works across a range of genres mirror and absorb archaeological methods and metaphors, and writers often figured themselves as exhumers of fragments from the stratified sediments of the past.[30] Joyce's *Ulysses* absorbs what Hugh Kenner identified as 'Homer's sticks and stones' in the form of archaeological material form Schliemann's Troy filtered through scholarship on Homer, but more recent archaeological analogies, like the 'rubbages' of Oxyrhynchus or the '[c]offined thoughts ... in mummycases, embalmed in spice of words' (*Ulysses* 9.35–3) also left sedimentary traces into Joyce's work.[31] Ezra Pound's poetry can be read (as Colby reads it), as, in one way or another, structured by archaeological thinking.[32] If philology offered techniques of textual excavation to a 'hinter-time' before the established classical canon,[33] archaeology offered the means and methods to extract long-forgotten fragments from the debris of history. Like Flinders Petrie, who had brought back archaeological and papyrological treasures from Egyptian tombs (including the precious papyrus of Homer's *Iliad* which inspired Grenfell and Hunt's digs), Pound figured himself as an excavator among ancient burial sites: 'I, who have laboured long in the tombs,/Am come back therefrom with riches.'[34] As T. S. Eliot put it, Pound was at his most 'original (in the right sense) when he was at his most archaeological (in the ordinary sense)',[35] and the *Cantos* have been shown to operate on a poetics of excavation, their multiple temporal layers mirroring the strata of an archaeological dig where artistic treasures are buried among the sediments.[36] Eliot's archaeological analogy could equally apply to the 'stony rubbish' of *The Waste Land* (1.20 = *PTSE* 1.55), which collocates the fragments of the past with the stratified debris of modernity in what has been seen as an echo of the 'reassuring science of archaeology'.[37]

[28] Colby (2009), 3. [29] Colby (2009).

[30] Rather (1993); Finn (2004); Colby (2009); Kocziszky (2015); Dobson and Banks (2018).

[31] Kenner (1969). For Oxyrhynchus in the 'rubbages' of *Finnegans Wake*, see also Chapter 1, p.40.

[32] Colby (2009), 115–32.

[33] Pound to W. H. D. Rouse 23 May 1935: Paige 363. Cf. Chapter 2, p.66.

[34] 'Epilogue' (1912) in Pound (1977), 209.

[35] T. S. Eliot, Preface to *Selected Poems* (1928) = Pound, *SP*, 10–11. [36] Colby (2009), 115–30.

[37] For *The Waste Land* and the rubbish heap of Oxyrhynchus, see Chapter 1, pp.41–2.

158 FRAGMENTARY MODERNISM

Though Pound and Eliot tend to be seen as Anglophone modernism's most archaeological poets, perhaps the most imaginatively saturated by archaeology of them all was H. D. Unlike Pound, who only visited Greece in 1965 at the age of eighty and was reportedly disappointed in Rome, or Eliot, who never went to Greece, H. D. was an extensive archaeological traveller. She visited Athens in 1920 and Egypt in 1923 around the time of the Tutankhamun excavations; in 1932, shortly before she became Freud's patient in Vienna (a relationship that was itself marked by a shared archaeological interest), she went on an Hellenic cruise with her daughter Perdita.[38] Although the landing at Knossos had to be abandoned because the sea was too rough,[39] she managed to see Schliemann's excavations, and she stopped at the islands of Delphi and Aegina. In her unpublished short story 'Aegina', the unnamed speaker travelling around Greece experiences a quasi-religious epiphany on the island. H. D.'s version of the island – which was re-excavated in the early part of the twentieth century in the search for missing pieces of the famous 'Aegina Marbles' in Munich – is based on accurate descriptions of the archaeological landscape as well as its natural detail.[40] The narrator notes the 'stones piled in heaps' as she overhears 'donnish' tourists discuss the island temple, its famous sculptures (casts of which H. D. herself would have seen in the British Museum), 'unhappily in Munich or Berlin' (p.1).[41]

H. D.'s reception of archaeology was often profoundly visual, crossing boundaries between the poetics of excavation to its analogues in visual culture. She probably took a folding pocket Kodak with her on her trips to Greece and Egypt, and, like many, she linked her archaeological experience with the fast developing medium of photography.[42] Photography had emerged in partnership with archaeology (both Schliemann and Evans used expensive photographers to construct the public reception of their work), and the relationship between the archaeological object and the photographic image coloured the reception of how archaeology was experienced and received.[43] As H. D. put it in the quasi-autobiographical *Palimpsest*, for modern consumers of archaeology, the photograph seemed to have the power to trap 'the reality...of the blue temples of Thebes, of the white colonnades of Samos' in the 'semi-transparence of shallow modernity', transforming the stone remains of the past into the silver crystals trapped in

[38] For H. D. and Freud, see H. D.'s own *Tribute to Freud* (= H. D. (1974)) and discussion in Gere (2009), 'Crete on the Couch', 164–71 with Hollenberg (2022), 141–84.

[39] H. D. (1974), 175.

[40] 'Seven Stories', YCAL MSS 24, H. D. Papers, American Literature Collection, Beinecke Rare Book and Manuscript Library, Yale University. The mis-identification of the famous temple of Aphaia as that of 'Hygenea' is highly likely to have been deliberate: Roessel and Conover (2012).

[41] For a broader reading of the 'palimpsestic' poetics of archaeology in H. D.'s work, see Colby (2009), 132–9.

[42] Collecott (1986), 181 n.63. The popular type of camera, which produced postcard-sized images included in the price of the film, was sold in Britain and America between 1903 and 1934.

[43] On the close relationship between photography and archaeology, see esp. Riggs (2020); Lyons (2005); Tsirgialou (2015).

'the jellified and sticky substance of a collection of old colourless photographic negatives'.[44]

In the 1920s and early 1930s, H. D. developed a complex and intimate language of photographic images with her romantic partners, Bryher (Annie Winifred Ellerman) and Kenneth Macpherson.[45] She would send sequences of images to Macpherson, which he likened to the artistic endeavours of Surrealism, the dreamlike collocations of which often involved Greek myth and archaeological material.[46] These image sequences are now impossible to reconstruct, but a photomontage scrapbook – known as the 'H. D. Scrapbook', which was probably produced collaboratively by H. D., Bryher, and Macpherson – preserves something of the visual language in which they engaged.[47] The montage images in the scrapbook clearly draw on techniques of filmmaking with which the three were also experimenting (they founded the film magazine *Close Up* and produced films together).[48] But what H. D. called their involvement with 'pictures' was also significantly archaeological. The scrapbook is dominated by 'Greek stuff': photographs which H. D. herself must have taken on her travels, postcards she had picked up, cut-outs from brochures and other postcards from museums elsewhere.[49] On several pages, photographs of the poet, frequently naked, are spliced with pictures of the archaeological sites and objects she had seen: an unclothed H. D. walking among broken temple columns, or crouching down on the ground next to a fragmented statue of Nike.[50] In one particularly striking montage (Figure 5.2), H. D., walking among white irises, has been juxtaposed with a series of images of Athens: a blurred 'semi-transparent' postcard-sized image of the Parthenon, perhaps taken on site by the poet herself, pasted flush next to a clearer image of the Byzantine Monastery of Daphne in Athens, and overlayed with a top layer of what looks like a catalogue or postcard cut-out of one of the Archaic female figures found on the Athenian Acropolis (the so-called 'Chian Kore').[51]

The result mixes memory and desire on a biographical level (Bryher and H. D. began their relationship around flower names in the *Greek Anthology*,

[44] 'Murex', *Palimpsest* (1969), 157–8. [45] Collecott (1986).

[46] Collecott (1986), 320; Yatromanolakis (2012). For the analogy with Surrealism (from Macpherson's letter to H. D. probably dating from 1933 or 1934), see Collecott (1986), 320.

[47] The scrapbook is discussed in detail in Collecott (1986) (who argues on the basis of an inscription on p.29 of the scrapbook that Macpherson was the author), and Vetter (2003) and Czelustek (2022) (who both follow an attractive suggestion by Friedman (1991), xii that the scrapbook was likely to have been the result of collaborative authorship). An online copy is easily accessed from the digital collections of the Beinecke Library, Yale University: https://collections.library.yale.edu/catalog/2008034.

[48] For the relationship between *Close Up* and the scrapbook, see Czelustek (2022).

[49] Macpherson promised to bring H. D. 'armfuls of Greek stuff' back from Berlin: Collecott (1986), 321. Seventeen of the forty-two pages in the scrapbook feature archaeological sites or objects. One page includes Egyptian material, but the rest is Greek or Roman.

[50] Collecott (1986), 333 identifies the image with the famous Winged Nike of Samothrace in the Louvre, but the scrapbook image shows a Nike of the Paionios type, with bare breast and raised arm.

[51] On the statue in the Acropolis Museum (no. 675), which was put together from three separate pieces, see Dickins (1912), 216–17. For the discovery of the *korai*, see pp.161–4 with Figure 5.4 below.

Figure 5.2 From the 'H. D. Scrapbook'. H. D. Papers. American Literature Collection, Beinecke Rare Book and Manuscript Library, Yale University, YCAL MSS 24.

including 'the spice-scented flowering iris of Nossis'[52]) but it also taps into the palimpsestic character of archaeological memory.[53] Echoing Freud's famous archaeological analogy between the unconscious and the many layers of the imagined archaeological site of Rome in *Civilization and its Discontents* (which was published in English translation by Virginia and Leonard Woolf's Hogarth Press in 1930, around the time the scrapbook was probably made), Athens is presented not only as an archaeological entity but as 'a mental entity'.[54] Like the temporal layers of Pound's *Cantos*, each image evokes a different stratigraphic layer all the way from the Archaic period to the present day, mapping the complex and contested site of Athens onto the fragmented ways in which it is experienced in memory.[55] At the same time, the scrapbook page also taps into some of modernism's greatest archaeological obsessions. It gestures to the Parthenon, whose fragments in the

[52] Mackail (1911), 93; Collecott (1999), 204.
[53] For the autobiographical nature of the scrapbook, see Vetter (2003).
[54] Freud (1930), 15–18, 17. For Freud's intense interest in archaeology, see esp. Armstrong (2005), 109–12, 183–200 with further references.
[55] The Daphne Monastery is situated in the Athenian suburb of Chaidari, but it evokes the many post-classical layers removed in the 'purification' of the actual site of the Acropolis by archaeologists: see esp. Hamilakis (2007).

British Museum were crucial to the dialogue with Greek fragments with which, as H. D. said, 'it all began', but it also evokes, in the topmost layer of the scrapbook surface, a new interest in Archaic sculpture that had been discovered in the ground beneath the Parthenon itself.

II. 'sleeping under the foundations of the Parthenon': The Archaics and the Moderns

Around the last quarter of the nineteenth century, what Adolf Michaelis called 'a lost chapter of the history of art' was revealed beneath Greek soil.[56] Figurative sculpture from the so-called Archaic period of Greek art (around 650 to 480 BCE) was uncovered at various sites around the Greek world, changing the established narrative of the history of ancient sculpture. In what seemed like a powerful realization of a metaphor, some of the most significant discoveries were made on the Athenian Acropolis, almost literally – in Rivière's terms – 'sleeping under the foundations of the Parthenon'. When the Turkish garrison was disbursed in the aftermath of the Greek War of Independence (1821–32), examples of early Greek sculpture from the late sixth to the early fifth centuries were revealed hidden in the ground beneath it. More and more material emerged in the ensuing decades, and when in the 1860s foundations were dug for an antiquities museum to hold the new material, even more pieces came to light.[57] The iconic 'Moschophoros' ('the calf-bearer', c.570–560 BCE) was discovered in pieces in 1864 (the base and feet emerged separately in 1887), and the early classical Kritios Boy (c.480 BCE) 'the first beautiful nude in art' in Kenneth Clark's formulation, was found the following year, initially headless, though it was reunited with its missing head in the 1880s (Figure 5.3).[58]

More systematic excavations of the site began in 1882 under the auspices of the Greek Archaeological Society.[59] Trenches were dug below the east façade of the Parthenon and other locations on the Acropolis, 'and the results were instantaneous'.[60] Over the course of two days in 1886, around fourteen Archaic statues were found near the north-west corner of the Erechtheion.[61] Characterized

[56] Michaelis (1908), 242. [57] Mallouchou-Tufano (1994), 75.

[58] Clark (1956), 27. Keesling (2003), 49 suggests the possibility of a later date; cf. Dickins (1912), 156–60 no. 624 (Moschophoros); 264–6 no. 698 (Kritios Boy): the sculpture was initially fitted with the wrong head in 1880 which was then replaced when a better candidate emerged in 1888.

[59] For the dynamics of Greek nation-building governing the archaeological agenda, see Hamilakis (2007).

[60] Dickins (1912), 3.

[61] Kavvadias and Kawerau (1906), 28; 'Statues Found on the Acropolis of Athens', *Illustrated London News*, 10 July 1886, pp.37–8.

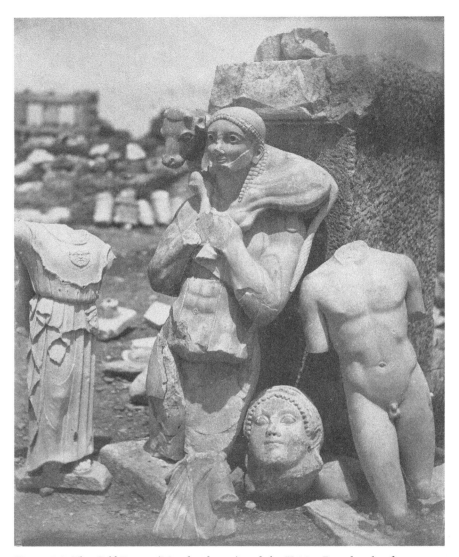

Figure 5.3 The Calf-Bearer (Moschophoros) and the Kritios Boy shortly after exhumation on the Acropolis, *c.*1865. Albumen silver print from glass negative. Metropolitan Museum of Art (2005.100.56).

by an aesthetic that would come to be strongly associated with modern sculpture, these *korai*, or 'maidens' as they were known to anglophone audiences, had been carved directly in stone. They were sculpted frontally in rigid columnar forms, their faces and figures abstracted to simple shapes, and their hair geometrically arranged. Clothed in various garments, including one striking example of a full-length peplos (Figure 5.4), the legs were typically held stiffly together and one or

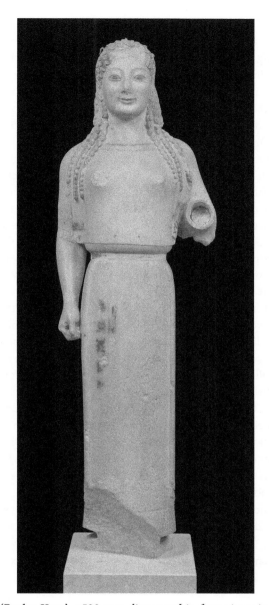

Figure 5.4 The 'Peplos Kore', *c*.530 BCE, discovered in four pieces in 1886. Parian marble, 1.2 m. Acropolis Museum (679).

both arms outstretched, as if extending a votive offering. On their simplified faces, in what would come to be seen as the central characteristic of Archaic art, the corners of the mouth were slightly upturned in the so-called 'archaic smile', more alluring, as the French novelist and critic André Beaunier saw it in 'Le

164 FRAGMENTARY MODERNISM

Sourire d'Athéna' (1911), because the living emotions it once signified had been lost forever.[62]

As if following archaeological fashion, a whole series of Archaic stone figures were unearthed in the closing decades of the nineteenth century and on into the twentieth. These included examples that pre-dated the earlier finds, like the *kore* from the 'Daedalic' period (*c*.650–625 BC) known as the 'Lady of Auxerre', found languishing in a storeroom of a municipal French museum in 1907.[63] From Delos to Delphi and Olympia to Samos, multiple sites of excavation followed the new archaeological trend, producing not only female *korai* but their male counterparts, *kouroi* ('youths'), or 'Apollos' as they were initially called after the god whom they were thought to represent. Similarly abstract and also frontally oriented, the *kouroi*, unlike their female partners, were sculpted nude, their arms held stiffly by their sides, their legs parted with one foot (usually the left) striding forwards (Figure 5.5).

The influx of Archaic 'Apollos and Maidens' made a powerful impact on the visual culture of modernism. As Kenneth Haynes puts it, '[a]s a visual icon, the archaic *kouros* was to the first half of the twentieth century what the Laocoön group was to the late Renaissance and Baroque'.[64] Emerging from familiar soil but far removed from the classical ideal, what Brâncuşi called 'the nearly archaic Greeks'[65] were welcomed from their slumbers beneath the foundations of the Parthenon as a liberating alternative to the traditional canon of classical art. *Kouros* and *kore* sculpture-types were quoted again and again in modern painting, from Picasso to Pierre Bonnard,[66] leaving their imprint on the work of some of the most radical artists of the period.[67]

As I argued in Chapter 4, despite his well-documented interest in world sculpture, Jacob Epstein was drawn to classical Greek sculpture in the fragmentary condition in which it had come to modernity, and used the British Museum in London as a key site of engagement. But it was not only classical Greek material to which Epstein was drawn. Examples of the *kouros* and *kore* were on display when Epstein made his regular visits to the British Museum's Greek and Roman collections, including three 'Apollos' in the Archaic Room,[68] as well as several copies of key finds like the *korai* of the Acropolis on show in the cast gallery.[69] *Girl with a Dove* (Figure 5.6) was produced during the period when Epstein first moved to London and started making frequent trips to the Greek galleries in the

[62] 'Qu'ils sont émouvans, ces sourires qui ont survécu au sentiment dont ils furent le signe, ces sourires dont l'objet est perdu!' (Beaunier (1911), 343). On the reception of the archaic smile, see also Rather (1993), 44, 57–8.

[63] Martinez (2000). [64] Haynes (2007), 101.

[65] Dorothy Dudley, 'Brancusi', *Dial* 82 (February 1927), 130; Bach (1987), 328.

[66] Prettejohn (2012), 185–6.

[67] Rather (1993) focuses on the American sculptor Paul Manship, but includes broader discussion of the widespread phenomenon of archaism in modern sculpture, including the influence of Archaic Greek sculpture.

[68] *A Guide to the Exhibition Galleries of the British Museum* (London, 1892), 15.

[69] Pryce (1913), 17–18.

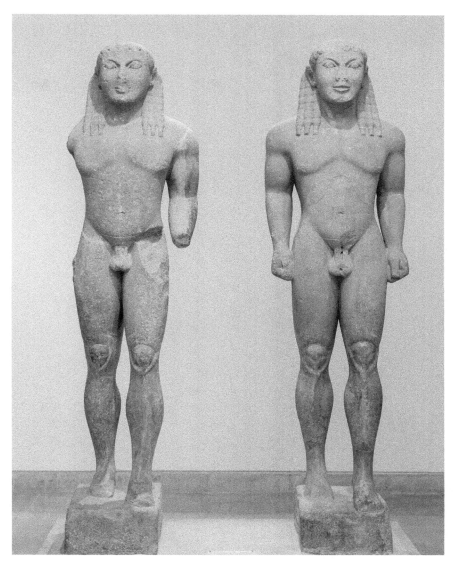

Figure 5.5 Two male *kouroi* ('Kleobis and Biton'), excavated at Delphi in 1893 and 1894. Delphi Museum.

museum. The sculpture was originally produced in 'black wax, life-size or slightly over', as the architect Charles Holden remembered it.[70] Only a drawing now

[70] From Holden's memoir, Royal Institute of British Architects archive, AHP 26/25/1, p.i. I am grateful to Fiona Orsini for supplying me with a copy of the document. The sculpture led Holden to give Epstein the commission for the eastern-inspired sculptures for the façade of the British Medical Association that catapulted him into the public eye.

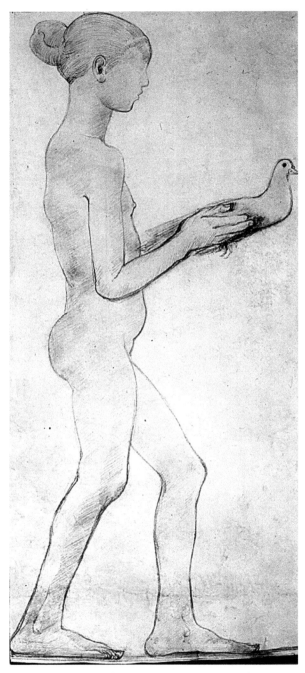

Figure 5.6 Jacob Epstein, *Girl with a Dove* (1906–7). Pencil drawing. Walsall, Garman-Ryan Collection (1973.065.GR).

ARCHAEOLOGISMS 167

survives, but it is clear that Epstein had absorbed both the male and the female *kouros* types in *Girl with a Dove*. The work is at once unclassically naturalistic and studiedly 'archaic'.[71] Naked, feet flat on the floor, the stiffly formed figure steps forward like the stylized male *kouros*, but her arms, characteristically levered at the elbow, are held out in a gesture of offering that recalls the Athenian *korai*.[72]

Epstein destroyed the work shortly after it was produced (as he did several of his early works), ostensibly to liberate himself from the 'dead hand of Athens' and open up to extra-European influences.[73] Yet the abstract features of the *kouros*, its upright stiffness and the legibly transcultural 'primitive' dynamic it displayed, continued to be foundational for Epstein's later sculptural developments.

There were several compelling reasons why Archaic sculpture could become imaginatively important for modernism. First, as objects, the new finds often carried stories of burial and exhumation that emphasized their status as fragments. The Athenian *korai*, in particular, tell a complex story of destruction and fragmentation. After the Persian sack of Athens in 480–479 BCE, the debris left behind – or 'Perserschutt' as contemporary German archaeologists called it – was buried to make the foundations for a new temple compound, triumphantly crowned by the Parthenon.[74] The statues had already suffered significant damage at the point of burial, and when the *korai* were found in the 1880s, as Michaelis put it, '[e]ach single statue had to be pieced together out of numerous fragments'.[75] The pieces were painstakingly assembled by archaeologists (the Austrian archaeologist Franz Studniczka was particularly celebrated for his skill in matching seemingly disparate bits together), but the process was slow, and the results still bore the scars of the objects' fragmentary histories.[76] As *The Illustrated London News* reported in 1886, in the fall-out of modern political upheavals, the *korai* emerged into the modern world among 'common stones...bits of sculpture, heads and feet...potsherds and rubbish', in a romanticized 'dump' prefiguring accounts of the Oxyrhynchus papyri ten years later.[77]

[71] Buckle (1963), 24; Silber (1986), 16, 120; Gilboa (2009), 75, 80.

[72] Gilboa (2009), 75 suggests in passing that the figure echoes the male (but not the female) *kouros* pose. The work has also been linked with a classical Greek stele at the Metropolitan Museum of Art showing a girl with doves (Met. 27.45: Cork (1985), 15), but the stele only entered the Metropolitan Museum collection in 1927 (from the private collection of the Earl of Yarborough), which means that Epstein could not have seen it in New York and is unlikely to have seen it in Britain: see Arrowsmith (2011), 15, who finds alternative non-Greek genealogies for Epstein's work.

[73] Arrowsmith (2011), 22–3.

[74] More recent analyses of the individual Acropolis deposits have questioned the dating of parts of the material: Keesling (2003), 49–50 with Lindenlauf (1997).

[75] Michaelis (1908), 242.

[76] Rachel Kousser has more recently argued that several of the *korai* show traces of deliberate mutilation, suggesting that they had already been fragmented in antiquity during the Persian sack itself: the line of the breaks imply that they were toppled over and snapped; traces of thermal damage indicate attempted destruction by fire, while the mutilated faces, whose fractures do not always follow the natural line of the stone, combined with unusual point marks to the bodies, imply that chisels, axes, or mallets were used to damage the originals: Kousser (2009) and (2017), 93–119.

[77] 'Statues Found on the Acropolis of Athens', *The Illustrated London News* 10 July 1886, 37–8 (38).

168 FRAGMENTARY MODERNISM

The new Archaic sculpture held a further advantage in that it could be co-opted into a generalized mixture of 'primitive' aesthetics drawn from a mish-mash of what Henri Gaudier-Brzeska called 'the barbaric peoples of the earth . . . for whom we have sympathy and admiration'.[78] On this view, the 'archaic smile' character-istic of the Greek sculpture of the period could easily be conflated, in Rivière's terms, with 'a Khmer smile'. The *kouros* sculpture-type was particularly amenable to this sort of appropriation because it could already be seen in its own right as a manifestation of world sculpture. Connections had been made in antiquity between Archaic Greek sculpture and Egyptian statues,[79] and Greece's transcul-tural dialogues with Egypt were frequently identified in the background to key features of the *kouroi* by the archaeologists who discovered and discussed them. Their posture and structure, their clenched hands, the disposition of the hair elaborated into tresses and bound at the ends: all openly suggested Egyptian influence and even the influence of Mesopotamian art, where a similar articulation of the musculature into decorative patterns can be seen.[80] As André Beaunier put it, there was a strong sense that these works lay 'sous l'influence vivifiante des civilisations orientales', and this played right into the modernist hunger for world sculpture.[81]

The abstract features, simplified poses, and transcultural look of the *kouroi* clearly rhymed with the work of modern sculpture. But the primary link centred on questions of technique. As had become clear over the course of the nineteenth century, much of the canon of Greek sculpture consisted of Roman marble copies of Greek bronzes. To make the copy, a plaster cast was made from the original bronze from which measurements or 'points' were then taken and marked onto the marble block to be copied. A similar procedure was thought to lie behind some later sculpture carved in marble: the artist first made a clay figure which would be copied in stone by his assistants.[82] The technique of modelling was still being used by sculptors in the twentieth century, and most notoriously by Rodin 'at his plaster-castiest'.[83] But in the first decades of the twentieth century, a new gener-ation of sculptors rapidly dispensed with clay models to carve directly into the stone itself. With its association of freedom, vitality, and artistic integrity, direct carving became, in Evelyn Silber's words, 'a password for sculptural modernity'.[84]

[78] Gaudier-Brzeska, 'Mr Gaudier-Brzeska on "The New Sculpture"', *The Egoist*, 1.6, 16 March 1914, 117–18 (118); cf. Haynes (2007), 101–2. It was not only contemporary artists but archaeologists themselves who made the connection: as Theopille Homolle put it, 'primitive forms of art now take pride of place in archaeological research': in 'Découvertes de Delphes', *Gazette des Beaux-Arts* 3.13 (1895), 207: quoted and translated in Barber (1990), 398.
[79] Diodorus 1.97.6, 1.98.9: Richter (1970), 2; Hurwit (1985), 196–7.
[80] Richter (1970), 2–3. Hurwit (1985), 131–5; cf. Dickins (1912), 159 noting the eastern influence evident in the inlaid eyes of the Moschophoros.
[81] Beaunier (1911), 346.
[82] Gardner (1890), 138, for example, supposes the process to date back as early as Lysippus in the fourth century BCE, though it would not have been universal or common 'in good Greek times'.
[83] Ezra Pound, *Egoist*, I, 4, 1914, pp.67–8 (67). [84] Silber (1996), 93.

It is partly for this reason that modernist sculpture tends to be seen as predicated on a technical revolution that is emphatically un-Greek,[85] reinforcing the traditional art-historical narrative of the violent rejection of ancient Greece in the visual cultures of modernism. Just as they moved outwards in space to models from India, Africa, China, South America, and the South Pacific and 'other districts equally remote', as Pound put it, so, the story goes, modern sculptors also adopted extra-European sculptural techniques of carving directly in stone.[86]

Yet – as classical archaeologists were emphasizing – Archaic Greek sculpture *was* carved directly in stone. Moreover, just as modernism was turning to the 'nearly archaic Greeks' for inspiration, the new sculpture and its technical revolution in direct carving underwrote the scholarly investigation of the carving techniques of Archaic sculpture. As Elizabeth Prettejohn has shown, 'the resonances of direct carving in classicists' accounts of Archaic Greek sculpture are analogous to those in accounts of modernist sculpture'.[87] The connotations of free-carving in the rhetoric and practice of modern art crossed over into classical scholarship, with archaeologists often employing some of the same terms to talk about Archaic Greek sculpture which modernists used about their own sculptural practice. The cross-fertilization was made possible substantially because, as Prettejohn points out, classical archaeology and modern art were not separate fields of activity in the first half of the twentieth century. Stanley Casson, whose comments on archaeologism I quoted in the introduction to this chapter, produced not only *The Technique of Early Greek Sculpture* (1933) and a catalogue of sculpture in the Acropolis Museum but two books on modern sculpture.[88] When, in 1929, the archaeologist and art historian Gisela Richter wrote the influential *Sculpture and Sculptors of the Greeks*, she freely quoted parallels from the direct carver Eric Gill (one of Ezra Pound's favourite artists).[89] She herself drew on 'new insight' gained from attending a stone-carving class in New York run by Robert Laurent, the leading direct carver in the USA,[90] and acknowledged the work of her sister Irma Richter, 'an artist by profession' who revised the 'whole first part of the ms'. By 1942, when Richter published her seminal study of the *kouros*, *Kouroi*,

[85] Arrowsmith (2011), 23.

[86] Ezra Pound, 'The Caressability of the Greeks', the *Egoist*, I, 6, 1914, p.117.

[87] Prettejohn (2012), 208.

[88] *Some Modern Sculptors* (1928) and *XXth-Century Sculptors* (1930): Prettejohn (2012), 208. The audience of Casson's books also crossed over between the two fields: Casson's *Some Modern Sculptors* was reviewed in the *American Journal of Archaeology* 34.3 (1930), 395–6, while *The Technique of Early Greek Sculpture* would be reviewed in the art journal *Parnassus* 6.1 (Jan. 1934), 26–7.

[89] Prettejohn (2012), 208; Richter (1929), 142 n.43 (with an extensive quotation from Eric Gill's *Sculpture, An Essay in Stone Cutting*). Richter also cites 'the illuminating remarks' (27 n.15) from the German sculptor Adolf von Hildebrand's influential *Das Problem der Form* (1893) (she used the 3rd and 4th editions of 1918), whose influence was so strong that 'the reader begins to suspect that Richter's authority for this view came from modern sculptural theory rather than any ancient source': Prettejohn (2012), 208–9.

[90] Prettejohn (2012), 208; Richter (1929) viii, and 144 n.56.

170 FRAGMENTARY MODERNISM

Archaic Greek Youths, it was her artist sister Irma who wrote the pages on the procedure of direct carving. Comparing the process to music (12), Irma outlines a method in which 'all shapes were ranged and related to each other according to their proportions' (12), yet carved such that the early *kouroi* still 'retain[ed] a close connection with the blocks out of which they were hewn' (11).[91] Richter's book was highly influential and is still a standard work on the topic, which makes it all the more striking that the vision of Archaic Greek sculpture it presents is deeply embedded in the terms which the direct carvers of modernism habitually used to describe their own work.

By crossing over into the territory of modern art, then, classical scholars presented Archaic sculptors 'as the avant-garde of ancient art'.[92] But the avant-garde potential of Archaic sculpture had already been realized by modernists encroaching on the territory of archaeologists. In reply to a staged argument with Aldington and Gaudier-Brzeska in the correspondence pages of the *Egoist* about the value of Greek art, Ezra Pound had famously declared that '[t]he modern renaissance, or awakening' was based on the liberation from '*this pother about the Greeks*'.[93] Two years later, however, he announced his plans to cut through the pother by writing a new monograph on early Greek sculpture. As Pound wrote in a little-known letter to the New York lawyer and art collector John Quinn in August 1916:

> I propose also to back up the Gaudier book, by a monograph on Greek sculpture before Phideas, H. Watt, the agent, has the profuse illustrations now in hand and is hunting an Eng. publisher. Text would be very brief. Tracing the development of forms (vorticisticly) in early Pisistratan stuff and before then. The 'Moscophoras' *is* good. Greece had one really fine sculptor & has forgotten his name. Encyclopedia Britannica on g/ = sculpture is the 'aunt sally'. (By the way Flinders Petrie has just brought out a book on Egyptian sculpture that you will want. I haven't yet read it but he must *know* or he couldn't have chosen his illustrations so well.)[94]

Pound's book on ancient sculpture was imagined as a kind of companion 'backing up' his art-historical memoir of Henri Gaudier-Brzeska, who had been killed fighting for the French army the previous year. Unlike the entry on Greek art in the contemporary edition of the *Encyclopaedia Britannica*, which essentially ran through the well-known greatest hits of classical and later sculpture, Pound's book would focus on the 'early Pisistratan stuff' *c.*560–527 BCE 'and before that', which

[91] Richter (1970), 11–12. Irma also cites Hildebrand's *Das Problem der Form* (1893).
[92] Prettejohn (2012), 202.
[93] Ezra Pound, 'The Caressability of the Greeks', the *Egoist*, I.6, 1914, p.117.
[94] Ezra Pound to John Quinn, 31 August 1916: Materer (1991), 86. On Quinn, see Reid (1968).

ARCHAEOLOGISMS 171

he seems to freely associate with the illustrations in a recent book on Egyptian art
by Flinders Petrie, the Egyptologist who had 'laboured long in the tombs' to find
Greek papyri in the Fayum, and, like Pound, seemed to be able to see the
modernity in antiquity.[95]

Though the images he gathered are now lost, Pound was particularly attentive
to photographic reproductions in this period (he was working with Walter
Benington for his memoir of Gaudier), and he may have looked at Henri
Lechat's richly illustrated *La Sculpture avant Phidias* (1904) in the British
Library, the title of which directly recalls the wording of his planned book in the
letter to Quinn. Pound probably did not get very far with his research (the
monograph never materialized), but it is clear that what he saw in the images he
had gathered for J. Hansard S. Watt, of the literary agents A. P. Watt & Son (who
also had Pound's 'big Noh book' in hand and acted as an agent for W. B. Yeats),
was the essential modernism of Archaic sculpture.[96] Instead of a narrative of
development towards the naturalism that would peak in the classical sculptors
whose names were still celebrated, Pound proposed an alternative narrative that
would 'trac[e] ... the development of forms' 'vorticisticly'. On this outline, Archaic
sculpture would be cast not so much as a precursor to the ideal of classical Greek
sculpture, but to the modernist enterprise of Vorticism. 'Backing up' his study of
the direct carvings of Gaudier, Pound's new history of Greek art would free the
story of art from the 'caressable' end-point of the classical canon. On the new
narrative, Archaic art could become the missing piece in an evolutionary story not
of Greek art, but of modernism. The 'Art-instinct is permanently primitive', the
Vortex manifesto declared: rejecting the ideal of beauty represented all too long by
classical art, it is centred on the energy of sculptural planes and surfaces and the
relations between them (or as Richter would put it, 'all shapes ... related to each
other ... in a pre-conceived three-dimensional space').[97] As both classical scholars
and modernists were realizing, the Archaic sculpture found beneath Greek soil in
the lead-up to the twentieth century shared key aspects of the modernist 'Art-
instinct'. As Gaudier-Brzeska himself had put it, writing in a longer version of a
letter published in the *Egoist*, a new revolutionary alliance between 'the archaics

[95] 'Epilogue': Pound (1977). 209. Pound mentioned Flinders Petrie's book (probably *The Arts and Crafts of Ancient Egypt* (London, 1910)) to his father as well (19 September 1916 = *EPHP* 377): 'The illustrations are good. Havent [*sic*] yet had time to read the text.' He also wrote to Quinn that he would like to see 'egyptian [*sic*] sculpture (roughly) put in place of the Farnese Bull in the academic curriculum' (3 September 1916): Materer (1991), 87.

[96] Pound mentioned the topic to Quinn again in January 1917, but seems to have forgotten about his intention to write the book by then (letter to John Quinn, 24 January 1917: Zinnes (1980), 280). The Wilson Special Collections Library at the University of North Carolina at Chapel Hill holds papers relating to Watt's publication of Pound's *The Classic Noh Theater of Japan*, but there is nothing on the projected monograph (A. P. Watt Records, Pound, Ezra, Noh, 11036, Folder 181.2).

[97] *Blast* I, 20 June 1914, 33; Richter (1970), 11–12. Pound's enterprise echoes Gaudier's own essay in *Blast* I, 20 June 1914, pp.155–8, which gives a 'vorticistic' history of art all the way from the 'paleolithic vortex' to 'we moderns'.

172 FRAGMENTARY MODERNISM

and the moderns like Epstein & Brancusi' had been forged.[98] Though 'the moderns' engineered a rhetorical battle against 'those *damn* Greeks' ('the outcome of school teaching' from which the new sculpture 'differ[ed] ... in kind'[99]), archaic Greek art – and the archaeologists who discovered the mirror image of modernity under the foundations of the Parthenon – were also implicated in that alliance.

III. Reconstituting Knossos

In the spring of 1900, Arthur Evans began digging on the island of Crete.[100] Crete had been the mythological home of Knossos, the legendary city of King Minos and his daughter Ariadne, associated with the world-famous engineer Daedalus and the labyrinth he built to contain the Minotaur. Remnants of the ancient city were known to lie in Kephala near Heraklion. The site – which would soon become the type-site for what Evans dubbed 'Minoan' archaeology – had already come to prominence in 1878–9, when excavations were carried out by the Cretan scholar and businessman Minos Kalokairinos. Kalokairinos had found significant archaeological evidence for what he identified as 'the Palace of King Minos'.[101] But because of the fractious political situation in Crete (which was under Ottoman control until 1898), and the likelihood that any new archaeological treasures would be removed to Istanbul (Ottoman law required all originals of excavated items to be taken to the Museum of Constantinople),[102] despite multiple attempts by several archaeologists including Heinrich Schliemann, excavation had stalled.[103] In March 1894, Evans, who would shortly be appointed Keeper of the Ashmolean Museum in Oxford, travelled to Crete for the first time.[104] He was shown around the site by Kalokairinos and purchased several antiquities from the area. Crucially, he also managed to track down the Turkish owners of the site of Kephala and buy a quarter share of the land.

[98] The longer, unpublished version of Gaudier's letter to the *Egoist* ('Mr Gaudier-Brzeska on "The New Sculpture"', the *Egoist*, 1.6, 16 March 1914, 117–18) is held in the Tate Gallery Archives, TGA 911/33.

[99] Quoted from the longer version of the letter to the *Egoist* (n.98, above) and Gaudier's refrain (Pound, *Gaudier-Brzeska*, 23; 33).

[100] Michaelis (1908); Brown (1986); Momigliano (1999); Gere (2009); Marinatos (2015); Momigliano (2020); Shapland (2023).

[101] Kalokairinos' role is gaining increasing recognition; his portrait bust, cast in bronze, now stands at the entrance to the Palace of Knossos: see esp. Kopaka (2015); Shapland (2023), 87–91.

[102] Brown (1986), 38; Panagiotaki (2004), 514.

[103] Heinrich Schliemann, famous for his work at Hisarlik (Troy), whom Evans met for the first time in 1893 (Hood (2004), 558), had attempted unsuccessfully to excavate at Kephala several times before his death in 1890: Brown (1986), 42; Panagiotaki (2004); Momigliano (2020), 43–5.

[104] Evans was appointed Keeper (Director) of the Ashmolean three months later, in June 1894: Hood (2004), 558.

Six years later, after a series of complex negotiations, Evans managed to purchase the rest of the site and was able to begin to dig.[105] On 23 March 1900, assisted by Duncan Mackenzie and a growing force of local excavators (men and women selected from both sides of the Christian and Muslim divide), Evans began excavating Knossos.[106] The finds came thick and fast. On 13 April they unearthed what Evans immediately declared was 'the Throne of Ariadne', shortly to be revised as the throne room of her father Minos.[107] More and more pieces of the puzzle emerged, especially between 1900 and 1905, including the 'Grand Staircase' on which Isadora Duncan would later perform an impromptu dance,[108] as well as 'The Hall of the Double Axes' and a series of beguiling 'snake goddess' figurines buried in pieces in the Temple Repositories.

The digs at Knossos sparked a cultural outbreak of 'Cretomania'.[109] As the London archaeologist Ronald M. Burrows declared in 1907, 'nothing in archaeology has made such a vivid impression on the popular imagination'.[110] Infiltrating multiple areas of popular culture from the décor of the ocean liner *Aramis* to Hollywood costume designs, Evans' Minoan Knossos was one of the major pressure points in the reception of antiquity in the first half of the twentieth century.[111] Within this context, the impact of Knossos on what Cathy Gere terms 'the prophets of modernism', has been well documented.[112] In visual culture, what Gaudier-Brzeska singled out in the *Egoist* as the 'archaic works discovered at Gnossos'[113] underpinned Picasso's Minotaur,[114] Paul Klee's snake goddess (1940),[115] Ted Shawn's experimental dance *Gnossienne* (choreographed to the music of Eric Satie),[116] and Léon Bakst's costumes and set designs.[117] Knossos loomed over the obsessions of H. D. and Sigmund Freud (who was desperate to procure a snake goddess to add to his own collection of antiquities);[118] it underwrote Joyce's 'Dedalus',[119] coloured the 'Minoan undulation' of Pound's

[105] For the history of the negotiations which led to the purchase of the land, including reproductions of the contracts from the Herakleion and Archanes Land Registries, see Panagiotaki (2004).

[106] On Mackenzie's crucial role in the excavations, as well as that of Gregorius Antoniou and Emmanuel Akoumianakis ('Manolaki'), see Momigliano (1999). For excavations at other sites, beginning with Federico Halbherr's digs at Phaistos a few weeks after Evans began his, see Momigliano (2020), 17. For Evans' 'paternalistic' politics, see McEnroe (2002), 63–4.

[107] Gere (2009), 77, 79. [108] Gere (2009), 94–5.

[109] For the term, see Momigliano and Farnoux (2017). [110] Ziolkowski (2008), 12.

[111] Boucher (2017) (on the *Aramis*). Momigliano (2020), 180–2 discusses elements from Knossos in the costumes for the 1927 film *Helen of Troy*.

[112] See esp. Hamilakis (2002); Hamilakis and Momigliano (2006); Ziolkowski (2008); Gere (2009); Momigliano and Farnoux (2017); Momigliano (2020).

[113] Gaudier-Brzeska, 'Mr Gaudier-Brzeska on "The New Sculpture"', the *Egoist*, 1.6, 16 March 1914, 117–18 (117).

[114] Ziolkowski (2008), 74–80. [115] Momigliano (2020), 14, 124–5. [116] Morris (2017).

[117] Momigliano (2020), 74–6, 78–91.

[118] Gere (2009); Momigliano (2020), 1–2. H. D. remembered Crete as a crucial theme in her analysis, and she and Freud 'spoke of Evans and his work there': H. D. (1974), 175.

[119] Ziolkowski (2008), 145.

174 FRAGMENTARY MODERNISM

Hugh Selwyn Mauberley,[120] and reverberated through Proust's *À la recherche du temps perdu*.[121]

As commentators regularly point out, the explosive reception of 'Minoan' civilization would have been impossible without the radical ways in which Evans himself interpreted, disseminated and recreated what he had found. Effectively, Minoan Crete became a joint creation of the Bronze Age people who lived on the island and Evans' own 'interpretative incontinence'.[122] 'Knossos', in its early reception, was synonymous with what the *Illustrated London News* called (in a five-page exposition of the digs) 'Minoan "modernity"' (433),[123] creatively transformed in response to a range of modern desires. In Mary Beard's words, Evans 'gave (or rather fed back to) the early twentieth century exactly the image of a primitive culture that it wanted':[124] pacifist and savage, orientalized and quintessentially 'European', ruled by a priest-king and fundamentally matriarchal.

In publicly fashioning modern Knossos, Evans did not just present the first half of the twentieth century with new paradigms for modernity. He presented the archaeological consumers of his day with modern fragments. Much of the material discovered at Knossos was emphatically fragmentary. Some of the objects Evans and his excavators discovered may even have been deliberately broken up before they were buried by the Bronze Age community to whom they were originally meaningful.[125] In part, what Evans did with the fragments he found could be seen as a particularly extreme continuation of the fragmentary histories of previously repurposed and reinvented archaeological material on the site. Evans himself observed that the city's ancient inhabitants were already actively engaged with the ruins of the past, inventing new myths from the remnants of earlier material culture that survived on the site, and that observation has been echoed by modern archaeologists, who have similarly found evidence that fragments of Minoan material culture were re-used by later generations, suggesting that Bronze Age remains had a transformative cultural agency in the later history of the site.[126]

Far from stripping Minos of his 'halo of legends', as Rivière put it, Evans 'mythologized' the emerging pieces of the past almost as soon as they were excavated, placing them into the familiar narratives of ancient myth.[127] He claimed to have found Ariadne's dancing floor, the site (so he thought, drawing on James Frazer's *The Golden Bough*) of a pagan ritual that could still be seen in contemporary Cretan folk dancing.[128] 'The Hall of the Double Axes' was

[120] Pound (1920), 26. Cf. Colby (2009), 127–8, who links Pound's 'basket-work of braids which seem as if they were/Spun in King Minos' hall' (Pound (1920), 28) with the famous 'Parisian' hairstyle of the female figure in one of the restored frescoes.
[121] Basch (2016). [122] Gere (2009), 5. [123] 30 September 1930, 433–7 (433).
[124] Beard (2014), 21. [125] Simandiraki-Grimshaw and Stevens (2013).
[126] Prent (2003); Momigliano (2020), 23–5.
[127] Gere (2009) 243 instructively compares Duncan Mackenzie's factual daybooks with Evans' more imaginative Knossos diary.
[128] Gere (2009), 84–5. On Frazer as a precursor to Evans, see Ziolkowski (2008), 17.

presented as the origin of the mythical labyrinth through a supposed etymological link with the word *labrys*, which (according to Plutarch) was a Lydian word for 'double axe'.[129] The 'Minotaur' was frequently read into the iconography,[130] and what looked like 'an artificial cave' with three roughly cut steps leading down to a recess, could 'only be described as a lair adapted for some great beast' – perhaps the Minotaur itself.[131] These mythical narratives were crucial to the dissemination of Evans' activities. Schliemann had telegraphed his findings to *The Times* and other newspapers, and Evans, too, used his journalistic skill (he had been a well-known reporter for the *Manchester Guardian*) to publicize his discoveries. He authored a series of artfully pitched newspaper articles and public lectures, whose content was often reprinted or summarized in the press, as well as a range of scholarly publications, culminating in his multi-volume *The Palace of Minos* (1921–35).[132] A media storm accompanied the digs at Knossos, fuelled by a broad range of popular media outlets in Britain, Europe, and the United States which latched onto Evans' material, often accentuating the mythological links about which he was initially comparatively circumspect.[133] In the process, Evans himself was transformed into a minor celebrity, a man who had made possible 'the verification of ancient legends' in the material culture of the distant past.[134]

Evans' well-publicized technique of using the existing structures of ancient myth to make sense of the archaeological fragments he found was paralleled in the work of his modernist contemporaries. In a much-quoted review of Joyce's *Ulysses* published in the *Dial* in November 1923 – originally couched as a 'mock quarrel'[135] with Richard Aldington – T. S. Eliot famously declared that by mapping contemporary experience onto the ancient narrative of the Homeric *Odyssey*, Joyce had led the way to a new methodology for modernism.[136] 'Instead of narrative method', Eliot stated, 'we may now use the mythical method' (483). The new method offered 'a way of controlling, of ordering, of giving a shape and a significance to the immense panorama of futility and anarchy which is contemporary history' (483) by manipulating 'a continuous parallel between contemporaneity and antiquity' (483). Joyce – in what quickly became one of the seminal texts of

[129] Evans (1901b); Momigliano (2020), 57. The etymological link was called into question almost immediately by W. H. D. Rouse: Rouse (1901).

[130] Krzyszkowska (2005), 8–9; Momigliano (2020), 10, 59: Many of the images Evans identified as representations of the Minotaur are now thought to represent monkeys, goats, or perhaps goat-human hybrids.

[131] Evans, 'New Discoveries at Knossos', *The Times*, 14 July 1922, issue 43083, p.11, col. D.

[132] For contemporary media reports, see Sherratt (2009) with 622 on published summaries of public lectures (Grenfell and Hunt's public lectures were similarly reported in the press). For details of Schliemann's reports, see Calder and Trail (1986), 240–60.

[133] Sherratt (2009). Evans also hired the Cretan photographer Marayiannis at considerable expense: Brown (1994), 11, 21. On Evans' photographs, see German (2005).

[134] 'The Truth of Tradition', *The Globe*, 15 August 1901: Sherratt (2009), 625.

[135] Litz (1972), 16.

[136] 'Ulysses, Order, and Myth', *The Dial* 75.5, 480–3; Richard Aldington, 'The Influence of Mr. James Joyce', *English Review* 32, April 1921, 333–41.

176 FRAGMENTARY MODERNISM

modernism – showed how the fragments of modernity could now be codified and controlled through sustained relation to the structures of ancient myth.

For Eliot, Joyce's breakthrough had 'the importance of a scientific discovery' (482), and he linked it to the theories of Albert Einstein (483) and contemporary developments in the disciplines of psychology and ethnography, including James Frazer's work on comparative religion and myth in *The Golden Bough*, which had been important to Eliot's own mythical method in *The Waste Land*, published the previous year.[137] But other disciplines and other breakthroughs were also underwriting the cultural moment which had 'concurred to make possible what was impossible before' (483), not least what Eliot had elsewhere called 'the reassuring science of archaeology'.[138] In the numerous media publications about Knossos in the period leading up to Eliot's essay, Evans, like Joyce, had given 'shape and significance' to the fragments he dug up from the ground using the 'scaffolding' (480) of Greek myth. Tapping into many of the same cultural preoccupations, including Frazer's *The Golden Bough*, he, too, had operated using a 'mythical method' which gave structure and meaning to fragments, and which enabled him to fashion them into an image of Minoan modernity that paralleled the needs and desires of the present.[139] The results – from the snake goddesses to the frescoes – were foundational for classical reception in the period, even infiltrating some of the details of Joyce's *Ulysses*.[140] More than that, however, Evans' method of archaeological mythology *itself*, with its tendency to attach mythical meanings and contemporary relevance to newly found fragments, also coincided significantly with the 'mythical method' that Eliot was calling on modern writers to deploy.[141]

It was not only mythical 'scaffolding' that Evans erected for the fragments he was finding. One of the most striking things about Knossos is the fact that very little of the site as it now stands is unequivocally ancient. Evans, who had hired the architect Theodore Fyfe, initially used what were felt to be authentic materials (wood, limestone, and rubble masonry) to protect the newly exposed finds. But these were quickly degraded by a combination of poor choices and climate damage. Between 1905 and 1910, now working with the London architect Christian Doll, Evans turned to more modern materials. Parts of the Grand Staircase were on the verge of collapse,[142] and they used iron girders and concrete

[137] '[P]sychology ... ethnology, and *The Golden Bough* have concurred to make possible what was impossible even a few years ago' (483). For Frazer's relationship to archaeology, see Insoll (2004), 44.

[138] T. S. Eliot, 'Tradition and the Individual Talent' (Part I), *The Egoist* 4.6, September 1919, 54–5 (54).

[139] The striking parallel is insightfully made by Gere (2009), 142–6. On Joyce and Frazer, see Vickery (1973).

[140] Ziolkowski (2008), 145; Gere (2009), 144–6.

[141] Cf. Gere (2009), 146 on how 'Evans had arrived at the same idiom as Joyce, and filled the vacuum left by the death of god with the same maternal archetype.'

[142] Evans, 'The Sixth Campaign at Knossos', *The Times*, 31 October 1905, p.4; Brown (1986), 80; Kienzle (1998), 223, citing Duncan Mackenzie's diary entries for 1–2 March 1905.

to stabilize the structure. Doll's use of concrete was still relatively conservative, and though he utilized some exposed concrete in 1910 to represent wood,[143] he generally attempted to recreate the appearance, if not the reality, of Bronze Age materials: the visible parts of the new iron beams, for example, were generally covered with timber, at least partly masking the modern materials they concealed.[144]

When, after the First World War, Evans employed the Leeds architect Piet De Jong (from 1922 to 1930), the whole tenor of the site changed significantly. De Jong now turned to ferro-concrete as his material of choice and the result was shockingly contemporary. What Evans called his 'reconstitutions'[145] notoriously represented the first use of reinforced concrete on the island. As one visitor put it, the new structures seemed to have much in common with 'garages and public lavatories' of the modern urban environment.[146] The area of and around the Throne Room has been described as 'the best-preserved and finest examples of Art Deco and Art Nouveau architecture in Greece'.[147] More radically, the clean lines of Evans' 'reconstituted' buildings echo the architectural style of Le Corbusier whose *Vers une architecture*, 'Towards a New Architecture' was translated into English in 1927 (even as Corbusier's style was also being channelled by the archaeologist Bernard Ashmole, building his modernist house in Buckinghamshire).[148]

On the South Propylaion, Evans also erected the iconic 'Horns of Consecration' (Figure 5.7). Based on a fragment of a 'rounded limestone block' which may once have been covered with a layer of painted stucco,[149] Evans' horns echo the stylized bull's horns found throughout the site (including house models found in the Loomweight Basement), but the end result recalls the abstract carvings of Gaudier-Brzeska or Brâncuşi and could easily be mistaken for what Cathy Gere aptly calls a 'sub-Barbara Hepworth sculpture'.[150] Even the famous Knossos frescoes (which are now seen as shockingly mismatched with the probable iconography of the originals) were totally 'reconstituted' from the fragments Evans had found into creations that, at the time, evinced what Evelyn Waugh called 'a predilection for the covers of *Vogue*'.[151]

Concrete could be cast to suggest the invented breakage and damage suffered by the fragments of antiquity, but it could also pre-emptively suggest the fragmentation that would one day affect the modern structures themselves. Even the most obviously 'modern' reconstitutions on the site could be partial at the point of creation, as if already subject to the processes of fragmentation which the ancient

[143] Kienzle (1998), 235, 257, 266. [144] Kienzle (1998), 220–66. [145] E.g., Evans (1927).
[146] The much-quoted phrase is from the unpublished notebooks of the Oxford philosopher R. G. Collingwood (quoted, e.g., in Hood (1995), 176), though Mario Praz, for one, also had the same impression: Momigliano (2020), 116.
[147] Papadopoulos (1997), 110; Blakolmer (2017), 45.
[148] Chapter 4, pp.124–6. Cathy Gere suggests that the naked concrete surfaces pre-echo the brutalism of Alexey Shchusev's 1930 Lenin Mausoleum in Moscow: Gere (2009), 1.
[149] Evans (1928), 160. [150] Gere (2009), 1. [151] Waugh (1930), 137.

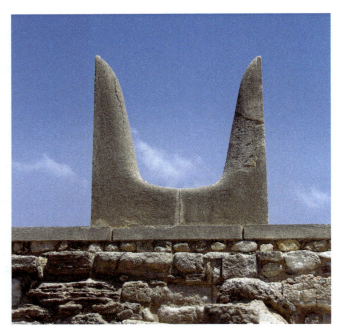

Figure 5.7 'The Horns of Consecration', Knossos.

remains had undergone. So, for example, a curtailed flight of steps to nowhere (Figure 5.8) flanked by 'broken' concrete pillars leads up to an imaginary third storey from what Evans called the 'Piano Nobile' above the Throne Room.[152] The 'broken' pillars and incomplete staircase echo in modern materials the condition of the ancient site eroded over time, but they also suggest the future ruination of the concrete Knossos. The site is now often criticized for causing confusion among contemporary visitors, who find it hard to distinguish the original from the reconstruction. But that is partly because Evans' concrete city was always already in ruins, an issue now further compounded by the fact that the reconstructions themselves have become subject to their own programme of restoration.[153]

From the point of view of the history of conservation, the reconstructions at Knossos were in some ways surprisingly anachronistic from the start. Extensive restoration was practiced at other archaeological sites, notably the reconstruction of the Parthenon by Nikolaos Balanos which took place in phases between 1898 and 1933.[154] Much to the dismay of contemporary artists (including Auguste Rodin[155]),

[152] Hitchcock and Koudounaris (2002), 42. Cf. Schmidt (1993), 107 on Knossos as a fake ruin.

[153] Hitchcock and Koudounaris (2002), 51. See also Schmidt (1993), 107 on how the restorations themselves have achieved the status of 'Denkmal'.

[154] Hurwit (1999), 299. On the restorations of the Parthenon and other sites on the Acropolis by Kavvadias and Balanos, see Mallouchou-Tufano (1994), (2007a); Bouras (1994); Loukaki (2008), 208–14; Schmidt (1993), 81–7.

[155] Rodin (1905); Farge, Garnier, and Jenkins (2018), 40–2.

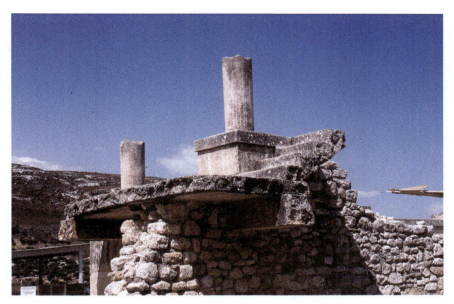

Figure 5.8 Stairs from the 'Piano Nobile' to an imaginary third storey. Photograph: Louise A. Hitchcock.

if not the professional archaeological community who at first enthusiastically approved of the project, Balanos turned the Parthenon into a picturesque ruin of the kind popular in the nineteenth century, in an image of 'how the Parthenon would have looked had it not been transformed into a Byzantine church or an Ottoman mosque, but instead fallen gracefully into disrepair'.[156] Evans, too, was a builder of ruins ('le constructeur des ruines'), as a French journalist described him in 1930.[157] But where Balanos aimed for what he called *anastylosis* (from ἄνα, 'again', and στηλόω = 'set up a monument'), Evans did not set out to 're-erect' a putative 'original' ruin.[158] Instead, he consciously fashioned a radically modern image of the fragmentary remains of Knossos. As he himself warned: 'the lover of picturesque ruins may receive a shock'.[159]

The shock of the new at Knossos, then, was not simply down to the use of ferroconcrete on the site. Evans' reconstructions were far removed from the dilapidated structures overcome by nature and time valued by 'the lover of picturesque ruins'. Like other ruins which index the conditions of their own erosion, the ruins of Knossos remain *in situ*, but they do not chart the processes of on-site decay

[156] See Bilsel (2012), 231 on Balanos' 'picturesque realism' with Thompson (1981).
[157] Quoted in Farnoux (1996), 187. The phrase has also been used by Mary Beard as a title of an article published in the *London Review of Books* in November 2000 and republished in Beard (2014).
[158] For Balanos' *anastylosis*, see Mallouchou-Tufano (1994), esp. 83 on the establishment of the term.
[159] Evans (1927), 258.

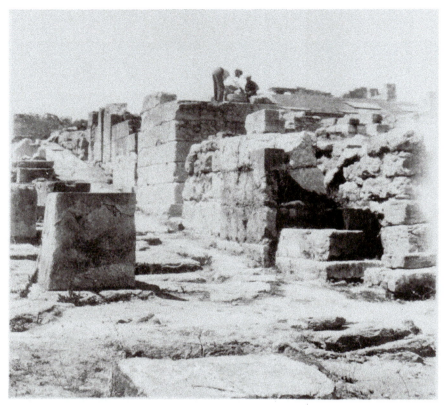

Figure 5.9 North Entrance before 'reconstitution', from Evans, *The Palace of Minos*, Vol. III, p.159. © Ashmolean Museum/Mary Evans.

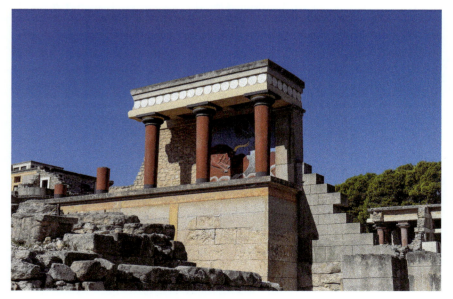

Figure 5.10 The West Portico of the North Entrance after reconstruction. Photograph: Anton Starikov/Alamy Stock Photo.

in a straightforward way. Evans' Knossos presented its early twentieth-century audience with a 'fetish of the lost object'.[160] But it was an object that never quite existed. Like the fragments engineered by his modernist contemporaries, Evans' reconstitutions in Crete were uncompromisingly modern, positing imaginary wholes which gesture to antiquity, but which were never really attainable. If, in Eliot's terms, archaeology could 'make the modern world possible for art' through its scientific methodology,[161] Arthur Evans seemed to bring the shock of the new associated with the art of the modern world to the science of archaeology.

Historians of archaeology often stress the fact that the development of the discipline was closely linked with modernity. Political change, urban expansion, and technological innovation all combined to produce the conditions in which archaeology as a discipline was able to develop.[162] In that sense, archaeology has much in common with modernism, which is likewise tied in with the political and socio-technological upheavals of modernity.[163] Yet more than parallel enterprises reacting to similar catalysts, modernism and archaeology frequently strayed into each other's territories in the first part of the twentieth century. For artists and writers looking to the disciplines of modernity to make the contemporary world possible for art, archaeology offered a grammar of excavation with which to make sense of the fragments of the present and the past. It put pressure not only on the 'fragment' but also on the 'classical', unearthing versions of modernity from deep temporal layers underground, dating to a time well before the traditional classical canon. At the same time, it is important to remember that archaeologists were not sealed off from the revolution in contemporary art and writing that was unfolding around them. There was no hard line dividing one sphere of activity from the other, and the ways in which both archaeologists and modernists invented archaeological objects in the image of modernity (and in the case of Evans' Knossos, whole archaeological sites) attest to the permeability of the notional boundary between modernism and archaeology.

That observation becomes more compelling if we see it as part of a wider network of interactions between modernism and classical scholarship in the first half of the twentieth century. Modernism shifted the parameters of how antiquity could be read and viewed. It reached the minutiae of philology and the typography of papyrology, the space of the modern museum, and the excavations of archaeology. Subtly (and sometimes not so subtly), the pieces of the past were given new contours and meaning through the paradigm shifts that modernism effected. That was not just because modernists were interested in classical antiquity and its prehistory. From the outset, the classical receptions of modernism were enmeshed

[160] Hitchcock and Koudounaris (2002), 51.
[161] 'Ulysses, Order and Myth' (1922), Eliot, *CP* II, 479.
[162] Esp. Thomas (2004) and Schnapp, Shanks, and Tiews (2004).
[163] See esp. Schnapp, Shanks, and Tiews (2004).

with the seemingly objective activities of classical scholars, even in the most ostensibly scientific of contexts. We might think of the two areas as wholly separate: the classicists coughing in ink in disapproval of the amateur scholarship of modernism, and modernists railing against the safe and dead obfuscations of classical scholarship. But the evidence clearly shows that was not the case. Modernism and classical scholarship came together in a vital network of reticulated interactions that crossed almost every area of the discipline into modern art and writing and back again. Above all, the modernist obsession with the fragment reacted in tandem with the intense activity of classical scholars who were unearthing, deciphering, and disseminating the pieces of antiquity for modernity. The constructions of 'the classical fragment' shaped by those mutual interactions and others like them – whether in compliance or dissent – have played a key role in the ways in which the remains of antiquity have been imagined and disseminated for over a century.

Postscript

After Modernism

> The fragment is king.
> André Malraux, *The Museum without Walls*

> For here on the edge,
> I said, there's always
> a margin of error.
> Josephine Balmer, *The Paths of Survival*[1]

Anne Carson's *If not, Winter: Fragments of Sappho*, first published in 2002, testifies to the continued afterlife of fragmentary modernism. Carson is well known as both a professional classicist and a major contemporary poet, and her ambidextrous position – or '*in*disciplinarity' as Laura Jansen calls it – embodies, in a single œuvre, some of the dialogues across the breach between classical scholarship and modernist practice that I have mapped out in this book.[2] Carson has been called a 'late modernist',[3] and her creative and scholarly work is marked by an interprofessional interest in the fragments of Greek poetry: Simonides in *Economy of the Unlost* (1999); Mimnermus in *Plainwater* (1995); Stesichorus in *Autobiography of Red* (1998), and Sappho in *Men in the Off Hours* (2000) and *If not, Winter*.[4] Her version of Sappho Fragment 95 – the top part of which Ezra Pound replicated in 'Papyrus' – could be read as a direct continuation of the classical fragments of modernism:[5]

not

]

]

Gongyla

'Brackets are an aesthetic gesture toward the papyrological event rather than an accurate record of it', Carson explains – in words that could just as easily

[1] Malraux (1949), 27; Balmer (2017), 57 (quoted with permission). [2] Jansen (2021a), 2.
[3] Scroggins (2015), 58–73. [4] Cf. Gurd (2021) and Jansen (2021b).
[5] Carson (2003), 189. For the idea that Carson's poetry 'belongs on the same shelf as Pound's "Papyrus"', see Scroggins (2015), 58–9, 66.

Fragmentary Modernism: The Classical Fragment in Literary and Visual Cultures, c.1896–c.1936. Nora Goldschmidt,
Oxford University Press. © Nora Goldschmidt 2023. DOI: 10.1093/oso/9780192863409.003.0007

184 FRAGMENTARY MODERNISM

describe the typographical and interdisciplinary mimicry of the papyrologies of modernism.[6]

Around a century on, the apotheosis of the fragment that emerged at the meeting point between classical scholarship and modernist practice at the beginning of the twentieth century is still a key mediating factor in the modern reception of the classical fragment. If modernism and classical scholarship once stood on opposing sides of a conceptual breach, now collaborations between modern practitioners and classical scholars (which are often incentivized financially by academic funding bodies) have become a standard part of scholarly and creative practice. Classical scholars and those working in the creative industries actively share practices and expertise across different spheres of activity in joint enterprises that often involve different ways of 'making art out of fragments' across global and intersectional divides.[7]

The 'modernist episteme',[8] meanwhile, has become integrated into attitudes and practices of the fragment in classical scholarship on a broad scale. Even in scholarly fields characterized by what Mary Barnard once called 'the whiskered mumble-/ment of grammarians' ('Static', 1980), 'the educative potential of antiquity to heal the fragmented and divided nature of the modern condition with visions of wholeness and unity' that might once have been associated with the enterprise of classical scholarship is barely recognizable.[9] Philologists now are just as likely as modern poets to describe the import of classical fragments in modernist terms: 'in a deep sense our lives are ineluctably all fragments', writes the classical philologist Glenn Most,[10] or, as the poet Josephine Balmer puts it in *The Paths of Survival* (2017) which tracks the recovery and loss of pieces of Aeschylus' *Myrmidons*, 'scrap[s] of frayed papyrus' naturally symbolize to us the 'stark lacunae we all must someday face'.[11] As the modernist template filters through the concerns of postmodernism and metamodernism, which revel in fragments as 'the interruption of the incessant' (as Maurice Blanchot describes fragmentary writing), it is often in fragments rather than as wholes that antiquity holds its value.[12] What Page duBois has called 'our will to make the broken material evidence of the past whole',[13] seems to have ceded to a clear preference for

[6] Carson (2003), xi.

[7] 'Making Art out of Fragments' is the title of a new play by the British classical scholar Laura Swift, made in collaboration with theatre-makers: https://www.potentialdifference.org.uk/posts/making-theatre-out-of-fragments (last accessed 22.4.22). Notable recent collaborations include *Liquid Antiquity*, an exhibition held at the DESTE Foundation for Contemporary Art, Athens, in 2017 and the associated book (= Holmes and Joannou (2017)).

[8] Guignery and Drąg (2019), xi.

[9] 'Static': Barnard (1979), 64; Fitzgerald (2022), 14 (on neoclassicism). Cf. Holmes (2018), 143 on contemporary art's move away from 'persistent fantasies of wholeness reconstructed from fragments'.

[10] Most (2009), 18. [11] Balmer (2017), 11.

[12] Blanchot (1986), 21. For some of the postmodern frames of Greek tragic fragments in reception, see Ioannidou (2017).

[13] duBois (1997), 31.

fragment forms: 'If we had to choose between the fragment and the whole of which it once formed part', Glenn Most asks, 'are we quite sure that we know which one we would prefer?' More often than not, it is still the fragment rather than the whole which 'can come to seem far more satisfying to us ... than the real original could ever be'.[14]

There are, of course, other ways of telling the story. If the apotheosis of the fragment continues to structure the reception of fragmentary texts and objects in the twenty-first century, it is also paralleled by the continued search for different kinds of wholeness more or less removed from 'the real original'. Publications of fragmentary texts on papyrus, though often supplemented by editorial conjecture, still typically look like versions of Pound's 'Papyrus' or Carson's Sappho, where brackets, dots, and white space on the page reinforce a modernist ideal of the fragment form. But papyrologists today are much more interested in documenting papyri as archaeological objects with a local habitation and a name.[15] Where Greek literary papyri were once embraced as shards of lost texts from ancient Greece sitting in a no-man's land somewhere between modernity and antiquity, scholars now are actively seeking to insert them back into the circuit of activities belonging to the Egyptian past in which they are implicated.

Editors of fragmentary texts that survive through citation in the works of other authors, too, are increasingly arguing for the reinstatement of the excerpted or summarized 'fragments' back into the contexts of their transmission. Textual fragments like these have, since the sixteenth century, typically been presented surrounded by white space on the page, almost as if they had physically been broken off from a papyrus or parchment manuscript. But the viability of fully extracting original pieces of text from later contexts has increasingly been called into question, particularly in editions of fragmentary Latin authors like Sander Goldberg and Gesine Manuwald's Loeb edition of the Latin poet Ennius,[16] the major new edition of the Roman Historians edited under Tim Cornell,[17] and the new edition of the fragments of the Roman Republican orators led by Catherine Steel.[18] Fragments transmitted through quotation and summary now tend to be seen as ultimately inextricable from the contexts and even the words of the later

[14] Most (2009), 18. In a reiteration of his views (published in German and more clearly inflected by postmodern critical theory), Most notes that a 'real original' (*ein echtes Ganzes*) is always already subject to disintegration, while the imagined wholes which we reconstruct on the basis of fragments – and which never quite existed in reality – remain the only 'wholes' that are truly immune from decay: Most (2011), 42.

[15] Nongbri (2018), 216–46; Sampson and Uhlig (2019); Sampson (2020); Mazza (2021), (2022).

[16] Goldberg and Manuwald (2018): see esp. the rationale in their introduction on p.xxxiv. Jocelyn (1967) had employed a similar practice, but he was at the time going against the grain of scholarly practice.

[17] Cornell et al. (2013).

[18] For the attitude to 'fragments' that underlies the project, cf. Gray et al. (2018). Cf. also Graham (2010) which puts the fragments and testimonia of the early Greek philosophers into a 'global order' rather than 'a random one (such as Diels intentionally used for Heraclitus)', 7.

186 FRAGMENTARY MODERNISM

authors who cite them, so much so that it might not be possible to speak of them as fragments at all.[19]

In museums, fragmentary display was never the only mode of presenting and preserving antiquity. The modern derestoration movement which began in the 1890s with Georg Treu's removal of baroque completions from ancient sculptures in the Albertinum in Dresden – a move that coincided with Treu's enthusiasm for Rodin's modern fragment sculptures – was never universally embraced.[20] In 1972, the Aegina pediments in the Glyptothek in Munich were unveiled to the public, denuded of Bertel Thorvaldsen's neoclassical restorations, which had been attached to the sculptures for almost 150 years. The moment has become one of the most well-known examples of twentieth-century derestoration.[21] But the process did not quite present the ringing endorsement of modernist fragment culture that it might suggest. Thorvaldsen had cut the edges of the breaks smooth in order to join the new parts to the original marble; the newly exposed clean lines where arms, legs, and heads had once been, combined with the gleaming metal rods that were now required to hold up the fragments, made the newly displayed Aegina marbles seem like hypermodern fragments: 'a violent modern imprint on ancient objects, whose pure, archaeological state was no longer recoverable'.[22] And yet the sculptures had not been completely derestored; the round shields, for example, were retained, and, as William Diebold has shown, the process was tied in with a network of memory wars that associated the old neoclassical restorations with the aesthetics of National Socialism.[23] More recently, when a special exhibition on the restorations was held in 2011, synthetic marble copies of the sculptures were made using moulds taken from plaster casts preserved in just the kinds of cast collections iconoclastically destroyed in the early twentieth century and combined with Thorvaldsen's marble completions to make the sculptures into wholes once again.[24]

[19] The issues are particularly acute for prose: Gesine Manuwald notes in her recent Loeb edition of Republican Latin oratory that it is 'questionable whether one can speak of "verbatim fragments of Roman oratory" at all' (Manuwald (2019), xxiv).

[20] Howard (1990), (2003), 34–5; Podany (2003). On Treu and Rodin, see Chapter 4, p.135.

[21] Wünsche (2011), 163–86.

[22] True (2003), 6; Daehner (2011), 47, though some ancient sculpture – like the Venus de Milo, whose right arm is iconically broken off in a smooth line mid-humerus – was originally carved from more than one piece of marble and jointed later, leaving similarly smooth 'stumps': Ridgway (2000), 169; Martin and Langin-Hooper (2018), 116.

[23] As Diebold (1995), 61 points out, the overall effect is still arguably 'modernist': the smooth metal rods holding up the fragments and perfect circles of the shields 'give the installation an abstract, modernist look that corresponds closely in appearance to the stripped-down modernism of Josef Wiedemann's interior re-design of the museum'. Knell and Kruft (1972); Diebold (1995) (on National Socialism); Ernst (1996) 119–21; Wünsche (2011), 163–86.

[24] Wünsche (2011), 187–221; Vout (2018), 244–5. For the story of European cast collecting and its decline in the twentieth century, see Haskell and Penny (1981), 79; Beard (1994); Born (2002); Frederiksen and Marchand (2010). On the recent rehabilitation of cast copies, including the production of 3D prints that can be accessed by audiences at home, see Lending (2017), esp. 231–2. The Digital

As I write, the sculptures from the Parthenon in the British Museum still stand on their plinths as 'a series of extremely beautiful fragments', as Bernard Ashmole and his colleagues described them in 1929, bearing no trace of the of plaster casts of the missing pieces which had once been adjusted to the marble. By contrast, when the Acropolis Museum in Athens opened in 2009, plaster casts of missing fragments from other collections around the world – above all from the British Museum in London – were attached to the original pieces of marble sculpture that remained in Athens. In some ways, the decision could be seen as a conscious reversion to the practice of the old Elgin Room, once denigrated as 'a fraud upon the public'.[25] But unlike the casts in the old Elgin Room, the plaster casts in Athens are not offered exclusively as an attempt to present an archaeologically complete picture of the past. An alternative considered at the planning stage involved the installation of empty niches for the diasporic fragments missing from the Athenian collection.[26] The plan was rejected as potentially too shocking for visitors,[27] but the plaster additions that were installed instead (whose white surface clearly stands out from the amber hue of the Pentelic marble) similarly mark a politically charged absence that might be rectified in the here and now by the repatriation of the missing fragments into something resembling a unified whole.[28] The display in Athens appeals to the 'restitution-paradigm',[29] which calls for the return of the fragments to the soil of their origin and the correction of the imbalances of history. Yet in doing so it also re-emphasizes the historical value of the sculptures and the necessity for architectural completeness over the fragmentary aesthetic which the redisplay in the British Museum had once been designed to promote.

Digital technologies, meanwhile, promise to step in where plaster and marble have failed by making whole again the pieces of the past that have been lost or scattered all over the world. In April 2016, The Institute of Digital Archaeology (IDA) unveiled a three-dimensional marble replica of the Triumphal Arch from Palmyra, the original of which had been blown up by Islamic State in 2015. The results, initially installed in London's Trafalgar Square, were welcomed by Boris Johnson, then Mayor of London, as 'a triumph of technology and determination', and by Jean-Bernard Münch, president of the UNESCO Swiss Commission, as a triumph over *'la fragilité de notre humanité'*.[30] The arch, which had been recreated using photographs, was criticized for its inaccuracy, but the IDA have also turned their attention to making wholes out of fragments that have been displaced rather than destroyed. In March 2022, having been refused official access to the

Sculpture Project are creating similar reconstructions of some of the baroque restorations derestored by Georg Treu in Dresden in the 1890s: http://www.digitalsculpture.org/archive/alexander/index.html (last accessed 4.4.2023).

[25] Rees Leahy (2011); Pandermalis et al. (2013), 38. [26] Rees Leahy (2011), 185–6.
[27] Rees Leahy (2011), 186. [28] Pandermalis et al. (2013), 38. [29] Herman (2021).
[30] http://digitalarchaeology.org.uk (last accessed 30.8.23).

188 FRAGMENTARY MODERNISM

sculptures from the Parthenon in the British Museum, the IDA were reported to have scanned them by stealth in the Duveen Gallery using technology embedded in camera phones and iPads, ready for full digital reconstruction from direct scans of the objects themselves.[31] The optimism may be misplaced: reproduction, too, can have the effect of emphasizing fragmentation. As Henry Thornton Wharton worried over one hundred years earlier when he printed what were then high-tech photographic reproductions of parchment fragments of Sappho, something of the original is always 'lost in the copy'. But unlike the reproduction technologies available in the nineteenth century, which had the effect of obscuring the minutiae of ancient texts and objects, the IDA promises to produce absolute copies more perfect than the original. Though some archaeologists warn of the consequent 'Disneyfication' of heritage, or the troubling deletion of the history of destruction which 'real' fragments can carry,[32] in the domain of the hyperreal where reality and its simulation are impossible to separate, classical fragments may yet be made into wholes seemingly more complete than the originals ever were.[33]

Now perhaps more than ever before, there are multiple ways of doing things with fragments. Yet the act of seeing a classical fragment in a modern museum, reading a damaged text in a modern edition, or consuming new artistic fragments inflected by classical antiquity remains freighted with a powerful history of fragment viewing and fragment making. 'It all began with the Greek fragments', H. D. declared, but it still often ends with the version of the classical fragment that was crystallized in the dialogues between classical scholarship and artistic practice in the first part of the twentieth century. Whatever we do with ancient fragments now – even when we try to make them into wholes – our relationship with antiquity, in one way or another, will always be based on a constitutive relationship to loss mediated by the interventions of fragmentary modernism.

[31] Simon de Bruxelles, 'Stealth 3D scans of Elgin Marbles could support the call for their return to Greece', *The Telegraph*, 24 March 2022.

[32] Bacchi (2016); Cunliffe (2016); Khunti (2018).

[33] The concept of the hyperreal, whereby the imitation comes to seem more present than the original itself, is associated particularly with Baudrillard (1983).

Bibliography

Aldington, R. (1915) 'The Poets' Translation Series: Announcement', *The Egoist* 2.8 (2 August 1915), 131 = *The Little Review* 2.6, 45–6.

—— (1916) *Images Old and New*, Boston, MA: Four Seas.

—— (1941) *Life for Life's Sake: A Book of Reminiscences*, New York: Viking.

Armstrong, R. (2005) *A Compulsion for Antiquity: Freud and the Ancient World*, Ithaca, NY: Cornell University Press.

Armstrong, T. (1998) *Modernism Technology and the Body: A Cultural Study*, Cambridge: Cambridge University Press.

Arrowsmith, R. R. (2011) *Modernism and the Museum: Asian, African, and Pacific Art and the London Avant-Garde*, Oxford: Oxford University Press.

Arrowsmith, W., trans. (1960) *The Satyricon: Petronius*, New York: New American Library.

Ashmole, B. (1949) *A Short Guide to the Sculptures of the Parthenon in the British Museum*, London: The Trustees of the British Museum.

Auden, W. H. (1965) 'T. S. Eliot, O. M.: A Tribute', *The Listener*, 7 January 1965, p.5.

Ayers, D. (2004) *Modernism: A Short Introduction*, Malden, MA: Blackwell.

Azzarà, S. (2002) 'Osservazioni sul senso delle rovine nella cultura antica', *Annali della Scuola normale superiori di Pisa* 4.14, 1–12.

Babcock, R. (1990) 'H. D.'s "Pursuit" and Sappho', *H. D. Newsletter* 3.2, 43–7.

—— (1995) 'Verses, Translations, and Reflections from "The Anthology"': H. D., Ezra Pound, and the *Greek Anthology*', *Sagetrieb* 14.1–2 (Spring/Fall 1995), 202–16.

Bacchi, U. (2016) 'Palmyra Arch in London: "Unethical" Reconstruction of "Disneyland" Archaeology Criticised', *International Business Times UK*, 19 April <http://www.ibtimes.co.uk/palmyra-arch-london-unethical-reconstruction-disneylandarchaeology-criticised-1555659> (last accessed 1.5.22).

Bach, F. T. (1987) *Constantin Brancusi. Metamorphosen Plastischer Form*, Cologne: DuMont.

Bach, F. T., M. Rowell, and A. Temkin, eds (1995) *Constantin Brancusi: 1876–1957*, Philadelphia, PA: Philadelphia Museum of Art.

Bacon, H. (1958) 'The Sibyl in the Bottle', *Virginia Quarterly Review* 34, 262–76.

Badenhausen, R. (2004) *T. S. Eliot and the Art of Collaboration*, Cambridge: Cambridge University Press.

Baker, A. (2019) *Troy on Display: Scepticism and Wonder at Schliemann's First Exhibition*, London: Bloomsbury Academic.

Baldick, C. (1996) *Criticism and Theory 1890 to the Present*, Abingdon: Routledge.

Baldwin, B. (1985) 'Palladas of Alexandria: A Poet between Two Worlds', *L'Antiquité Classique* 54, 267–73.

Ballantyne, A. (1988) 'Knight, Haydon, and the Elgin Marbles', *Apollo* 128, 155–9.

—— (2013) 'Modernity and the British', in D. Peters Corbett, ed., *A Companion to British Art, 1600 to the Present*, Malden, MA: Blackwell, 38–59.

Balm, R. (2015) *Archaeology's Visual Culture: Digging and Desire*, London: Routledge.

Balmer, J. (2017) *The Paths of Survival*, Bristol: Shearsman Books.

Bandinelli, R. B. (1930) 'The Modernity of Etruscan Art', *Formes* 8, 5–6.

190 BIBLIOGRAPHY

Barber, R. (1990) 'Classical Art: Discovery, Research and Presentation 1890–1903', in Cowling and Mundy (1990), 391–411.

Barnard, M. (1958) *Sappho: A New Translation*, Berkeley, CA: University of California Press.

—— (1979) *Mary Barnard: Collected Poems*, Portland, OR: Breitenbush.

Barnsley, S. (2013) *Mary Barnard: American Imagist*, Albany, New York: SUNY Press.

Barnstone, W., trans. (2006) *The Complete Poems of Sappho*, Boston, MA: Shambhala Books.

Basch, S. (2016) 'Proust à Cnossos ou le cosmopolitisme archéologique. Échos de la Grèce archaïque et reflets de la "crétomanie"'. Art nouveau dans *À la recherche du temps perdu*', in N. Mauriac and A. Comagnon, eds, *À la recherche du temps perdu. Du côté de chez Swann ou le cosmopolitisme d'un roman français*, Paris: Champion, 103–30.

Bassani, E. (1989) *Jacob Epstein, Collector*, Milan: Associazione Poro.

Baudrillard, J. (1983) *Simulacres et Simulation*, Paris: Galilée.

Baumbach, M, A. Petrovic, and I. Petrovic, eds (2010) *Archaic and Classical Greek Epigram*, Cambridge: Cambridge University Press.

Beard, M. (1994) 'Casts and Cast-offs: The Origins of the Museum of Classical Archaeology', *Proceedings of the Cambridge Philological Society*, 39, 1–29.

—— (2002) *The Parthenon*, London: Profile Books.

—— (2014) *Confronting the Classics: Traditions, Adventures and Innovations*, London: Profile Books.

Beasley, R. (2007) *Ezra Pound and the Visual Culture of Modernism*, Cambridge: Cambridge University Press.

—— (2019) 'The Direct Method: Ezra Pound, Non-Translation, and the International Future', in J. Harding and J. Nash, eds, *Modernism and Non-translation*, Oxford: Oxford University Press, 67–85.

Benstock, S. (1994) 'Expatriate Sapphic Modernism: Entering Literary History', in K. Jay and J. Glasgow, eds, *Lesbian Texts and Contexts: Radical Revisions*, New York: New York University Press, 183–203.

Ben-Mere, D. (n.d.) ' "There must be great audiences too"—*Poetry: A Magazine of Verse*', <https://modjourn.org/there-must-be-great-audiences-too-poetry-a-magazine-of-verse/> (last accessed 25.11.22).

Bergk, T., ed. (1882) *Poetae lyrici Graeci*, Leipzig: Teubner.

Bernhart, W. and A. Englund (2021) *Arts of Incompletion: Fragmentation in Words and Music*, Leiden: Brill.

Bernstein, S. D. (2014) *Roomscape: Women Writers in the British Museum from George Eliot to Virginia Woolf*, Edinburgh: Edinburgh University Press.

Beta, S. (2017) 'The Trackers', in K. N. Demetriou, ed., *Brill's Companion to the Reception of Sophocles*, Leiden: Brill, 561–72.

Beaunier, A. (1911) 'Le Sourire d'Athéna', *Revue des Deux Mondes*, 6.3, 328–58.

Bilsel, C. (2012) *Antiquity on Display: Regimes of the Authentic in Berlin's Pergamon Museum*, Oxford: Oxford University Press.

Bing, P. (2009) *The Scroll and the Marble: Studies in Reading and Reception in Hellenistic Poetry*, Ann Arbor, MI: University of Michigan Press.

Birien, A. (2012) 'Pound and the Reform of Philology', in S. G. Yao and M. Coyle, eds, *Ezra Pound and Education*, Orono, ME: National Poetry Foundation, 23–46.

Blänsdorf, J. (2008) *Siste viator et lege—Bleib stehen, Wanderer, und lies. Die lateinischen Inschriften der Stadt Mainz von der Antike bis zur Neuzeit*, Mainz: J. Blänsdorf.

Blanchot, M. (1986) *The Writing of the Disaster*, A. Smock, trans., Lincoln, NE: University of Nebraska Press.

Blakolmer, F. (2017) 'The Artistic Reception of Minoan Crete in the Period of Art Deco: The Reconstruction of the Palace of Knossos...and Why Arthur Evans was Right', in Momigliano and Farnoux (2017), 39–68.

Blissett, W. (2001) 'Eliot and Heraclitus', in J. Spears Brooker, ed., *T. S., Eliot and our Turning World*, London: Palgrave Macmillan, 29–45.

Bonaventura, P. and A. Jones, eds (2011) *Sculpture and Archaeology*, London and New York: Routledge.

Booth, A. (2015) *Reading The Waste Land from the Bottom Up*, New York: Palgrave Macmillan.

Born, P. (2002) 'The Canon is Cast: Plaster Casts in American Museum and University Collections', *Art Documentation: Journal of the Art Libraries Society of North America* 21.2, 8–13.

Bornstein, G. (2005) 'The Book as Artefact: Historicizing Ezra Pound's First Thirty Cantos', *Variants: Journal of the European Society for Textual Scholarship* 4, 151–64.

Boroughs, R. (1995) 'Oscar Wilde's Translation of Petronius: The Story of a Literary Hoax', *English Literature in Translation, 1880–1920* 38.1, 9–49.

Boucher, A. (2017) 'The Ocean Liner *Aramis*: A Voyage to the Land of Minos and Art Deco', in Momigliano and Farnoux (2017), 124–56.

Bouras, C. (1994) 'Restoration Work on the Parthenon and Changing Attitudes towards the Conservation of Monuments: A Theoretical Contribution to Restoration Work Today', in, P. Tournikiotis, ed., *The Parthenon and Its Impact on Modern Times*, Athens: Melissa, 312–39.

Bowman, A. K. (2006) 'Recolonising Egypt', in T. P. Wiseman, ed., *Classics in Progress: Essays on Ancient Greece and Rome*, Oxford: Oxford University Press, 193–224.

Bowman, A. K., R. A. Coles, N. Gonis, D. Obbink, and P. J. Parsons, eds (2007) *Oxyrhynchus: A City and Its Texts*, London: Egypt Exploration Society.

Bowman, L. (2019) 'Hidden Figures: The Women Who Wrote Epigrams', in C. Henriksén, *A Companion to Ancient Epigram*, Hoboken, NJ: Wiley Blackwell, 77–92.

Braden, G. (2016) 'Epic Annoyance, Homer to Palladas', *Arion* 24.1, 103–124.

Breccia, E. (1911) *Iscrizioni Greche e Latine. Catalogue général des antiquités égyptiennes du Musée d'Alexandrie*, Cairo: Imprimerie de l'Institut français d'archéologie orientale.

Breunig, L., ed. (1972) *Apollinaire on Art: Essays and Reviews*, S. Suleiman, trans., New York: Viking.

Brewer, J. (1997) *The Pleasures of the Imagination: English Culture in the Eighteenth Century*, London and New York: Routledge.

Briefel, A. (2006) *The Deceivers: Art Forgery in the Nineteenth Century*, Ithaca, NY: Cornell University Press.

Briend, C. and D. Lemny (2009) *Henri Gaudier-Brzeska dans les collections du Centre Pompidou*, Paris: Centre Pompidou.

Briggs, J. (2005) 'Printing Hope: Virginia Woolf, Hope Mirrlees, and the Iconic Imagery of Paris', in K. V. Kukil, ed., *Woolf in the Real World: Selected Papers from the Thirteenth International Conference on Virginia Woolf*, Clemson, SC: Clemson University Digital Press, 31–6.

—— (2007) 'Hope Mirrlees and Continental Modernism', in B. Kime Scott, ed., *Gender in Modernism: New Geographies, Complex Intersections*, Urbana: University of Illinois Press, 261–303.

192 BIBLIOGRAPHY

Brinkman, B. (2009) 'Making Modern "Poetry": Format, Genre and the Invention of Imagism(e)', *Journal of Modern Literature* 32. 2 (Winter 2009), 20–40.

—— (2016) *Poetic Modernism in the Culture of Mass Print*, Baltimore, MD: Johns Hopkins University Press.

Brinkman, B. and B. Brinkman (2016) 'Educating the "Perfect Imagist": Greek Literature and Classical Scholarship in the Poetry of H. D.', in Goldwyn and Nikopoulos (2016), 38–52.

Bromberg, J. (2021) *Global Classics*, Abingdon: Routledge.

Brown, A. (1986) 'I propose to begin at Gnossos', *Annual of the British School at Athens*, 81, 37–44.

—— (1994) *Arthur Evans and the Palace of Minos*, Oxford: Ashmolean Museum.

Bruns, G. L. (2018) *Interruptions: The Fragmentary Aesthetic in Modern Literature*, Alabama: University of Alabama Press.

Bücheler, F., ed. (1904) *Petronii Saturae et Liber Priapeorum*, Berlin: Weidmann.

Buckle, R. (1963) *Jacob Epstein: Sculptor*, Cleveland, OH: World Publishing.

Burkert, W. (1999) 'Diels' Vorsokratiker. Rückschau und Ausblick', in W. M. Calder and J. Mansfeld, eds, *Hermann Diels (1848–1922) et la science de l'antiquité*, Geneva: Fondation Hardt, 169–97.

Burnet, J. (1908) *Early Greek Philosophy*, 2nd edn, London: A. & C. Black.

Burström, M. (2013) 'Fragments as Something More: Archaeological Experience and Reflection', in A. González-Ruibal, ed., *Reclaiming Archaeology: Beyond the Tropes of Modernity*, London and New York: Routledge, 311–22.

Bush, R. (1989) *The Genesis of Ezra Pound's Cantos*, Princeton, NJ: Princeton University Press.

Butrica, J. L. (2007) 'History and Transmission of the Text', in M. B. Skinner, ed., *A Companion to Catullus*, Malden, MA: Blackwell, 13–34.

Caires, V. (1980) 'Originality and Eroticism: Constantine Cavafy and the Alexandrian Epigram', *Byzantine and Modern Greek Studies* 6, 131–55.

Calame, C. (1970) *Etymologicum Genuinum. Les citations de poètes lyriques*, Rome: Ateneo.

Calder, W. M. (1979) 'The Correspondence of Ulrich von Wilamowitz-Moellendorff with Edward Fitch', *Harvard Studies in Classical Philology* 83, 369–96.

Calder, W. M. and D. A. Trail, eds (1986) *Myth, Scandal, and History: The Heinrich Schliemann Controversy and a First Edition of the Mycenaean Diary*, Detroit: Wayne State University Press.

Cambria, M., G. Gregorio, and C. Res., eds (2018) *Un-representing the Great War: New Approaches to the Centenary*, Newcastle upon Tyne: Cambridge Scholars.

Cameron, A. (1993) *The Greek Anthology from Meleager to Planudes*, Oxford: Clarendon Press.

Capelle, W., trans. (2008) *Die Vorsokratiker. Die Fragmente und Quellenberichte*, new edn, Stuttgart: Alfred Kröner.

Caracciolo, P. L. (1996) 'The Metamorphosis of Wyndham Lewis's *The Human Age*: Medium, Intertextuality, Genre', in I. Willison et al., eds, *Modernist Writers and the Marketplace*, London: Palgrave Macmillan, 258–86.

Carden-Coyne, A. (2009) *Reconstructing the Body: Classicism, Modernism, and the First World War*, Oxford: Oxford University Press.

Carr, H. (2009) *The Verse Revolutionaries: Ezra Pound, H. D. and the Imagists*, London: Jonathan Cape.

—— (2012) '*Poetry: A Magazine of Verse* (1912–36): "Biggest of Little Magazines"', in P. Brooker and A. Thacker, eds, *The Oxford Critical and Cultural History of Modernist Magazines, Vol. 2, North America, 1894–1960*, Oxford: Oxford University Press, 40–60.

Carson, A. (2003) *If not, Winter: Fragments of Sappho*, London: Virago [1st edn New York: Alfred A. Knopf, 2002].

Casson, S. (1928) *Some Modern Sculptors*, Oxford: Oxford University Press.

Cè, M. (2019) 'Translating the *Odyssey*: Andreas Divus, Old English, and Ezra Pound's Canto I', in Hickman and Kozak (2019), 33–44.

Certeau, M. de (1995) 'History and Mysticism', in J. Revel and L. Hunt, eds, *Histories: French Constructions of the Past*, trans. A. Goldhammer et al., New York: New Press, 437–47.

Chapman, J. (2000) *Fragmentation in Archaeology: People, Places and Broken Objects in the Prehistory of South Eastern Europe*, London: Routledge.

Chisholm, D. (1996) 'Pornopoeia, the Modernist Canon, and the Cultural Capital of Sexual Literacy: The Case of H. D.', in M. Dickie and T. Travisano, *Gendered Modernisms: American Women Poets and Their Readers*, Philadelphia: University of Pennsylvania Press, 69–94.

Chrétien, F. [Quintus Septimus Florens Christianus] (1608) *Epigrammata ex libris Græcæ Anthologiæ a Q. Septimio Florente Christiano selecta, & Latinè versa... Accessit Musæi Poëmatium versibus ab eodem expressum*, Paris: R. Stephanus.

Childs, J. S. (1986) *Modernist Form: Pound's Style in the Early Cantos*, Selinsgrove, PA: Susquehanna University Press.

Chinitz, D. E. (1999–2000) 'T. S. Eliot's Blue Verses and Their Sources in the Folk Tradition', *Journal of Modern Literature* 23, 329–33.

Clark, K. (1956) *The Nude: A Study in Ideal Form*, New York: Pantheon.

Clifford, J. (1981) 'On Ethnographic Surrealism', *Comparative Studies in Society and History* 23.4, 539–64.

Clubb, M. D. (1961) 'The Heraclitean Element in Eliot's *Four Quartets*', *Philological Quarterly* 40, 19–33.

Coburn, K., ed. (1973) *The Notebooks of Samuel Taylor Coleridge*, Vol. 3, Abingdon: Routledge.

Cohen, B. (2015) 'Displaying Greek and Roman Art in Modern Museums', in C. Marconi, ed., *The Oxford Handbook of Greek and Roman Art and Architecture*, Oxford: Oxford University Press, 473–98.

Cohen, J. I. (2020) *Black Art Renaissance: African Sculpture and Modernism across Continents*, Oakland, CA: University of California Press.

Cohen, W. A., ed. (2004) *Filth: Dirt, Disgust and Modern Life*, Minneapolis, MN: University of Minnesota Press.

Colby, S. (2009) *Stratified Modernism: The Poetics of Excavation from Gautier to Olson*, Bern: Peter Lang.

Cole, R. (1978) *Burning to Speak: The Life and Art of Henri Gaudier-Brzeska*, Oxford: Phaidon.

—— (1980) *Gaudier-Brzeska: Chronology*, unnumbered pamphlet published to accompany the exhibition at Anthony d'Offay Gallery, London, 19 September–16 October 1980.

Coles, R. A. (2007) 'Oxyrhynchus: A City and Its Texts', in Bowman et al. (2007), 3–16.

Collecott, D. (1986) 'Images at the Crossroads: The "H. D. Scrapbook"', in M. King, ed., *H. D.: Woman and Poet*, Orono, ME: National Poetry Foundation, 319–67.

—— (1999) *H. D. and Sapphic Modernism, 1910–1950*, Cambridge and New York: Cambridge University Press.

—— (2000) '"This Pother about the Greeks": Hellenism and Anti-Hellenism in 1914', in H. M. Dennis, ed., *Ezra Pound and Poetic Influence: The Official Proceedings of the 17th*

International Ezra Pound Conference Held at Castle Brunnenburg, Tirolo di Merano, Amsterdam: Rodopi, 55–69.

Collignon, A. (1892) *Etude sur Pétrone. La critique littéraire, l'imitation et la parodie dans le Satiricon*, Paris: Hachette.

Connors, C. M. (1998) *Petronius the Poet: Verse and Literary Tradition in the Satyricon*, Cambridge: Cambridge University Press.

Cope, J. I. (1966) 'From Egyptian Rubbish-Heaps to "Finnegans Wake"', *James Joyce Quarterly* 3.3, 166–70.

Cork, R. (1985) *Art Beyond the Gallery in Early Twentieth-Century England*, New Haven, CT: Yale University Press.

Cornell, T. et al., eds. (2013) *The Fragments of the Roman Historians*, 3 vols, Oxford: Oxford University Press.

Cowling, E. and J. Mundy, eds (1990) *On Classic Ground: Picasso, Léger, de Chirico and the New Classicism 1910–1930*, London: Tate Gallery.

Cox, E. M. (1925) *The Poems of Sappho, with Historical and Critical Notes, Translations, and a Bibliography*, London: Williams and Norgate.

Coyle, M. (2016) '"Afternoon" at the British Museum', in F. Dickey and J. D. Morgenstern, eds, *The Edinburgh Companion to T. S. Eliot and the Arts*, Edinburgh: Edinburgh University Press, 36–50.

Čulik-Baird, H. (2022) *Cicero and the Early Latin Poets*, Cambridge: Cambridge University Press.

Culligan Flack, L. (2015) *Modernism and Homer: The Odysseys of H. D., James Joyce, Osip Mandelstam, and Ezra Pound*, Cambridge: Cambridge University Press.

—— (2020) *James Joyce and Classical Modernism*, London: Bloomsbury Academic.

Cunliffe, E. (2016) 'Should We 3D Print a New Palmyra?', *The Conversation* <http://theconversation.com/should-we-3d-print-a-new-palmyra-57014> (last accessed 1.5.22).

Curtis, G. (2003) *Disarmed: The Story of the Venus de Milo*, New York: Alfred A. Knopf.

Curtis, P. (1999) *Sculpture After Rodin: 1900–1945*, Oxford: Oxford University Press.

Cuvigny, H. (2009) 'The Finds of Papyri: The Archaeology of Papyrology', in R. S. Bagnall, ed., *The Oxford Handbook of Papyrology*, Oxford: Oxford University Press, 30–58.

Czelustek, S. (2022) 'Scrapped: Fragments of Modernity in the Little Magazine *Close Up* and H. D.'s Scrapbook', in F. Brinker and R. Mayer, eds, *Modernity and the Periodical Press: Trans-Atlantic Mass Culture and the Avant-Gardes, 1880–1920*, Leiden: Brill, 101–117.

Daehner, J. M. (2011) 'Antiquities Made Modern: Double Takes at Ancient Art', in Green and Daehner (2011), 43–63.

Dällenbach, L. and C. L. H. Hart Nibbrig, eds (1984) *Fragment und Totalität*, Frankfurt am Main: Suhrkamp.

Davenport, G. (1980) 'Satyr and Transcendentalist', *Parnassus: Poetry in Review* 8, 42–50.

Davis, D. (1986) 'Heliodora's Greece', in M. King, ed., *H. D.: Woman and Poet*, Orono, ME: National Poetry Foundation, 143–56.

Davoli, P. (2015) 'Papyri, Archaeology and Modern History: A Contextual Study of the Beginnings of Papyrology and Egyptology', *Bulletin of the American Society of Papayrologists* 52, 87–112.

Derda, T., J. Hilder, and J. Kwapisz, eds (2017) *Fragments, Holes, and Wholes: Reconstructing the Ancient World in Theory and Practice*, JJP Supplement 30, Warsaw: University of Warsaw.

Deuel, L. (1965) *Testaments of Time: The Search for Lost Manuscripts and Records*, New York: Alfred A. Knopf.

BIBLIOGRAPHY 195

Dickey, F. (2012) *The Modern Portrait Poem: From Dante Gabriel Rossetti to Ezra Pound*, Charlottesville, VA: University of Virginia Press.

Dickins, G. (1912) *Catalogue of the Acropolis Museum, Volume I: Archaic Sculpture*, Cambridge: Cambridge University Press.

Diebold, W. J. (1995) 'The Politics of Derestoration: The Aegina Pediments and the German Confrontation with the Past', *Art Journal* 54.2, 60–66.

Diels, H., ed. and trans. (1903) *Die Fragmente der Vorsokratiker*, Berlin: Weidmann.

——, ed. and trans. (1912) *Die Fragmente der Vorsokratiker*, 3rd edn, 2 vols, Berlin: Weidmann.

Dingee, W. (2019) 'Did their Propertius Walk that Way?: Ezra Pound's *Homage to Sextus Propertius* as a Complaint against Classical Philology', *Classical Receptions Journal* 11.1, 81–99.

Dionisotti, C. (1997) 'On Fragments in Classical Scholarship', in Most (1997), 1–33.

Divus, A. (1538) *Homeri Odyssea ad verbum translata, Andrea Divo Iustinopolitan interprete*, Paris: Andreas Wechelus.

Dobson, E. and G. Banks, eds (2018) *Excavating Modernity: Physical, Temporal and Psychological Strata in Literature, 1900–1930*, New York: Routledge.

Dodds, E. R. (1968) 'Homer', in M. Platnauer, ed., *Fifty Years (and Twelve) of Classical Scholarship*, Oxford, repr. in I. J. F. De Jong, *Homer: Critical Assessments*, Vol. I, London and New York: Routledge, 3–16.

Drake, W. (1989) *Sara Teasdale: Woman and Poet*, Knoxville, TN: University of Tennessee Press.

duBois, P. (1996) 'H. D. and Sappho', in E. Greene, ed., *Reading Sappho: Contemporary Approaches*, Berkeley, CA: University of California Press, 79–88.

—— (1997) *Sappho is Burning*, Chicago, IL: University of Chicago Press.

Duveen, J. (1930) *Thirty Years of British Art*, London: Studio.

Dyson, S. L. (2006) *In Pursuit of Ancient Pasts: A History of Classical Archaeology in the Nineteenth and Twentieth Centuries*, New Haven, NJ: Yale University Press.

Ede, H. S. (1930) *A Life of Gaudier-Brzeska*, London: Heinemann.

—— (1971) *Savage Messiah: Gaudier-Brzeska*, London: Gordon Fraser [1st edn, 1931].

Edmonds, J. M. (1909a) 'Three Fragments of Sappho', *Classical Review*, 23.4, 99–104.

—— (1909b) 'More Fragments of Sappho', *Classical Review* 23.5, 156–8.

—— (1922) *Lyra Graeca*, London: Heinemann.

Edwards, C. (2011) 'Imagining Ruins in Ancient Rome', *European Review of History: Revue europeenne d'histoire*, 18.5–6, 645–61.

Elias, C. (2004) *The Fragment: Towards a History and Poetics of a Performative Genre*, Bern: Peter Lang.

Eliot, T. S. (1966) 'American Literature and the American Language', *Sewanee Review*, 74.1, 1–20.

—— (1993) *The Varieties of Metaphysical Poetry*, R. Schuchard, ed., London: Faber & Faber.

—— (2015) *The Letters of T. S. Eliot, Volume 5: 1930–31*, V. Eliot and J. Haffenden, eds, London: Faber & Faber.

Ellmann, M. (1987) *The Poetics of Impersonality: T. S. Eliot and Ezra Pound*, Brighton: Harverster.

Elsen, A. E. (1963) *Rodin*, New York: Museum of Modern Art.

—— (1969) *The Partial Figure in Modern Sculpture from Rodin to 1969*, Baltimore, MD: Baltimore Museum of Art.

——, ed. (1981) *Rodin Rediscovered*, Washington, DC: National Gallery of Art.

196 BIBLIOGRAPHY

Epp, E. J. (2007) 'New Testament Papyri and the Transmission of the New Testament', in Bowman et al. (2007), 315–31.

Epstein, J. (1940) *Let There be Sculpture!*, New York: Michael Joseph.

Ernst, W. (1996) 'Framing the Fragment: Archaeology, Art, Museum', in P. Duro, ed., *The Rhetoric of the Frame: Essays on The Boundaries of The Artwork*, Cambridge: Cambridge University Press, 111–35.

Espey, J. (1972) 'Towards Propertius', *Paideuma: Modern and Contemporary Poetry and Poetics* 1.1, 63–74.

Etienne, R. and F. Etienne (1992) *The Search for Ancient Greece*, New York: Harry N. Abrams.

Evans, A. J. (1901a) 'The Palace of Knossos: Provisional Report of the Excavations for the Year 1901', *Annual of the British School at Athens* 7, 1–120.

—— (1901b) 'Mycenaean Tree and Pillar Cult and Its Mediterranean Relations', *Journal of Hellenic Studies* 21, 99–204.

—— (1912) 'The Minoan and Mycenaean Element in Hellenic Life', *Journal of Hellenic Studies* 32, 277–97.

—— (1927) 'Work of Reconstitution in the Palace of Knossos', *Antiquaries Journal* 7.3, 258–67.

—— (1928) *The Palace of Minos at Knossos*, Vol. 2, Part I, London: Macmillan.

Evangelista, S. (2018) 'Cosmopolitan Classicism: Wilde between Greece and France', in K. Riley, A. J. L. Blanshard, and I. Manny, eds, *Oscar Wilde and Classical Antiquity*, Oxford: Oxford University Press, 209–28.

Fabre-Serris, J. (2016) 'Anne Dacier (1681), Renée Vivien (1903): Or What Does it Mean for a Woman to Translate Sappho?', in R. Wyles and E. Hall, eds, *Women Classical Scholars: Unsealing the Fountain from the Renaissance to Jacqueline de Romilly*, Oxford: Oxford University Press, 78–102.

Farge, C., B. Garnier, and I. Jenkins, eds (2018) *Rodin and the Art of Ancient Greece*, London: British Museum.

Farnoux, A. (1996) *Knossos: Unearthing a Legend*, London: Thames & Hudson.

Faulkner, A., ed. (2011) *The Homeric Hymns: Interpretative Essays*, Oxford: Oxford University Press.

Fearn, D. (2010) 'Imperialist Fragmentation and the Discovery of Bacchylides', in M. Bradley, ed., *Classics and Imperialism in the British Empire*, Oxford: Oxford University Press, 158–85.

Fellini, F. (1978) 'Preface to *Satyricon*', in P. Bondanella, ed., *Federico Fellini: Essays in Criticism*, New York: Oxford University Press, 16–19.

Fernald, A. (2006) *Virginia Woolf: Feminism and the Reader*, New York: Palgrave Macmillan.

Finglass, P. J. (2021a) 'Sappho on the Papyri', in P. J. Finglass and A. Kelly, eds, *The Cambridge Companion to Sappho*, Cambridge: Cambridge University Press, 232–46.

—— (2021b) 'Editions of Sappho since the Renaissance', in P. J. Finglass and A. Kelly, eds, *The Cambridge Companion to Sappho*, Cambridge: Cambridge University Press, 247–60.

Finn, C. A. (2004) *Past Poetic: Archaeology in the Poetry of W. B. Yeats and Seamus Heaney*, London: Duckworth.

Fitzgerald, W. (2022) *The Living Death of Antiquity: Neoclassical Aesthetics*, Oxford: Oxford University Press.

Ford, M. (2016) *Thomas Hardy: Half a Londoner*, Cambridge, MA and London: Harvard University Press.

Formichelli, J. (2002) *Scenes and Situations in T. S. Eliot's Epigraphs*, PhD Diss., Cambridge University.

Forster, E. M. (1923) *Pharos and Pharillon*, London: Hogarth Press, 2nd edn.

Frederiksen, R. and E. Marchand, eds (2010) *Plaster Casts: Making, Collecting and Displaying from Classical Antiquity to the Present*, Berlin: De Gruyter.

Freud, S. (1930) *Civilization and Its Discontents*, J. Riviere, trans., London: Hogarth Press.

Friedman, S. S. (1991) *Penelope's Web: Gender, Modernity, H. D.'s Fiction*, Cambridge: Cambridge University Press.

—— (2015) *Planetary Modernisms: Provocations on Modernity Across Time*, New York: Columbia University Press.

Frisby, D. (1985) *Fragments of Modernity: Theories of Modernity in the Works of Simmel, Kracauer and Benjamin*, Cambridge: Polity Press.

Fyfe, G. (2006) 'Sociology and the Social Aspects of Museums', in S. Macdonald, ed., *A Companion to Museum Studies*, Malden, MA: Blackwell, 33–49.

Gange, D. (2013) *Dialogues with the Dead: Egyptology in British Culture and Religion, 1822–1922*, Oxford: Oxford University Press.

Gardner, E. A. (1890) 'The Processes of Greek Sculpture as Shown by Some Unfinished Statues at Athens', *Journal of Hellenic Studies* 11, 129–42.

Garnier, B. (2013) 'Collectionner la vie', in Picard (2013), 306–21.

—— (2018) '"My dream as a sculptor": The Thousand Parthenons of Auguste Rodin', in Farge, Garnier, and Jenkins (2018), 34–53.

Gazis, G. (2018) *Homer and the Poetics of Hades*, Oxford: Oxford University Press.

Gere, C. (2006) *The Tomb of Agamemnon*, London: Profile Books.

—— (2009) *Knossos and the Prophets of Modernism*, Chicago, IL: University of Chicago Press.

German, S. C. (2005) 'Photography and Fiction: The Publication of the Excavations at the Palace of Minos at Knossos', *Journal of Mediterranean Archaeology* 18.2, 209–30.

Getsy, D. J. (2010) *Rodin: Sex and the Making of Modern Sculpture*, New Haven, CT: Yale University Press.

Gibson, R. and C. Whitton (2023) 'Introduction: Texts, Tools, Territories', in R. Gibson and C. Whitton, eds., *The Cambridge Critical Guide to Latin Literature*, Cambridge: Cambridge University Press, 1–42.

Gilboa, R. (2009) *'And There Was Sculpture': Jacob Epstein's Formative Years, 1880–1930*, London: Paul Holberton.

Ginelli, F. and F. Lupi (2021) *The Continuity of Classical Literature through Fragmentary Traditions*, Berlin and Boston: De Gruyter.

Goldberg, S. and G. Manuwald, eds. (2018) *Fragmentary Republican Latin: Ennius, Testimonia, Epic Fragments*, Vol. I, Loeb Classical Library 294, Cambridge, MA: Harvard University Press.

Goldscheider, L., ed. (1996) *Auguste Rodin*, 10th edn, London: Phaidon [1st edn, 1939].

Goldschmidt, N. (2012) 'Absent Presence: *Pater Ennius* in Renaissance Europe', *Classical Receptions Journal* 4.1, 1–19.

—— (2019) '"Orts, scraps, and fragments": Translation, Non-translation and the Fragments of Ancient Greece', in J. Harding and J. Nash, eds, *Modernism and Non-translation*, Oxford: Oxford University Press, 49–66.

Goldwyn, A. J. (2016) 'Creating the Modern Rhapsode: The Classics as World Literature in Pound's *Cantos*', in Goldwyn and Nikopoulos (2016), 53–72.

Goldwyn, A. J. and J. Nikopoulos, eds (2016) *Brill's Companion to the Reception of Classics in International Modernism and the Avant-Garde*, Leiden: Brill.

Graham, D. W. (2010) *The Texts of Early Greek Philosophy*, Cambridge: Cambridge University Press.

198 BIBLIOGRAPHY

Grant, M. ed. (1982) *T. S. Eliot: The Critical Heritage*, 2 vols, London: Routledge.
Gray, C. et al., eds (2018) *Reading Republican Oratory: Reconstructions, Contexts, Receptions*, Oxford: Oxford Universtiy Press.
Green, C. (2011) '"There is no antiquity": Modern Antiquity in the Work of Pablo Picasso, Giorgio de Chirico, Fernand Léger, and Francis Picabia (1906–36)', in Green and Daehner (2011), 1–15.
Green, C. and J. M. Daehner, eds (2011) *Modern Antiquity: Picasso, De Chirico, Léger, Picabia*, Los Angeles, CA: J. Paul Getty Museum.
Greenfield, J. (1996) *The Return of Cultural Treasures*, Cambridge: Cambridge University Press.
Gregory, E. (1997) *H. D. and Hellenism: Classic Lines*, Cambridge: Cambridge University Press.
Grenfell, B. P. (1896/7) 'Oxyrhynchus and Its Papyri', *Egypt Exploration Fund Archaeological Report*, 1–12.
Grenfell, B. P. and A. S. Hunt, eds (1898) *The Oxyrhynchus Papyri, Part I*, London: Egypt Exploration Fund.
—— (1899) *The Oxyrhynchus Papyri, Part II*, London: Egypt Exploration Fund.
—— (1900) *Fayûm Towns and Their Papyri* (with D. G. Hogarth), London: Egypt Exploration Fund.
—— (1922) *The Oxyrhynchus Papyri, Part X*, London: Egypt Exploration Fund.
Grenfell, B. P., A. S. Hunt, and J. Gilbart Smyly, eds (1902) *The Tebtunis Papyri, Part I*, London: Humphrey Milford.
Groddeck, W. (1999) 'Blendung: Betrachtung an Rilkes zweiten Apollo-Sonett', in W. Groddeck, ed., *Interpretationen: Gedichte von Rainer Maria Rilke*, Stuttgart: Reclam, 87–103.
Grossman, J. B., J. Podany, and M. True, eds (2003) *History of Restoration of Ancient Stone Sculptures*, Los Angeles, CA: J. Paul Getty Museum.
Guest, B. (1984) *Herself Defined: The Poet H. D. and Her World*, Garden City, NY: Doubleday.
Güthenke, C. (2020) *Feeling and Classical Philology: Knowing Antiquity in German Scholarship, 1770–1920*, Cambridge: Cambridge University Press.
Gutzwiller, K. J. (1993) 'Anyte's Epigram Book', *Syllecta Classica* 4, 71–89.
—— (1998) *Poetic Garlands: Hellenistic Epigrams in Context*, Berkeley, CA: University of California Press.
Gurd, S. (2021) 'Carson Fragment', in Jansen (2021a), 75–88.
Guignery, V. and W. Drąg (2019) *The Poetics of Fragmentation in Contemporary British and American Fiction*, Wilmington, DE: Vernon Press.
Guldbrandsen, E. E. and J. Johnson (2015) *Transformations of Musical Modernism*, Cambridge: Cambridge University Press.
Hakutani, Y. (2009) *Haiku and Modernist Poetics*, Basingstoke: Palgrave Macmillan.
Hale, W. G. (1919) 'Pegasus Impounded', *Poetry: A Magazine of Verse* (April), 14.1, 52–5.
Hales, S. (2002) 'How the Venus de Milo Lost her Arms', in D. Odgen, ed., *The Hellenistic World: New Perspectives*, Swansea: Classical Press of Wales, 253–74.
Hall, E. (2021) *Tony Harrison: Poet of Radical Classicism*, London: Bloomsbury Academic.
Hamilakis, Y. ed. (2002) *Labyrinth Revisited: Rethinking 'Minoan' Archaeology*, Oxford: Oxbow.
—— (2007) *The Nation and Its Ruins: Antiquity, Archaeology, and the National Imagination in Greece*, Oxford: Oxford University Press.

BIBLIOGRAPHY 199

Hamilakis, Y. and N. Momigliano, eds (2006) *Archaeology and European Modernity: Producing and Consuming the 'Minoans'*, Creta Antica 7, Padua: Bottega d'Erasmo.

Hammill, F. (2016) *Modernism's Print Cultures*, London: Bloomsbury Academic.

Hamnett, N. (1932) *Laughing Torso*, New York: Ray Long and Richard R. Smith.

Harbison, R. (2015) *Fragments and Ruins: Tales of Loss and Rediscovery*, London: Reaktion Books.

Hardie, P. R. (2007) Review of Martindale and Thomas (2006), *Translation and Literature* 16.2, 240–4.

Harrison, J. (1903) *Prolegomena to the Study of Greek Religion*, Cambridge: Cambridge University Press.

Harrison, T., trans. (1975) *Palladas: Poems*, London: Anvil.

—— (1991) *The Trackers of Oxyrhynchus*, London: Faber & Faber.

Haskell, A. (1932) *The Sculptor Speaks: Jacob Epstein to Arnold L. Haskell: A Series of Conversations on Art*, Garden City, NY: Doubleday.

Haskell, F. and N. Penny (1981) *The Taste for the Antique: The Lure of Classical Sculpture, 1500–1900*, New Haven, NJ: Yale University Press.

Haslam, S. (2002) *Fragmenting Modernism: Ford Madox Ford, the Novel and the Great War*, Manchester: Manchester University Press.

Hausmann, U. (1947) *Die Apollosonette Rilkes und ihre plastische Urbilder*, Berlin: Gebr. Mann.

Haynes, K. (2007) 'Modernism', in C. Kallendorf, ed., *A Companion to the Classical Tradition*, Malden, MA: Blackwell, 101–14.

H. D. (Hilda Doolittle) (1925) 'Winter Roses', Review of Cox (1925), *The Saturday Review of Literature* 14 March 1925, 596.

—— (1938) 'A Note on Poetry', in W. R. Benét and N. H. Pearson, eds, *Oxford Anthology of American Literature*, Vol. II, New York: Oxford University Press, 1287–8.

—— (1974) *Tribute to Freud, Writing on the Wall, Advent*, Boston: D. R. Godine.

—— (1979) *End to Torment: A Memoir of Ezra Pound*, New York: New Directions.

—— (1982) *Notes on Thought and Vision & The Wise Sappho*, San Francisco, CA: City Lights Books.

—— (1992) *Asphodel*, Robert Spoo, ed., Durham, NC and London: Duke University Press.

Herman, A. (2021) *Restitution: The Return of Cultural Artefacts*, London: Lund Humphries.

Heseltine, M., trans. (1913) *Petronius: The Satyricon*, London: Heinemann.

Heubeck, A. and A. Hoekstra (1989) *A Commentary on Homer's Odyssey, Volume II, Books IX–XVI*, Oxford: Clarendon Press.

Heuving, J. (2016) *The Transmutation of Love and Avant-Garde Poetics*, Tuscaloosa, AL: University of Alabama Press.

Hickey, T. M. (2011) 'Writing Histories from the Papyri', in R. S. Bagnall, ed., *The Oxford Handbook of Papyrology*, Oxford: Oxford University Press, 495–520.

Hickman, M. and L. Kozak, eds (2019) *The Classics in Modernist Translation*, London and New York: Bloomsbury Academic.

Hickman, M. and J. McIntyre, eds (2012) *Rereading the New Criticism*, Columbus, OH: Ohio State University Press.

Highet, G. (1961) 'Beer-bottle on the Pediment', *Horizon* 3.3, January 1961, 116–18.

Hiscock, M. (2020) 'Reception Theory, New Humanism, and T. S. Eliot', *Classical Receptions Journal* 12.3, 323–39.

Hitchcock, L and P. Koudounaris (2002) 'Virtual Discourse: Arthur Evans and the Reconstructions of the Minoan Palace at Knossos', in Hamilakis (2002), 40–58.

200 BIBLIOGRAPHY

Hollenberg, D. K. (2022) *Winged Words: The Life and Work of the Poet H. D.*, Ann Arbor, MI: University of Michigan Press.

Holmes, B. (2018) 'On Liquid Antiquity', in Squire et al. (2018), 141–6.

Holmes, B. and D. Joannou, eds (2017) *Liquid Antiquity*, Athens: Deste Foundation for Contemporary Art.

Hood, S. (1995) 'Collingwood on the Minoan Civilisation of Crete', in D. Boucher and B. Haddock, eds, *Collingwood Studies II*, Swansea: Collingwood Society, 175–9.

—— (2004) 'The Early Life of Sir Arthur Evans', *British School at Athens Studies* 12, 557–559.

Hooper-Greenhill, E. (2006) 'Studying Visitors', in S. Macdonald, ed., *A Companion to Museum Studies*, Malden, MA: Blackwell, 362–76.

Howard, S. (1990) *Antiquity Restored: Essays on the Afterlife of the Antique*, Vienna: IRSA.

—— (2003) 'Restoration and the Antique Model: Reciprocities between Figure and Field', in Grossman, Podany, and True (2003), 25–44.

Howarth, P. (2011) *Cambridge Introduction to Modernist Poetry*, Cambridge: Cambridge University Press.

Hughes, J. (2018) 'Tiny and Fragmented Votive Offerings from Classical Antiquity', in Martin and Langin-Hooper (2018), 48–71.

Hulme, T. E. (2003) *Selected Writings*, edited with an introduction by P. McGuinness, Manchester: Carcanet.

Humphreys, R., ed. (1985) *Pound's Artists: Ezra Pound and the Visual Arts in London, Paris and Italy*, London: Tate Gallery.

Hunt, A. S., ed. (1903) *The Oxyrhynchus Papyri, Part III*, London: Egypt Exploration Fund.

—— (1914) 'The New Lyric Fragments', *Classical Review* 28.4, June 1914, 126–7.

Hurwit, J. M. (1985) *The Art and Culture of Early Greece, 1100–480 BC*, Ithaca, NY: Cornell University Press.

—— (1999) *The Athenian Acropolis: History, Mythology, and Archaeology from the Neolithic Era to the Present*, Cambridge: Cambridge University Press.

Ioannidou, E. (2017) *Greek Fragments in Postmodern Frames: Rewriting Tragedy 1970–2005*, Oxford: Oxford University Press.

Insoll, T. (2004) *Archaeology, Ritual, Religion*, London: Routledge.

Ireland, G. (1956) *Jacob Epstein: A Camera Study of the Sculptor at Work*, with an introduction by L. Laurie, London: Andre Deutsch.

Jafari, A., B. Taheri, and D. vom Lehn (2013) 'Cultural Consumption, Interactive Sociality, and the Museum', *Journal of Marketing Management* 29:15–16, 1729–52.

Jailant, L. and A. E. Martin (2018) 'Introduction: Global Modernism', *Modernist Cultures* 13.1, 1–13.

Jain, M. (1992) *T. S. Eliot and American Philosophy: The Harvard Years*, Cambridge: Cambridge University Press.

Janowitz, A. (1990) *England's Ruins: Poetic Purpose and the National Landscape*, Oxford: Blackwell.

—— (1999) 'Romantic Fragments', in D. Wu, ed., *A Companion to Romanticism*, Oxford: Blackwell, 479–88.

Jansen, L. (2018) *Borges' Classics: Global Encounters with the Graeco-Roman Past*, Cambridge: Cambridge University Press.

——, ed. (2021a) *Anne Carson: Antiquity*, London: Bloomsbury Academic.

—— (2021b) 'The Gift of Residue', in Jansen (2021a), 89–104.

Jay, P., ed. (1973) *The Greek Anthology and Other Ancient Greek Epigrams: A Selection in Modern Verse Translations*, London: Allen Lane.

BIBLIOGRAPHY 201

Jenkins, I. (1990) 'Acquisition and Supply of Casts of the Parthenon Sculptures by the British Museum, 1835–1939', *Annual of the British School at Athens* 85, 89–114.

—— (1992) *Archaeologists and Aesthetes in the Sculpture Galleries of the British Museum, 1800–1939*, London: British Museum.

—— (2001) *Cleaning and Controversy: The Cleaning of the Parthenon Sculptures 1811–1939*, London: British Museum.

Jenkyns, R. (1982) *Three Classical Poets: Sappho, Catullus, and Juvenal*, London: Duckworth.

Jocelyn, H. D., ed. (1967) *The Tragedies of Ennius: The Fragments*, Cambridge: Cambridge University Press.

Johnson, J. de M. (1914) 'Antinoë and Its Papyri: Excavation by the Greek and Roman Branch, 1913–1914', *Journal of Egyptian Archaeology* I.3, 168–81.

Johnson, W. A. (2012) 'The Oxyrhynchus Distributions in America: Papyri and Ethics', *Bulletin of the American Society of Papyrologists* 49, 209–22.

Jusdanis, G. (2004) 'Farewell to the Classical: Excavations in Modernism', *Modernism/ Modernity* 11.1, 37–53.

Kahane, A. (1999) 'Blood for Ghosts? Homer, Ezra Pound, and Julius Africanus', *New Literary History* 30.4, 815–36.

—— ed. (2011) *Antiquity and the Ruin*, special issue of *European Review of History: Revue europeenne d'histoire*, 18.5–6.

Kaibel, G. (1878) *Epigrammata Graeca ex lapidibus conlecta*, Berlin: G. Reimer.

Kavvadias, P. and G. Kawerau (1906) *Die Ausgrabung der Akropolis vom Jahre 1885 bis zum Jahre 1890*, Athens: Hestia.

Keenan, J. (2011) 'The History of the Discipline', in R. Bagnall, ed., *The Oxford Handbook of Papyrology*, Oxford: Oxford University Press, 59–78.

Keesling, C. M. (2003) *The Votive Statues of the Athenian Acropolis*, Cambridge: Cambridge University Press.

Kelly, J. (2007) *Art, Ethnography and the Life of Objects, Paris c.1925–35*, Manchester: Manchester University Press.

Kenner, H. (1969) 'Homer's Sticks and Stones', *James Joyce Quarterly* 6.4, 285–98.

—— (1971) *The Pound Era*, Berkeley, CA: University of California Press.

—— (1973) 'The Urban Apocalypse', in A. W. Litz, ed., *Eliot in His Time*, Princeton, NJ: Princeton University Press, 23–49.

—— (1985) 'Pound and Homer', in G. Bornstein, ed., *Ezra Pound among the Poets*, Chicago, IL: University of Chicago Press, 1–12.

—— (2006) 'Ezra Pound', in P. Makin, ed., *Ezra Pound's Cantos: A Casebook*, Oxford: Oxford University Press, 29–46 (originally published in H. Vendler, ed. *Voices and Visions: The Poet in America*, New York).

Kern, S. (2017) *Modernism after the Death of God: Christianity, Fragmentation, and Unification*, New York and London: Routledge.

Khunti, R. (2018) 'The Problem with Printing Palmyra: Exploring the Ethics of Using 3D Printing Technology to Reconstruct Heritage', *Studies in Digital Heritage* 2.1, 1–12.

Kienzle, P. (1998) 'Conservation and Reconstruction at the Palace of Minos at Knossos', Phd Diss., University of York.

King, J. and L. Miletic-Vejzovic, eds (2003) *The Library of Leonard and Virginia Woolf: A Short-Title Catalog*, Pullman, Washington: Washington State University Press.

Kirchhoff, A. (1879) *Die Homerische Odyssee*, 2nd edn, Berlin: Hertz.

Knell, H. and H.-W. Kruft (1972) 'Re-Opening of the Munich Glyptothek', *Burlington Magazine* 114, June 1972, 431–6.

Knoll, K., ed. (1994a) *Das Albertinum vor 100 Jahren—die Skulpturensammlung Georg Treus*, Dresden: Staatliche Kunstsammlungen.

—— (1994b) 'Die Abnahme der Ergänzungen von den antiken Skulpturen in die Einrichtung und Einstellung der Antikensammlung', in Knoll (1994a), 131–42.

—— (2003) '"Ein wirkliches Rettungswerk": Zur sog. Entrestaurierung der Dresdener Antiken', in Kunze and Rügler (2003), 223–8.

—— (2011) 'Der Umgang mit den Antikenergänzungen in Dresden', in K. Knoll, C. Vorster, and M. Woelk, eds, *Skulpturensammlung, Staatliche Kunstsammlungen Dresden: Katalog der antiken Bildwerke, Band II 1–2. Idealskulptur der römischen Kaiserzeit*, Munich: Hirmer, 81–97.

Kocziszky, E. (2015) *Das fremde Land der Vergangenheit: Archäologische Dichtung der Moderne*, Cologne: Böhlau.

Kolocotroni, V. (2012) 'Still Life: Modernism's Turn to Greece', *Journal of Modern Literature* 35.2, 1–24.

Kopaka, K. (2015) 'Minos Kalokairinos and his Early Excavation at Knossos. An Overview, a Portrait, and a Return to the Kephala pithoi', in C. F. Macdonald, E. Hatzaki, and S. Andreou, eds, *The Great Islands: Studies of Crete and Cyprus presented to Gerald Cadogan*, Athens: Kapon Editions, 143–51.

Koulouris, T. (2011) *Hellenism and Loss in the Work of Virginia Woolf*, Farnham: Ashgate.

—— (2019) 'Virginia Woolf's "Greek Notebook" (VS Greek and Latin Studies): An Annotated Transcription', *Woolf Studies Annual* 25, 1–72.

Kousser, R. (2009) 'Destruction and Memory on the Athenian Acropolis', *Art Bulletin* 91.3, 263–82.

—— (2017) *Afterlives of Greek Sculpture: Interaction, Transformation, and Destruction*, Cambridge: Cambridge University Press.

Kritzman, L. D. and J. P. Plottel eds (1981) *Fragments: Incompletion and Discontinuity*, New York: New York Literary Forum.

Krzyszkowska, O. (2005) *Aegean Seals: An Introduction*, London: Insistitue of Classical Studies.

Kunze, M. and M. Rügler, eds (2003) *'Wiedererstandene Antike'. Ergänzungen antiker Kunstwerke seit der Renaissance*, Munich: Biering & Brinkmann.

Kurtz, D., ed. (1994) *Bernard Ashmole: An Autobiography*, Oxford: Oxbow.

—— (2000) *The Reception of Classical Art in Britain: An Oxford Story of Plaster Casts from the Antique*, Oxford: Archaeopress.

Kutzko, D. (2003) 'Cavafy and the Discovery of Herodas', *Classical and Modern Literature* 23.2, 89–109.

Lacoue-Labarthe, P. and J.-L. Nancy (1988) *The Literary Absolute: The Theory of Literature in German Romanticism*, P. Barnard and C. Lester, trans., Albany, NY: State University of New York.

Laes, C. (1998) 'Forging Petronius: François Nodot and the Fake Petronian Fragments', *Humanistica Lovaniensia* 47, 358–402.

Laks, A. (2018) *The Concept of Presocratic Philosophy*, trans. G. Most, Princeton, NJ: Princeton University Press [*Introduction à la "philosophie présocratique"* (Paris 2006)].

Lamari, A. A., F. Montanari, and A. Novokhatko, eds (2020) *Fragmentation in Ancient Greek Drama*, Berlin: De Gruyter.

Lang, A. (1893) *Homer and the Greek Epic*, London and New York: Longmans.

Latham, S. and G. Rogers (2015) *Modernism: Evolution of an Idea*, London: Bloomsbury Academic.

—— (2021) *The New Modernist Studies Reader: An Anthology of Essential Criticism*, London: Bloomsbury Academic.

BIBLIOGRAPHY 203

Latifi, K. (2019) 'Fragmente und Ruinen. Zur Schlussstrophe von T. S. Eliots "The Waste Land"', in *Poetica* 50.3/4, 38–258. Leiden: Brill.

Lattimore, R. (1942) *Themes in Greek and Latin Epitaphs*, Urbana, IL: University of Illinois Press

Lawton, P. (2012) 'For the Gentleman and the Scholar: Sexual and Scatological References in the Loeb Classical Library', in S. J. Harrison and C. Stray, eds, *Expurgating the Classics: Editing Out in Greek and Latin*, London: Bloomsbury Academic, 175–96.

Le Breton, G. (1965) 'T. S. Eliot et la dialectique d'Héraclite', *Mercure de France* 353, 518–23.

Le Corbusier (1927) *Towards a New Architecture*, trans. F. Etchells, London.

Lees, N. (1966) 'Mr. Eliot's Sunday Morning Satura: Petronius and "The Waste Land"', *Sewanee Review*, 74.1, 339–48.

Lemprière, J. (1912) *A Classical Dictionary, Containing a Copious Account of all the Proper Names Mentioned in Ancient Authors*, 8th edn, London: Routledge.

Lending, M. (2017) *Plaster Monuments: Architecture and the Power of Reproduction*, Princeton, NJ: Princeton University Press.

Le Normand-Romain, A. (2007) *The Bronzes of Rodin: Catalogue of Works in the Musée Rodin*, Paris: Musée Rodin, 2 vols.

Levene, D. S. (1992) 'Sallust's *Jugurtha*: An "Historical Fragment"', *Journal of Roman Studies* 82, 53–70.

Lichtenstein, J. (2009) 'The Fragment: Elements of a Definition', in Tronzo (2009), 115–29.

Liebregts, P. (2004) *Ezra Pound and Neoplatonism*, Madison, NJ: Fairleigh Dickinson University Press.

—— (2010) 'The Classics', in I. Nadel, ed., *Ezra Pound in Context*, Cambridge: Cambridge University Press, 171–80.

—— (2019) *Translations of Greek Tragedy in the Work of Ezra Pound*, London: Bloomsbury Academic.

Lindenlauf, A. (1997) 'Der Perserschutt der Athener Akropolis', in W. Hoepfner, ed., *Kult und Kultbauten auf der Akropolis*, Berlin: Archäologisches Seminar der Freien Universität Berlin, 45–115.

Litz, A. W. (1972) 'Pound and Eliot on *Ulysses*: The Critical Tradition', *James Joyce Quarterly*, 10.1, 5–18.

Locke, A. (2011) 'Looking around at Leisure: Sculptors at the British Museum', in P. Curtis and K. Wilson, eds, *Modern British Sculpture*, London: Royal Academy of Arts, 84–91.

Loebenstein, L. (1983) 'Vom "Papyrus Erzherzog Rainer" zur Papyrussammlung der Österreichischen Nationalbibliothek. 100 Jahre Sammeln, Bewahren, Edieren', in *Festschrift zum 100-jährigen Bestehen der Papyrussammlung der Österreichischen Nationalbibliothek*, Vienna: Verlaf Brüder, 3–39.

Lorimer, N. (1913) *The Wife out of Egypt*, New York: Brentano's.

Loukaki, A. (2008) *Living Ruins, Value Conflicts*, Aldershot: Ashgate.

Loy, M. (1997) *The Lost Lunar Baedeker*, Manchester: Carcanet.

Luck, G. (1954) 'Die Dichterinnen der griechischen Anthologie', *Museum Helveticum* 11, 170–87.

Lyons, C. L. (2005) 'The Art and Science of Antiquity in Nineteenth-Century Photography', in C. L. Lyons et al., (2005), 22–66.

Lyons, C. L., J. K. Papdopoulos, L. S. Stewart, and A. Szegedy-Maszak, eds (2005) *Antiquity and Photography: Early Views of Ancient Mediterranean Sites*, Los Angeles: J. Paul Getty Museum.

Lyons, M. (2021) *The Typewriter Century: A Cultural History of Writing Practices*, Toronto: University of Toronto Press.

204 BIBLIOGRAPHY

McCabe, S. (2005) *Cinematic Modernism: Modernist Poetry and Film*, Cambridge: Cambridge University Press.

—— (2021) *H. D. & Bryher: An Untold Love Story of Modernism*, Oxford: Oxford University Press.

MacDougall, S. and R. Dickson (2006) *Embracing the Exotic: Jacob Epstein and Dora Gordine*, London: Ben Uri Gallery.

McEnroe, J. C. (2002) 'Cretan Questions: Politics and Archaeology 1898–1913', in Hamilakis (2002), 59–72.

McFarland, T. (1981) *Romanticism and the Forms of the Ruin: Wordsworth, Coleridge, the Modalities of Fragmentation*, Princeton, NJ: Princeton University Press.

McGann, J. (1991) 'Pound's *Cantos*: A Poem Including Bibliography', in *The Textual Condition*, Princeton, NJ: Princeton University Press, 129–52.

Mackail, J. W. (1911) *Select Epigrams from the Greek Anthology*, 3rd edn, London and New York: Longmans.

[Mackail, J.W.] (1916) 'Note of the Classical Revival', *Times Literary Supplement* No. 746, 4 May, p.210.

[Mackail, J.W.] (1919) 'Poets' Translations', *Times Literary Supplement* No. 931, 20 November, p.666.

MacKay, M. (2007) *Modernism and World War II*, Cambridge: Cambridge University Press.

Mackay, P. (2011) 'H. D.'s Modernism', in N. Christodoulides and P. Mackay, eds, *The Cambridge Companion to H. D.*, Cambridge: Cambridge University Press, 51–62.

MacLeod, K. (2018) *American Little Magazines of the Fin de Siècle: Art, Protest, and Cultural Transformation*, Toronto: University of Toronto Press.

McManus, B. F. (2007) '*Macte nova virtute, puer!*': Gilbert Murray as Mentor and Friend to J. A. K. Thomson', in Stray (2007), 181–99.

McMullan, L. (2017) 'Counter-Philology: Ezra Pound as Translator of Provençal and Cavalcanti', *Textual Practice* 33.4, 585–604.

McNelly Kearns, C. (1987) *T. S. Eliot and Indic Traditions: A Study in Poetry and Belief*, Cambridge: Cambridge University Press.

Magid, D. M. (1975) 'A Note on Brancusi and the London Salon', *Art Journal* 35.2, 105–6.

Mallouchou-Tufano, F. (1994) 'The History of Interventions at the Acropolis', in R. Economakis, ed., *Acropolis Restoration: The CCAM Interventions*, London: Academy Editions, 69–85.

—— (2007a) 'The Vicissitudes of the Athenian Acropolis in the 19th Century: From Castle to Monument', in P. Valavanis, ed., *Great Moments in Greek Archaeology*, Los Angeles, CA: J. Paul Getty Museum, 36–57.

—— (2007b) 'The Restoration of Classical Monuments in Modern Greece: Historic Precedents, Modern Trends, Peculiarities', *Conservation and Management of Archaeological Sites*, 8.3, 154–73.

Malraux, A. (1949) *The Museum without Walls (The Psychology of Art, I)*, trans. S. Gilbert, London: A. Zwemmer [Le Musée imaginaire (La Psychologie de l'art, i), Geneva, 1947].

Manuwald, G. ed. (2019) *Fragmentary Republican Latin, Vol. III: Oratory, Part I*, Loeb Classical Library, 540, Cambridge, MA: Harvard University Press.

Mao, D., ed. (2021) *The New Modernist Studies*, Cambridge: Cambridge University Press.

Mao, D. and R. Walkowitz (2008) 'The New Modernist Studies', *PMLA* 123.3, 737–48.

Marcus, J. (1981) *New Feminist Essays on Virginia Woolf*, Lincoln, NE: University of Nebraska Press.

Marinatos, N. (2015) *Sir Arthur Evans and Minoan Crete: Creating the Vision of Knossos*, London: Bloomsbury Academic.

Marshall, C. R. (2011) '"The finest sculpture gallery in the world": The Rise and Fall – and Rise Again – of the Duveen Sculpture Galleries at the Tate Britain', in C. R. Marshall, ed., *Sculpture and the Museum*, Farnham: Ashgate, 177–95.

—— (2012) 'Athens, London or Bilbao?: Contested Narratives of Display in the Parthenon Galleries of the British Museum', in S. Macleod, L. Hourston Hanks, and J. Hale, eds, *Museum Making: Narratives, Architectures, Exhibitions*, Abingdon: Routledge, 34–47.

Mastellari, V., ed. (2021) *Fragments in Context/Frammenti e dintorni*, Göttingen: Vandenhoeck & Ruprecht.

Martin, S. R. and S. Langin-Hooper, eds (2018) *The Tiny and the Fragmented: Miniature, Broken, or Otherwise Incomplete Objects in the Ancient World*, Oxford: Oxford University Press.

Martin, S. (2016) *The Mythic Method: Classicism in British Art 1920–1950*, Chichester: Pallant House Gallery.

Martindale, Charles (1993) *Redeeming the Text: Latin Poetry and the Hermeneutics of Reception*. Cambridge: Cambridge University Press.

—— (1999) 'Ruins of Rome: T. S. Eliot and the Presence of the Past', in C. Edwards, ed., *Roman Presences: Receptions of Rome in European Culture 1789–1945*, Cambridge: Cambridge University Press, 236–55.

—— (2013) Response to Forum Debate, *Classical Receptions Journal*, 5.2, 246–51.

Martinez, J.-L. (2000) *La dame d'Auxerre*, Paris: Musée du Louvre.

Martz, L. L., ed. (1983) *H. D., Collected Poems 1912–1944*, New York: New Directions.

Materer, T. (1975) 'Henri Gaudier's "Three Ninas"', *Paideuma* 4.2/3 (Fall and Winter), 323–4.

——, ed. (1991) *The Selected Letters of Ezra Pound to John Quinn: 1915–1924*, Durham, NC and London: Duke University Press.

Mayo Roos, J. (1986) 'Rodin's Monument to Victor Hugo: Art and Politics in the Third Republic', *Art Bulletin* 68.4 (December 1986), 632–56.

—— (1998) *Rodin's Monument to Victor Hugo*, London: Merrell Holberton.

Mazza, R. (2022) 'Narratives of Discovery: Petrie, Grenfell and Hunt, and the First Finding of the Oxyrhynchus Papyri', *Bulletin of the American Society of Papyrologists* 59, 221–58.

—— (2021) 'Descriptions and the Materiality of Texts', *Qualitative Research* 21.3, 376–93.

Mellor, L. (2011) *Reading the Ruins: Modernism, Bombsites and British Culture*, Cambridge: Cambridge University Press.

Merry, M. M. and Riddell, J., eds (1886) *Homer's Odyssey: Books i–xii*, Oxford: Clarendon.

Meyer, D. (1993) 'Die Einbeziehung des Lesers in den Epigrammen des Kallimachos', in M. A. Harder, R. F. Regtuit, and G. C. Wakker, eds, *Callimachus*, Groningen: Egbert Forsten, 161–75.

Michaelis, A. (1908) *A Century of Archaeological Discoveries*, B. Kahnweiler, trans., London: J. Murray.

Michel, W. (1971) *Wyndham Lewis: Paintings and Drawings*, London: Thames & Hudson.

Miller, J. E. (1977) *T. S. Eliot's Personal Waste Land: Exorcism of the Demons*, Philadelphia, PA: Pennsylvania State University Press.

—— (2005) *T. S. Eliot: The Making of an American Poet*, Philadelphia, PA: Pennsylvania State University Press.

Mills, J. (2014) *Virginia Woolf, Jane Ellen Harrison, and the Spirit of Modernist Classicism*, Columbus, OH: Ohio State University Press.

206 BIBLIOGRAPHY

Mitchell, C., ed. (2004) *Rodin, the Zola of Sculpture*, Aldershot: Ashgate.

Momigliano, N. (1999) *Duncan Mackenzie: A Cautious Canny Highlander and the Palace of Minos at Knossos, BICS Supplement 72*, London.

—— (2020) *In Search of the Labyrinth: The Cultural Legacy of Minoan Crete*, London: Bloomsbury Academic.

Momigliano, N. and F. Farnoux, eds (2017) *Cretomania: Modern Desires for the Minoan Past*, Abingdon: Routledge.

Monroe, H. (1926) *Poets and Their Art*, New York: Macmillan.

Montserrat, D. (2007) 'News Reports: The Excavations and Their Journalistic Coverage', in Bowman et al. (2007), 23–39.

Moody, A. David (2007) *Ezra Pound: Poet. A Portrait of the Man and His Work. Volume 1. The Young Genius 1885–1920*, Oxford: Oxford University Press.

Moody, A. and S. Ross, eds (2020) *Global Modernists on Modernism: An Anthology*, London: Bloomsbury Academic.

Moore, C. H. (1904) 'The Oxyrhynchus Epitome of Livy in Relation to Obsequens and Cassiodorus', *American Journal of Philology* 25.3, 241–55.

Morris, C. (2017) 'Lord of the Dance: Ted Shawn's *Gnossienne* and Its Minoan Context', in Momigliano and Farnoux (2017), 111–23.

Most, G., ed. (1997) *Collecting Fragments/Fragmente sammeln*, Göttingen: Vandenhoeck & Ruprecht.

—— (1998) 'À la recherche du texte perdu: On Collecting Philosophical Fragments', in W. Burkert, M. L. Gemelli Marciano, E. Matelli, and L. Orelli, eds, *Fragmentsammlungen philosophischer Texte der Antike/Le raccolte dei frammenti di filosofi antichi*, Göttingen: Vandenhoeck & Ruprecht, 1–15.

—— (2009) 'On Fragments', in Tronzo (2009), 9–20.

—— (2010) 'Fragments', in A. Grafton, G. Most, and S. Settis, eds, *The Classical Tradition*, Cambridge, MA: Harvard University Press, 371–7.

—— (2011) 'Sehnsucht nach Unversehrtem. Überlegungen zu Fragmenten und deren Sammlern', in P. Kelemen, E. K. Szabó, and Á. Tamás, eds, *Kulturtechnik Philologie. Zur Theorie des Umgangs mit Texten*, Heidelberg: Winter, 27–43.

Müller, K., ed. (2003) *Petronii Arbitri Satyricon Reliquiae*, Munich and Leipzig: Saur.

Munich, A. (2004) 'Family Matters: Genealogies and Intertexts in Amy Lowell's "The Sisters"', in A. Munich and M. Bradshaw, eds, *Amy Lowell, American Modern*, Piscataway, NJ: Rutgers University Press, 9–26.

Murray, G. (1907) *The Rise of the Greek Epic*, Oxford: Clarendon Press.

Myers, M. (2006) 'Ezra Pound Me Fecit: Memorial Object and Autonomous Poem in the *The Cantos*', *Paideuma*, 35.3, 67–92.

Nagy, G. (2010) 'Poetics of Fragmentation in the Athyr Poem of C. P. Cavafy', in Panagiotis Roilos, ed., *Imagination and Logos: Essays on C. P. Cavafy*, Cambridge, MA: Harvard University Press, 265–72.

Neils, J. (2003) Review of Jenkins (2001), *American Journal of Archaeology* 107.3, 507–9.

Netz, R. (2020) *Scale, Space and Canon in Ancient Literary Culture*, Cambridge: Cambridge University Press.

Neumann, P. (1984) 'Rilkes "Archaischer Torso Apollos" in der Geschichte des modernen Fragmentarismus', in Dällenbach and Hart Nibbrig (1984), 257–74.

Newhouse, V. (2005) *Art and the Power of Placement*, New York: Monacelli.

Nisbet, G. (2003) *Greek Epigram in the Roman Empire: Martial's Forgotten Rivals*, Oxford: Oxford University Press.

—— (2013) G. Nisbet *Greek Epigram in Reception: J. A. Symonds, Oscar Wilde, and the Invention of Desire, 1805–1929*, Oxford: Oxford University Press.

—— (2014) 'Epigrams: The Classical Tradition', in P. Ford, J. Bloemendal, and C. Fantuzzi, eds, *Brill's Encyclopaedia of the Neo-Latin World*, Leiden: Brill, 379–86.

Nochlin, L. (1994) *The Body in Pieces: The Fragment as a Metaphor of Modernity*, London: Thames & Hudson.

Nongbri, B. (2018) *God's Library: The Archaeology of the Earliest Christian Manuscripts*, New Haven: Yale University Press.

Norman, C. (1972) *E. E. Cummings: The Magic-Maker*, New York: Bobbe-Merrill [1st edn, 1958].

Norsa, M. (1937) 'Versi di Saffo in un ostrakon del sec. II a. C.', *Annali della Reale Scuola Normale Superiore di Pisa*, 2nd ser. 6, 8–15.

—— (1953) '1300. Dal primo libro di Saffo', *Papiri Greci e Latini* 13, 44–50.

Obbink, D. (2011) 'Vanishing Conjecture: Lost Books and their Recovery from Aristotle to Eco', in D. Obbink and R. Rutherford, eds, *Culture in Pieces: Essays on Ancient Texts in Honour of Peter Parsons*, Oxford: Oxford University Press, 20–49.

O'Keefe, P. (2004) *Gaudier Brzeska: An Absolute Case of Genius*, London: Allen Lane.

Orban, C. (1997) *The Culture of Fragments: Words and Images in Futurism and Surrealism*, Amsterdam: Rodopi.

Orrells, D. (2012) 'Headlam's Herodas: The Art of Suggestion', in S. J. Harrison and C. Stray, eds, *Expurgating the Classics*, London: Bloomsbury Academic, 53–72.

Ostermann, E. (1991) *Das Fragment. Geschichte einer ästhetischen Idee*, Munich: Fink.

Pachet, P. (2011) *Du fragment*, Paris: Éditions Ophrys.

Page, D. L., ed. (1941) *Select Papyri*, Vol. 3, Cambridge, MA: Harvard University Press.

—— (1955) *The Homeric Odyssey*, Oxford: Clarendon Press.

——, ed. (1982) *Further Greek Epigrams*, Cambridge: Cambridge University Press.

Panagiotaki, M. (2004) 'Knossos and Evans: Buying Kephala', in G. Cadogan, E. Hatzaki, and V. Vasilakis, eds, *Knossos: Palace, City, State, British School at Athens Classical Studies* 12, London: British School at Athens, 513–36.

Pandermalis, D. et al. (2013) *The New Acropolis Museum*, New York: Skira Rizzoli.

Papadopoulos, J. K. (1997) 'Knossos', in M. de la Torre, ed., *The Conservation of Archaeological Sites in the Mediterranean Region*, Los Angeles: Getty Conservation Institute, 93–125.

Park, J. (2019) 'The Transnational Turn', in M. Byron, ed., *The New Ezra Pound Studies*, Cambridge: Cambridge University Press, 181–95.

Parkyn, L. (2022) 'The Originality and Influence of Tony Harrison's *The Trackers of Oxyrhynchus*', in S. Byrne, ed., *Tony Harrison and the Classics*, Oxford: Oxford University Press, 117–34.

Parmar, S., ed. (2011) *Hope Mirrlees: Collected Poems*, Manchester: Carcanet.

Parsons, P. (2007) *City of the Sharp-Nosed Fish: Greek Papyri beneath the Egyptian Sand Reveal a Long-Lost World*, London: Phoenix.

Paul, C. E. (2002) *Poetry in the Museums of Modernism: Yeats, Pound, Moore, Stein*, Ann Arbor, MI: University of Michigan Press.

Paul, J. (2009) 'Fellini-Satyricon: Petronius and Film', in J. R. W. Prag and I. D. Repath, eds, *Petronius: A Handbook*, Oxford: Wiley Blackwell, 198–217.

Payne, E. M. (2021) *Casting the Parthenon Sculptures from the Eighteenth Century to the Digital Age*, London: Bloomsbury Academic.

Pearson, M. and M. Shanks (2001) *Theatre/Archaeology*, London: Routledge.

208 BIBLIOGRAPHY

Peddie, R. A. (1912) *The British Museum Reading Room: A Handbook for Students*, London: Grafton and Co.

Perloff, M. (1986) *The Futurist Movement: Avant-garde, avant-guerre, and the Language of Rupture*, Chicago, IL: University of Chicago Press.

Petzl, G. (1969) *Antike Diskussionen über die beiden Nekyiai*, Meisenheim am Glan: Hain.

Picard, P., ed. (2013) *Rodin, La lumière de l'antique*, Paris: Beaux arts éditions.

Pinelli, O. R. (2003) 'From the Need for Completion to the Cult of the Fragment: How Tastes, Scholarship, and Museum Curators' Choices Changed our View of Ancient Sculpture', in Grossman, Podany, and True (2003), 61–74.

Pingeot, A., ed. (1990) *Le Corps en morceaux*, Paris: Éditions de la Réunion des musées nationaux.

Pintaudi, R. (2012) 'Grenfell-Hunt e la papirologia in Italia', *Quaderni di storia* 75, 205–98.

Piperno, M. (2020) *L'antichità 'crudele'. Etruschi e italici nella letteratura italiana del Novecento*, Rome: Carocci.

Podany, J. (2003) 'Lessons from the Past', in Grossman, Podany, and True (2003), 13–24.

Pondrom, C. (1985) 'H. D. and the Origins of Imagism', *Sagetrieb* 4, 73–97

Postclassicisms Collective (2020) *Postclassicisms*, Chicago, IL: University of Chicago Press.

Pound, E. (1916) *Lustra of Ezra Pound*, London: Elkin Mathews (September 1916).

—— (1920) *Hugh Selwyn Mauberley*, London: Ovid Press.

—— (1925) *A Draft of XVI Cantos of Ezra Pound*, Paris: Three Mountains Press.

—— (1952) *Guide to Kulchur*, London.

—— (1977) *Collected Early Poems of Ezra Pound*, ed. M. J. King, London [1st edn. 1926].

—— (2005) *Early Writings: Poems and Prose*, ed. I. B. Nadel, London: Penguin.

Pound, O. and A. W. Litz, eds (1984) *Ezra Pound and Dorothy Shakespear: Their Letters 1909-1914*, London: Faber & Faber.

Prent, M. (2003) 'Glories of the Past in the Past: Ritual Activity at Palatial Ruins in Early Iron Age Crete', in R. M. Van Dyke and S. E. Alcock, eds, *Archaeologies of Memory*, Malden, MA: Blackwell, 81–103.

Prettejohn, E. (2006) 'Reception and Ancient Art: The Case of the Venus de Milo', in C. Martindale and R. F. Thomas, eds, *Classics and the Uses of Reception*, Malden, MA and Oxford: Blackwell, 227–49.

—— (2007) *Art for Art's Sake: Aestheticism in Victorian Painting*, New Haven, CT: Yale University Press.

—— (2008) 'Solomon, Swinburne, Sappho', *Victorian Review* 34.2, 103–28.

—— (2012) *The Modernity of Ancient Sculpture: Greek Sculpture and Modern Art from Winckelmann to Picasso*, London: I. B. Tauris.

Prins, Y. (1997) 'Sappho's Afterlife in Translation', in E. Greene, ed., *Re-Reading Sappho: Reception and Transmission*, Berkeley, CA: University of California Press, 36–67.

—— (1999) *Victorian Sappho*, Princeton, NJ: Princeton University Press.

—— (2005) 'OTOTOTOI: Virginia Woolf and "The Naked Cry" of Cassandra', in F. Macintosh, P. Michelakis, and O. Taplin, eds, *Agamemnon in Performance 458 B.C. to 2004 A.D.*, Oxford: Oxford University Press, 163–87.

Pryce, F. N. (1913) *A Guide to the Collection of Casts in the Department of Greek and Roman Antiquities in the British Museum*, London: Trustees of the British Museum.

Pryor, S. (2016) 'Inhuman Words: Philology, Modernism, Poetry', *Modernism/Modernity* 23.3, 555–71.

Quartermain, P. (1998) '"The Tattle of Tongue-play": Mina Loy's *Love Songs*', in M. Shreiber and K. Tuma, eds, *Mina Loy: Woman and Poet*, Orono, ME: National Poetry Foundation, 75–85.

Qian, Z. (2003) *The Modernist Response to Chinese Art: Pound, Moore, Stevens*, Charlottesville, VA: University Press of Virginia.

Radford, A. (2007) *The Lost Girls: Demeter-Persephone and the Literary Imagination, 1850–1930*, Amsterdam: Rodopi.

Rainey, L. S. ed. (2006) *The Annotated Waste Land with Eliot's Contemporary Prose*, New Haven, CT: Yale University Press.

Raphael, R. (2014) 'In English Accents', *Times Literary Supplement*, 30 May, No. 5800, pp.3–5.

Rather, S. (1993) *Archaism, Modernism, and the Art of Paul Manship*, Austin, TX: University of Texas Press.

Rawles, R. (2018) 'Simonides on Tombs and the "Tomb of Simonides"', in *Tombs of the Ancient Poets: Between Literary Reception and Material Culture*, N. Goldschmidt and B. Graziosi, eds, Oxford: Oxford University Press, 51–68.

Rea, W. R. (2011) 'Shared Sites and Misleading Affinities: Sculpture as Archaeology and Archaeology as Sculpture', in Bonaventura and Jones (2011), 19–30.

Reckford, K. (1995–6a) 'Recognizing Venus (I): Aeneas Meets His Mother', *Arion* 3.2/3, 1–42.

—— (1995–6b) 'Recognizing Venus (II): Dido, Aeneas, and Mr. Eliot', *Arion* 3.2/3, 43–80.

Rees Leahy, H. (2011) 'Fix'd statue on the pedestal of Scorn': The Politics and Poetics of Displaying the Parthenon Marbles in Athens and London', in Bonaventura and Jones (2011), 179–96.

—— (2012) *Museum Bodies: Politics and Practices of Visiting and Viewing*, Farnham: Ashgate.

Reeves, G. (1989) *T. S. Eliot: A Virgilian Poet*, Basingstoke and London: Palgrave Macmillan.

Regier, A. (2010) *Fracture and Fragmentation in British Romanticism*, Cambridge: Cambridge University Press.

Reibetanz, J. M. (1983) *A Reading of Eliot's Four Quartets*, Ann Arbor, MI: UMI Research Press.

Reid, B. L. (1968) *The Man from New York: John Quinn and His Friends*, New York: Oxford University Press.

Reitlinger, G. (1963) *The Economics of Taste*, Vol. 2, *The Rise and Fall of the Object d'Arts Market since 1750*, New York: Holt, Rinehart & Winston.

Reynolds, M. (2000) *The Sappho Companion*, London: Chatto & Windus.

Ricks, C. and J. McCue, eds (2015) *The Poems of T. S. Eliot*, 2 vols, London: Faber & Faber.

Ricks, D. (2007) '"A faint sweetness in the never-ending afternoon'?: Reflections on Cavafy and Greek Epigram', *ΚΑΜΠΟΣ: Cambridge Papers in Modern Greek*, 15, 149–69.

Ridgway, B. S. (2000) *Hellenistic Sculpture II, The Styles of ca. 200–100 B.C.*, Madison, WI: University of Wisconsin Press.

Richardson, J. (2007) *A Life of Picasso: The Triumphant Years, 1917–1932*, London: Jonathan Cape.

Richter, G. M. A. (1929) *The Sculpture and Sculptors of the Greeks*, New Haven: Yale University Press.

—— (1970) *Kouroi, Archaic Greek Youths: A Study of the Development of the Kouros Type in Archaic Greek Sculpture*, 3rd edn, with I. A. Richter, London and New York: Phaidon.

Riegl, A. (1903) 'Der modern Denkmalkultus, sein Wesen, seine Entstehung' = The Modern Cult of Monuments: Its Character and Its Origin', K. Forster and D. Ghirardo, trans., *Oppositions* 25 (1982), 21–51.

Riggs, C. (2020) 'Archaeology and Photography', in G. Pasternak, ed., *The Handbook of Photography Studies*, London and New York: Routledge, 187–206.

210 BIBLIOGRAPHY

Riikonen, H. K. (2008) 'Ezra Pound and the Greek Anthology', *Quaderni di Palazzo Serra* 15, 181–94.

Rimell, V. (2002) *Petronius and the Anatomy of Fiction*, Cambridge: Cambridge University Press.

Riobó, C. (2002) 'The Spirit of Ezra Pound's Romance Philology: Dante's Ironic Legacy of the Contingencies of Value', *Comparative Literature Studies* 39.3, 201–22.

Ripoll, R., ed. (2001) *L'écriture fragmentaire. Théories et pratiques*, Perpignan: Presses universitaires de Perpignan.

Rivière, G.-H. (1926) 'Archaeologisms', *Cahiers d'art* 1.7, 177, trans. M. Tiews, *Modernism/Modernity*, 11.1, January 2004, 179–80; originally published in French as 'Archéologisme' in *Cahiers D'Art* 1.7 (1926), 177.

Rodin, A. (1905) 'Le Parthénon et les Cathédrales', *Le Musée: revue d'art antique* 2.1, 66–8.

Robinson, F. C. (1993) 'Ezra Pound and the Old English Translational Tradition', in F. C. Robinson, ed., *The Tomb of Beowulf and Other Essays on Old English*, Cambridge, MA and Oxford: Blackwell, 259–74.

Roessel, D. and V. Conover (2012) 'Introduction: Two Unpublished Stories by H. D.: "Hesperia" and "Aegina"', *Paideuma*, 39, 3–16.

Rohrbach, E. (1996) 'H. D. and Sappho: "A Precious Inch of Palimpsest"', in E. Greene, ed., *Re-reading Sappho: Reception and Transmission*, Berkeley, CA: University of California Press, 184–98.

Rollyson, C. (2013) *Amy Lowell Anew: A Biography*, Lanham, MD: Rowman & Littlefield.

Rosenblitt, A. (2016) *E. E. Cummings' Modernism and the Classics: Each Imperishable Stanza*, Oxford: Oxford University Press.

Root, O. (1898) 'Merit Register, Classes of 1897–1907', MS, Hamilton College.

Rosenberg, J. E. (2021) *Wastepaper Modernism: Twentieth-Century Fiction and the Ruins of Print*, Oxford: Oxford University Press.

Rothenberg, J. (1977) *Descensus ad terram: The Acquisition and Reception of the Elgin Marbles*, New York: Garland.

Rouse, W. H. D. (1901) 'The Double Axe and the Labyrinth', *Journal of Hellenic Studies* 21, 268–74.

Runia, D. T. (2008) 'The Sources for Presocratic Philosophy', in P. Curd and D. Graham, eds, *The Oxford Handbook of Presocratic Philosophy*, Oxford: Oxford University Press, 27–54.

Rumpf, A. (1953) *Archäologie. I Einleitung, Historischer Überblick*, Berlin: De Gruyter.

Ruthven, K. K. (1969) *A Guide to Ezra Pound's Personae*, Berkeley, CA: University of California Press [first edn 1926].

Ryan, M. J., trans. (1905) *Petronius: Cena Trimalchionis*, New York: Walter Scott.

Sampson, P. M. (2020) 'Deconstructing the Provenances of P.Sapp. Obbink', *Bulletin of the Society of American Papyrologists* 57, 143–69.

Sampson, P. M. and Uhlig, A. (2019) 'The Murky Provenance of the Newest Sappho', *Eidolon* <https://eidolon.pub/the-murky-provenance-of-the-newest-sappho-aca671a6d52a>

Schleiermacher, F. (1807) 'Herakleitos der Dunkle von Ephesos, dargestellt aus den Trümmern seines Werkes und den Zeugnissen der Alten', in F. A. Wolf and P. Buttmann, eds, *Museum der Altertumswissenschaft*, Vol. 1, 315–533, Berlin: Realschulbuchhandlung.

Schmeling, G. R. (2011) *A Commentary on the Satyrica of Petronius*, Oxford: Oxford University Press.

BIBLIOGRAPHY 211

———, ed. and trans. (2020) *Petronius: Satyricon, Seneca: Apocolocyntosis*, Cambridge, MA: Harvard University Press.

Schmeling, G. L. and Rebmann, D. R. (1975) 'T. S. Eliot and Petronius', *Comparative Literature Studies* 12.4, 393–410.

Schmidt, H. (1993) *Wiederaufbau. Denkmalpflege an archäologischen Stätten* 2, Stuttgart: Theiss.

Schnapp. J. T., M. Shanks, and M. Tiews, eds (2004) *Archaeologies of the Modern, Modernism/Modernity* 11.1, January 2004.

Schoenberg, A. (1967) *Fundamentals of Musical Composition*, G. Strang and L. Stein, eds, London: Faber & Faber.

Schork, R. J. (1998) *Greek and Hellenic Culture in Joyce*, Gainesville, FL: University Press of Florida.

——— (2008) 'The Singular Circumstance of an Errant Papyrus', *Arion* 16.2, 25–47.

Schubart, W. (1902) 'Neue Bruchstücke der Sappho und des Alkaios', *Sitzungsberichte der Königlich Preussischen Akademie der Wissenschaften zu Berlin*, Berlin, 195–209.

Schubart, W. and U. von Wilamowitz-Moellendorff, eds (1907) *Lyrische und dramatische Fragmente*, Berlin: Weidmann.

Schwartz, R. L. (1988) '"Broken Images": A Study of "The Waste Land"', Lewisburg, PA: Bucknell University Press.

Schweighäuser, J. (1804) *Athenaei Naucratitae Deipnosophistarum libri quindecim*, Zweibrücken: Typographia Societatis Bipontinae.

Scroggins, M. (2015) *Intricate Thicket: Reading Late Modernist Poetries*, Tuscaloosa, AL: University of Alabama Press.

Secrest, M. (2005) *Duveen: A Life in Art*, Chicago, IL: University of Chicago Press.

Seelbach, W. (1970) 'Ezra Pound und Sappho fr. 95 L.-P.', *Antike und Abendland* 16.1, 83–4.

Shapland, A. (2023) *Labyrinth: Knossos Myth and Reality*, Oxford: Ashmolean Museum.

Sharp, D. (2007) 'The Greenside Case: Another One Bites the Dust', in S. Macdonald, K. Normandin, and B. Kindred, eds, *Conservation of Modern Architecture*, Shaftesbury: Donhead, 117–30.

Sherratt, S. (2009) 'Representations of Knossos and Minoan Crete in the British, American and Continental Press, 1900–c.1930', *Creta Antica* 10/11, 619–49.

Siegel, J. (2015) 'Art, Aesthetics, and Archaeological Poetics', in N. Vance and J. Wallace, eds, *The Oxford History of Classical Reception in English Literature*, Vol. 4, Oxford: Oxford University Press, 203–41.

Silber, E. (1986) *The Sculpture of Epstein*, London and New York: Phaidon.

——— (1996) *Gaudier-Brzeska: Life and Art*, London: Thames & Hudson.

Silver, K. E., ed. (2010) *Chaos and Classicism: Art in France, Italy, and Germany, 1918–1936*, New York: Guggenheim Museum.

Simandiraki-Grimshaw, A. and F. Stevens (2013) 'Destroying the Snake Godessess: A Re-examination of Figurine Fragmentation at the Temple Repositories of the Palace of Knossos', in J. Driessen, ed., *Destruction: Archaeological, Philological and Historical Perspectives*, Louvain-La-Neuve: Presses Universitaires de Louvain, 153–70.

Skaff, W. (1986) *The Philosophy of T. S. Eliot: From Skepticism to Surrealist Poetic, 1909–1927*, Philadelphia, PA: University of Pennsylvania Press.

Skinner, M. (1989) 'Sapphic Nossis', *Arethusa* 22.1, 5–18.

Slater, N. W. (2009) 'Reading the *Satyrica*', in J. Prag and I. Repath (2009), 16–31.

Smith, A. H. (1892) *A Catalogue of Sculpture in the Department of Greek and Roman Antiquities, British Museum*, Vol. 1, London: Trustees of the British Museum.

212 BIBLIOGRAPHY

—— (1904) *A Catalogue of Sculpture in the Department of Greek and Roman Antiquities, British Museum*, Vol. 3, London: Trustees of the British Museum.

—— (1908) *A Guide to the Sculptures of the Parthenon in the British Museum*, revised by C. H. Smith, London: Trustees of the British Museum.

—— (1912) *A Guide to the Department of Greek and Roman Antiquities in the British Museum*, London: Trustees of the British Museum.

—— (1917) *Guide to the Select Greek and Roman Inscriptions Exhibited in the Department of Greek and Roman Antiquities in the British Museum*, London: Trustees of the British Museum.

Smith, C. H. (1963) *T. S. Eliot's Dramatic Theory and Practice: From* Sweeney Agonistes *to the Elder Statesman*, Princeton, NJ: Princeton University Press.

Smith, G. (1974) *T. S. Eliot's Poetry and Plays: A Study in Sources and Meaning*, 2nd edn, Chicago, IL: University of Chicago Press.

Smith, S. (1994) *The Origins of Modernism: Eliot, Pound, Yeats and the Rhetoric of Renewal*, Hemel Hempstead: Harvester Wheatsheaf.

Smyers, V. L. (1990) '"Classical" Books in the Bryher Library', *H. D. Newsletter* 3.1, 15–25.

Snyder, J. M. (1997) *Lesbian Desire in the Lyrics of Sappho*, New York: Columbia University Press.

Sojer, S. (2021) 'Fragmente—Fragmentkunde—Fragmentforschung', *Bibliothek Forschung und Praxis* 45.3, 533–53.

Sorrentino, A. (1950) *Il frammentismo nella letteratura Italiana del novecento*, Rome: Azienda.

Sourvinou-Inwood, C. (1995) *'Reading' Greek Death: To the End of the Classical Period*, Oxford: Clarendon.

Spalding, F. (1998) *The Tate: A History*, London: Tate Gallery Publishing.

Spears Brooker, J., ed. (2004) *T. S. Eliot: The Contemporary Reviews*, Cambridge: Cambridge University Press.

Spooner, J. (2002) *Nine Homeric Papyri from Oxyrhynchus*, Florence: Istituto papirologico G. Vitelli.

Squire, M. J., J. Cahill, and R. Allen, eds. (2018) *The Classical Now*, London: Elephant Publishing.

Stansky, P. (1996) *On or about December 1910: Early Bloomsbury and Its Intimate World*, Cambridge, MA: Harvard University Press.

St. Clair, W. (1998) *Lord Elgin and the Marbles: The Controversial History of the Parthenon Sculptures*, Oxford: Oxford University Press.

—— (2022) *Who Saved the Parthenon?: A New History of the Acropolis Before, During and after the Greek Revolution*, Cambridge: Open Book.

Steinberg, L. (1972) *Other Criteria: Confrontations with Twentieth-Century Art*, New York: Oxford University Press.

Steiner, G. (1984) 'Das totale Fragment', in Dällenbach and Hart Nibbrig (1984), 18–29.

Stevens, H. (1977) *Souvenirs and Prophecies: The Young Wallace Stevens*, New York: Alfred Knopf.

Stevenson, A. E. (2015) 'Egyptian Archaeology and the Museum', in C. Godsen, ed., *Oxford Handbook of Topics in Archaeoligy* (online), Oxford Academic, DOI: 10.1093/oxfordhb/9780199935413.013.25.

—— (2019) *Scattered Finds: Archaeology, Egyptology and Museums*, London: UCL Press.

Stoicheff, P. (1995) *The Hall of Mirrors: Drafts and Fragments and the End of Ezra Pound's Cantos*, Ann Arbor, MI: University of Michigan Press.

Stoppard, T. (1997) *The Invention of Love*, London: Faber & Faber.

BIBLIOGRAPHY 213

Strack, F. and Eicheldinger, M., eds (2011) *Fragmente der Frühromantik. Edition und Kommentar*, Berlin: De Gruyter.

Strathman, C. (2006) *Romantic Poetry and the Fragmentary Imperative: Schlegel, Byron, Joyce, Blanchot*, Albany, NY: State University of New York Press.

Stray, C. (2003a) *Promoting and Defending: Reflections on the History of the Hellenic Society (1879) and the Classical Association (1903)*, London: The Classical Association.

——— (2003b) *The Classical Association: The First Century 1903–2003*, Oxford: Oxford University Press.

———, ed. (2007) *Gilbert Murray Reassessed: Hellenism, Theatre, and International Politics*, Oxford: Oxford University Press.

Sullivan, J. P. (1968) *The Satyricon of Petronius: A Literary Study*, Bloomington, IN: Indiana University Press.

Sullivan, H. (2011) 'Classics', in J. Harding, ed., *T. S. Eliot in Context*, Cambridge: Cambridge University Press, 160–79.

Susini-Anastopoulos, F. (1997) *L'écriture fragmentaire. Définitions et enjeux*, Paris: Presses Universitaires de France.

Svensson, L. H. (2003) 'Modernism and the Classical Tradition: The Examples of Pound and H. D.', in M. Thormählen, ed., *Rethinking Modernism*, Basingstoke: Palgrave, 112–31.

Swann, T. B. (1962) *The Classical World of H. D.*, Lincoln, NE: University of Nebraska Press.

Symonds, J. A. (1873) *Studies of the Greek Poets*, London: Smith, Elder & Co.

Taxidou, O. (2021) *Greek Tragedy and Modernist Performance: Hellenism as Theatricality*, Edinburgh: Edinburgh University Press.

Taylor, R. D. (1997) 'The History and State of the Texts', in L. S. Rainey, ed., *A Poem Containing History: Textual Studies in the Cantos*, Ann Arbor, MI: University of Michigan Press, 235–66.

Tearle, O. (2019) *The Great War, The Waste Land and the Modernist Long Poem*, London: Bloomsbury Academic.

Terrell, C. (1980) *A Companion to The Cantos of Ezra Pound*, Berkeley, CA: California University Press.

Tröndle, M., S. Wintzerith, R. Wäspe, and W. Tschacher (2012) 'A Museum for the Twenty-First Century: The Influence of "Sociality" on Art Reception in Museum Space', *Museum Management and Curatorship*, 27.5, 461–86.

Thatcher, D. S., ed. (1970) 'Richard Aldington's Letters to Herbert Read', *Malahat Review* 15, 5–44.

Thomas, J. (2004) *Archaeology and Modernity*, London and New York: Routledge.

Thomas, S. (2008) *Romanticism and Visuality: Fragments, History, Spectacle*, New York and London: Routledge.

Thompson, M. W. (1981) *Ruins: Their Preservation and Display*, London: British Museum Publications.

Thomson, J. A. K. (1914) *Studies in the Odyssey*, Oxford: Clarendon.

Thornton, A. (2015) 'Exhibition Season: Annual Archaeological Exhibitions in London, 1880s–1930s', *Bulletin of the History of Archaeology* 25.2, 1–18.

Tickner, L. (1993) 'Now and Then: The Hieratic Head of Ezra Pound', *Oxford Art Journal*, 16.2, 55–61.

Timpanaro, S. (2005) *The Genesis of Lachmann's Method*, trans. G. Most, Chicago, IL: Chicago University Press [*La genesi del metodo del Lachmann*, 2nd edn, Padova, 1981].

Tobias, R. (2006) *The Discourse of Nature in the Poetry of Paul Celan: The Unnatural World*, Baltimore, MD: Johns Hopkins University Press.

214 BIBLIOGRAPHY

Toner, A. (2015) *Ellipsis in English Literature: Signs of Omission*, Cambridge: Cambridge University Press.

Tracy, D. (2020) *Fragments: The Existential Situation of Our Time: Selected Essays*, Vol. 1, Chicago, IL: University of Chicago Press.

Tronzo, W., ed. (2009) *The Fragment: An Incomplete History*, Los Angeles, CA: Getty Publications.

Trotter, D. (2000) *Cooking with Mud: The Idea of Mess in Nineteenth-Century Art and Fiction*, Oxford: Oxford University Press.

—— (2001) *Paranoid Modernism: Literary Experiment, Psychosis, and the Professionalization of English Society*, Oxford: Oxford University Press.

True, M. (2003) 'Changing Approaches to Conservation', in Grossman, Podany, and True (2003), 1–11.

Tsirgialou, A. (2015) 'Photographing Greece in the Nineteenth Century', in P. Carabott, Y. Hamilakis, and E. Papargyriou, eds, *Camera Graeca: Photographs, Narratives, Materialities*, Farnham: Ashgate, 77–93.

Turner, E. G. (1980) *Greek Papyri: An Introduction*, 2nd edn, Oxford: Oxford University Press.

—— (2007) 'The Graeco-Roman Branch of the Egypt Exploration Society', in Bowman et al. (2007), 17–27.

Turner, F. (1997) 'The Homeric Question', in I. Morris and B. Powell, eds, *A New Companion to Homer*, Leiden: Brill, 123–45.

Tytell, J. (1981) 'Epiphany in Chaos: Fragmentation in Modernism', in Kritzman and Plottel (1981), 3–15.

Tzouvelēs, S. (2016) *The Greek Poet Cavafy and History*, Newcastle upon Tyne: Cambridge Scholars.

Ullyot, J. (2017) 'Ezra Pound's Medieval Classicism: The Spirit of Romance and the Debt to Philology', in S. Marshall and C. M. Cusack, eds, *The Medieval Presence in the Modernist Aesthetic: Unattended Moments*, Leiden: Brill, 43–61.

Unger, L. (1961) *T. S. Eliot*, Minneapolis, MN: University of Minnesota Press.

Vandiver, E. (2019) '"Seeking...Buried Beauty": The Poets' Translation Series', in Hickman and Kozak (2019), 7–18.

Van Minnen, P. (1993) 'The Century of Papyrology (1892–1992)', *Bulletin of the American Society of Papyrologists*, 30.1/2, 5–18.

—— (2009) 'The Future of Papyrology', in R. S. Bagnall, ed., *The Oxford Handbook of Papyrology*, Oxford: Oxford University Press, 644–60.

Vannini, G., ed. (2010) *Petronii Arbitri 'Satyricon' 100–115, Edizione critica e commento. Beiträge zur Altertumskunde*, Vol. 281, Berlin and New York: De Gruyter.

Varia, R. (1986) *Brancusi*, New York: Rizzoli.

Varley-Winter, R. (2018) *Reading Fragments and Fragmentation in Modernist Literature*, Brighton: Sussex Academic.

Varney, J. (2010) 'The "Wobbling" Translation: H. D. and the Transmission of the Classics', *Translator* 16.1, 1–18.

Vetter, L. (2003) 'Representing "a Sort of Composite Person": Autobiography, Sexuality, and Collaborative Authorship in H. D.'s Prose and Scrapbook', *Genre* 36.1–2, 107–29.

Vickery, J. B. (1973) *The Literary Impact of the Golden Bough*, Princeton, NJ: Princeton University Press.

Vout, C. (2018) *Classical Art: A Life History from Antiquity to the Present*, Princeton, NJ: Princeton University Press.

BIBLIOGRAPHY 215

Wagner, A. (1993) 'Rodin's Reputation', in L. Hunt, ed., *Eroticism and the Body Politic*, Baltimore, MD: Johns Hopkins University Press, 191–242.

Walker, C. (1991) *Masks Outrageous and Austere: Culture, Psyche, and Persona in Modern Women Poets*, Bloomington, IN: Indiana University Press.

Wanning Harries, E. (1994) *The Unfinished Manner: Essays on the Fragment in the Later Eighteenth Century*, Charlottesville, VA: University Press of Virginia.

Warner, M. (1999) *A Philosophical Study of T. S. Eliot's Four Quartets*, Lewiston and Lampeter: Mellen.

Waugh, E. (1930) *Labels: A Mediterranean Journal*, London: Duckworth.

Waugh, J. (1991) 'Heraclitus: The Postmodern Presocratic?', *Monist* 74.4, 605–23.

Weinstein, A. (2014) 'Fragment and Form in the City of Modernism', in K. McNamara, ed., *The Cambridge Companion to the City in Literature*, Cambridge: Cambridge University Press, 138–52.

Wharton, H. T. (1895) *Sappho: Memoir, Text, Selected Renderings, and a Literal Translation*, London: John Lane, 3rd edn.

Whitaker, G. (2007) '*... brevique adnotatione critica...*: A Preliminary History of the Oxford Classical Texts', in C. Stray, ed., *Classical Books: Scholarship and Publishing in Britain since 1800, Bulletin of the Institute of Classical Studies Supplement*, London, 113–34.

Whitehorne, J. (1995) 'The Pagan Cults of Roman Oxyrhynchus', *ANRW* II.18.5, 3050–91.

Whiteley, G. (2017) 'Pater's Heraclitus: Irony and the Historical Method', in C. Martindale, S. M. Evangelista, and E. Prettejohn, eds, *Pater the Classicist: Classical Scholarship, Reception, and Aestheticism*, Oxford: Oxford University Press, 261–73.

Wilamowitz-Moellendorff, U. von (1884) *Homerische Untersuchungen*, Berlin: Weidmann.

Wilenski, R. H. (1932) *The Meaning of Modern Sculpture*, London: Faber & Faber.

Wilkinson, K. W. (2009) 'Palladas and the Age of Constantine', *Journal of Roman Studies* 99, 36–60.

Wilson, D. (2002) *The British Museum: A History*, London: British Museum Press.

Williams, E. (1977) *Harriet Monroe and the Poetry Renaissance: The First Ten Years of Poetry, 1912–22*, Urbana, IL: University of Illinois Press.

Witemeyer, H., ed. (1996) *Pound/Williams: Selected Letters of Ezra Pound and William Carlos Williams*, New York: New Directions.

Woolf, V. (1993–4) *The Letters of Virginia Woolf*, N. Nicolson and J. Trautmann Banks, eds, 6 vols, London: Hogarth Press.

Worman, N. (2018) *Virginia Woolf's Greek Tragedy*, London: Bloomsbury Academic.

Worthington, J. (1949) 'The Epigraphs to the Poetry of T. S. Eliot', *American Literature* 21.1, 1–17.

Wright, F. A. (1924) *Poets of the Greek Anthology*, London: Routledge.

Wünsche, R. (2011) *Kampf um Troja. 200 Jahre Ägineten in München*, Lindenberg im Allgäu: Fink.

Wyke, M. (1997) *Projecting the Past: Ancient Rome, Cinema, and History*, London and New York: Routledge.

Xiros Cooper, J. (1995) *T. S. Eliot and the Ideology of* Four Quartets, Cambridge: Cambridge University Press.

Yao, S. G. (2019) 'Foreword: The Classics, Modernism and Translation: A Conflicted History', in Hickman and Kozak (2019), xv–xvi.

—— (2002) *Translation and the Languages of Modernism: Gender, Politics, Language*, New York and Basingstoke: Palgrave Macmillan.

216 BIBLIOGRAPHY

Yatromanolakis, D. (2012) *Greek Mythologies: Antiquity and Surrealism*, Cambridge, MA: Harvard University Press.

Yeats, W. B. (1961) *Essays and Introductions*, London and Basingstoke: Palgrave Macmillan.

Zeitlin, F. (1971) 'Petronius as Paradox: Anarchy and Artistic Integrity', *Transactions and Proceedings of the American Philological Association* 102, 631–84.

Zilboorg, C. (1990) 'H. D.'s Influence on Richard Aldington', in C. Doyle, ed., *Richard Aldington: Reappraisals*, Victoria, BC: University of Victoria, 26–44.

—— (1991a) 'Joint Venture: Richard Aldington, H. D. and the Poets' Translation Series', *Philological Quarterly* 70.1, 67–98.

—— (1991b) '"Soul of my soul": A Contextual Reading of H. D.'s *Heliodora*', *Sagetrieb* 10.3, 121–38.

——, ed. (2003) *Richard Aldington & H. D.: Their Lives in Letters, 1918–1961*, Manchester: Manchester University Press.

Zinn, E. (1959) 'Fragment über Fragmente', in J. A. Schmoll (Eisenwerth), ed., *Das Unvollendete als künstlerische Form*, Bern and Munich: Francke, 161–71; 176–8.

Zinnes, P., ed. (1980) *Ezra Pound and the Visual Arts*, New York: New Directions.

Ziolkowski, T. (2008) *Minos and the Moderns: Cretan Myth in Twentieth-Century Literature and Art*, Oxford: Oxford University Press.

—— (2015) *Classicism of the Twenties: Art, Music, and Literature*, Chicago, IL: University of Chicago Press.

Index

For the benefit of digital users, indexed terms that span two pages (e.g., 52–53) may, on occasion, appear on only one of those pages.

Acropolis Museum, Athens 187
'Aegina Marbles' 117, 158, 186
Agathias Scholasticus 108
Albertinum (Dresden) 119–20, 135, 186
Alcaeus 23–5
Aldington, Richard 6, 17–18, 34–5, 48–9,
 75–6, 81–2, 85, 99–100, 109–10, 128–9,
 137–40, 170, 175–6
 and *Poetry Magazine* 84–5
 as a reader in the British Library 17–18, 81–2
 creative relationship with H. D. 99–100
 Poets' Translation Series 34–5, 75–6, 99–100,
 106, 109–11
 use of scholarly editions 48–9
 Works:
 'At the British Museum' 81–2
 '*ΞΟΡΙΚΟΣ*' ('Choricos') 84–5
 'Engraved on a Statue of Aphrodite' 106
 'Stele' 101–2
 'To a Greek Marble' 128–9
 'To Atthis' 18, 35–7, 43n.157
 translations of Anyte of Tegea 34–5, 95–6,
 99–100, 106, 110–11
 translations of Meleager 99–100, 102
 see also: 'H. D.'
Allied Artists Association 140n.130, 156
Alma Tadema 20–1
Antipator of Sidon 95
Anyte of Tegea 14, 85, 92–6, 99–100, 105–6
Apollinaire, Guillaume 144n.142
archaeology 15–16, 151–82
 as the science of the fragment 152–3, 156–7
 and photography 158–9
Archaic Greek sculpture 161–72
Aristophanes 38, 40, 40n.132
Arrowsmith, Rupert Richard 113–14,
 137–40
Asclepiades 102
Ashmole, Bernard 119–20, 124–8, 134–5, 148–9,
 177, 187
Athenaeus 74–5, 104–5
Auden, W. H. 51–2

Bacchylides 19–20
Bakst, Léon 173–4
Balanos, Nikolaos 118–19, 178–80
Balmer, Josephine 183–5
Barnard, Mary 25–6, 45–6, 184–5
Barry, Iris 25–6, 90, 102
Beardsley, Aubrey
 cover design for Wharton's *Sappho* 21–2
 echoed by Pound 22n.26
Beaunier, André 161–4, 168
Beazley, John Davidson 119–20
Bergk, Theodor 20–2, 46–9
Bibliotheca Teubneriana 48–9, 73–4
Blanchot, Maurice 184–5
Blass, Friedrich 18
Blast 140–3
Boni & Liveright 51–2
Bourdelle, Antoine 154–6
Brâncuşi, Constantin 154–6, 164, 171–2, 177
 and Rodin 156
 torso sculptures 154–6
British Library, *see*: 'British Museum, Old
 Reading Room of the British Library'
British Museum 13–14, 78–9, 81–2, 113–50,
 154–6, 158, 187
 'Hall of Greek and Roman Inscriptions'
 13–14, 78, 80–9, 93–4, 100–1, 108–10,
 127–8
 Old Reading Room of the British Library
 13–14, 17–19, 31–4, 64, 78, 103–4, 127–8
 plan of, *fig.* 3.1 82
 sculptures from the Parthenon in 14–15,
 115–27, 187
Brodzky, Horace 137–40
Bryher (Annie Winifred Ellerman) 49n.19,
 99–100, 159–61
Bücheler, Franz 54–6, 62, 75–6

Carson, Anne 42, 183, 185
Casson, Stanley 153–4, 169–70
Cavafy, C. P. 27–8, 34, 77–8, 90
Celan, Paul 60n.86

218 INDEX

Cephalas 102–3
Certeau, Michel de 28–9
Chrétien, Florent (Quintus Septimus Florens
 Christianus) 103–9
Classical Review, The 5 with n.23, 17–19,
 31–4, 37
Claudel, Camille 154–6
Collignon, Albert 55–6
Connell, Amyas 124
Cournos, John 143–4
Cox, Edwin Marion 36–7
Creuzer, Georg Friedrich 46–7
Cummings, E. E.
 copy of Wharton's *Sappho* 26 with n.39
 editions of classical texts used by 48–9
 use of typography 42–3

De Chirico, Giorgio 154
De Jong, Piet 177
Demeter of Cnidus 115–17
derestoration 115–27, 186
Diels, Hermann 26–7, 46–7, 58–66, 75–6
direct carving 156n.27, 168–70
Divus, Andreas 72–4, 104
Doll, Christian 176–7
Duncan, Isadora 173
Duveen, Joseph 120, 126–7, 144–5

Edmonds, J. M. 17–19, 31–4, 36–7, 43–4, 48–9
Egoist, The 34–5, 73–4, 99–100, 137–40,
 143–4, 170–4
Egypt Exploration Fund (later Society) 19–20,
 28–31
 see also: 'The Oxyrhynchus Papyri'
Elgin, Thomas Bruce, Earl of 117 with n.21,
 118–19
Eliot, George 46–7
Eliot, T. S. 6–8, 13–16, 34, 38, 40–3, 46, 50–67,
 75–6, 79, 107–9, 158, 175–6, 180–1
 and Aristophanes 38n.119
 and Mackail 85, 89–99
 classical education at Harvard 38 with n.119,
 55–6, 62
 on archaeology 15–16, 152–3, 157
 on Ezra Pound 8, 107–9, 157
 on Imagism 28–9, 79
 on James Joyce 175–6
 on Sappho 45
 president of the *Classical Association* 112
 publishes Cavafy 77–8
 reader's ticket for the British Library 81–2,
 128–9
 Works:
 'Afternoon' 128–9

Four Quartets 13, 58–66, 90
 epigraph from Diels' *Vorsokratiker* 58–66
 Burnt Norton 58–66
 The Dry Salvages 65–6
 East Coker 46–7, 65–6
 Little Gidding 65–6
 'Fragments' (early poem) 28–9
 'Prufrock' 4–5
 Sweeney Agonistes (= 'Fragments of a Prologue'
 and 'Fragments of an Agon') 38
 The Sacred Wood 54
 The Waste Land 34, 40–3, 46, 50–8, 157, 176
 and the *Greek Anthology* 90, 107–8
 and Ovid 57–8
 and papyrological waste 40–2
 and the *Pervigilium Veneris* 57–8
 and Petroinus 58–66
 and Sappho 40–2, 57–8
 and Virgil 56–8
 'Ulysses, Order, and Myth' 175–6
Elsen, Albert 129–30
epigram 79
 as fragment 79–80, 87–93
 Ergänzungsspiel 93
Epstein, Jacob 14–15, 115–17, 143–9, 156, 171–2
 and Rodin 145–6
 bronze portrait sculptures 144–5
 letters to the *Times* 115–16, 144–5, 148–9
 private collection including Graeco-Roman
 fragments 144 with n.148
 studio of 137–40, 145
 visits the British Museum 144, 146–8
 Works:
 Angel of the Annunciation 145
 Female Figure in Flenite 144
 Girl with a Dove 164–7
 Marble Arms 145–8
 Rock Drill 144
Estiene, Henri (Henricus Stephanus) 104
Evans, Arthur 15–16, 67, 124–6, 151–3,
 172–82

Fellini, Federico 57–8
Firbank, Ronald
 Vainglory and Oxyrhynchus 29–31
Firebaugh, W. C. 51–3
Flint, F. S. 90–1
Forster, E. M. 77–8, 81–2, 128n.74
Fragment
 as fracture 10–12
 as trace/'leavings' (*reliquiae*) 10–13
 definitions of 10–12
 editions of ancient texts in 31–3, 47–66
 epigraphs as 57–8

extracted from citations (indirect transmission) 11–12, 45–9
in the Romantic period 8–9, 118
restoration and derestoration of 115–27, 186
Frazer, James 69–70, 174–6
Freud, Sigmund 40, 158–61, 173–4
Fyfe, Theodore 176–7

Gardner, Percy 116, 146
Gaudier-Brzeska, Henri 6, 14–16, 101–2, 114, 126–7, 135–44, 154–6, 168, 170–1, 173–4, 177
 and Jacob Epstein 137–40, 143–4
 and Rodin 135–6
 direct carving 137–40
 sketches in the British Museum 136
 Works:
 Hieratic Head of Ezra Pound 101–2, 135–6
 Red Stone Dancer 135–6
 torso sculptures (*Torso I, Torso III*) 140–4
 Torso II 141n.133
Gill, Eric 126–7, 169–70
Glyptothek, Munich 117
Greek Anthology
 as an anthology of anthologies 13–14, 36–7, 79–80, 89–100, 102–3, 159–61
 as fragment collection 14
 manuscript tradition of 102–3
 Neo-Latin translation by Chrétien 103–9
 see also: 'Anyte of Tegea', 'Meleager', 'Moero', 'Nicarchus', 'Nossis', 'Palladas', 'Zonas'.
Grenfell, Bernard Pyne 12–13, 19–20, 26–34, 157
 and Arthur Hunt in the public imagination 29–31
 appointed Oxford Professor of Papyrology 19–20
 diagnosis of paranoid schizophrenia 26–7, 40n.134
 public lectures 29
 see also: 'Oxyrhynchus' and '*The Oxyrhynchus Papyri*'

haiku 79
Hale, William **Gardner** 3–5
Hamnett, Nina 140–3
Hardy, Thomas 129
Harrison, Jane 40, 69–70, 85n.40, 128n.74
Harrison, Tony
 The Trackers of Oxyrhynchus 27–8
 translations of Palladas 106
H. D. (Hilda Doolittle)
 and archaeology 158–61
 and Bryher (Annie Winifred Ellerman) 99–100
 and Freud 158

and photography 158–9
and the *Greek Anthology* 36–7, 85, 89–99
and the Oxyrhynchus papyri 36–7
and the Poets' Translation Series 27–8, 99–100, 110–11
and Sappho 36–8, 46, 93, 95–6
copy of Wharton's *Sappho* 26 with n.39, 36–7, 48–9
creative relationship with Aldington 99–100
in the British Museum 13–14, 81–2, 85, 127–8
meeting with Ezra Pound in or near the British Museum 83, 90–1, 145
pen name 83–4
transcribes Sappho in the British Library 17–18, 95–6
translations from Euripides 110–11
use of scholarly editions 48–9
Works:
'Aegina' 158
Asphodel 127–8
'Chorus Sequence (from *Morpheus*)' 37
'Demeter' 127–8
'Epigram (*After the* Greek)' 84–9, 93–4
End to Torment 109–10, 188
'Fragment' poems based on Sappho 37, 46, 48–9, 93, 95–6
'Garland' 80, 92–6
'Heliodora' 99–100
Heliodora 97
'Hermes of the Ways' 36–7, 84–5, 87, 95–6
'Hermonax' 95
'Nossis' 97–100
Palimpsest 158–9
'Priapus, Keeper of Orchards' ('Orchard') 84–5, 87, 94–5, 99–100
Sea Garden 95
'The Greek Boy' 127–8
'The Shrine' 95–6, 106
'The Wise Sappho' 36–7, 96–7
'Why Have You Sought the Greeks, Eros' 37, 98–9
see also: 'H. D. Scrapbook'
'H. D. Scrapbook' 159–61
Heraclitus 46–7, 58–66, 74–6
Herculaneum 151–2
Herodas 18–19, 22
Heseltine, Michael (translator of Petronius) 53–5
Hesiod 40
'High and Over' (Bernard Ashmole's modernist house) 124–6
Hipponax 107–8
Holden, Charles 164–7
Homer 13, 39, 66–76, 101–2, 151–2, 157, 175–6
 Odyssey 66–76, 101–2, 175–6

220 INDEX

Homeric Hymns 72–4
Hulme, T. E. 135
Hunt, Arthur 12–13, 19–20, 26–34, 157
 and Grenfell in the public imagination 29–31
 emendation used in the poetry of H. D. 37
 see also: 'Grenfell, Bernard Pyne',
 'Oxyrhynchus', 'The Oxyrhynchus Papyri'

Ibycus 18–19, 27–8, 46, 74–5
Imagism 13–14, 79–80, 83–5, 87–91, 93–4, 99,
 102, 105–7, 109–14, 127–9
Institute of Digital Archaeology 187–8

Jacobs, Friedrich 89–90, 103–4
Jacoby, Felix 46–7
Johnson, Samuel 107–8
Jowett, Benjamin 47
Joyce, James 173–6
 Finnegans Wake and papyrus discoveries 40
 Ulysses 34, 40–2, 67, 74–5, 157, 173–6

Kaibel, Georg 86, 89–90
Kalokairinos, Minos 172
Keats, John 8–9, 118
Kenner, Hugh 35, 46–7, 67, 72, 127–8, 149,
 151–2, 157
Kirchhoff, Adolf 68
Klee, Paul 173–4
Knossos 15–16, 67, 124–6, 151–3, 158, 172–82
kore 159, 161–70
kouros 151–2, 164–70
Kritios Boy 161

Lachmann, Karl 48
Lawrence, D. H. 40
Le Corbusier 124–6, 177
Legros, Alphonse 154n.20
Loeb Classical Library 48–9, 53
Lorimer, Norma
 The Wife out of Egypt 29–31
Louvre 118, 122n.49, 127–31, 134, 152–3
Lowell, Amy 37–8
Loy, Mina 37–8
Ludwich, Arthur 73–4

Mackail, John William
 reviews the Poets' Translation Series in the
 TLS 14, 81, 110–12
 Select Epigrams from the Greek Anthology
 13–14, 79–80, 85, 89–99, 102–4,
 106–8, 110
Marinetti, F. T. 152–3
MacKenzie, Duncan 173
Macpherson, Kenneth 159

Macpherson, Perdita 158
Marx, Friedrich 46–7
Marx, Karl 58–9
Masters, Edgar Lee 90, 110
Meleager of Gadara 89, 92–3, 95–100, 102–3, 108
Meleager (mythological figure) 101–2
Metropolitan Museum of Art 126
Michaelis, Adolf 151–2, 161, 167
Mirrlees, Hope 40–2, 48–9
 Paris: A Poem 40–2
modernism
 and waste 39–42
 definitions of 6–7, 6n.31
 mise-en-page and papyrology 33, 42
 'typewriter century,' 17–18, 42
Moero 14, 92–3
Monroe, Harriet 83–5
Moore, Albert 115, 116n.16
Moore, Clifford Herschel 54–6
Moschophoros 161, 170
Murray, Gilbert 68–70
Museum of Fine Arts, Boston 134

New Criticism 22 with n.32
Nicarchus 108–9
Nietzsche, Friedrich 8–9, 60, 63–4, 75–6
Nike of Samothrace 122n.49, 128n.71, 136n.119,
 152–3
Noack, Ferdinand 120
Nossis 14, 92–3, 96–9, 159–61

Ovid 40–2, 57–8, 74–5
Oxyrhynchus (el-Bahnasa) 12–13, 26–34,
 157, 167
 and the foundation myth of papyrology 27–8
 and modernism 34–44
 and the poetics of waste paper 40–2
 international reception of 34n.91
 in the popular imagination 29–31
 Latin texts found in 27n.46
Oxyrhynchus Papyri, The 31–3, 37
 and the poetry of H. D. 37
 and the typography of the fragment 31–3
 in Lorimer's *The Wife out of Egypt* 29–31
 international reception of 34n.91
 popularity of 31
 The Times book of the week 31

palimpsests 36–7
Palladas 106–8
Pater, Walter 60, 128n.74
Paton, William Roger 48–9, 79, 90,
 106 with n.136
Papyrus: A Magazine of Individuality 38–9

papyrology 17–44
 established as a sub-discipline 19–20, 27–31
 foundation myth of 27–8
 see also: 'Grenfell, Bernard Pyne',
 'Hunt, Arthur', 'Oxyrhynchus'
Parry, Milman 70–1
Parthenon
 restoration of 118–19, 135n.108
 sculptures from in the British Museum 117–49
 sculptures in the Acropolis Museum,
 Athens 187
Peschmann, Hermann 63–4
Petrie, Flinders 26n.40, 27–8, 30n.71, 157, 170–1
Petronius 50–8, 75–6
Pervigilium Veneris 57–8
Pevsner, Nicholas 124–6
Phidias 134–6, 171–2
photography 23, 158–61, 171–2, 187–8
Picasso, Pablo 113–14, 136, 164, 173–4
plaster casts 118–19, 148–9, 186
Poetry: A Magazine of Verse 4–5, 34–5, 71–2,
 83–91, 93–5, 102
Pompeii 151–2
Pope, John Russell 120–2, 124n.51, 126–7, 144–5
Pound, Ezra
 and Ibycus 46
 and Petronius 51
 and Sappho 17–19, 25–6, 34–5, 42–4, 72,
 77–8, 102, 183, 185
 and Stesichorus 46 with n.8, 74–5
 and the Greek Anthology 13–14, 100–9
 as archaeologist 157
 attempts at sculpture 156
 buys Gaudier's Torso III 140–3
 classical education of 70–1
 copy of Wharton's Sappho 26 with n.39
 edits H. D.'s poetry in or near the British
 Museum 83, 90–1, 127–8
 endorses Papyrus magazine 38–9
 in the British Museum 13–14, 81–2, 100–1,
 103–4, 128–9
 on H. D. 37–8, 94–5
 on Imagism 90–1
 on Jacob Epstein 14–15
 on the Bibliotheca Teubneriana 48, 73–4
 on T. S. Eliot 51, 56–7
 on world sculpture 113–14, 149
 Works:
 abandoned monograph on early Greek
 sculpture 170–2
 Cantos 4–5, 40, 66–76, 80, 157, 159–61
 Canto 1 13, 66–76
 Canto 4 74–5
 Canto 5 35, 74–5

Canto 8 56–7
Canto 14 74–5
Canto 23 74–5
Canto 25 152–3
Canto 39 74–5
Canto 63 74–5
Canto 64 51
Canto 80 81–2, 100–1, 113–14, 127–8
Canto 107 143–4
'Epitaph' 100–1
Gaudier-Brezska: A Memoir 170–1
'Greek Epigram' 102
Homage to Sextus Propertius 3–5, 104, 108
'Homage to Quintus Septimius Florentis
 Christianus' 102–9
Hugh Selwyn Mauberley 173–4
'Ἱμέρρω' ('O Atthis') 34–5
Lustra 17, 102
'Moeurs contemporaines' 100–2
'Papyrus' 17–19, 25–6, 34–5, 42–4, 72, 77–8,
 102, 183, 185
'Phyllidula' 102
A Quinzaine for his Yule 102
'Stele' 100–2
'The Caressability of the Greeks' 116
'The Cloak' 102
'The Spring' 46
Praxitiles 66–7
Preston, Raymond 63–4
Proust, Marcel 173–4

Quinn, John 140–3, 170

Rand, E. K. 54–6
rappel à l'ordre 114, 143–4
restoration 115–27, 186
 see also: 'derestoration'
Ribbeck, Otto 46–7
Richter, Gisela 169–70
Riegl, Alöis 122–4
Rilke, Rainer Maria 130–1
Rivière, Georges–Henri 151–2, 161, 168, 174–5
Robertson, Donald 119–20, 120n.44
Rodin, Auguste 129–36, 143–6, 154–6, 168–9,
 178–80
 Iris, Messenger of the Gods 131–4
 protests against the restoration
 of the Parthenon in
 Athens 135n.108
 sends Jacob Epstein a Christmas
 card 145n.155
Romanticism 8–9
Rouse, W. H. D. 66, 71–2
Russell, Bertrand 62

222 INDEX

Sappho 2, 17–26, 34–5, 45, 95–6
 and Amy Lowell 37–8
 and Ezra Pound 17–19, 25–6, 34–5, 42–4, 72,
 77–8, 102, 183, 185
 and H. D. 36–7, 46, 48–9, 93, 95–7
 and Sara Teasdale 37–8
 and T. S. Eliot 40–2, 45, 57–8
 'Fayum fragments' 22–7
 Fragment 1 21–2, 38–9, 45 with n.1
 Fragment 3 33
 Fragment 4 (= P. Berol. 5006) 25
 Fragment 5 27–8, 31–2
 Fragment 15 19 with n.8
 Fragment 16 28–9, 37, 98–9
 Fragment 36 35n.97, 45
 Fragment 37 45–6
 Fragment 65 37
 Fragment 94 58n.71
 Fragment 95 and Ezra Pound's
 'Papyrus' 17–19
 Fragment 96 34–5, 74–5
 Fragment 104a 58 with n.71
 Fragment 146 98–9
 fragment inscribed on an ostracon 19–20
 fragments on parchment and papyrus 17–19,
 22–45, 95–6
 fragments quoted by other authors 45–6,
 57–8, 64, 74–5, 93, 95–6
 in Firbank's *Vainglory* 29–31
 in The Poets' Translation Series 34–5,
 99–100
 Mina Loy as 37–8
Schlegel, Friedrich 8–11, 46–7, 58
Schleiermacher, Friedrich Daniel 46–7, 58, 60
Schliemann, Heinrich 67, 151–2, 157–9, 172
Schweighäuser, Johann 74–5
Schwob, Marcel 34
Sextus Empiricus 64
Shawn, Ted 173–4
Sibyl 56–7, 59–60
Sigeum Stele 82–3
Smith, Arthur (Keeper of Greek and Roman
 Antiquities, British Museum) 116–17,
 119–22, 126–7, 146
Sophocles 27–8, 34n.91, 37n.103

Stesichorus 46 with n.8, 74–5, 183
Stevens, Wallace 90
Stoppard, Tom 47
Storer, Edward 34–5, 110–11
Strater, Henry 73–4
Sullivan, J. P. 4–5, 51
Surrealism 7–8, 159
Symonds, John Addington 20–1, 25, 103n.124

Teasdale, Sara 37–9
textual transmission (direct and indirect)
 45–9, 64
 see also: 'papyrus', 'papyrology'
Thomson, James Alexander Ker 69–70
Thorvaldsen, Bertel 117, 120n.44, 186
Townley Venus 128
Treu, Georg 119–20, 135, 186

Vahlen, Johannes 46–7
Veii 151–2
Venus de Milo 118, 140–3, 186n.22
Virgil 39, 56–8
Vorticism 113–14, 135–40, 143–4, 170–2

Wadsworth, Edward 143–4
Waugh, Evelyn 177
Wharton, Henry Thornton 20–6, 187–8
 *Sappho: Memoir, Text, Selected Renderings
 and a Literal Translation* 8–9, 20–7,
 29–31, 34–7, 46, 48–9, 89–90, 95–6,
 98–9, 187–8
 'Fayum fragments' 22–7, 30n.74
Wilamowitz-Moellendorff, Ulrich von 68, 152
Wilde, Oscar 22, 34
Wilenski, Reginald H. 134–5, 144–5
Williams, William Carlos 128–9
Wolf, Friedrich August 46–7, 50
Woolf, Virginia 9–10, 31n.75, 40, 42–3, 48–9,
 50n.23, 81–2, 90
Wyndham Lewis, Percy 101–2, 113–14, 126,
 143–4

Yeats, W. B. 4–5, 81–2, 90, 128–9, 171–2

Zonas 85, 92, 94–5, 99–100